THE AUTHOR Dr Chambers was born in Queensland and though he has travelled widely and lived in other countries he has passed more than half his life in Australia. He has five degrees from universities and colleges on three continents and specialises in writing and teaching history and philosophy. His latter positions were Senior Lecturer at the Tasmanian State Institute of Technology and Visiting Professor at the City College of the City University of New York. This is his fifth book.

SERIES EDITOR Professor Denis Judd is a graduate of Oxford, a Fellow of the Royal Historical Society and Professor of History at the University of North London. He has published over 20 books including biographies of Joseph Chamberlain, Prince Philip, George VI and Alison Uttley, historical and military subjects, stories for children and two novels. His most recent book is the highly praised *Empire: The British Imperial Experience from 1765 to the Present*. He has reviewed and written extensively in the national press and in journals, has written several radio programmes and is a regular contributor to British and overseas radio and television.

Other Titles in the Series

THE TRAVELLER'S HISTORY SERIES

'Ideal before-you-go reading' *The Daily Telegraph*

'An excellent series of brief histories' *New York Times*

'I want to compliment you ... on the brilliantly concise contents of your books' *Shirley Conran*

Reviews of Individual Titles

A Traveller's History of France

'Undoubtedly the best way to prepare for a trip to France is to bone up on some history. *The Traveller's History of France* by Robert Cole is concise and gives the essential facts in a very readable form.' *The Independent*

A Traveller's History of China

'The author manages to get 2 million years into 300 pages. An excellent addition to a series which is already invaluable, whether you're travelling or not.' *The Guardian*

A Traveller's History of India

'For anyone ... planning a trip to India, the latest in the excellent Traveller's History series ... provides a useful grounding for those whose curiosity exceeds the time available for research.' *The London Evening Standard*

A Traveller's History of Japan

'It succeeds admirably in its goal of making the present country comprehensible through a narrative of its past, with asides on everything from bonsai to *zazen*, in a brisk, highly readable style ... you could easily read it on the flight over, if you skip the movie.' *The Washington Post*

A Traveller's History of Ireland

'For independent, inquisitive travellers traversing the green roads of Ireland, there is no better guide than *A Traveller's History of Ireland*.' *Small Press*

A Traveller's History of
Australia

For Reg Grundy, who took Australian television
to the world

A Traveller's History of Australia

JOHN H. CHAMBERS

Series Editor DENIS JUDD
Line Drawings *JOHN HOSTE*

INTERLINK BOOKS
An Imprint of Interlink Publishing Group, Inc.
NEW YORK

First American edition published in 1999 by
INTERLINK BOOKS
An imprint of Interlink Publishing Group, Inc.
99 Seventh Avenue • Brooklyn, New York 11215 and
46 Crosby Street • Northampton, Massachusetts 01060

The front cover shows Aboriginal paintings of Lightning Brothers
(Yagdjabula & Jabriringi) Photo © John Miles

Library of Congress Cataloging-in-Publication Data

Chambers, John H., 1939–
 A traveller's history of Australia/John H. Chambers. – 1st American ed.
 p. cm. – (The traveller's history series)
 Includes bibliographical references and index.
 ISBN 1-56656-323-2 (paperback)
 1. Australia–History. I. Title. II. Series: Traveller's history.
 DU112.C53 1999
 994–dc21 99-10052
 CIP

Printed and bound in Great Britain

To order or request our complete catalog,
please call us at **1-800-238-LINK** or write to:
Interlink Publishing
46 Crosby Street, Northampton, MA 01060
e-mail: interpg@aol.com • website: www.interlinkbooks.com

Table of Contents

Preface

It is one of the merits of this well researched and attractively written book that it begins with a thorough analysis of Australia's physical environment, its flora and fauna and of the aboriginal people who inhabited it for millennia prior to the arrival of the Europeans and the hegemony of the British. If the United States is sometimes sneeringly described as 'having no history worth speaking of', Australia is even more open to such ill-found dismissal. The fact that the 'first fleet', its holds packed with convicted British felons, did not make its landfall at Botany Bay until 1788 is partly responsible for this attitude. There again, it is less than one hundred years since the federation, or Commonwealth, of Australia was established thus bringing together the continent's various colonies and territories for the first time.

Having read this informative and intelligent book, nobody will end up believing Australia's history to be a slight and insubstantial affair. Not merely is the pre-colonial period a fascinating one, but the continent's subsequent story is full of extraordinary events and remarkable individuals. The strange thing is that the Portuguese and the Spanish did not get there before the rival north European colonial powers, the Dutch and British. In fact, the Spanish registered a near miss in 1606 when Luis de Torres, seeking the huge southern continent that ancient Greek geographers had argued must exist in order to balance the globe, sailed through the straits that bear his name but failed to sight the mainland. By then Dutch explorers had sighted Australia – more or less by accident it must be said.

Nearly two centuries later, the British established their control of Australia also primarily through an accident of history; the successful

rebellion of the American colonies had deprived the penal system of the convict dumping grounds of the deep south colonial settlements, and the apparently empty Australian continent seemed an appropriate replacement. Partly because of the transportation system, partly because of the low opinion Europeans formed of the native people, partly because of the sheer cussedness of the Australian environment, the continent was not highly valued for some considerable time. Early British observers saw a dark, barbarous landscape, a 'wretched place' where 'all nature was reversed'.

Certainly the first British settlers – free and convict – found little that reminded them of home. The seasons ran in opposite directions to those of the northern hemisphere, the skies at night contained strange constellations, the wildlife was bizarre and appeared to derive from an age before the ark, the woodlands seemed to shed their leaves all the year round and the gods which dominated the legendary landscape of Europe were totally absent. Nor was it easy to force a living out of the hot, red Australian earth: European grain, flung on the ground either failed to grow or withered and died on the stem; trees were so hard that they broke axes, and livestock failed to thrive as they did in lush, green English pastures.

Slowly the tide turned: gold was discovered at Ballarat and Bendigo and from all over the globe men left their loved ones and their homes to seek their fortunes beside some god-forsaken creek; more reliably, sheep farming proved so successful that Australia was soon supplying much of the wool that kept the mills of Halifax and Bradford turning. As the colonies prospered during the Victorian era, so a particular kind of English-speaking citizen emerged. He and she were hard working, practical and optimistic. They were mostly imbued with a passion for democracy and a commitment to 'the fair go'. Australian trade unionism was to become the most resolute and hard-bitten in the English-speaking world, and an easy going comradeship, often described as 'sticking by your mates' affected both shearing shed and burgeoning town.

But until fairly recently, Australia was also bound by a complicated emotional network to the 'old country', and to European ways in general, despite the rampant individualism and the lack of respect –

especially among Irish Australians – for English snobbery and class differentials. Where was 'home'? Could Australians, without the protection of the Royal Navy, defend themselves in their isolated position at the edge of Asia and in the face of what many perceived as the 'yellow peril'? If freer immigration policies were adopted would this not mean the end of old, English-speaking, fundamentally monarchist Australia?

As we approach the end of the millennium a good many of these questions seem either settled or nearly so. Nobody can doubt that within a few years Australia will become a republic and fully accept its Asian identity. Cosmopolitan, multi-cultural, self-confident and forward-looking, Australia has already become a cultural force to be reckoned with – whether judged by the phenomenal success of its TV soap operas, by its sophisticated film industry or through its international sporting success (of which still the most satisfying triumphs lie in dishing it out to the 'Poms' at cricket or rugby). Despite its relative youthfulness and its modest population size, Australia has truly arrived. Those who travel in increasing numbers to visit this familiar and yet unfamiliar country will be well advised to carry with them Dr Chambers's concise and wonderfully satisfying history.

Denis Judd
London, 1999.

Two Beginnings

Australian history began twice. The first beginning is lost in the mists of time at least 53,000 years ago and, a few archaeologists are beginning to speculate much longer than that, when the first Australian Aborigines reached the continent. At intervals during most of this vast time they continued to come. They were aided by land bridges exposed during the last ice age when the surface of the world's oceans was several hundred feet lower than it is today.

At first they probably travelled in small groups of a few families, out of eastern Asia, across the Indonesian archipelago and perhaps New Guinea, and slowly they colonized Australia. Archaeologists have distinguished several different racial types arriving at different times. With the final land bridges disappearing underwater about 10,000 years ago, the last Aboriginal occupiers would have had to come partly by sea, and some arrivals may even have been as recent as 3000 BC.

The Aborigines kept no record or memory of these Asian origins, and produced creation myths to account for their existence. But folk memory retained certain traces of their long history. For instance, long cross-sea canoe journeys feature in many Aboriginal legends.

The second beginning of Australian history was also a coming of a new people, this time Europeans. And they carried with them not folk memory, but writing and books and scientific knowledge, and all the paraphernalia of the emerging modern Western political, economic, and industrial world. This second beginning took place on precise dates, 18, 19, and 20 January 1788, when eleven British sailing ships, containing 736 convicts (188 women) and about 300 free persons –

mainly marines to protect the colony – landed in Botany Bay in what is now the state of New South Wales.

The modern Australian nation is the complex result of these two very different beginnings.

The Physical Environment

The immemorial way of life of the Aborigines was determined in large measure by the physical environment of the continent. Similarly, when the white settlers arrived and moved inland from Sydney and then from the other early settlements, it was the physical features and climate which were to make or break their pioneering. The 210 years of white settlement have been a continual struggle with a continent far more recalcitrant than the pioneers had to face in the Americas. Settlers pushing west from the coast of Australia met a desert like that of Arizona about 400 miles from the ocean; in comparison, North American settlers 400 miles from the east coast reached the green and pleasant lands of Ohio and Tennessee.

Physical Geography

A popular misconception about Australia – one that endures because it seems to explain its uniqueness and idiosyncracies – is that it is the oldest of all the continents.

In fact, the cores of all continents are about the same age. Rocks of every geological age, volcanic, sedimentary and metamorphic, are to be found in Australia. The erroneous belief about age is fed by the fact of the continent's bland and eroded surface. This surface is the long-term product of Australia's relative stability and the absence of geologically recent movements of the Earth's crust, such as those that built the Himalayas and the Rockies. The Australian continent sits squarely in the middle of a tectonic plate. And it is on the edges of this plate, in New Zealand, and in various Indonesian islands, that the volcanoes of the region exist, and the greatest earthquakes take place.

3

The continental mass has three great basic structural units. First, in the west is a stable and resistant shield, made up of ancient rocks that have remained unfolded during the last 1000 million years. Today, this Western Plateau covers close to two-thirds of the continent. Mostly flat, it averages between 1000 and 1500 feet above sea-level. Here and there it is interrupted by spectacular, sharply rising inselbergs (isolated hills above flat plains) such as Ayers Rock (Uluru), by large clusters of ancient inter-related sandstone fold ranges, and plateaux such as the Kimberleys of the north-west, by old folded ridges such as the Mac-donnell Ranges in central Australia (which were as tall as the Himalayas about 300 million years ago) and the Flinders Ranges in South Australia, and by vast, shallow, blinding-white salt 'lakes', which may temporarily fill with water once in a generation or two. On the west coast, occasional slow-flowing rivers have cut their way to the sea. The oldest rocks of the continent lie in the south-west of this region, and are believed to be about 3000 million years old.

Second, in the east lies an ancient belt of fold mountains, greatly eroded but also uplifted and eroded again, and its attendant eastern coastal plain. This is the area of the Great Dividing Range which traverses the whole eastern part of the continent, and is so called because it divides the eastward-flowing rivers from those flowing west. The greatest elevations occur in the mountains and plateaux of the south-east, in New South Wales and Victoria, in the section of the Great Dividing Range known as the Australian Alps. Here stand the continent's highest peaks, including Mount Kosciusko which, at 7310 feet, is a mere mound by world standards but a monster in low-lying, flat Australia; the surrounding region, an area larger than Switzerland, is covered in snow in winter. The Range reappears across Bass Strait in the mountains of Tasmania. The eastern coast plain is the best drained and most fertile stretch of land in Australia, and from the Great Dividing Range many considerable rivers cross it to empty into the Pacific Ocean.

In the ocean for about 1250 miles along the Queensland coast stretches the greatest entity currently constructed by biological organisms: the Great Barrier Reef. Some 200 miles from the coast in the south near Gladstone, as the English navigator Lieutenant James

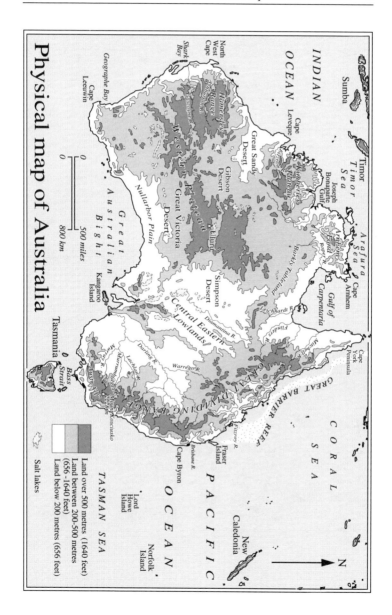

Physical map of Australia

Salt lakes

Land over 500 metres (1640 feet)
Land between 200-500 metres (656 -1640 feet)
Land below 200 metres (656 feet)

INDIAN OCEAN

Sumba

Timor

Timor Sea

Arafura Sea

Cape Arnhem

Cape York Peninsula

Gulf of Carpentaria

Joseph Bonaparte Gulf

Arnhem Land

North West Cape

Cape Leveque

Great Sandy Desert

Kimberley

Kimberley

Hamersley Range

Geographe Bay

Cape Leeuwin

Shark Bay

West Australian Plateau

Gibson Desert

Great Victoria Desert

Western Plateau

Nullarbor Plain

Great Australian Bight

Kangaroo Island

Uluru

Simpson Desert

Central Eastern Lowlands

Diamantina R.

Darling R.

Warrego R.

Barkly Tableland

Leichhardt R.

Flinders R.

Mitchell R.

GREAT DIVIDING RANGE

GREAT BARRIER REEF

Fitzroy R.

Brisbane R.

Cape Byron

Fraser Island

CORAL SEA

Murray

Murrumbidgee R.

Lachlan R.

Murray R.

Mt Kosciusko

Bass Strait

Tasmania

TASMAN SEA

Lord Howe Island

Norfolk Island

PACIFIC OCEAN

New Caledonia

0 500 miles
0 800 km

N

Cook (1728–79), would find to his dismay in 1770, it gradually approaches the coast to be just 20 miles off Cairns, and even closer in some far northern areas off Cape York.

Third, between the Western Plateau and the Great Dividing Range is the area of the central plains, or the Central Eastern Lowlands which slope slowly west from the Dividing Range; their metamorphic or folded rocks are covered by sedimentaries. These plains involve several huge geographical basins that stretch from the southern edge of the Gulf of Carpentaria through the Queensland Channel Country and into the continent's greatest water system, the Murrumbidgee-Murray-Darling Rivers. Underground, in the sedimentary rocks of these central plains, lies the great artesian water basin, which has been collecting the western run-off from the Great Dividing Range during tens of thousands of years. In the last 100 years, these artesian waters have made pastoral activities possible in this otherwise dry region.

Of Australia's almost three million square miles only 6 per cent lies above 2000 feet, a situation due mainly to the long period during which there has been endless wearing and erosion and no significant geological uplift, no folding and buckling to produce new and lofty mountain ranges. Lack of young mountain ranges has also prevented the deposition of new and fertile alluvial soils. This fact has contributed to the barrenness of so much of Australia.

Climate

Excepting Antarctica, Australia is not only the flattest continent, but the driest – a fact which would spell disaster for many settlers. Australia straddles the driest belt of the southern latitudes. In northern and southern hemispheres such latitudes contain the world's deserts. About a third of Australia, close to a million square miles, is desert, another 700,000 square miles is semi-desert or steppe country. Only the Sahara and the deserts of Central Asia can compete in size with the Australian desert. If the continent lay nearer the pole (or nearer the equator), as it did in the ancient past, it would receive a higher total of rainfall. The semi-desert areas of Australia are expanding: in prolonged

droughts, dust storms, occasionally with fronts as long as 500 miles carry away the top soil.

Some 40 per cent of Australia lies within the tropics. The far northern parts thus receive rain from the summer monsoons as the sun in its apparent path moves south to the Tropic of Capricorn. (The people of the far north talk about the two seasons of the year: The Wet and The Dry – both are hot.)

The south-west and south-east sections of the continent receive winter rain as the sun 'moves' north towards the Tropic of Cancer, and generally experience a climate like that of Mediterranean countries, but rather hotter in summer. The whole east coast receives rain throughout the year from the Trade Winds, with some seasonal variation, but the amount of rain decreases rapidly further inland, for the tangled mountains of the Great Dividing Range draw off most of the moisture. Thus, only in the east and south-east coastlands is rainfall enough to support a quality of vegetation sufficient to protect the surface from erosion.

Except for that of the far north and the east coast (about one-seventh of the continent only), Australian rainfall is also extremely unreliable. Everywhere in Australia rainfall also declines rapidly further inland. It is this lack of rain and its unreliability which would make so much pioneering of inland Australia problematic. The great almost million square miles of desert average less than 10 inches of rain a year, and half of that less than 5 inches. In some years there is no rain at all. The semi-desert receives less than 20 inches of rainfall. In contrast, much of the east coast plain and the northern parts of Western Australia and the Northern Territory (about 10 per cent of the country) receive over 40 inches, and substantial pockets in northern Cape York Peninsula receive more than 60 inches a year. Here lies a belt of tropical rainforest or jungle which receives the highest rainfall in the continent.

With so much tropical land and desert, Australia is a hot country. The town of Marble Bar in Western Australia holds what is probably the world record for a sustained heatwave, with 152 days at over 100°F and an average maximum of 109°F. Even the city of Melbourne, far away on the Mediterranean-like south coast, normally endures some summer days of 100°F or more.

Flora

Evolution has done much in the forty or so million years during which Australia has been separated from the other continents, and has produced the unique fauna and flora that so delighted the English naturalist, Joseph Banks (1743–1820), on Cook's expedition.

The richest habitat is the tropical rainforest, mostly in far north Queensland, but also in patches of the Northern Territory and Western Australia. The usual vegetation of the tropics is sparse eucalypt savanna, with torrid mangrove swamps on the coast.

Great forests also cover much of the Great Dividing Range. Most of Australia's trees are eucalypts (or gum trees), with some 360 known species. These vary from the magnificent 300–foot karri of the south-west and the great mountain ash of the coastal forests of Victoria, through the red gums and ghost gums, to the low-growing mallee scrub of the semi-desert, its long roots seeking far for their water. West of the Great Dividing Range was originally mostly great savanna lands studded with eucalyptus trees, many of which have now been felled to make way for agriculture and grazing. In many present-day pastoral areas, native grasses have been replaced by high-yielding imported varieties.

Terrifying, rapidly moving bushfires are regular features of Australian eucalyptus forests, for the trees' oils burns fiercely. The seeds of some eucalypt species even require fire to enable them to germinate. Over eons the Aborigines had developed a way of life that made allowance for such fires but, when the settlers arrived, these dangers had to be newly met and coped with.

The desert and semi-desert are home to the low-growing acacias, the mulga or brigalow, and, in still-dryer areas, to the saltbush and the corroded-green spinifex. Meanwhile, the seeds of multifarious plants lie dormant for years to await the rare rainfall that allows them to flower in all their colour and magnificence for a month or two.

Botanists still find surprises. Only in 1989 was the pseudo-oak, *Allacasuarina portuensis*, identified.

Marsupial Fauna

In the ecological niche left empty because there were no mammals, the isolated Australian continent evolved the quasi-mammals, the marsupials, with their pouches in which the young sit, suckle, and grow strong. Instead of the horse came the kangaroo; instead of the bear, the koala; instead of the monkey squirrel and opossum, the possum; instead of the dog or wolf, the thylacine; instead of the cat, the wombat dasyurid and Tasmanian devil.

Kangaroos and wallabies inhabit most parts of the country. They have developed in considerable variety, from the great red more than 6 feet tall, to the tiny quokkas of Rottnest Island near Perth, originally mistaken for rats. There is also the cat-sized musky rat-kangaroo of the north Queensland forest, the only kangaroo that does not hop, but gallops. Koalas, which do not drink, have evolved to eat only eucalyptus leaves and only a very few species of these, and spend some 20 hours of the day asleep. But nothing has emphasized the peculiarities of Australian animals so much as the amphibious monotreme, the platypus. Half-way on the evolutionary ladder between reptiles and mammals, the platypus is leathery duck billed, with web-footed legs, and sharp claws attached. Its body and flat tail are covered in thick fur. It is egg-laying, possesses a cloaca (single alimentary, urinary, and reproductive aperture), and eats most things voraciously, including grass, worms, butterflies, small fishes, and small crustaceans. It lives in the cool streams of the eastern mountains. This collection of attributes is so bizarre that the first preserved specimen sent to Britain was thought to be a hoax.

In Australia there were no flying marsupials. But unique bird life, such as the ostrich-like emu, the black swan of the south-west, the raucous kookaburra, the screeching multicoloured cockatoo parrot and galah, the magnificent mimicking lyrebird, the bower-bird that hoards shiny objects, and the tiny colourful budgerigar, all added to the uniqueness of Australia.

Then there were the dozens of different lizard species, including, at more than 6 feet long, the formidable Perentie of central Australia, and the freshwater and saltwater crocodiles in the tropics, some of the latter

growing to more than 20 feet. And there are hundreds of species of snakes, more than half of them venomous. The latter include some of the world's most deadly snakes, the so-called Fierce Snake of south-west Queensland, the Taipan (almost as bad), and the Tiger Snake.

Such was the vast and challenging environment first mastered by the Aborigines, and much later met with by the white explorers and colonists.

CHAPTER TWO

Aboriginal Australia

The Australian Aborigines pursued a nomadic life, hunting and gathering. Although they painted complicated, often beautiful, symbolic murals in caves and on rocky outcrops, like several other civilizations they did not learn how to write. They were not seafarers; and, cut off from contact with other continents, they did not grow crops, or use metals, or make pottery. Like the Native Americans, they failed to discover the wheel, and they built no roads or towns. As far as we know, in all that protracted period of time and in all Australia's nearly three million square miles they rarely built a habitation more substantial than a tiny one-room hut with mortarless stone walls 3 or 4 feet high, covered with a roof of brush and bark. In fact, because of their nomadic lifestyle, most Aborigines lived in temporary bark and brush huts.

Nevertheless, theirs is today the world's oldest continuous culture, with easily the world's oldest continuous religion. And their religion and culture were embedded in a way of life most subtly adapted to the environment and to the seasonal supplies of food. More than that, they had achieved a successful, almost symbiotic relationship with the land, living within it without destroying it or the other living species that depended upon it.

Substantial racial similarities have been noted between the Aborigines of Australia and other aboriginal groups such as the Mundas of central India, the Veddans of Sri Lanka, and even, some anthropologists argue, the Ainu of Japan. Such resemblances are strong evidence for an Asian origin.

Fruits of Archaeology

Australia is a barren continent. To appreciate how barren, one needs to fly across it. Hour after hour, one looks down upon the parched reds, browns, rusts, ochres, and greys of the inland, with its ancient plateaux and moulded and buckled mountain ranges, and its dry riverbeds. But there are fertile exceptions in the south-west, the south-east, the east coast, and the northern tropics. When one traverses the Yellow Water Billabong, and other primeval, unspoiled waterways of Kakadu National Park in the tropical Northern Territory, the sights and sounds might come straight from the Book of Genesis: vast waves of Jabiru (storks) and Water Whistle Ducks take to the air, and monstrous crocodiles lie in wait for the unwary animal or bird. Kakadu, like many other parts of the continent, remains just as it has been from the very earliest times of Aboriginal settlement. This is fortunate, for Kakadu and similar areas help us today to understand the Aboriginal way of life during all those thousands of years.

During the last fifty years, modern archaeology has revealed the extent of Aboriginal antiquity across every part of the continent, in such wonderful discoveries as: the earliest human occupation, 53,000 years ago at Malakunanja in the Northern Territory; the wall paintings of Koonalda Cave in South Australia, some 200 feet underground; the 26,000-year-old cremated remains of a young woman at Lake Mungo in New South Wales (the world's oldest evidence of cremation), as well as ancient heating bricks for cooking; the 19,000-year-old flint tools of Kenniff Cave in the Great Dividing Range of Queensland; the remnants of forty or so male bodies buried at Kow Swamp near the Murray River in Victoria, the skulls of which have strongly marked eyebrow ridges, receding foreheads, and large jaws which indicate an Aboriginal type distinct from those in other parts of Australia; the 24,000-year-old ground-edged axes discovered at various sites in Arnhem Land, Northern Territory, which have special grooves for fitting a handle – an innovation earlier in Australia than in any other continent.

Every few months archaeologists reveal something new and startling.

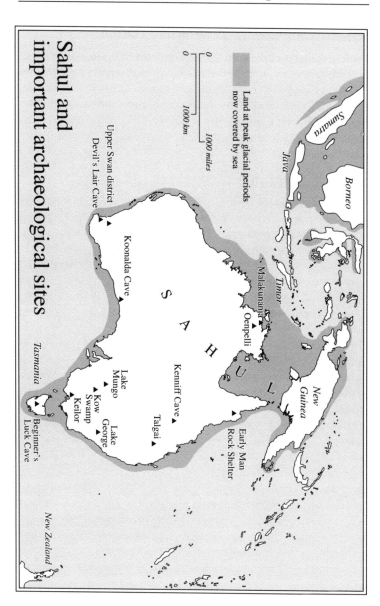

Sahul and important archaeological sites

Land at peak glacial periods now covered by sea

0
1000 km
0
1000 miles

Sumatra
Java
Borneo
Timor
Malakunanja
Oenpelli
New Guinea
Early Man Rock Shelter
Upper Swan district
Devil's Lair Cave
Koonalda Cave
S A H U L
Lake Mungo
Kenniff Cave
Kow Swamp
Keilor
Lake George
Talgai
Tasmania
Beginner's Luck Cave
New Zealand

Tribes, Languages, Territories, Battles

Because the level of the world's oceans was much lower at the time of the Aborigines' first arrival than it is today, what is now the Australian continent was joined to the large islands of New Guinea and Tasmania, and, with the additional land all around the coast, Australia proper was about a sixth greater in area than it is now. To distinguish it from the present landmass, historians and anthropologists call this older Australian landmass 'Sahul'.

A CHANGING ECOLOGY

For many of those tens of thousands of years, the Aborigines shared the continent with several species of giant herbivorous marsupials such as: the 7-feet-high, lake-dwelling Diprodoton – rather like a monstrous hippopotamus and perhaps related to the wombat; the forbidding, flat-faced, giant kangaroo, Procoptodon, which could stand 10 feet tall; and even Thylacoleo, a marsupial lion. Aboriginal legends recall these giant animals with fear and awe. Climatic changes contributed to the extinction of these marvellous creatures, perhaps assisted by Aboriginal hunting.

The ocean's waters rose, the climate changed, and the landscape of Australia slowly became drier. The Aborigines adapted themselves to these changes, and evolved a way of life that was highly appropriate to the unique and often unforgiving environment. Australia is a continent lacking large mammals such as cattle, sheep, and pigs to be domesticated: as a result, the Aborigines became hunters and gatherers.

TRIBES

Aboriginal population was never large. Traditionally, the figure given for 1788 has been about 300,000 individuals but some recent scholars claim there were perhaps a million. Given the absence of agriculture and of pastoral pursuits in the Aboriginal lifestyle, the larger figure seems unlikely. Perhaps 500,000 people is a reasonable assumption. Several cultural factors would also have restricted the population. Until they were about three years old, children were fed on mother's milk,

thus limiting pregnancies; and, in some regions, men refrained from sex while women were breast-feeding. Again, as far as we know, Aborigines did not live to an old age. For one thing, living in the open, they were attacked by natural enemies, bitten by venomous snakes, and, in the tropics, all too often taken by crocodiles. Population was also reduced by fighting.

In the eighteenth century, there were an estimated 500 tribes (if that is the right word). Tribes consisted of from just a few hundred people to several thousand, but there was no strong central authority within the tribe as is found in other continents among, for example, the Zulu of Africa or the Cherokee of North America.

There were elders but no tribal chiefs. Among the males there were no superiors or subordinates, no masters or servants. There were only two classes, the superior males and the inferior females. Nevertheless, there were differences of status based on the knowledge of tribal tradition. For it was tradition that ruled the tribe and Aboriginal culture more generally. And it was the old men who understood and were the repositories of tradition. They would pass it on to the younger men when they revealed themselves as worthy.

Extended family groups, or clans, were often fairly autonomous and, because of the difficulty of procuring enough food, many tribes – particularly the large ones – would never actually come together as a whole, not even at ceremonies. The egalitarian relationships among the men probably derived from the fact that the Aborigines lived off the immediate land, had no storable wealth, and so could not accumulate wealth to produce social divisions.

Each tribe called itself by one name but was given a different (and usually insulting) name by its several neighbours. Regular relationships between tribes might extend over distances of 100 or 200 miles but, in no sense of the words, were the Aborigines a nation or a state.

Depending on size, tribes might be divided into clans, clans into moieties, and moieties into sections, each with its own important totem, with which the people had a continuing ritual connection. There were, of course, traditional, intricate, and strict rules for social relationships between such parts of a tribe.

The Aborigines of Tasmania, the large 26,000-square-mile island to

the south of mainland Australia, were racially slightly different, probably the descendants of an early wave of immigration cut off from contact with mainland people by the formation of Bass Strait some 12,000 years ago. In contrast to the straight or wavy hair of the mainlanders, the Tasmanians had frizzy hair and generally darker skins. Very likely, one or more of the other racial branches of Australian Aborigines invaded their lands and drove them far to the south. Their population was perhaps never more than 3000 or 4000. These Tasmanians would once have been the world's most southerly people, until the Patagonians and Fuegans populated southern South America.

TERRITORIES

The Nyungar people of the central south-west of the continent are also racially distinguishable from peoples of the north and east, further suggesting that the Aborigines occupied the continent through several waves of invasion. Perhaps the Nyungars, like the Tasmanians, were also pushed into a far corner by later-comers.

Land, the giver of life, was regarded as belonging to the whole tribe. That some piece of land could be 'owned' by an individual person, or that the tribal lands could be held by a chief on behalf of the tribe were ideas not just alien to Aborigines, but entirely inconceivable. Reciprocally, within their complex metaphysics, the tribe also 'belonged' to the land.

Tribal lands were large in the dry red heart of the continent, smaller in the regions of the east coast where rainfall was more plentiful. Where possible, territories were marked by natural barriers such as rivers. The elongated harbour on which the modern city of Sydney stands was one such boundary. Given the detailed and subtle Aboriginal knowledge of the land and its vegetation, however, much of it handed down in songs and chants, lack of such physically obvious features was no problem. The demarcation of tribal lands, invisible to non-Aboriginal eyes, would have been well known to everyone in adjacent tribes. This is why since the earliest days of European settlement, Aborigines – so-called 'Black Trackers' – have been used to help in the pursuit of convicts, criminals, and bushrangers (highway robbers) fleeing across the outback. Hunting and gathering were allowed to cross such tribal

boundaries provided permission had been obtained. This was usually given because reciprocal permission might be needed in times of scarcity.

In parts of the continent, such as Cape York Pensinula in the lands of the Yit-Yorant people, tribal claims to specific areas were much more loosely defined. Tribal territories interleaved and overlapped, and neighbouring tribes mingled, foraged, and hunted in one another's lands.

Where boundaries were strict, unauthorized trespass was strongly repulsed, and spearings and even battles and wars (an extended series of battles) could result. Enmity between tribes could be intense. There is even evidence, pre-1788, of one tribe usurping the territory of another. Thus, the Konejandi people of the far north-west had their plains lands (but not their hilly territories) taken from them forcibly by Walmadjari. The Koreng tribe of the areas that are now the Western Australian wheatlands were also forced farther west by their neighbours.

BATTLES

The vast area of Australia and the small Aboriginal population helped limit intertribal conflict, but it was still common. Most battles between tribes were over hunting territory, but honour was often satisfied without a death.

But one significant source of friction and death was the destructive tradition of 'pay-back' which, like the vendettas of the Caucasus Mountains, might continue endlessly in a sort of stop-go warfare. Deaths from fighting clearly helped restrict the population. In one tribal battle recorded in 1875 in central Australia, about 100 Aborigines were killed, including women and children – indeed, in this encounter, the limbs of the infants were deliberately smashed.

A deadly weapon used in the highlands of the south-east was the barbed death spear, which consisted of a row of rough stone fragments sealed with the gum of the Grass Tree into a groove at the spearhead. Because of the angle of the chips, when the head entered animal or human being it could not be pulled out and caused fatal loss of blood. But, unlike almost every other culture in world history, as far as we know, the Aborigines refrained from cold-bloodedly capturing and

torturing their enemies. After a battle, however, they might sometimes rope the enemy's women.

LANGUAGES

There were approximately 250 Aboriginal languages most comprised of several dialects, more than half of which are now dead. Besides their own language, it is likely that most Aborigines could speak some of the language of neighbouring tribes.

These languages were quite complex – the grammar book for one extant language running to some 500 pages. Though their vocabularies were less than that of a modern European language, they were immensely subtle in the descriptions of things upon which life depended, or which interested them. For instance, living in the open air, the Aranda of Central Australia had words not just for sunset, but also for the short period just afterwards when the sky is coloured red and yellow, and a third word for twilight. Indeed, eighteen words were used to describe the subtly different phases of the night.

Large numbers of words derived from many different Aboriginal languages have entered modern Australian English. From the Sydney region came boomerang, corroboree, dingo, gin (woman), wallaby, wombat, koala; from southern South Australia, willy-willy (a whirlwind); from Perth, karri (a eucalyptus tree), jarrah (a tall, very hard eucalyptus tree); from inland Victoria came mallee (a stunted tree), mulga (a kind of wattle tree); from inland New South Wales, billabong (a cut-off river meander), and budgerigar (a bird); from south-east Queensland came yakka (work), and barramundi (a fish); from north Queensland came cooee (a call to signal one's whereabouts in the bush), and, most famous of all, kangaroo.

Folk memory kept alive much ancient information in a non-sequential form. For instance, any map of the Australian state of Victoria will show you that the city of Melbourne stands on the Yarra River, at the northern end of the wide waters of Port Phillip Bay, and that the bay joins the ocean through what are called The Heads, some 30 miles to the south. But, in 1857, a Victorian Aborigine reported that his grandfather had traced the Yarra River across dry land until it entered the ocean at The Heads! Now it is a fascinating fact that

modern undersea mapping techniques have revealed that there certainly is an underwater river valley running from Melbourne all the way to The Heads! So was all Port Phillip Bay actually dry land as recently as 200 years ago?

Of course not. For it was not the Aborigines' *grandfather* who had traced the old, longer Yarra River, but his great-great-great ... grandfather hundreds of times over! Amazingly, ideas about Sahul, the old larger Australia, some 16,000 years ago before the rising of the oceans, had thus been handed down generation upon generation and so kept in Aboriginal folk memory throughout that immense span of time!

Dependence on the Natural Environment

Because of the complete dependence upon the bounties of nature in a specific region, the lifestyle of a particular Aboriginal tribe varied from a continual struggle for existence in the semi-desert regions of the inland, to an easy-going, almost lotus-eating life in the most fertile and well-watered coastal areas.

FOODS

Life on the western plains and in the great inland, involved a continual search for sustenance, but intelligently took into account the food available at different places at a particular season. There were roots, nuts, berries, seeds, ants, gum, native honey, grubs, caterpillars, lizards, snakes, small rodents, birds, including emus and emu eggs, and, where possible, wallabies and kangaroos.

Life was less harsh on the coastal plains and in the forests of the east, where the women would gather the wild fruits, dig for yams (a welcome part of a diet containing few sweet foods), and take seafood from the shallower waters; and the men would catch small sharks, spear fish in the rivers, kill possums and koalas, and hunt the multitudes of wallabies and kangaroos. Indeed, even today, one of the most profound sights of Australia for those fortunate enough to see it is a mob of fifty or so kangaroos stirring a great cloud of dust and grass as they thunder past, following their leader in their huge, rhythmic, elongated leaps across

the open country. One can imagine the excitement such a mob of kangaroos would have presented to hunting parties during the halcyon days of Aboriginal life.

In well-watered areas of the south-east were hundreds of thousands of ducks, brolgas, swans, and wild turkeys. Skilfully hit in flight by boomerang or stone, taken by slip nooses attached to long sticks, caught in grass-covered pits dug near the edge of lagoons, or grabbed by a stealthy underwater swimmer breathing through a reed tube, they provided much-welcomed food. In the rivers and pools of the east coast, turtles and young Platypuses also provided a luscious treat, together with crayfish and yabbies. On the coast occasional stranded whales were a welcome variation in diet.

Aboriginal diet, especially in the more fertile areas, appears to have been well balanced. By adopting Aboriginal foods, the first British settlers in Sydney counteracted an outbreak of scurvy. Certainly Aborigines made use of a wider and healthier range of foodstuffs than has the average European in the last few millenniums.

Sharing of food, indeed of most things – an ingrained reciprocity – characterized traditional Aboriginal society. Two environmentally related facts encouraged this social morality. First, there was no private land, tribal areas being held in common, with flora and fauna the 'possession' of all. So natural, ingrained, and immanent was this communal 'ownership' that tribes as far apart as Port Phillip and Cape York Peninsula had no word for 'thank you'. Second, the extended family was the economic unit for hunting and gathering, and had the ability to provide for every need.

REGULAR TRIBAL MOVEMENTS

Though deeply committed to their own territories, Aborigines rarely if ever settled in one place. They might stay for a few weeks or months in one location but, with few exceptions, they moved regularly.

Either sections of a tribe moved in sequence among time-honoured camping areas sited near rivers or billabongs or, in the semi-desert regions and over much larger areas, small family groups moved from water-hole to water-hole. Where possible, the Aborigines stayed in caves but they normally lived in 'gunyahs' or 'mia mias': tiny makeshift

huts formed from large pieces of bark, branches, and sundry other vegetation laced together with grass string or strips of bark. In any case, in good weather most Aborigines preferred to sleep in the open.

The Weipa people of Cape York Peninsula and some of the inhabitants of Arnhem Land moved less frequently. To facilitate the harvesting of the abundant sea-life which formed their staple food, they built their mia mias on the shore, sometimes right next to the water's edge. In the yearly wet season they necessarily moved to higher ground, but returned to the beaches when the rains ceased. Over hundreds of years, these Aborigines left massive middens of discarded shells. The great mounds near the modern bauxite-mining town of Weipa contain an estimated 9,000,000,000 shells!

All Aboriginal travel was made on foot, for there were no transport animals in Australia. Just as there were no horses in the Americas before the arrival of the Spanish, so there were no horses or cattle in Australia before the arrival of the British. And donkeys, camels, and buffaloes were not introduced until the mid-nineteenth century. So, before 1788, the largest Australian land animals were all marsupials, and the largest marsupial was the kangaroo: and you cannot ride a kangaroo or put a load on its back! (It is interesting to note that, after the arrival of Europeans, the word many Aborigines used for 'horse' meant 'white man's kangaroo'.)

THE MOTH-HUNTERS

The most fascinating example of seasonal movement was that of the Ngayawun tribe of the south-east, who lived not far from the present site of Australia's federal capital city of Canberra.

Each spring the Ngayawun travelled into the brisk heights of the Snowy Mountains, when the Snow Daisies were in bloom. They were on the trail of the Bogong Moth, the nutty sweetness of which they considered a special delicacy. This moth migrates hundreds of miles each year from its breeding grounds in the plains of western New South Wales and southern Queensland to spend the summer aestivating (in torpor) in cool, dry, dark crevices on the mountain tops: as many as 13,000 have been counted on a square yard of rock. (In some years they are blown off course and fail to reach the mountains – huge numbers

are then washed up on the beaches of Sydney.) With bell-shaped kangaroo skins and nets of bark fibre, the Aborigines would catch the moths in their thousands by scraping them from the crevice walls with sticks. Then they would roast the bodies in hot ashes and feast on them for weeks, growing fat. Sometimes the moths were ground to make a flour for 'moth cakes' to take with them. Initiation ceremonies would also occur (often the women were forbidden to eat the moths) after which the Ngayawun would return to the plains to resume their normal hunting and gathering.

TOOLS AND TECHNIQUES

Though their skills in using them were remarkable, most Aboriginal tools were basic: flint and other hard stones for cutting and scraping; pieces of wood and stone for wedges; stone axes, stones for grinding; bones for needles; bark and woven grasses for baskets and fishing nets. The Aboriginal people used scooped-out wooden dishes and cradles of bark, made long spears, and invented the woomera or spear-thrower. This was a brilliant extension of the arm, which allowed the thrower to use leverage to impart great velocity. Early British settlers were impressed by the extraordinary power and accuracy with which Aborigines could launch their spears. Unlike hunter-gatherers in other parts of the world, the Aborigines (except for a handful of people nearest to New Guinea) failed to discover the bow and arrow.

Long pieces of bark tied together with vine at the ends, with sticks as thwarts amidships, were used as fishing boats. Captain Watkin Tench (1758–1833), an officer of marines, who landed with the First Fleet in 1788 reported: 'Their dextrous management of [these canoes], added to the swiftness with which they paddle and the boldness that leads them several miles in the open sea are highly deserving of admiration.' In recent centuries, through links with Melanesia via the Torres Strait Islanders, the tribes of Cape York Peninsula in the far north made use of outrigger canoes. Also in recent centuries, the tribes of Arnhem Land acquired dugout canoes through links with the Macassans. In the riverine areas of the east coast, complex arrangements of simple materials for fish traps and weirs were set up.

Dingoes were sometimes used in hunting. These so-called 'native

dogs' perhaps entered Australia around 3000 or 4000 BC, possibly during a final Aboriginal invasion. Dingoes had a disastrous effect on native animals, and therefore on the Aborigines' sources of food as well. They soon killed off the carnivorous, dog-like marsupial thylacine, which then survived only in the dingo-free island of Tasmania. (There it later became known to white settlers as the Tasmanian Tiger, or Tasmanian Wolf.) The dingo would have destroyed many of the young of kangaroos and wallabies, other marsupials, and ground-nesting birds, until some sort of natural balance returned. Dingoes were often domesticated. Their pups were mothered by Aboriginal women, sometimes with milk from their own breasts.

The Aborigines went hatless and naked, or almost so, though they might wear kangaroo skins and possum or koala furs in cold weather. They were barefoot except for a sort of sandal sometimes used on the hot inland deserts. The tribes of the highland south-east, such as the Ngayawun, were the exception, wearing skin clothes for much of the year. Aboriginal hunters nimbly climbed trees to catch such animals, with their stone axes cutting toeholds up the trunk at intervals of about a yard.

The Aborigines had learned to make fire, and it was of great importance. Because fire-making was an onerous task, and a male prerogative, in camp, fires were kept burning, and groups generally carried live fire-sticks between one site and the next. In the Canberra district, for instance, the seed stalks of the Grass-tree were used to kindle fire by friction. In 1895, a local pastoralist recorded that,

> One of the pieces was flattened and laid on the ground, and the other, pared to a point, was twirled between the flat hands. The friction soon produced sufficient heat to cause some of the fine loosened particles ... to glow, which was, with the addition of some powdered charcoal and dry pounded bark fibre, fanned into a flame.

From infancy, Aboriginal children were taught how to use fire: to keep mosquitoes and evil spirits away; to cook, either directly or in the hot ashes; to use the smoke to signal; and to drive emus, wallabies and kangaroos into position to be speared – a large circle of fire with only one exit was a favourite ploy. Fire was also used to burn off excess

growth to prevent large-scale bushfires – a technique modern white Australians still have failed to master – and to encourage some wild food plants and discourage others. This was also a technique for attracting spearable animals: as the sweet young grass was renewed after the burning, kangaroos, wallabies, and other game would come back to the area.

It is now realized that many of the magnificent grasslands, so welcomed in the nineteenth century by the white settlers for their sheep and cattle, were actually the long-term result of Aboriginal burning-off, and historians have termed this practice 'fire-stick farming'.

As the whole world knows, the Aborigines invented the boomerang. There were hunting and returning boomerangs. There was also a wide variety of clubs shaped more or less like a boomerang. Whereas the returning boomerang was used mostly for amusement and contests of skill (which are still popular among today's Aborigines), the hunting boomerang was of fundamental importance. Hunting boomerangs were thrown so that they skipped off the ground to stun or break the legs of prey. They were thrown into flocks of birds. Heavy hunting boomerangs, up to 2 yards long, were also used in battle to break the legs of enemies or to kill them.

There was a little regional variation in weapons. Thus, the inhabitants of the north Queensland rainforest used a long, curved, hardwood sword.

EXCHANGE

There were no trade routes in the Western sense, that is, no routes travelled by merchants with goods over long distances. Valued or rare items, or products not obtainable in a certain area would, however, pass from one tribe to another through barter or as much-welcomed gifts. Axes, flints for spearheads and cutting tools, pearl shells, bamboo, little shell ornaments, woven bags, gum, pituri (a narcotic-cum-anaesthetic), and ochre for painting the body might, over years, cross hundreds or even thousands of miles. Indeed, the main routes by which such items slowly passed, and which criss-cross the continent, are now well known and mapped. Tribes would meet at their borders to exchange items.

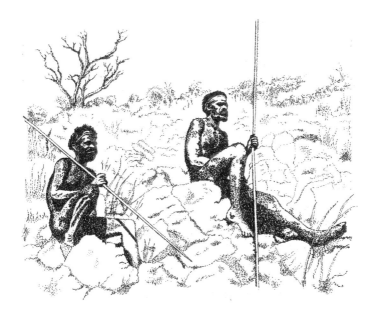

Nineteenth century Aborigines with hunting spears in Central Australia

Small groups would travel long distances for special needs – for instance, from near the Simpson Desert to the Flinders Ranges (about 300 miles) for quality red ochre – obtaining permission from the resident tribes along the route.

Aboriginal messengers were sent to spread important news such as of a forthcoming gathering, across several hundred miles; and smoke signals were used as a rapid means of communicating simple, commonly understood messages.

Social Relations

There were two 'classes' in Aboriginal society, men and women. Though women had complex ceremonial functions, their own secret lore, and could exert influence, men ruled.

WOMEN

Women performed all the laborious and monotonous work; the men hunted. The men carried spears and spear-throwers but the women carried everything else, including all heavy loads, in camp and on the trail. Women gathered the shellfish, in some regions even performing the dangerous task of diving for shellfish in deeper water.

Aboriginal men brutalized their women. There are well-documented accounts, from every part of the continent, of Aboriginal women being beaten with clubs, dragged around the campsite by the hair of their heads, even murdered by their menfolk. The words of Watkin Tench give some indication of this situation in 1788:

> Condemned not only to carry the children but all other burthens, [the women] meet in return for submission only with blows, kicks and every other mark of brutality. When an Indian [Aborigine] is provoked by a woman, he either spears her or knocks her down on the spot. On this occasion he always strikes on the head, using indiscriminately a hatchet, a club or any other weapon which may chance to be in his hand.

Sixty years later the following report was written:

> The men walk along with a proud and majestic air: behind them, crouching like slaves, and bearing heavy burdens on their backs, with the little ones astride on their shoulders, come the despised and degraded women. They are the drudges in all heavy work; and after their lords have finished the repast which the women have prepared for them, these despised creatures contentedly sit at a distance, and gather up the bones and fragments, which the men throw to them across their shoulders, just as we should throw meat to a dog.

At puberty, girls were secluded and certain foods forbidden. Ritual deflowering and cutting of the hymen or both were widely practised. In some tribes, female circumcision occurred: on Groote Eylandt in the Gulf of Carpentaria, girls' *labia majora* were removed.

MARRIAGE

Everyone married, and there were numerous serious and strictly enforced rules about which kin could and could not marry.

In choosing a mate the women normally had little share. Such matters were decided by custom and tradition as interpreted by the elders. Not surprisingly in such a system, older men had priority, and often made it difficult for young men to procure wives. And females entered marriage at a much earlier age than males.

Widows were redistributed among kin, under further elaborate rules. One widely acknowledged taboo was that, though a man could marry his cousin, he could not marry his mother-in-law. Besides formal betrothal, there occurred occasional elopements and frequent captures of women during tribal fighting and when women were alone gathering. Elopement was often accompanied by love-magic, performed by a sorcerer sympathetic to the couple.

Social relations within Aboriginal society allowed for the ceremonial exchange of women, and the sexual favours of women were commonly bestowed as a gesture of friendship. (Many early European exploring expeditions reported receiving such offers. No explorers admitted accepting them.)

Polygamy was common (it still occurs in some areas under tribal governance). Multiple wives, of course, enhanced male egos, and may have met economic needs. Perhaps polygamy was acquiesced in by the women because it meant a sharing of the responsibility for gathering food – though female opposition to the practice would have proved useless. It was quite usual for men to have two or three wives; in certain desert areas this might rise to four or five. James Morrill who, shipwrecked in 1846, lived with Aborigines in the Bowen area of north Queensland explained: 'The men have several wives – in some instances as many as eight or nine – and it is about their wives that all their wars, fights and feuds occur; they steal them from one another and frequently lend them, or sell them for a time.' The known record for wives is held by the Tiwi of Melville Island just northwest of modern Darwin. There, one man had twenty-nine. In recent decades, converted by missionaries, the Tiwi have become Roman Catholics, so polygamy is now frowned on.

But cultural rules and taboos still run deep. In many Aboriginal communities, relatives had to keep a certain physical distance from their immediate family and refrain from touching. Even today, in tribes such

as the Tiwi, once past puberty brothers and sisters are forbidden even to speak to one another, so they have to relay their messages via a third party.

Dreamtime Metaphysics: Religion, Art, Magic, and Medicine

The Dreaming or Dreamtime was the time of creation, and was (is) the core conception of Aboriginal culture. Dreaming goes under different names in different parts of the continent: it is 'Altjiranga' for the Aranda people of the Centre, 'Bugari' for the Kradjiri of the Kimberleys, and 'Njidding' for the Nyungars of the south-west. But the socioreligious content of the Dreaming remains remarkably similar right across Australia.

RELIGION OF THE DREAMING

During the Dreaming, the spiritual ancestors were supposed to have given order and form to the world; they created the landscape, the mountains and rivers, gave life to animals and people, and established the rules that govern Aboriginal society. But they did not stay in the past. In some complex sense they were assumed to be ever-present, watching over the world of men. Birth, life, and death were all part of a social-religious continuum, and a child's spirit was believed to come to the world from the Dreaming or Dreamtime.

In Aboriginal belief, the dead were also present everywhere, their spirits guiding the living. The various rituals of life were important in the nurture of the individual's spirit and, at death, in a sort of continuity, the spirit was assumed to re-enter the Dreaming or, as some Aborigines expressed it, it 'went into the country', which existed over the horizon or, for coastal peoples, over the ocean. It was necessary that correct ceremonies be performed lest the spirit continue to wander the tribal lands.

Aboriginal culture did not concern itself with motivation or morality. Behaviour was just appropriate or inappropriate, depending on how it related to the Dreamtime myths and tribal traditions.

Such religious-cultural assumptions were also deeply animistic,

connected with animals and the land. Natural geographic features, such as sheer gorges and hills of an unusual form such as Uluru (Ayers Rock), or unusual climatic phenomena, acquired profound meaning, and provided a basis for complex and imaginative creation stories. An example is the following legend of the Pitjantjatjara tribe that lives near Uluru. In the Dreamtime, Tjinderi-Tjinderiba, the Willy Wagtail Woman, set up her camp with her children at the northern point of Uluru. (The Willy Wagtail is a 5-inch black-and-white bird.) Not far away there lies a long cylindrical boulder: her body. The many children of Tjinderi-Tjinderiba were the boulders large and small, that dot the area. In a cave nearby are four smaller boulders – once four of her infants. According to Aboriginal belief, the cave itself provided an inexhaustible supply of spirit children who became real children when they contacted the right mother. To this day the Pitjantjatjara have a deep fear of the Willy Wagtail and believe it will do great damage to them if harmed.

In these special places the spirits were supposed to be particularly active, and hunting was therefore forbidden. Such non-rational Aboriginal belief could thus have significant rational effects. These areas became unintentional game reserves which, in fact, protected the life-giving animal population from over-hunting.

In contrast, the Aboriginal belief system clearly prevented the development of agriculture. Certainly they did everything they *believed* possible to encourage the rate of reproduction of the animals and plants upon which their lives depended. But they did it by way of ceremonial, ritual, rite, supplication, and sorcery. The tribal elders might go to a particular site associated with the body of some Dreamtime ancestor totemically connected with a plant or animal. There a stone might be rubbed and its powder blown into the air. Or its powder might be mixed with blood and taken to places where the continuation or increase in plants was desired; and so on.

A modern example of Aboriginal interpretation is provided by Cyclone Tracy. At Christmas 1974, this 200-mph cyclone reduced much of Darwin, the capital of the Northern Territory, to a heap of rubble, injuring 1000 people and killing sixty-five. Cyclone Tracy was construed by some Aborigines as showing the anger of the great spirits,

in particular of Jambuwal the Thunder Man, at the destruction of Aboriginal sites by mining ventures. One Aboriginal writer said that Jambuwal must have been terribly angry for never before had his voice been so loud. Jambuwal had made the earth tremble like a beaten snake, and was trying to roll the sea over the town and the white men, for to harm Jambuwal's people was to risk his great wrath.

At puberty, males were initiated in a series of the most important of all rituals. Initiation involved the passing down of religious-cum-cultural and practical knowledge from generation to generation, a process continued throughout adult life. At initiation, circumcision was almost universally practised throughout Australia (but not among the Nyungar people), and often the urethra was incised. Other common rituals were to scar the body with cicatrices, knock out a front tooth, and draw blood from arm or penis for anointing. (Red ochre [ferric oxide], from the crumbly surface layers of what are today in some cases hugely valuable iron-ore deposits, was also sometimes used.) In Central Australia, the Aranda people tore out the initiate's fingernails, and heads were gashed or bitten. In the Canberra area elders singed all the hair from initiates' heads. Such rites drew their significance and meaning from Dreamtime mythological-cum-religious precedents. They were aimed at spiritual release and undoubtedly produced a sense of belonging to the tribe and its traditions in some more profound measure. As part of initiation a great and exciting celebratory performance-cum-dance – males only – was held.

ART

At ceremonies the digeridoo would be played. Made from a single length of bamboo or from a branch naturally hollowed by termites, the didgeridoo produces a unique, undulating, bass, fog-horn sound. Though a basic sound is simple to produce, true mastery of the didgeridoo is difficult to achieve. The men's bodies would be decorated with ashes, feathers, white pipe clay, and with yellow or red ochre. Such body decoration was a complex and much-prized art. Besides the didgeridoo, sticks, clubs, and boomerangs were clapped together or pounded on the ground to provide accompaniment.

Religious rituals gave great scope for artistic expression, especially in

dramatic performances that involved stylized posturing and intricate dance movements. Not as psychologically intense, but often very elaborate, were the non-sacred ceremonies (corroborees) performed for entertainment. At these mixed celebrations in the south-east of Australia, women used pads of skin to beat the time. Some of the Aboriginal chants which have been preserved are truly beautiful. And there were long song-cycles. Aborigines loved the repetition of songs and poems. Bishop Salvado, a Spaniard who ministered to the Aborigines of Western Australia during the 1890s, wrote, 'they go on repeating these for an hour or two, getting more and more pleasure from them at each repetition – what we Europeans would find infinitely boring sends them into ecstacies of delight'.

Many tribes decorated sacred ritual objects such as bark shields and grave posts; others painted in ochre on pieces of bark for more purely aesthetic reasons. All Aboriginal visual art was totemic in one way or another, carrying a greater or lesser amount of coded meanings about lineages, Dreamtime origins, animal myths, local beliefs, social rules, and demarcation of clan and tribal areas.

By far the most common forms of art, however, were the visual arts of rock carving (not 'engraving' as it is sometimes erroneously termed) and multicoloured painting – forms found right across the continent, but with considerable variation, using the same pigments as for body painting. These were carried out in caves or upon rocky outcrops protected by some form of overhang, and roughly 6000 rock gallery sites are now known, with more being discovered each year. Some Aboriginal cave painting of animals predates the celebrated Lascaux cave paintings in France by thousands of years. Among the earliest examples, about 20,000 years old, are crude finger markings scraped across soft limestone cave walls. About 15,000 years ago, so-called 'Panarmittee' carvings began to appear, marking significant sites. Panarmittee carvings imitate the tracks of various animals surrounded by circles, spirals, and other abstractions.

The first representations of human and animal forms appeared about 10,000 years ago, usually as stick figures. Three of the most extraordinary kinds of representation were the Wonjina figures in the Kimberleys, the 'X-ray art' most common in Arnhem Land, and the

Quinkan art of Cape York Peninsula. Wondjina figures portrayed mythological beings associated with the creation of the world during the Dreaming. Monumental and ghost-like, they were painted without mouths, the large face white, the head surrounded with a red halo or horseshoe-shaped motif. The feet were often shown merely as footprints, perhaps an indication of the significance such a hunting culture placed upon identifying animal tracks. Water was symbolized in the white face, blood in the red halo. X-ray art showed the skeletons and internal organs of animals and people. Modern Aboriginal painters make great use of this last motif. Different again, Quinkan art gains its name from spirit figures with flat oval heads and radiating lines.

In recent centuries, some rock art even recorded the arrival of European ships and men on horses carrying muskets and guns. But, as the settlers thus portrayed dispossessed the various tribes from their customary lands, the Aboriginal painters' practice of periodically retouching such artworks ended, and many ancient examples of art are now being worn away.

MAGIC

Relations within Aboriginal groups involved the kinds of tensions, disputes, and fights found the world over – over hunting, competition for women, and conflicting social-cultural-religious interpretations; and, most of all, over the death of family members. For it was commonly believed that death was caused by sorcery, either through local magic by someone in the clan or tribe, or through that of some distant tribal enemy.

Unfortunately for social harmony, honour demanded that the person's relatives punish those responsible. Divination by the tribal sorcerer was then used to discover the secret sorcerer – and there was no way to appeal. The supposed sorcerer would then have to be exiled, or killed. (And the individual in exile, separated from the tribe which gave his whole life its meaning, would soon die.) The Aboriginal mind was so deeply committed to magical beliefs that it was widely believed that sorcerers could kill at a distance by projecting missiles such as small stones and quartz crystals out of their mouths, and at great velocity, into the bodies of their victims. To Westerners, at least, another mystifying

method of autosuggested killing was for sorcerers to 'point the bone' at victims. Previously, the sorcerer had 'sung' over the bone to place a curse upon it. Knowing this, the terrified victim would fret, lose all interest in normal tribal life, stop eating, and often die within a week or so.

Sorcerers were also used as avengers of wrongs, real and imagined. Aborigines believed that, through magic, men could see into the future, walk on the air several feet above ground, and travel on spirit journeys. They also believed that rain could be caused to fall and that the heat of the day could be reduced. With such supposed supernatural powers at work, the Aboriginal world would have been, at times, one of much worry and psychological insecurity.

MEDICINE

Some elders, men and women, nursed the sick by using leaves, roots, grasses, herbs, and fruits. Many of their treatments, such as eucalyptus leaves for various ailments, the plums of the Quandong Tree (which has high concentrations of vitamin C), or the leaves of the sticky Hop-bush to stop toothache, were effective and represented intuitive knowledge unknown in Western medicine. But they had no reciprocally inter-related body of theoretical knowledge that accurately explained why such treatments worked, that is, their knowledge was empirical not scientific.

One extraordinary example concerns the Queensland Aborigines' use of leaves from the Duboisia or Corkwood Tree to treat certain illnesses, to use as a narcotic, and to throw into small water-holes to stupify fish. Corkwood leaves actually contain the drug atropine which is used in modern medicine as a pre-anaesthetic, nausea suppressant, and for dilating the pupils. (Large amounts of Corkwood leaves were gathered in Queensland in early 1944 to yield atropine to prevent sea sickness during the D-day landings of World War II.)

There were varieties of 'chewing tobacco', picked from bushes and trees, to provide a mild narcotic. In many parts of Australia, Corkwood leaves were dried, chewed, and, with an ash of the acacia tree, lumped into a wad. Called 'pituri', this wad was carried behind the ear and enabled Aborigines to endure great fatigue on long journeys.

Some treatments were uncertain, and undesirable results could always be explained away as the result of further sorcery or as the intervention of evil spirits – tactics used after the fact the world over by sorcerers and shamans.

Infanticide was practised on deformed babies and on the less robust of twins, and abortion occurred. As groups moved from camp to camp, children, women, and old people who became too ill to travel or to be looked after might be abandoned.

First Contact with Outsiders

During most of these eons of time the Aborigines knew little or nothing of other continents or of the other peoples upon them. There was some contact with the Papuans on the other side of Torres Strait, and this resulted in the use of certain Papuan tools by a few tribes of far northern Cape York Peninsula.

The other foreign contact of which we are certain first occurred perhaps 500 years ago. Traders and fishermen from the Celebes (Sulawesi – now part of Indonesia) began arriving in December in their proas (sailing vessels) on the coast of what is now the Kimberley Region of Western Australia and Arnhem Land in the Northern Territory, to remain for the so-called Wet Season.

They sought tortoise shell, sandalwood, and, especially, trepang. Trepang, looking like great foot-long slugs, were boiled then dried or smoked, and traded in large quantities with Cantonese Chinese, who used them as an aphrodisiac and to flavour their soups.

In some years several thousand Indonesians would have arrived. They built themselves temporary thatched-leaf houses, and remained for about three months, collecting and processing trepang, before returning with it to their own islands. The Aborigines, who sometimes helped the Indonesians, left a record of these visits in their cave paintings and song-cycles. Some cultural diffusion occurred; for instance, the Aborigines of Arnhem Land acquired Macassan-type dugout canoes and the long-stemmed Macassan pipe for smoking. Aboriginal music and song were also affected, some songs reflecting the Aboriginal fascination with proas and their rigging.

Fights between Macassans and Aborigines, and even killings, occasionally occurred. Around 1850, twenty Macassar men and two Aborigines were killed in one such fight. But relations between the races were normally friendly. It is known, for example, that Aborigines occasionally sailed to the Indonesian islands with the fleet and returned home with the next fleet the following year.

This almost changeless nomadic Aboriginal life during the great ages of the past was the origin of the Aborigines of today. It determined the Aboriginal response to the arrival of the British in the epochal year of 1788, and much of the British response to the Aborigines. Had the Aborigines a culture more like that of, say, the eighteenth-century Indonesians or Japanese, historical relations between Aboriginal and white Australians during the last 210 years would have been radically different.

For nowhere else in the whole history of the world has there been a greater difference in two civilizations at first contact. The late eighteenth-century Aborigines had an Old Stone Age culture, while the British settlers were citizens of what was at that time the world's first and only industrialized nation and the powerhouse behind the burgeoning industrial and scientific revolutions. A people whose tribes held land communally now encountered a people for whom private property was sacrosanct. People who, lacking pottery and metal objects in which to heat water had rarely if ever even seen steam, were now face to face with people who had harnessed the mighty powers of iron and steam in the steam engine. This was like an encounter between the inhabitants of different planets. It was inevitable that race relations would be characterized by complexity, misunderstanding, tension, and tragedy.

The tensions generated in the first encounters between the races continue to the present day.

Europeans Arrive

From its very first accidental sighting by Dutch navigators on their way to the vast wealth of spices in the East Indies (Indonesia) in the early 1600s, Australia had gained a most negative reputation. Nevertheless, the Dutch still named it New Holland!

This reputation resulted from the fact that the Dutch had chanced upon the hot, dry, and mostly barren west and north coasts of the Australian continent. Nowhere in the world, except perhaps in Antarctica, is there a longer unenticing coastline. Fixated as these Dutchmen were on the rich trade of the Spice Islands, the desolation of Australia, the harsh living conditions of the scattered Aborigines, and their lack of anything worth trading, left a most unfavourable impression.

It is amusing to note that these western regions of Australia are now the source of immense wealth. Inland in the north lies the Kimberley area, half as big as France and now seen as a land of haunting tropical beauty, increasingly luring international tourists to its rivers and majestic gorges through the ancient rock. Some of its lush pockets of rainforest are essentially untouched and unwalked by humans – not even by the Aborigines. Farther south is home to offshore oil and gas, bauxite, copper, uranium, gold, and some of the world's largest and richest lodes of iron ore spread over areas several times the size of Holland. There is also the world's largest deposit of diamonds – which would have attracted any Amsterdam diamond merchant.

Dutch Voyages

From their earliest voyage in 1595, the Dutch had been following the

route pioneered by the Portuguese: round the Cape of Good Hope, up the East African coast, and across the Arabian Sea to the Indies and their base at Batavia (now Djakarta) in Java. In 1611 the Dutch captain, Hendrick Brouwer, tried something different.

ENCOUNTERS WITH THE WILD WEST COAST

Brouwer sailed 4000 miles due east from the Cape, then turned north towards Java. Specially favoured by wind and current as he had anticipated, he did the voyage in record time: less than six months instead of the average fifteen.

Back in Amsterdam, the canny directors of the Dutch East India Company were delighted and ordered all Dutch ships to follow the new route. Unknown to Brouwer and the Company, 4000 miles east from the Cape of Good Hope is very close to the western shores of

Hendrick Brouwer, the Dutch sea Captain, who discovered the short route to the Indies

Australia. And, because all mariners at that time had difficulty in calculating longitude, being forced to rely upon 'dead reckoning', it was inevitable that some Dutch captain or other would soon sail too far east and so find this land of Australia.

Dirck Hartog was the first Dutch captain to do so, in 1616, in the *Eendracht*, when he sighted land at Shark Bay about midway along the coast. To record his visit, he hammered flat a pewter dish, scratched on it the name of his ship, and nailed it to a tree. The dish is now in the Rijksmuseum, Amsterdam. Thereafter, Dutch captains were instructed to sail straight for this new 'land of Eendracht', as a convenient mark before turning north. So Hartog was succeeded by a long line of fine Dutch captains who sighted, and charted or, in some cases, were wrecked upon various sections of the western coast.

In 1622, the English ship *Trial* followed the Dutch route and was wrecked, her crew being the first Englishmen to see Australia. Later, the English explorer, surveyor, and buccaneer, William Dampier (1652–1715), landed in the north-west in 1688 and 1699. He was interested in the possibility of using New Holland as a base for English ships seeking access to the resources and markets of Spain's South American colonies. On each visit he remained for several weeks. His report of 1697 discouraged further voyages of discovery, for he agreed with the negative Dutch assessment, describing the coast as arid and lifeless, and calling the native Aborigines, 'the miserablest People in the World'.

MASSACRE

Francis Pelsart is the most famous of the many other Dutch captains to visit these regions. In 1629 his ship *Batavia* was wrecked in the Abrolhos Islands, but he managed to sail to Java in the ship's tiny pinnace to seek aid. Pelsart was the first person to write a description of a kangaroo (actually one of the smaller species), calling it 'a species of cats' which walks upon its hind legs. Pelsart became famous, not for this unique description, but because of the terrible events that took place during his absence.

The *Batavia* had left The Netherlands carrying not merely normal trading goods but twelve chests of silver coins and a great casket of

jewels, together with troops and passengers, totalling over 300. After the wreck most of these people, together with the treasure and the supplies, reached shore before *Batavia* finally sank. The under-merchant, Cornelisz, seized the treasure. He and his followers then indulged in an appalling orgy of murder and rape. Some 125 people were slaughtered, forty drowned trying to flee, and twenty died of disease. Some troops resisted Cornelisz's cutthroats and survived to tell the story.

When Pelsart returned with help ten weeks after reaching Java, Cornelisz and six others were hanged, and two mutineers marooned. In 1963, the remains of *Batavia* were discovered in about 40 feet of water. Restored and reconstructed, an impressive section of the stern can now be seen in the Western Australian Maritime Museum.

DUTCH VOYAGES IN THE NORTH AND TO TASMANIA

The Dutch, from their Company bases in Java, also explored much of the north Australian coast, but drew the same conclusion about the lack of anything of value.

In 1606, five years before Hartog (and so the first *known* Europeans to sight any part of Australia) the crew of the *Duyfken* (Little Hen) had charted some of the east coast of the Gulf of Carpentaria in the north and also described its coasts as barren. In 1623, after unsuccessfully searching the same gulf for a passage to the Pacific between New Guinea and northern Australia, the Dutch captain, Jan Carstens, wrote the following:

> We have not seen one fruit-bearing tree, or anything that man could make use of . . . the land contains no metals, nor yields any precious woods . . . In our judgment this is the most arid and barren region that can be found anywhere on the earth.

Dutchmen also charted parts of the thousand miles of the western end of the southern coast, which they called Leeuwin Land and Nuyt's Land – again mostly barren.

In 1642, on the other side of the continent from Nuyt's Land, the Dutch navigator, Abel Tasman (1603–59), had landed in the south of Tasmania and also charted some of the west coast of New Zealand, but

the eastern coast of Australia and the true extent of the landmass between these widely separated points remained unknown.

Near Misses by Spanish and Portuguese?

The Spanish also had come close to Australia. This was because they were interested in finding the so-called great South Land, *Terra Australis Incognita* – the huge and fabulously rich continent that many men of learning believed must lie in the South Pacific. Since the time of the ancient Greeks, geographers had believed that *Terra Australis Incognita* just had to exist in order to balance the mass of all the northern continents and so allow the Earth to rotate smoothly on its axis.

In their efforts to discover this mysterious south land the Spanish had reached as far west as Fiji and the New Hebrides (Vanuatu). And, in 1606, the seventeenth-century navigator, Luis Vaez de Torres, sailed right through the strait that now bears his name and separates New Guinea from northern Australia. This was precisely the strait searched for, but missed, by Jan Carstens. Though Torres must have been very near, it seems that he did not sight any part of the continent proper, but merely some of the Torres Strait islands.

There are also tantalizing possibilities of Portuguese landings in several parts of Australia, but nothing tangible. In 1516 the Portuguese had settled the island of Timor, only 300 miles north-west of Australia. It is possible that they pushed a little further and saw and charted parts of the north-west. If they did, they kept this knowledge secret, for there is no hard evidence. There are, however, intriguing claims for Portuguese maps of a large and mysterious land south of Java, named by them Java La Grande, maps supposedly lost in the 1755 Lisbon earthquake. There have also been claims that the wreck of a Portuguese ship was found along the coast of what is now the state of Victoria in the south-east, but then mysteriously swallowed by sand.

Also interesting is the fact that, in 1768, the French navigator, Louis Antoine de Bougainville (1729–1811), determined to find Australia's eastern coast, came west across the Pacific from the New Hebrides to within about 80 miles of the site of the present-day city of Cairns,

before he turned north, frightened off by the long line of surf breaking on what we now call the Great Barrier Reef.

So, by the year 1770, the only definite European knowledge of Australia proper, and the only navigation charts in existence, involved the barren north, west, and south-west coasts, mapped by the Dutch.

Cook's Voyage makes Modern Australia Possible

It would fall to the Englishman, Lieutenant James Cook (1728–79), to change Europe's negative image of Australia, for he was to chart the more fertile east coast. (Cook and de Bougainville had, in fact, fought on opposite sides in the famous battle for Quebec City in 1757.)

TAHITI, NEW ZEALAND, AND PARTS WEST

Cook joined the Royal Navy at an early age. His appearance, ability, and charisma caught the attention of his superiors and, in 1769, under the auspices of the British Government and the Royal Society, he was placed in charge of history's first full scientific expedition to the South Pacific. The ship chosen for the voyage was the sturdy, former Whitby collier, *Endeavour*, minute by modern standards at just 368 tons and under 98 feet long! (Today's ferries that ply Sydney Harbour are more than twice that length, and several times the weight.)

Cook's instructions were to reach the recently discovered island of Tahiti in the South Pacific to observe the path of Venus across the Sun, and so aid astronomers in calculating the Sun's distance from the Earth. Cook was then to open additional and secret sealed instructions. These gave him the fundamental reason for the voyage. He, too, was to search for that mysterious land, *Terra Australis Incognita*, in the regions to the south of Tahiti. Because of the many European voyages already made in other parts of the Pacific, it was now believed that the missing continent must lie there.

As far as practicable, Cook was to explore its coasts. His instructions also included the following important passage:

> You are also with the Consent of the Natives to take possession of
> Convenient Situations in the Country in the name of the King of Great

Britain; or, if you find the Country uninhabited take Possession for His Majesty by setting up Proper Marks and Inscriptions, as first discoverers and possessors.

Thirdly, Cook was to find out if the section of New Zealand discovered by Tasman in 1642 was part of *Terra Australis Incognita.*

The general plan of the British government was to pre-empt other European nations in these regions and prepare the way for British trade and supremacy in any such continent. Cook was then to return to England by whichever route, to west or east, he judged most suitable. Nothing in his instructions referred to New Holland (Australia).

Joseph Banks, FRS (1744–1820), a wealthy young botanist and man-about-town, headed the scientific and civilian personnel. He was accompanied by astronomers, botanists, and artists. As a result, the expedition would become famous for the extensive and magnificent

Joseph Banks, the botanist on Cook's first voyage, recommended convict settlement in Australia

botanical, zoological, and ethnographical collections, illustrations, and paintings that it brought back to Britain.

Following the successful observation of Venus, the expedition criss-crossed vast regions of ocean south of Tahiti, but no great southern continent was sighted. After accurately charting the New Zealand coastline, and realizing that the *Endeavour* was now in no suitable state to risk winter weather in high southern latitudes, Cook decided to continue north-west to refit in the Dutch East Indies (now Indonesia), and on the way to find and map the uncharted east coast of Australia. Of such chances is history made.

DISCOVERY OF BOTANY BAY

On an exciting day, 20 April 1770, the first Australian land was sighted. Cook continued up the coast looking for an anchorage, and on 29 April he found a '... bay, which appeared to be tolerably well sheltered from all winds'. It would later become famous as Botany Bay.

The *Endeavour* anchored in the bay about 2 p.m. and the English-men showed deep interest in the activities of a party of Aborigines who were cooking fish in hot ashes on the shore. Cook ordered a boat to take a landing party of himself, Banks, the Swedish botanist Dr Daniel Solander, a pupil of Linnaeus, and Tupia (a native interpreter who had accompanied them from Tahiti) 'in hopes of speaking with them'. As the boat was slowly rowed towards the beach, the Aborigines 'all made off except two Men who seemed resolved to oppose our landing. As soon as I saw this I ordered the boats to lie upon their oars.' The Englishmen, wanting friendly relations parleyed for about a quarter of an hour without any effect; Cook then fired a musket between the two Aborigines; Cook's party landed; the Aborigines hurled their spears; the Englishmen fired a round of small-shot; the two Aborigines ran away.

The *Endeavour* remained in Botany Bay for eight days. The array of scientifically unknown plants, animals, and birds, collected in such a short time has never been equalled. Realizing that this wealth of plants would revolutionize botany, Cook called the place 'Botany Bay'. A stream was discovered and assumed to be strong enough to power a water-mill; and, despite the generally sandy nature of the area, some

Cook's former collier ship, *Endeavour*, only 98ft long, in which he mapped the east coast of Australia in 1770

patches of 'deep black soil'. During a reconnoitre inland, the size of the grasslands stretching to the west amazed Cook.

A few hours after leaving Botany Bay, Cook sailed past two tall headlands, noted the inlet between them which he called Port Jackson, but did not enter. Years later this magnificent natural harbour would become the site chosen for the settlement of Sydney.

MODERN AUSTRALIA ALMOST DID NOT HAPPEN

As he continued north, Cook drew accurate maps of this uncharted coastline and gave names to capes and bays in what are now the states of New South Wales and Queensland.

Because the *Endeavour* sailed between the coast and the huge but unknown 1250-mile Great Barrier Reef, with increasing apprehension it was realized that the coral reef was coming ever closer to the shore and might be cutting them off from any exit. They were now, as Cook soon wrote, '... coasting the shore to the Northward through the most dangerous Navigation that perhaps ever ship was in'. One moonlight night, in deep water in the far north, their worst fears were realized as

the ship struck the reef. For a tantalizing 23 hours the *Endeavour* lay wedged on the coral, filling with water 20 miles from shore. In Cook's meticulous ship's log, may be found the following entry:

Tuesday 12th June 1770. By this time it was 5 o'clock, the tide we observed now began to rise and the leak increased upon us which obliged us to set the third pump to work as we would have done the fourth also, but could not make it work. At 9 o'clock the Ship righted and the leak gained upon the pumps considerably. This was an alarming and I may say terrible Circumstance and threatened immediate destruction on us as soon as the Ship was afloat.

To float the *Endeavour* off, the crew were ordered to heave overboard every unnecessary object, including several cannon! The ship slowly freed itself on an incoming tide, while the sailors fothered the holes with a ship's sail, which they fixed under the hull. Had Cook and his crew all drowned and his charts been lost, the history of modern Australia would have been different.

The ship limped into a river on Cape York Peninsula, which Cook named the Endeavour. There, in making temporary repairs during a humid six weeks, they discovered, 'that a large piece of Coral rock was sticking in one hole'. This broken-off coral, together with the fothered sail, had prevented the ship from sinking. At this site, Cooktown would grow up during the late nineteenth century. It was also during these days that the Britons, from their encounters with the local Guugu Yimidhirr Aborigines, learned the word 'kangaroo' to describe the strange hopping animal.

As Cook named many of the beautiful islands within the vast Reef, he could scarcely have guessed that many would become magnificent holiday sites two centuries later. At Cape York, Cook took possession of the eastern half of Australia for Britain. Because the coast reminded him of southern Wales, rather prosaically he called the new land New South Wales, and that was the name used for all of eastern Australia until many years later. (He took possession only of the eastern half in case the Dutch had desires on the west of New Holland.)

It will be recalled that Cook's instructions included the words, 'with the Consent of the Natives to take possession of Convenient

Situations', and, 'if you find the country uninhabited take possession'. Today, given the presence of the Aborigines, his annexation may look like an act of unacceptable arrogance. Such behaviour, however, was normal for the nations of the world at that period in history. Again, given the lack of any political organization linking the separate Aboriginal 'tribes', with whom could any meaningful treaty have been drawn up? It has also been suggested that, as Cook observed the nomadic life and saw neither towns nor villages nor cultivation nor pasture, he may have felt justified in regarding the land as, in effect, uninhabited. Certainly Cook differed from his precursors in his complimentary evaluation of the lifestyle of the east coast Aborigines, writing in his log:

> In reality they are far more happy than we Europeans, being wholly unacquainted not only with the superfluous but the necessary Conveniences so much sought after in Europe. They are happy in not knowing the use of them. They live in a Tranquility which is not disturbed by the Inequality of condition: the Earth and sea of their own accord furnish them with all things necessary for life.

After reaching Batavia in Java, where proper repairs were made, the *Endeavour* sailed all the way back to Britain, and Cook to immediate and everlasting fame.

Why Australia was Colonized by the British

A few years later, the American colonists broke away from Britain. This created a penal crisis for the following reason. In the previous 100 years many new offences had been made punishable by death. About half of these sentences were commuted and most such convicts were sent to work in the American colonies of Virginia and Maryland as indentured labour. In the sixty years prior to the American Revolution, some 50,000 had been transported. Now this was impossible.

WHERE TO FOUND A COLONY OF CONVICTS?

As a temporary measure, convicts in their thousands were being imprisoned in disused hulks on the Thames and in southern ports such

as Plymouth. A convict settlement overseas was clearly needed. Many possible sites around the world were considered and rejected. Finally, Cook's charting of eastern Australia became significant because Botany Bay was chosen. The decision was made even though Cook had landed only twice on the whole 2500-mile-long east coast of Australia.

The climate at Botany Bay was believed moderate. The Aborigines were seen as no threat because of the nature of their culture and their small numbers; indeed, Banks told the select committee of the House of Commons that the Aborigines were 'few and cowardly'. Cook and Banks seem greatly to have underestimated the size of the Aboriginal population. The soil was only moderately fertile so the convicts would need to work hard. If they escaped there was nowhere for them to go. Botany Bay was therefore believed to make an ideal prison.

ADDITIONAL REASONS FOR BOTANY BAY

There were other factors behind the final decision in favour of Botany Bay. At the time, Britain was concerned that the Dutch might prevent British ships from passing through the East Indies. So it was hoped that Botany Bay would then service an alternative sea route to China and the Far East, particularly for the tea trade. Secondly, it was also planned to establish a sister convict colony on uninhabited Norfolk Island to the north-east of Botany Bay. That island, discovered by Cook during his second great voyage, was believed to be a source of superior flax for sails and ropes, and tall pine trees for ships' masts – extremely important matters for the world's greatest naval and commercial power. Thirdly, some members of government saw Botany Bay as a future strategic presence in the South Pacific. As with many decisions by governments, the project was only partly thought out and different men envisaged its future in different ways.

One omission was to have serious repercussions: the legal and land rights of the Aborigines were never properly considered. The assumption was probably that they became instant British subjects and so the traditional Common Law of England would cover their case. Certainly, all the land was immediately assumed to be Crown Land. Thus, in 1836–37 a Select Committee of the Colonial Office pointed out that, in the settling of the Australian colonies, the 'territorial rights'

of Aborigines went unconsidered and that 'Such omissions must surely be attributed to oversight'. Such an oversight is perhaps understandable if we remember that this was a plan for a *convict* colony taking up a very restricted area of land in a vast continent; and, with the Aborigines being so scattered, the assumption was that there would be very limited contact between the two races. There was no conception that decades later an enormous pastoral industry would erupt across the inland, or that Australia would become the site of history's greatest goldrushes.

At the end of the American Revolution in 1783 an alternative proposal had been made for Botany Bay. There were 100,000 Loyalist colonists in America, opposed to the actions of their fellow colonials, who no longer wished to remain in that country. It was suggested that these Loyalists, with or without convicts, should be settled in Botany Bay. Nothing came of this idea, but how different the Australian nation's origins and future history might then have been!

The First Fleet

The man chosen to head the fleet of convict ships and be first governor was the semi-retired naval officer, Captain Arthur Phillip (1738–1814). He proved to be an excellent choice. Conscientious and perceptive, Phillip was also a man of strong character and moral rectitude. For several years he served in the Portuguese Navy, and had commanded ships of Portuguese convicts being sent to Brazil. Because he became the most important single influence on the success of the new colony, it is worth quoting the opinion of his Portuguese superior officer:

> He is an active and intelligent officer. His health is very delicate but he never complains excepting when he has nothing to do for the Royal Service . . . he accepts reason and does not fall into exaggerated excesses of temper. He is an officer of great truth and is very brave, and is no flatterer, saying what he thinks, but without temper or want of respect.

Against great government inertia, Phillip fought for and achieved much-improved provisioning for the fleet and the colony – though, as later events would show, these were still inadequate.

The audacity of the plan was breathtaking: to found, in an age of

sailing ships, a self-supporting convict colony which, on the very shortest achievable sea route, was 14,000 miles from its homeland, on the other side of the Earth. Never in the history of the world had so many people travelled so far together.

A 14,000-MILE VOYAGE

The First Fleet, as it is now called, of eleven ships sailed from Portsmouth on 13 May 1787 – six convict transports, three store ships, and two warships.

The largest was the warship *Sirius*, 612 tons and 132 feet. The warships were to protect the fleet and British interests. In a sense, this was the beginning of the approximately 150 years in which the Royal Navy would protect Australian shores from foreign invasion, making possible the unchallenged and relatively harmonious growth of that nation.

Tightly packed into these tiny ships were about 1400 men, women, and children, some 784 of whom were convicts, the remainder mostly sailors, and marines to guard the colony.

The Fleet put in to port at the Canary Islands, Rio de Janeiro, and Cape Town. Of course, the convicts were not allowed ashore. Without loss of a single ship – something of an achievement for that time – but with the loss of forty-eight unfortunates who died *en route*, the fleet reached Botany Bay eight months later, straggling into the bay on 18, 19, and 20 January 1788. This was to be a scenario repeated many more times in the colonization of Australia: hundreds of men and women dropped onto a coast the true potential of which for good or evil was unknown. People from cool, cloudy, luxuriant, well-watered islands, lying in latitudes 50 to 60 degrees north were about to settle torrid, continent-sized Australia, lying between latitudes 10 and 43 degrees south.

CRISIS

Botany Bay was a profound disappointment. Phillip needed a good stream of fresh water, a healthy site, and a place where ships could anchor close to shore. None of these needs was met. Cook had visited Botany Bay in a season of uncharacteristic rainfall and plenty whereas, when Phillip landed, the area had reverted to normality so the stream

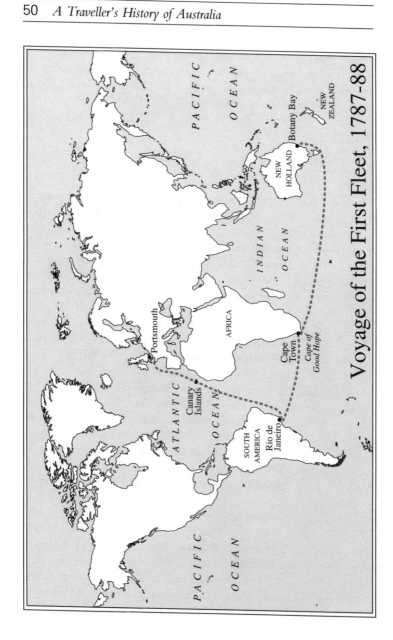

Voyage of the First Fleet, 1787-88

had dried and the waving fields of grass had withered. This was just such sleight of hand as the Australian climate would play on colonists over and over again in later decades: they would be encouraged by good seasons to extend their farming and grazing far inland into what appeared fertile country with adequate rainfall, only to find everything destroyed by drought a few years later.

Settlement at Sydney Cove

For the British, some 6000 miles from the nearest British help in India, matters were serious. Anxiously Phillip explored north in the ship's cutter.

Investigating Port Jackson (Sydney Harbour), which Cook had not entered, Phillip was astonished at its size and depth. After exploring several coves, he decided upon one which became known as Sydney Cove. Not only did it have a fair stream of fresh water, but was so deep that ships could anchor very close to shore. The next day the fleet left for the new site. In describing Sydney Harbour, Phillip wrote that it was 'the finest harbour in the world, in which a thousand sail of the line may ride in the most perfect security'.

Amazingly, as Phillip sailed out of Botany Bay, the French explorer, Jean-François de La Pérouse sailed in. La Pérouse believed a colony had already been established. The previous forty years had seen four earlier French expeditions to the South Pacific – so interested were the French in that part of the world. Later, in 1792, the French admiral, Bruni D'Entrecasteaux, would explore much of the southern coastline of Australia as well as Van Diemen's Land (Tasmania). In 1802–03, Captain Nicolas Baudin's French expedition would chart much of the west and south coasts and Van Diemen's Land again. Baudin would even rename Spencer and St Vincent's Gulfs on the south coast, Golfe Bonaparte and Golfe Josephine! And an 1814 French expedition would explore another large section of Australia's southern coast, calling it 'Terre Napoléon': Australians could easily have had a modern problematic Quebec all their own. Equally, the Dutch East India Company could have colonized the west, as was suggested by their captain J. P. Purry in 1718. But the Dutch did nothing even though the British

made no claims to the west until the late 1820s. So it remains historically remarkable that the vast Australian continent finally fell in its entirety into British hands, and that a single nation was able to establish itself upon it.

BEGINNINGS

On 26 January (now the Australian national holiday) 1788, Phillip landed. Over several days most of the male convicts and marines, the stores, and the cattle and sheep came ashore. The sheep had been brought for their mutton, not their wool. About thirty-six children and babies also landed, for forty of the marines came with their wives and families, and several of the convict women gave birth during the voyage.

On 6 February there occurred another event, hidden from polite accounts of the landing. It was on this day that the 188 women convicts finally came ashore. According to letters and diaries written by several of the civil and marine officers, 'debauchery and riot' then took place. Just how we should describe these activities in the 1990s remains an open question, for some of the offended officers were certainly puritanical moralists. The next day, Phillip's commission as governor was read out; he charged the convicts to reject former ways and to earn their freedom through honest labour; he urged couples to marry; he promised that any man found entering the womens' tents after dark would be shot by the sentries. The following Sunday after the sermon, the Reverend Richard Johnson married fourteen couples. The area where the first settlement was made is now called Circular Quay. The great Sydney Harbour Bridge dominates one side, the famous Sydney Opera House the other, and here many modern tourists disembark from their luxury liners.

LEAN YEARS

The back-breaking work began immediately. The hard wood of the eucalyptus trees had to be cut even before tents could be pitched. The governor's five-roomed, prefabricated canvas house was quickly erected. Within a few months, rough huts had been built as cover for the officers and civil office bearers. Something like a plan for the tiny

town had been evolved. With the shortage of materials and skilled labour, at first nothing was built for the convicts, who had to do their best in caves or in makeshift 'lean-tos' under trees.

A little bridge was constructed across the life-giving stream of fresh water, which had soon acquired the name, 'Tank Stream'. Phillip hoped that the small settlement would evolve into an elegant city to be called 'Albion'. In fact, after he departed, Sydney grew in a haphazard manner. The main streets became narrower and the convict and lower-class area of 'The Rocks' on the western side of the Cove became a crime-ridden slum.

Most of the convict ships of the First Fleet and subsequent arrivals did not remain in port, but departed for China to take on chests of tea for the return trip to Britain. Within a few years, many such ships would return with tea to Australia instead. Tea-drinking in the thirsty climate quickly became an all-important social custom in the cities and in the outback. It has remained so to this day.

As governor, Phillip had been given almost unlimited authority. He could pardon convicts, make laws, grant land, use the government's funds: he was king, prime minister, ombudsman, psychological counsellor, prison governor, all in one.

His problems began almost immediately: the streams tended to disappear in hot, dry weather; no stream capable of turning a mill was found; the eucalyptus timber blunted the saws, broke the axes, and warped and shrank as it dried; no chalk or limestone being found, it had to be produced by laboriously burning seashells; many convicts fell ill, many were poor material for carving out a settlement, and the marines proved reluctant supervisors; medical supplies were low, and the surgeons had to experiment with local medications such as red eucalyptus gum for dysentery, yellow gum for lung problems; the pigs continually broke free, running wild and eating people's belongings; cattle and sheep had been purchased when the First Fleet stopped at Cape Town (Phillip thought they made the Fleet look like Noah's ark) but most of these died, or strayed, or were speared by Aborigines. Within six months, scurvy had broken out in Sydney because of the lack of fresh vegetables – until the colonists learned to eat Aboriginal food, such as certain grasses, berries, and vines.

For the convicts and marines, everything was strange, harsh, and forbidding. The eucalyptus trees shed their bark rather than their leaves. The emu did not fly, and the kookaburra emitted a raucous laughing sound. Kangaroos and wallabies hopped rather than ran or galloped. The climate was hotter than most had ever experienced. Sweltering Christmas came in the middle of summer, and winter in June and July. There seemed to be only two real seasons, summer and winter, not four. Such upside-down experiences gradually, but inevitably, began the changes that later became observable in the Australian national consciousness, as the new residents of this old land slowly came to internalize its quirks and to accept its idiosyncracies as normal.

At the expiration of their sentences or when pardoned for exemplary behaviour, convict men who showed promise each received a free plot of 30 acres, and, if they had wives, each received 50 acres. Though there were patches of fertile soil, the land around Sydney Cove was inadequate for the farming needs of the population. Good land, however, was finally found at the head of the harbour. Here the farming settlement of Parramatta was set up in late 1788.

Realizing that a year or more might pass before more food could arrive from Britain, Phillip despatched Captain John Hunter (1737–1821) in the *Sirius* to Cape Town to purchase supplies. To take advantage of the westerly winds, Hunter followed the much longer, but also faster, route east across the South Pacific, around Cape Horn, and across the South Atlantic to the Cape. With his supplies, he then continued eastwards once again across the Indian and Southern Oceans to Sydney. In this extraordinarily dangerous voyage, continually threatened by icebergs and almost destroyed by storm off Tasmania, Hunter actually sailed right around the world! Soon after, on the way to China for food, *Sirius* was wrecked on Norfolk Island.

A heavily laden storeship sent from Britain hit an iceberg and sank off the Cape of Good Hope. In 1790 more convicts arrived in Sydney in the 'Second Fleet' and the 'Third Fleet'. Many were too ill or too old to work, and strained already inadequate resources. In April 1790 the only remaining ship, the tiny *Supply*, was sent to buy food in Java. Food was so short that for six weeks all men (including Phillip) were restricted to a weekly ration of $2\frac{1}{2}$ lb flour, 2 lb cured pork, 2 lb rice. Women were

even worse off, receiving only two-thirds of the male ration. And children, worst of all, had only a third. Every possibility of food production was tried. Men were ordered to hunt kangaroos and to fish in the harbour. All work on public projects ceased at 1 p.m., and convicts worked on their own little plots. Crows, parrots, rats, snakes, and dingoes were eagerly swallowed.

Many convicts became too weak to work. Some committed suicide. When other convicts began eating all their ration in the first few days and starving the rest of the time, the food had to be issued daily. There were several cases of convicts starving to death. Matters were close to desperation. Had it been easier to evacuate, the white settlement of Australia might well have been abandoned during these first years. But, by the end of 1790, though there were shortages, the period of real crisis had passed.

The man who showed the way in farming was the pardoned convict, James Ruse, on his grant of land at Parramatta. He was proud of his achievement. On his tombstone, in what is now suburban Camp-belltown, are the words from his own epitaph: 'I sowd the Forst Grain'. With grants of land, other ex-convicts followed his example. By November 1791, there were forty-four ex-convicts farming their own grants of land in Parramatta. Men who had been reluctant to work under prison conditions became industrious when working for them-selves. It appeared that Australia might become a country of small farmers.

During the early years, about 10 per cent of convicts tried extreme means of escape. Learning that, after leaving Sydney, the convict ships went to China to take on tea, various unfortunates assumed China to be not far over the hills, and within walkable distance. Unaware of the vast extent of Australia, they escaped west, only to die slow deaths lost in the tangled gullies, or quick deaths speared by Aborigines.

A few escapees were more imaginative. In 1791 Mary Bryant, a sailor's daughter, her husband, their two children, and seven other convicts stole the governor's cutter and rowed it down the harbour out to sea. In ten weeks they sailed north, were stranded on the Great Barrier Reef, and pursued by New Guinea cannibals. Her husband and children perished during this 3000-mile adventure, but Mrs Bryant

survived and got as far as Dutch Timor where she was arrested and shipped back to England, where she was pardoned.

Relations with the Aborigines

Was Australia settled or invaded? Pioneered or conquered? The white achievement in Australia was all of these things.

CULTURE CLASH

In the eyes of the newcomers, New South Wales was a colony of settlement, not of conquest. Indeed, Phillip's instructions were clear, to 'open an intercourse with the natives, and to conciliate their affections, enjoining all our subjects to live in amity and kindness with them'. Given Cook's and Banks's original estimation that the Aborigines were few in number and scattered, this seemed a feasible instruction. But the legal status of the Aborigines remained ambiguous. Some decades later the Secretary of State for the Colonies issued a precise statement, when he informed Governor Sir Richard Bourke (1777–1855) that the Aborigines were to be protected by British justice and were not aliens 'with whom a war can exist'.

Phillip had believed there could be good relations with the Aborigines and tried harder than most men would, or could, to achieve this. With hindsight, his hopes look forlorn, for the Aborigines were much more numerous than expected, and no convicts and few marines were men of his moral fibre. Even with the best of intentions, the immense differences meant misunderstandings would occur. From the beginning, the clash of cultures, and later the vast distances involved and the impossibility of government control on the expanding frontier, made contacts between the races complex and problematic. Within eighteen months of the first landing, something more like petty skirmishing than peaceful settlement was the norm.

What made bloodshed inevitable was the fact that the best Aboriginal hunting lands were also the best lands for the settlers' farming. Clearing the land of trees and rocks was sometimes clearing the land of significant Aboriginal sites. Killing kangaroos and emus for meat was at the very same time taking Aboriginal food. Whereas the

whites took such Aboriginal food just as they pleased, the Aborigines were not allowed to kill the settlers' cattle and sheep. As everywhere else in the history of the world, land became the central issue, the bone of contention between the two races. In the last two decades of the twentieth century, it would become so again.

Reprisal followed injury – on both sides. In September 1790, Phillip himself was wounded by a 10-foot long Aboriginal spear; he ran for his life, the spear still sticking from his shoulder. The wound did not become infected, and he survived. Characteristically, he did not retaliate, assuming that the attack was merely repaying some earlier injustice rendered by some convict or marine. Indeed, Phillip also severely punished a gang of convict bricklayers who, in 1789, organized their own punitive expedition against the natives to avenge the death of one of their number. These convicts all received 150 lashes for taking the law into their own hands. (The reaction of any Aborigines who witnessed such floggings was uniformly unfavourable. Abaroo, an Aborigine who lived for some time with the whites, always showed disgust and terror.)

PEMULWUY

The Aborigines certainly offered resistance although, fortunately for Phillip, never enough to imperil the settlement. One particular Aborigine led what can be seen in modern terms as a resistance or guerilla band. His name was Pemulwuy. Between 1790 and 1802, when he was shot by two settlers, he and his followers fought a gallant hit-and-run campaign against the whites of the Sydney region. He was wounded, captured, escaped, wounded, several times over. Indeed, a legend of immortality grew up around his name. At one point the then governor offered a reward for Pemulwuy dead or alive, of 20 gallons of spirit, two suits of clothes, and, if a convict, a free pardon and recommendation for a return passage to Britain. In praising this enemy of the settlement, the third governor, Captain Philip Gidley King (1758–1808) wrote about Pemulwuy, 'Altho' a terrible pest to the colony, he was a brave and independent character'. Such racial strife would continue for the rest of the century as the settlers expanded inland.

But something more deadly than white men's muskets had soon begun destroying the Aboriginal population. As early as the end of 1788, convicts and marines going about their chores around the harbour began to see Aboriginal corpses lying in increasing numbers on the beaches and in the coves. This situation was the result of the spread of fatal disease, probably smallpox, inadvertently brought by the newcomers, and especially potent to these Aboriginal people who had developed no immunity. Within a few years, mortality was so high that social life for the tribes around Sydney had completely broken down. Later, similar disasters would be repeated throughout the continent.

A Modest Success

THIEVES

Naturally, with food so short for so long, some convict thieves practised their skills in the government food store. But, in the harsh and dangerous circumstances of Sydney Town, as the settlement was at first called, where everyone's life was at stake, such theft was intolerable, and Phillip was determined to end it. Food thieves were flogged, and the most dangerous recidivists hanged. Theft decreased. The colonists at Sydney and Parramatta struggled on.

NORFOLK ISLAND

In late February 1788 twenty-three convicts and marines were despatched to Norfolk Island 900 miles to the north-east to establish a second colony. Norfolk Island was the earliest example of the casual attitude to daunting distances that would become a commonplace of the Australian psyche as the white settlers spread across the continent in later decades.

Within a year, on the island's fertile soil, this little outpost became self-supporting, and so another 200 convicts were sent. Unfortunately, the native flax and the tall pine trees of the island proved to be unsuitable for sails and masts.

DEPARTURE OF PHILLIP

Governor Phillip was small, and of light build; he was often seasick aboard ship, and ill for much of the time he was governor; but he was a man of probity (certainly by the morality of his time, and in many respects by that of ours as well) and acted with imagination as each difficulty arose.

When Phillip departed for Britain on 11 December 1792, there were more than 4000 white people in the colony, including some 300 Australian-born children. The population was settled in three places: Sydney Town, Parramatta, and Norfolk Island. More than a third of the farming was being done by emancipated convicts on their own plots. The first thirteen free immigrants would arrive the next year. White Australia had been definitely established.

The Convict System and the Growth of the First Two Colonies

During the early decades of the 1800s Sydney grew and New South Wales continued to develop, settlers expanding into the vast potential pastoral lands across the Great Dividing Range. There was an extended political and economic struggle between the early governors and a clique of army officers. The large island of Van Diemen's Land (Tasmania) was settled and given a separate administration.

Convicts continued to be sent to both colonies and made important contributions to the economy, some even becoming extremely wealthy. The first industries of importance were sealing and whaling, which provided the first exports, and, for a time, it looked as though Australia would have a great maritime future.

Free settlers were arriving in increasing numbers, and they and their capital helped develop the wool-growing industry which would later be of such importance. By 1830, the broad outlines of the economic future of south-east Australia had been established, as well as the first stirrings of democracy. Australian national feeling was also beginning.

The Convict System

By the time the last convict ship arrived, about 163,000 convicts, men, women, and occasional children, had been transported to this vast open gaol. In those numbers there was an imbalance of more than six to one of men to women. These were crucial facts of life in the Australian settlements. And, though the number of convicts was to be made insignificant in later decades by the numbers of native-born Australians and by the arrival of hundreds of thousands, and in the twentieth

century of millions, of free immigrants, the values and attitudes of the earliest arrivals left their mark.

CONVICT WAY OF LIFE

Though sentences were extremely harsh by modern standards, most convicts were not quite the innocents often supposed. The noble poachers and political martyrs comprised a small minority. About two-thirds had previous convictions. Many had work skills but most, including the women, were thieves and pickpockets from the lanes of London, Dublin, and other large towns. Out of every twenty convicts, thirteen were English (including Welsh), six Irish, one Scottish. Rarely was a convict over 50 years old. Modern research shows that most convicts stole things well worth stealing.

More than half of all convicts had seven-year sentences, others were given fourteen and twenty-one years, and a few were transported for life. On the long voyage out shipboard conditions were severe. In the early years, one in every twenty-four convicts died. Conditions improved somewhat after surgeon-superintendents were assigned to each ship.

The convict 'system' was capricious. Convict life was a gamble, in which the severity of punishment was too often unrelated to the crime, but determined by the colonial circumstances in which convicts found themselves. A man might be set to clear fierce, almost unclearable scrub; or he might be used as a tutor to the master's children. Tradesmen were much valued and it was in the interests of their masters to treat them well. But, because of the chronic shortage of labour, unscrupulous employers also felt a standing temptation to keep convicts from gaining their release.

On arrival convicts were assigned to the governor of the colony. They were then employed by the government or, after free settlers began to arrive, reassigned to them. Reassignment saved the government money, and was a source of cheap labour for the settlers. Within two decades, the majority of convicts were not working for the government but for settlers.

The consensus is that the worst evils of the system were inflicted not by the settlers but on the government convicts who worked in barracks

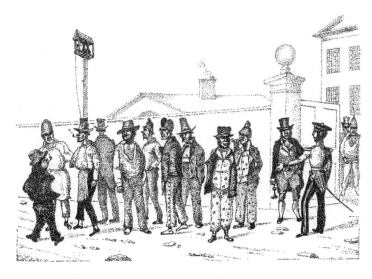

A government gaol gang

and road gangs, and most of all in the secondary penal settlements. For many convicts committed minor offences in Australia, and about 10 per cent were charged with serious crimes. In time, these latter were sent to specially established secondary settlements such as Coal River (Newcastle), Moreton Bay (Brisbane), and Port Arthur in Van Diemen's Land (Tasmania). Isolated from the moderating influences of the wider community, with no separation of newcomer from old lag, these places could be abominations. Hundreds of convicts 'bolted'. Many of these 'bolters' became bushrangers (outlaws).

Under the reassignment system, a flogging could be administered only by order of a magistrate but, because magistrates were almost always fellow landholders or friends of the convict's employer, a convict's word carried little weight. The following eyewitness account suggests something of the brutality:

 I saw a man walk across the yard with the blood that had run from his lacerated flesh squashing out of his shoes at every step he took. Ants were carrying away great pieces of human flesh that the lash had scattered about

the ground ... The infliction was a hundred lashes, at about half-minute time, so as to extend the punishment through nearly an hour ... They had a pair of scourgers, who gave each other spell and spell about; and they were bespattered with blood like a couple of butchers ... It brought my heart into my mouth.

Though such punishments seem extraordinary to modern Western minds and morals, it is important to recognize the context of the times and to recall that such treatment was the norm throughout the world. In European countries, schoolboys were liberally thrashed. In the contemporary United States, Latin America, much of Africa, and in Muslim lands, slavery was thriving. It is also important to remember the harsh conditions in the world's armies and navies, where the lash was a normal punishment.

FEMALE CONVICTS

In the early years of Sydney, many officers and officials seem to have held a callously dismissive attitude to the convict women, resulting in unnecessarily cruel treatment, although some women who were young and good looking attracted protectors. In general, women convicts were at a double disadvantage. Being from an inferior economic class, they were looked down upon. Because in the early fleets they had been sent to the colony to service the male convicts, they were often judged to be unredeemably immoral, whether they were so or not. Lord Sydney had said the presence of women was necessary to prevent 'the gross irregularities and disorders which would otherwise arise'. The official plan was that women from the nearer Pacific islands would be persuaded to come to service those marines and convicts who arrived without wives. A mixed race would have resulted. This part of the plan did not take place, and the gross imbalance between the sexes became accepted as normal.

The typical female convict had been a domestic servant caught in theft. Some were prostitutes – though no woman was ever transported for prostitution as such. Some young women were forced into prostitution on the voyage out, as captains and officers took expedient advantage of their vulnerable state. As a generalization, it can be said

that about a third of these women were recidivists, a third had committed offences now and then, and the other third were probably unlucky to be transported for minor transgressions. Through their domestic skills, and in some cases through their knowledge of farm life, most of these women eventually made an important contribution to the developing Australian economy.

In New South Wales, given the sexual imbalance, the convict woman would soon be taken up by a man, sometimes with little say in the matter. Women, convict and free, bore children at a rate greater than in Britain. A convict midwife, Margaret Catchpole, wrote: 'It is a wonderful country for to have children, even very old women have them that never had none [sic] before'. The benign and sunny climate, the plentiful food (after the early years of scarcity), the lack of European diseases, made for healthy mothers – and healthy children. By the twenty-fifth anniversary of Sydney's founding, a quarter of the white population was under twelve years of age.

Many of the sons of convicts took up trades or worked 60-acre farms. Most of the daughters married young to continue the native-born tradition.

SUCCESS OF EXCEPTIONAL CONVICTS

The governor had the authority to emancipate convicts for good behaviour. Acceptable behaviour could result in 'tickets of leave' (freedom within the colony), and even in pardons. When their sentences had expired, most convicts became part of the general mass of the evolving Australian population. There were exceptions, people whose strength of character, sagacity, ability, or cunning helped themselves and the development of their new country in a remarkable way. Consider the following intriguing cases.

In one of history's most fascinating reversals, in October 1994, the image of the female convict Mary Reibey née Haydock (1777–1855) appeared on the new, plastic, counterfeit-countering, Australian $20 note. In 1790, this Lancashire lass had been sentenced when thirteen to seven years for stealing a horse – borrowing without permission she deemed it. At seventeen she married a free colonist, Thomas Reibey, and opened her own store. At thirty-five she had seven children and a

thriving mixed business. At fifty she owned two ships, eight farms, numerous houses, and rented premises to the Bank of New South Wales, in which she held one of the largest accounts. At sixty, and a multi-millionaire in modern terms, she drove about Sydney in a splendid carriage drawn by two white horses. At seventy, the Anglican bishop of Sydney called her, 'praiseworthy in the highest degree for her exertions in the cause of religion'. Her grandson became Premier of Tasmania.

Samuel Terry (1776–1838) was charged with stealing 400 pairs of stockings. After serving his seven years, he became an innkeeper and farmer, married a well-off wife, and then acquired wealth so rapidly that, for several years after 1817, he underwrote a fifth of all the registered mortages in the colony. Though some of his deals were of dubious legality he was one of the key shareholders of the first bank. After that he bought farms, flour mills, breweries, and much property in the heart of the city. At his death in 1838 he was worth £250,000, a prodigious amount in the values of the day, equivalent to tens of millions now. Though he was shunned and kept out of polite society, one of his daughters became the first mayoress of the city when municipal government was allowed in 1842.

Simeon Lord (1771–1840), transported at twenty for theft, established a retail business which eventually dealt in just about everything in which Sydneysiders traded. The ideal emancipist, Lord was even appointed a magistrate, and often attended Governor Macquarie's receptions. Like Terry, he came to own a great share of Sydney real estate, 18,000 acres of farm, as well as a fleet of sealers and whalers, and even two ships that transported convicts.

Solomon Levey (1794–1833), transported in 1814 for theft, was given a 'ticket-of-leave' and, like Lord and Terry, became one of Sydney's great capitalists. While on business in London, he encouraged migration, especially Jewish, to Australia. His money played a key, though secret, part in the foundation of the colony of Western Australia.

Cantankerous Francis Greenway (1777–1837) had been transported in 1814 for concealing assets. While still serving his sentence, he was promoted by Governor Macquarie to the post of official architect and

St Matthew's Church, Windsor, designed by convict architect
Francis Greenway

civil engineer, revealed a genius for architectural style, and is celebrated
today as Australia's first great figure in these fields. His Hyde Park
Convict Barracks, St James's Church, Sydney, and St Matthew's,
Windsor, have not merely survived but are now fully restored and are
regarded as unique national treasures.

REFORMERS AND POLITICALS

In 1813, sixty so-called 'Luddites' were transported. These men were
industrial workers who had smashed the newly invented machinery of
the Industrial Revolution which was making them unemployed. In the
early 1830s came 481 farm labourers who, with similar motives, had
destroyed the new steam-driven threshing machines and burned the
haystacks. These men were very different types from the town convicts.
Healthy, hardy, fine farm workers, they were in fact welcomed to the
colony by the *Sydney Herald*.

In 1834 six farm labourers from the village of Tolpuddle in Dorset, led by a ploughman and lay preacher, George Loveless, were transported for trying to form a trade union. Becoming famous in Britain as the 'Tolpuddle Martyrs', their case was re-examined, and they were eventually freed and repatriated. They are now icons of British Trade Unionism. The country of their exile would become a bastion of such unionism by the end of the century.

There were also political prisoners. The earliest were the 'Scottish Martyrs', transported in 1794 for urging greater democracy. In 1839–40, after the rebellions in Canada, nearly 100 French Canadians were sent to Sydney and a number of Anglo-Canadians to Van Diemen's Land. Because New South Wales was part of the vast imperial network, convicts were sent from South Africa, too. There were also Irish political prisoners, the earliest being members of the 1798 rebellion. Perhaps only 4 or 5 per cent of the Irish were true political prisoners. Most were thieves and poachers.

On the completion of their sentences, some convicts returned to Britain. A handful of these committed new offences there and were once again transported! In their case, the main point of transportation, namely deterrence, had obviously failed. And in such cases as those of Reibey and Terry, transportation to Australia had been, to say the least, a paradoxical punishment.

THE LONG-TERM EFFECTS

In Britain the convict system came under heavy criticism during the 1830s as its evils and expense to the government became better understood and as alternative schemes for colonizing Australia with free immigrants became popular. As more free settlers arrived in the colonies, local agitation against the system also became vehement. As a result, the last convicts were sent to New South Wales in 1842 and to Van Diemen's Land in 1852. (To show their contempt for the convict era, in 1857 the colonists renamed their island 'Tasmania'.)

Just how much the character of modern Australians derives from the convicts has been much debated. We can, if we like, see in the convicts the beginning of the well-known egalitarianism and dismissive attitude to authority characteristic of modern Australians. For the convicts had

little respect for the guards or for many of the free settlers who employed them, and less for the legal system that had sent them so far away from home. Probably, the Irish convicts, with their almost 30 per cent of the population, were important in the development of such attitudes. These arguments are at least plausible. As subsequent chapters will show, independence, self-reliance, and egalitarian attitudes were characteristic of much else that happened in later Australian history, and this may have strengthened early convict attitudes.

Over the eighty years of transportation only about 25,000 transportees were women. The consequent shortage of women had a decidedly negative effect, especially in New South Wales and Tasmania. In contrast with other British colonies of settlement with a more normal balance, it produced a cruder, more rugged society dominated by male values. It also gave a distorted position to women, tending to place them in the gutter or on a pedestal. The male-dominated society it created is in some respects still with us.

What have been the effects of convicts on morals? It is clear that whatever negative effects convicts may have had on Australian morality during the early decades of colonization (they far outstripped the free settlers in their crime rate, for example), there was little permanent negative effect. The native-born descendants of such convicts in general rejected whatever criminal traits their parents may have had. In Australia by 1800 there was no need for such attitudes. Labour was short and even children could be assured of regular well-paid work. Equally important in rejection of criminal values was the fact that New South Wales society was more open than that of the British Isles. The children of convicts had no experience of the complex economic society which had helped shape their parents' attitudes. There is thus much truth in Charles Darwin's 1836 observation that transportation had succeeded, 'to a degree perhaps unparalleled in history' in changing criminals and their families into useful citizens. Soon, despite the bushrangers, crime and corruption were no more a feature of Australian life than they were in Great Britain or in other British Empire countries such as Canada, and probably less so than in the United States. And today Australia has less crime than most countries in the world.

The convict effect on the Australian accent is easier to show. A disproportionate number of early convicts were what we should now call working-class Londoners. Some spoke the 'flash' language of the London underworld. And the evolution from Cockney glottal stops and consonant substitutions and omissions to the nasal Australian accent with its vowel shifts is no great one. No doubt all sorts of cross-pollination with other English and Irish accents and dialects occurred on the ships out. Very early a distinctive accent had evolved. In 1809, King Kamehameha of Hawaii employed eight escaped convicts as official distillers to his court. One of them, 'Long William' talked with a visiting Scotsman, who reported:

> Here was a language which was new to me though not for its oaths. It was like Cockney such as I had heard about the docks in London, but Cockney with a different flavour and with queer turns of speech that those who lived in New Holland or Australia soon acquired.

Certainly the convict system did not have much deterrent effect on crime in the British Isles. On the voyage out, and in Australia, the system clearly corrupted some people. Still, it is generally agreed that the skills and exertions of convicts and ex-convicts were of great significance in making New South Wales, Tasmania, and Western Australia economically viable, and in founding Queensland. And for more than 150 years these regions remained loyal to Britain.

Whatever may have been the long-term results, the convict system provided a bizarre beginning for what would become a great democratic nation.

Sydney under the New South Wales Corps

In 1790, half-way through Phillip's tenure, the Second Fleet had arrived. With it came not only more convicts, but a specially recruited regiment of soldiers, known as the New South Wales Corps, to replace the reluctant marines. A London newspaper, sarcastically expecting the worst, dubbed the Corps the 'Botany Bay Rangers'. As events would show, the paper was saying more than it realized.

THE RUM CORPS

One important officer of the New South Wales Corps was the young and endlessly ambitious subaltern, John Macarthur (1767–1834), who duelled with (sometimes literally) or denigrated everybody who ever opposed his wishes and designs, suitably gaining the nickname, 'the Grand Perturbator'. Once in New South Wales, Macarthur would became the *de facto* leader of the Corps officers.

In 1793, having learned there was now a British colony in the South Seas the Yankee ship *Hope* sailed into Sydney with a cargo of general goods and 7500 gallons of rum! The skipper, Benjamin Page, refused to sell any general cargo unless he sold all the rum as well. Supported by the lieutenant-governor, Major Francis Grose (1758?–1814), John Macarthur and his clique of fellow officers quickly organized a cartel to eliminate competition in the buying and so deal with Page in his own coin. They purchased the whole cargo.

Thereafter the Corps officers, drawing upon their credit back in Britain, and unworried by scruple in their trade dealings with the soldiers and convicts, cornered the commerce of the colony. Much of this trading continued to be in rum – mostly from far away Cape Town and Calcutta. Thus, circumstances modified the original plan for convict New South Wales as a place of self-supporting small emancipated convict farmers. The age of capitalist free enterprise in Australia began.

This change might have been slower without the catalyst of the New South Wales Corps, but it had to happen, for the climate and soils of New South Wales restricted the possibilities for small farming. With one or two exceptions, such as in the wheat lands of South Australia, peasant-type farming was impossible in Australia. Equally, this meant that the economic and social life of the colony would become dominated by the pastoral enterprises of large landowners and the trading of merchants. Many decades later, when New South Wales farming did thrive, it was not in small farms but in the large inland wheatlands on the other side of the Great Dividing Range.

Whereas Governor Phillip had consistently refused to grant land to his officers, the acting governors and commanders of the New South

Wales Corps, first Major Grose and later Captain William Paterson (1755–1810), took full advantage of the almost three-year interim before the arrival of the next governor to provide their officers with grants of land and convicts to work them.

As New South Wales was a convict colony, the matter of money had not been addressed. Various expedients were resorted to – promissory notes, the military paymaster's notes, bills of exchange, foreign coins, traders' tokens eased along with lots of barter. With so much barter, it was rum which, infinitely divisible, quickly became a *de facto* currency! So central were the officers of the New South Wales Corps in this rum trade that they have become known to history as 'the Rum Corps'. Practically every officer was involved. In September 1800, for instance, the two chief medical officers of the Corps held 4500 gallons of rum and spirits. Convicts were encouraged with rum, and privates in the Corps were often forced to accept rum or other trade goods as pay – at grotesquely inflated rates.

The judge-advocate, David Collins, said that, among the convicts, 'rum operated like a mania'. Rum drinking quickly became a social problem, reproducing all the evils of Hogarth's *Gin Lane*. Heavy drinking thus began at this very early stage of the nation's history, under the Rum Corps. Many small settlers and emancipated convicts were destroyed by the twin demons of drink and debt to the Rum Corps.

In 1794, a new farming region was developed on the banks of the noble Hawkesbury River, about 20 miles to the north-west of the main settlements. Pioneered by the former farmer of Parramatta, James Ruse, this was a region of rich alluvial soil which, with the new town of Windsor as its centre, quickly attracted emancipist convicts and soon outstripped Parramatta in food production. But, by 1800, the white population was still only about 5000, living in or near the three little towns of Sydney, Parramatta, and Windsor. Twelve years after the First Fleet, Sydney had a rough and ready look. As a new arrival put it: 'more the appearance of a camp than a town, mixed with stumps and dead trees'.

As Sydney grew, it became a port for whaling and sealing around the Australian coast and in the South Pacific. The Corps officers profited from these developments, too, and became the real power in the little

colony. They remained so under the three succeeding governors – a situation that had not been anticipated in Britain.

COLONIES FACING THE SEA

Sydney and its hinterland were trapped between the sea and the Blue Mountains about 40 miles west, and Norfolk Island and Van Diemen's Land were themselves islands. The sea provided the main form of communication between and within the colonies. The products and interests of the sea long outshone those of the land. In the early decades, New South Wales looked as though it would be basically a convict colony, but one with some important maritime enterprises.

During this period sealing and whaling became the staple export industries of New South Wales. Increasingly, this trade came into the hands of the emancipated convicts and the native-born generation. As early as 1792, the English firm of Enderbys was using Sydney as its base for seal hunting. Free and emancipated Sydney merchants were employing hundreds of men in gangs in Bass Strait. A single ship brought 60,000 seal skins from the South Antipodes Islands in 1806, and cargoes of 15,000 skins were nothing unusual. One extraordinary method of sealing was as follows. Aboriginal women would be forced to swim out to the seal rocks, lie down quietly until the animals lost any fear, and then, on a signal, rise up and slaughter them.

Whaling took longer to develop and was more lasting. Bay whalers, in fact, made temporary settlements in what would become the colonies of Victoria, South Australia, and Western Australia decades before permanent settlers arrived. In the early 1830s, half the exports of New South Wales were still products of whaling.

Deep-sea whaling continued into the 1850s. By 1860, some thirty Hobart whalers were sailing as far south as mysterious, glaciated Kerguelen Island, nowadays unknown to the world except when some round-the-world yachtsman gets into difficulties in high latitudes. Within a few decades, these sources were depleted and whaling, like sealing, rapidly declined.

RUM REBELLION

True to their instructions, the next three governors, John Hunter,

Philip Gidley King, and William Bligh (1754–1817), all Royal Navy captains, tried to curtail the power of the Corps, and to encourage the farming and trading of the emancipated convicts and the handful of free settlers who were coming out from Britain.

The British government view remained that New South Wales should be primarily a prison and a colony for the rehabilitation of former convicts, based upon a self-supporting farm economy. But, as the colony had no proper police, the main coercive power to which the governors could resort was, of course, the New South Wales Corps itself. A continuing and bitter struggle ensued, at the centre of which was often to be found the person of John Macarthur.

A few years after arriving, Macarthur and other interested settlers, such as the Reverend Samuel Marsden (1764–1838), with a combination of luck and intuition, had perceived the country's hidden potential for sheep farming. On his granted lands, Macarthur, with the help of his talented wife, Elizabeth, and convict shepherds, experimented and developed a new kind of sheep. They crossed the Spanish breed, the merino, with several other hardy types. The hybrid and its variations proved spectacularly well suited to Australian conditions, and became the backbone of the gigantic Australian wool industry in later decades. But the antipathy he aroused in the governors and other free settlers may be gauged from the following memorable words of Governor King in 1801:

> His employment during the eleven years he has been here has been that of making a large fortune, helping his brother officers to make small ones ... and sowing discord and strife ... Experience has convinced every man in the colony that there are no resources which art, cunning, impudence, and a pair of basilisk eyes can afford that he does not put into practice to obtain any point he undertakes.

In the same year as Governor King wrote the above words, Macarthur wounded his own colonel in a duel. Fearing the consequences in Sydney of a court martial of this Corps favourite, King despatched him to Britain. Macarthur oozed braggadocio, and had luck as well. Meeting influential people on the voyage home, he was able to pull strings and have the charges quashed. He had also taken with him

some woollen samples from his farm. This timing was just right because Britain was at war with Napoleon who was blockading her European supplies of wool. Macarthur persuaded the government to try Australian wool and was even granted the right to purchase sheep from the king's flock! More arrogant than ever, he returned in triumph to Sydney in 1805 with a letter from the Colonial Secretary ordering that he be given a further grant of 5000 acres and the labour of thirty convicts to carry on his sheep breeding.

Success was not immediate: as late as 1819, Macarthur was complaining about the lack of interest his breeding experiments were attracting. Though we may deprecate his aggression, it must be acknowledged that it was he who, above all others, changed the attitude of the British government and of British investors towards the penal colony of New South Wales. He is one of the great figures of Australian history.

The struggle between the governors and the New South Wales Corps reached a crisis with the arrival of Governor William Bligh in 1806. Bligh was already famous as the centre of the mutiny on His Majesty's ship, the *Bounty* in 1789. Once in Sydney, he made sterling attempts to protect the rest of the colony, especially the impoverished emancipated settlers of the Hawkesbury River, from the New South Wales Corps. Naturally, the Corps believed Bligh was overriding the rights of property and of themselves as British subjects. For his efforts, Elizabeth Macarthur termed Bligh 'violent, rash and tyrannical', and Bligh repaid the compliment calling Macarthur, 'an arch-fiend, a constant disturber of public society, a venomous serpent to His Majesty's Governors'.

Bligh's attempts to curb the Corps, coupled with his notorious ill temper and the Corps' hauteur, provoked many explosive confrontations, and eventually led to – another mutiny against Bligh. Orchestrated by Macarthur, a detachment of the Corps (many the worse for rum, supplied by Macarthur) led by their commander Major George Johnston, band playing, marched to government house and placed Governor Bligh under house arrest. There he remained for eighteen months. This mutiny of the New South Wales Corps has been aptly dubbed 'the Rum Rebellion'.

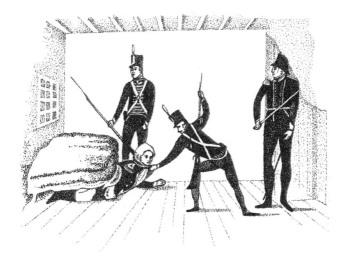

A cartoon suggesting Governor Bligh hid under his bed from the
New South Wales Corps

For this treason no one was hanged or even imprisoned. Macarthur
had friends in high places in London, so both sides were blamed.
Though Bligh was not reinstated, the New South Wales Corps was
disbanded, and the leaders of the mutiny, including Macarthur, were
recalled to remove them from their source of power. Johnston was
cashiered by a London court martial and Macarthur was forced to live
in Britain for eight years.

It is hardly surprising that the Rum Corps had been allowed such
licence for so long. Engaged for most of the period in war with
Revolutionary and Napoleonic France the British government had
more important matters on its mind.

In contrast to the situation in dozens of other countries colonized by
European powers, this bloodless 'Rum Rebellion' has been the only
military coup in Australian history – the early exception to what
became an evolving democratic tradition.

Macquarie and the Growth of Sydney

In 1810, a new governor, the Scot, Colonel Lachlan Macquarie (1762–1824) arrived, with his own regiment to enforce his authority and to replace the disgraced New South Wales Corps. He had fought in the British Army during the entire American Revolutionary War, as well as in arduous campaigns in India and Ceylon (Sri Lanka). Macquarie's was the first of fourteen successive British regiments that came out to guard this corner of the realm, the last departing in 1870.

CIVILIZING THE SETTLERS

By now the colony had a white population of more than 10,000, and was becoming a centre of commerce and trade, with significant sections of this commerce already in the hands of freemen and emancipated convicts.

The arrival of about 600 convicts a year during the period of the Napoleonic Wars increased to well over 2000 a year with the coming of peace in 1815 – for peace brought an increase in crime. Faced with such unprecedented numbers, and because few of these convicts could be allocated to the comparatively small numbers of free settlers, Macquarie was forced to employ most of them on government farms and on building projects, such as a handsome, three-storeyed, brick convict barracks and a new government store. A splendid hospital was constructed – known colloquially as 'The Rum Hospital' – part of it now serves as the parliament house of New South Wales. It gained that sobriquet because three leading settlers were granted a temporary monopoly over the import of rum and spirits and, in return, built the hospital without cost to the government. All Macquarie's structures were of local stone or brick, roofed with tiles locally made. On such buildings as exist today, the marks of the convict chisels can still be seen.

The remaining tree-stumps were removed from Sydney's streets, which were widened, paved, and straightened. At the south of the town proper, the open area was permanently set aside 'for the recreation and amusement of the inhabitants of the town, and as a field

of exercise for the troops'. The first properly recorded cricket match in Australia occurred in this open area in 1803. Designated 'Hyde Park', it remains today the principal park of central Sydney. Paved roads were built from Sydney to the other principal settlements of Parramatta, Windsor, and Liverpool.

ECONOMIC DEVELOPMENT

During Macquarie's governorship, commerce forged ahead in Sydney, with wholesalers, retailers, auction houses, butchers, bakers, rope-makers, and other specialisms developing. An outstanding example of such free enterprise occurred in 1814 when Simeon Lord built a factory near Botany Bay to produce shoes, hats, stockings, leather goods, and woollen cloth, and employed sixty convicts. The end of the Napoleonic Wars also brought an increase in the number of free settlers, the majority of whom were men of capital which they invested in the pastoral industry.

In 1817, a colonial bank, the Bank of New South Wales was set up – this was the beginning of Sydney's history as a centre of finance. The company has remained Australia's leading private bank until the present day: though, in 1978, in that breathtakingly casual way in which modern Australians can destroy their traditions, it was renamed 'Westpac' that is, Western Pacific. To produce a currency, Macquarie employed a gifted counterfeiter who converted £10,000-worth of imported Spanish dollars by cutting a circular piece from the middle. This 'dump' was worth 1 shilling and 3 pence, the doughnut-shaped outside 5 shillings ($\frac{1}{4}$ of a £). Rum was banned as money. A police force was organized.

All such development helped to expand the European population of the colony from 10,500 in 1810 to about 30,000 in 1821. Already, the town of Sydney was developing the sprawl that, encouraged by unlimited land and in contrast to the cities of Europe, would become characteristic of all Australian cities.

Shortly afterwards a curious new name for the native-born colonists was first used: 'Currency Lads and Lasses'. Just like the currency of promissory notes, they too were home made, not imported like so much else.

EMANCIPISTS AND EXCLUSIVES

The ex-convicts, 'emancipists' as they were called, became small-time farmers, labourers, and shopkeepers, and, in the outstanding cases such as Lord and Levey, entrepreneurs. Prior to and after the Rum Rebellion, many officers from the New South Wales Corps had resigned and taken up full-time trading and farming. They, and the free settlers, who by this time were now migrating from Britain in increasing numbers, considered themselves different from, and socially and morally superior to, the emancipated convicts.

So Australia's first class distinctions emerged, with the free 'exclusives' or 'exclusionists' trying to suppress the ex-convict 'emancipists' and their relatives, and exclude them from polite society. Differences were exacerbated by the fact that, for many decades, there was almost no middle class to function as a link. The emancipists were well aware of their supposed inferior status, and got some revenge by inventing derogatory epithets and curses, and by dubbing the more extreme exclusives 'pure merinos' (after the sheep).

Macquarie, though staunchly a soldier and a believer in authority, had an egalitarian streak: he preferred the emancipists, especially successful ones. He insisted that once a convict had served his time his past should be forgotten, encouraging emancipists, such as the architect Greenway, the surgeon William Redfern (1774–1833), and James Hutchinson who became the Superintendent of Convicts. [The shoplifter, George Howe (1769–1821), had earlier been editor of Australia's first newspaper, *The Sydney Gazette*.] To the disgust of the exclusives, Macquarie often invited leading emancipists to his dinner table.

Macquarie's attitude did little to change exclusives' views. As late as 1843, a visitor said with some accuracy, 'Caste in Hindostan [*sic*] is not more rigidly regarded than it is in Australia: the bond and free, emancipist and exclusionist, seldom associate together familiarly'. Other observers pointed out that, though in fact there was not much difference between the classes, nowhere else in the world did such a small difference mean so much to the class conscious.

The colony had previously been unable to discover a way through the Blue Mountains west of Sydney. As well as numerous private efforts, seven official attempts had been made to find a way across. At last, in 1813, a drought year, several Aborigines, two convicts, two free settlers (G. Blaxland and W. Lawson) and a Currency Lad (William Charles Wentworth 1790–1872) found a route across by following the ridges instead of the valleys which had thwarted all previous efforts. Though there is no evidence to the effect, it may be surmised that it was the Aborigines who were the key to this success – for many a later expedition benefited from Aboriginal guides. Vast waving grasslands were seen to stretch far into the west. Encouraged by the promise of a pardon, convicts built a road across the mountains and soon the first inland town in Australia, Bathurst, was founded in 1815.

There were no Roman roads, no Aztec stone paths or Inca viaducts, to be built upon: when Phillip's colonists landed, there was not a highway, not a lane in the whole continent. Over the centuries, by repeated Aboriginal movement, rough tracks had been worn here and there to some water-hole or meeting place, and sometimes the settlers were able to make use of these but that was all. For the British in Australia, roads such as that across the Blue Mountains had to begin from the beginning. To this day, road building has proved a costly burden in a barren continent with a widely scattered, comparatively small population.

COMMISSIONER BIGGE REPORTS

Meanwhile, Macarthur's clique had got the ear of powerful men in the British government, reporting a disturbing and distorted account of the situation in New South Wales. Consequently, a judicial commissioner, J. T. Bigge, was sent to find out how the convict system and the colony in general were run, and to suggest whether there should be changes in the nature of its governance. Macquarie found Bigge's activities insulting to his conscientious efforts, and eventually resigned.

Influenced by the exclusives, Bigge reported unfavourably on Macquarie's governorship, condemned his building programme, and found no sympathy for his support of emancipists and small farmers. In part Bigge was criticizing Macquarie's implementation of the very

policies for which the convict colony had been established, towards which Macquarie and all four previous governors had worked. The vast majority of colonists supported Macquarie. The cheering crowd of thousands who bade him farewell on the docks was his vindication – the largest gathering in the history of the colony.

With reference to future developments, Bigge's famous *Report* advised that large parcels of land, mainly for wool growing, should be granted to respectable free immigrants, and that the land should be allocated in proportion to the capital brought to the colony – with convicts to work for, and be maintained by, them. Recalcitrant convicts should be sent to secondary, harsher penal settlements.

Bigge's recommended changes were accepted. It was a turning point in the country's history. Thereafter for the British government, commerce increasingly replaced the convict purpose of the colonies. Many wealthy immigrants were now tempted to the come out to Australia with their capital. So the great interior grasslands of Australia were about to be opened up by explorers and by pastoralists with their sheep and cattle, and masses of Aboriginal hunting land were about to be appropriated.

Van Diemen's Land (Tasmania)

In 1789, at about the time the French Revolutionaries were storming the Bastille, the English naval surgeon, George Bass (1763–*c.* 1808) and Matthew Flinders (1774–1814) in a small boat had confirmed that Van Diemen's Land was not a long extension of the mainland but a large island. It was separated by the 150-mile wide Bass Strait. In 1803, to pre-empt the French, Governor King and the imperial authorities established settlements of marines and convicts in Van Diemen's Land. The initial settlement was at Risdon under Lieutenant John Bowen's (1780–1827) small party. In 1804, with the arrival of David Collins's party from Britain, the settlement was moved further south down the Derwent River to where the city of Hobart grew up – the most southerly British outpost in the world. Collins brought some 330 convicts, forty-eight marines, and sundry other settlers. He had originally been instructed to develop a settlement on the south coast of

the mainland in what is now the state of Victoria, but had found the site in Port Phillip unsuitable.

FORESTALLING THE FRENCH

Why were the British so afraid of French occupation? To understand why, we need to put ourselves in the minds of the New South Wales governor and settlers. Earlier French explorations of the South Pacific and the Australian coast have already been mentioned. The British were well aware of them, and Baudin's recent explorations in 1802 had set off new worries. The Revolutionary/Napoleonic Wars were at their height. For centuries France had been the aggressive colossus of Europe, dominating her neighbours and taking their territory. Large in population, fertile in industry, she was still the terror and bane of Europe. Neither Governor King nor the British government wanted the European situation perpetuated in the antipodes. Though nothing came of it, a few years later, in 1810, Napoleon actually advised the French governor of Mauritius in the Indian Ocean to 'capture the English colony at Port Jackson'.

TREATMENT OF CONVICTS

Soon free settlers arrived in Van Diemen's Land, to grow wheat and wool. But, with the island's endless inlets and estuaries, whaling and sealing became the first really important industries, their products being sent to far away China and Britain. By 1825, the colony, now also prosperous from farming, was separated from New South Wales under the rule of Lieutenant-governor George Arthur.

Arthur believed that rebellious convicts should suffer, well-behaved ones prosper. At Port Arthur he established a special penal colony for the rebellious. To thwart escapes, the penal colony was built on a peninsula, connected to the mainland by a narrow neck of land patrolled by guards and dogs. For the guards, Port Arthur was just as much exile as it was for the convicts, so they took out their frustrations and grievances on the unfortunate convicts, with floggings and sadistic punishments.

Governor Arthur faced two huge problems. The first was that of bushrangers. These were escaped convicts who, driven to recklessness

by their punishment, took to robbery and murder. Resolute action by Arthur, using soldiers and colonists, stamped out this threat.

CLASHES WITH THE ABORIGINES

The second problem was that of endless clashes between whites and Aborigines.

The Tasmanian Aborigines, somewhat different from the main-landers, were originally friendly and harmless. But the convicts and colonists did not understand their culture, and escaped convicts and bushrangers committed atrocities. Though the official British govern-ment policy was accommodation with the Aborigines, this was increasingly ignored by the settlers. Tragedy was brought about by arrogance, carelessness, and all the misunderstandings even of one another's best intentions, that have arisen throughout history when one group, race, or nation has entered the territory of another.

A fascinating example of this misunderstanding was the poster displayed in 1828 by order of Governor Arthur. In pictures and without words, it was supposed to show what would happen if a white man killed an Aborigine, and if an Aborigine killed a white man. Both would be punished equally by the governor, and hanged. The extra-ordinary assumption was made that, beginning at the top of the poster, illiterate, Tasmanian Aborigines would 'read' the pictures from left to right. But, if the Tasmanians 'read' as do, say, the Chinese, from top to bottom, the message given was that whenever an Aborigine speared a white man then another white man could shoot an Aborigine! And if the Tasmanians 'read' as do the Arabs, from right to the left, the even more extraordinary messages given were that, whenever the governor hanged an Aborigine, then an Aborigine could spear a white man, and that, whenever the governor hanged a white man, a white man could shoot an Aborigine!

In the competition for land, attitudes of both groups rapidly chan-ged. The result, despite repeated attempts by the governor and many humane settlers to treat the Aborigines justly, was ever-increasing bitterness resulting in ambush and secret murder by both sides, and eventually, outright warfare. It is estimated that in the three years of martial law about 200 whites and 800 Aborigines died.

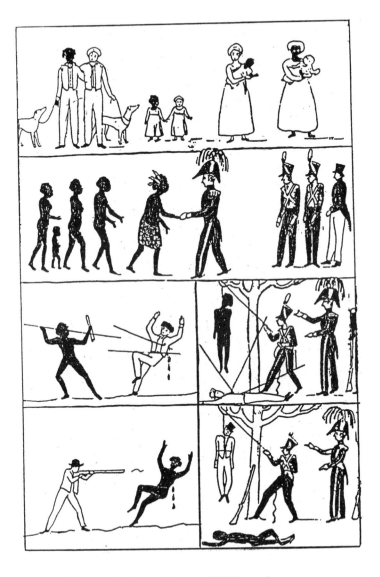

Governor Arthur's ambiguous 1828 Tasmanian poster

Moreover, deaths from European diseases killed more Aborigines than all the conflict. So, in just thirty years of settlement, an estimated 3000 or 4000 original Aborigines had been reduced to a few hundred. Finally, the surviving Aborigines, some 200 or so, after an unsuccessful quasi-military effort to capture them all, were persuaded by the missionary George Robinson (1788–1866) to transfer to Flinders Island in Bass Strait. The intention was that there they could settle and thrive but, within a decade, only forty-four were alive. The last person seen as a full-blood Tasmanian Aborigine, the woman, Truganini, died in 1876.

Descendants of these Aborigines have survived, however, through cohabitation of Aboriginal women with the sealers and whalers who frequented the Bass Strait islands. They are today increasing in numbers and proud of their Aboriginal inheritance.

Growth of National Feeling

So, by 1830, there were two separate colonies on the continent, and already aspects of that mysterious phenomenon, national identity, were established and growing. The people from the British Isles were subtly metamorphosing into Australians. Different climates and environments change people and, within several generations, the European settlers of Australia became subtly different in physique and values, from their northern hemisphere progenitors. In this change, the homogeneity of the convicts as a class, their disproportionate numbers, and the great imbalance in the sexes, were of fundamental importance.

Convict experiences, dismaying distances, new opportunities, situations requiring personal initiative, absolute dependence on one's immediate family and friends, new and abundant foods, a high-protein meat diet, outdoor, often hard work in fresh air and sunshine – such things and a hundred others also contributed.

Many convicts and free colonists, but especially the first native-born generations, began to feel that they really were different from other peoples of the world, different even from their own English, Scots, Welsh, and Irish. And there was proportionately more intermarriage

between these British nationalities than in the home countries, again introducing a difference.

Commissioner Bigge, a man not given to eulogize his social inferiors had the following fascinating words to say about the settlers who had been born in Australia. Though one or two characteristics appear distinctly odd, in this description from his *Report* of 1822 can be seen some of the core qualities that a modern observer might ascribe to Australians.

> The class of inhabitants who have been born in the colony affords a remarkable exception to the moral and physical character of their parents: they are generally tall in person, and slender in their limbs, of fair complexion, and small features. They are capable of undergoing more fatigue, and are less exhausted by labour than native Europeans; they are active in their habits . . . In their tempers they are quick and irascible, but not vindictive . . . they neither inherit the vices nor the feelings of their parents.

The people of New South Wales also had terms by which to mark their difference. For in 1803 the navigator Matthew Flinders had suggested the words 'Australia' and 'Australian'. And Governor Macquarie from 1817 used and recommended the adoption of 'Australia' rather than 'New Holland' or the Latin *Terra Australis*. The native-born now began to use 'Australia' with feeling. By 1826 the free immigrant E. S. Hall (1786–1860) of Sydney was writing the following revealing letter to London:

> I, Sir, speak as a father of eight Australian-born sons and daughters; and though I myself glory, and shall die glorying, in the name of *Englishman*, yet my children glory in *another* name. To be *Australian* is their signal word.

CHAPTER FIVE

New Britannias: Cities and Colonies all around the Coast

A dozen remarkable years shaped Australia's great cities. From 1824 to 1836 four of Australia's five largest cities were founded. In order of foundation they were: Brisbane, convicts at first – free settlers later (the colony of Queensland); Perth, free settlers first – convicts later (the colony of Western Australia); Melbourne, free settlers with some convicts (the colony of Victoria); and Adelaide, free settlers only (the province of South Australia).

During the remainder of the nineteenth century these new cities and their surrounding colonies became 'little-large' southern-hemisphere Britannias (little in population, large in area).

Common Characteristics

These cities opened up their hinterlands to agriculture, pasture, and mining; they shared a common British heritage continually being reinforced by immigration; they promoted free-enterprise capitalism aided by benevolent colonial government controls; their people spoke English; they developed vigorous parliamentary government; and they followed the precedents of British law. Thus, although they developed within the constraints of the Australian environment, they also adopted, adapted, and reacted to ideas, developments, and changes that had originated and still occurred in the parent nation of Britain.

These four cities were basically similar and uniquely Australian (as were Sydney and Hobart) in the following ways. They grew up prior to the full development of their hinterlands. They imposed on their regions the social and political values and institutions that their founders brought

with them from a specific historical period, namely 'the invisible luggage' of the European Enlightenment as interpreted in the first half of the nineteenth century. They rapidly came to hold extraordinarily large shares of the population of their colonies, and so corresponding weight in many of the activities of colonial society. They thus reversed the traditional experience and evolution of cities in the Old World.

The factors which made these cities and their inhabitants different from Old World cities were the idiosyncracies of the continent itself: its position, climate, physical features, and seemingly endless Aboriginal land. Again, through the chances of history and the variations of the local climate and topography, the main colonial cities developed some differences in their social styles and their relations with their hinterlands.

Brisbane and Queensland

The initial settlement in what is now Queensland was a tiny convict establishment made in 1824 on the coast of wide Moreton Bay, 500 miles north of Sydney, commanded by Lieutenant Henry Miller, and surveyor, Lieutenant John Oxley (1785?–1828). It was a secondary penal colony, holding thirty recidivist convicts. This first site is now the bay-side resort of Redcliffe.

THE CONVICT COLONY AT BRISBANE

In 1825 difficulties of soil prompted the site's rapid abandonment and a move some 20 miles up the Brisbane River [named for the then governor of New South Wales, Sir Thomas Brisbane (1773–1860)] to a new location which was also given the name, 'Brisbane'. So began today's vibrant subtropical city. For fifteen years the convicts laboured and suffered in the loneliness and heat, numbering at their greatest in 1831, some 1019 men and forty women.

Captain Patrick Logan (1791–1830) became commandant in 1826. Under his energetic, determined, and callous control, the colony soon became self-sufficient in corn. But a drought destroyed convict agriculture for the time being, the first of many droughts that areas of Queensland would suffer in later decades. Logan had more luck with sheep and cattle, which flourished on several outstations.

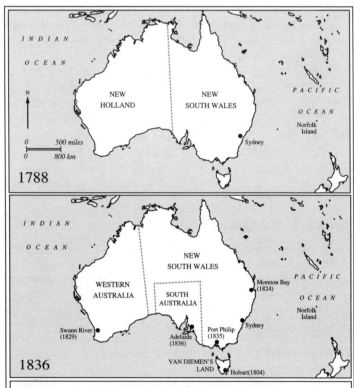

The evolution of colonial and
state boundaries showing capital cities

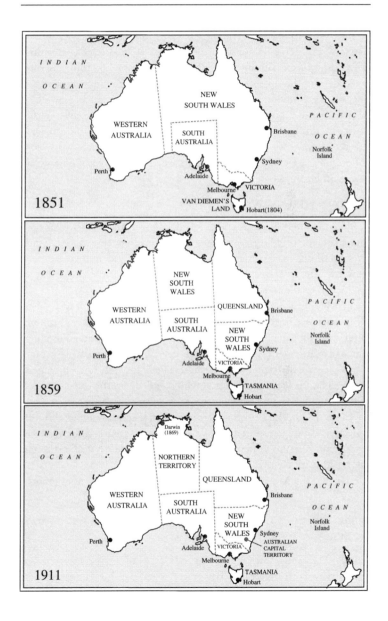

Like Governor Ralph Darling (1772?–1858), his master in Sydney, Logan was a fierce disciplinarian. Floggings were as regular as sunrise. Fifty lashes were supposed to be the maximum but this was often exceeded, to the tune of 200. Most convicts worked in irons, and cells for solitary confinement and a treadmill were erected. In one eight-month period, Logan ordered 200 floggings totalling over 11,000 strokes – this in a colony of fewer than 700 prisoners. Unsurprisingly, Logan was fiercely loathed. When he was murdered by local Aborigines in 1830, the convicts 'manifested insane joy at the news, and sang and hoorayed all night'.

A FRONTIER TOWN

Unlike the cities of Perth and Adelaide a few years later, Brisbane was not planned. Buildings were put up as convenience dictated. Tracks wound along in accordance with topography and immediate need, towards the river, or the government garden (later the Botanical Gardens), or the outstations.

In 1827, Logan discovered coal and limestone just west of Brisbane at Ipswich – named, as are hundreds of Australian towns and suburbs, after a British town or London suburb. The minerals proved useful for the early settlement. Later in the century, Welsh miners were brought out to work the deeper coal seams. These Ipswich finds presaged a mineral boom a few decades later which, luckily for the Queenslanders, has continued on and off ever since.

In the 1830s, the British government had second thoughts about the effectiveness of transportation and Brisbane was marked for abandonment but, somehow, neglected and criticized, the township stumbled along in a much-reduced state until the convicts were finally withdrawn and the Moreton Bay District was opened to free immigrants in 1842.

FREE SETTLERS AND SEPARATION FROM NEW SOUTH WALES

In 1840 Governor Sir George Gipps (1791–1847) gave instructions to the surveyors that Moreton Bay counties and parishes be mapped, and surveyed areas set aside for towns and other public needs.

So the years 1840–42 witnessed the first proper plan for what would become the city of Brisbane. It is historically fitting that the position of the great prisoners' barracks, built by sweat and blood in Logan's time, came eventually to have permanent significance. This structure, the only thing of its kind in the town, was large, solid, stolid, and immovable. When the first qualified surveyors arrived, its location at right-angles to the river determined how they had to orient not just the main street, Queen Street, in which it stood, but the rest of the city street plan!

The surveyors' new plan for Ipswich, then the second settlement of significance, had space for a town square, as in Spanish colonial towns. This was a far-sighted conception – a square as a place for leisure and social intercourse, an ideal model for all the later tropical towns of Queensland. It was not to be. Governor Gipps cancelled the idea of a square as too expensive, and Queensland urban history took a different path.

The rolling, fertile Darling Downs, just west of Brisbane, had been discovered by the botanist-explorer Allan Cunningham in 1827. These Downs became one of the first areas of free settlers – some squatters who came overland from the south with their sheep in 1842. The first was the 24-year-old Scot, Patrick Leslie, who, with the help of twenty-two conscientious and loyal convict and ticket-of-leave herdsmen, led 2100 sheep on to the Downs and exclaimed in wonder at the luxuriant grasses.

In 1847 north Australia almost had a different future. It was in that year that the colony of Northern Australia was proclaimed. A handful of convicts under Colonel Barney landed at Port Curtis, on what is now the central Queensland coast, and founded the village of Gladstone, named for the future British prime minister, as capital of the new colony. Northern Australia, to be cut from the territory of New South Wales, was to include most of what is today's Northern Territory and about two-thirds of what is now Queensland. But, with government changes in Britain, all interest in the colony ceased, and the colony of Northern Australia was still-born, much of it to be subsumed in the colony of Queensland in 1859. Abandoned, Gladstone was refounded by cattle farmers in 1853 and remained a hamlet until the twentieth century.

Because of the late start to free settlement, it was mid-century before the first immigrant ships from Britain sailed directly to Brisbane. Nevertheless, growing local sentiment, encouraged by local newspapers such as *The Moreton Bay Courier*, achieved separation from New South Wales in 1859. The new self-governing colony of Queensland had Sir George Bowen as first governor, a white population of 23,520, a black population several times that number, 3,500,000 sheep, 500,000 cattle, 20,000 horses, and a massive area of 667,000 square miles.

Perth and Western Australia

The first settlement in what is now the state of Western Australia was made in the south-east on magnificent King George Sound in 1826 by Major Lockyer with twenty troops and twenty convicts. They were some 2500 nautical miles from Sydney!

The settlement was to become another secondary penal station for refractory convicts, a port of supply on the sea route from Britain to Sydney, and a way of forestalling any French designs on the west. Lockyer, therefore, also took formal possession of the remaining western half of the continent, formerly unclaimed. The little settlement was politically absorbed into the larger colony of Western Australia in 1831, and slowly developed into the seaport of Albany.

PLANS FOR A PARADISE

Meanwhile, in March 1827, Captain James Stirling (1791–1865) had explored the Swan River district, 500 miles around the coast to the north-west. Visiting in a mild, wet summer of unusually balmy weather, rowing across the river's broad blue reaches, gazing upon the green and tree-covered countryside on both sides, Stirling was immensely impressed. This he believed was an idyllic place for a colony, the equal of the Plain of Lombardy.

Stirling was, in fact, repeating the error of Banks and Botany Bay. He failed to realize that a mile or two inland the land became one of sand-dunes and swamps; that the mighty, 300-foot Jarrah trees of the region had adapted to the environment over eons and belied the fact of the

shallow depth of the soil; and that, far from being typical of the land available in Western Australia, the Swan River region was unrepresentative and, despite its limitations, probably the most promising patch of alluvial land on the entire western coast. As a result he gained an entirely misleading idea of the suitability of the south-west for colonization.

Curious chances strengthened Stirling's conviction. His ship, the *Success* had fortuitously sailed through one of the few narrow channels into Cockburn Sound, the sea roads at the mouth of the river, which were actually deadly dangerous to anchored shipping when the north-westerlies blew. Somehow, the small boat he took upriver had also missed the sandbar at the mouth (which would prove a hindrance for the next fifty years) and, after recent rain, the upper reaches of the Swan River were uncharacteristically deep.

Despite Stirling's continuing entreaties, the British government at first refused permission to establish a settlement, then agreed, then refused again. After Stirling arranged for a private land-development company to take responsibility for the colony's expenses, for a third time the British government changed its mind, and he at last got his way! By late 1828 the government had decided to establish a Crown Colony.

To the delight of the parliamentary select committees who were recommending emigration as a solution to Britain's overpopulation, a young landowner Thomas Peel (1793–1865), chief supporter of the proposal, promised to take out thousands of migrants. A ship under Captain C. H. Fremantle, with a company of about 200 soldiers and marines, was despatched from the Cape of Good Hope to await the arrival of the colonists.

Dissatisfaction with abuses in the granting of lands in New South Wales had also helped persuade the government to try a new approach. Apart from the small civil and military establishment the British government was supposed to incur no expenses. To attract capital, 40 acres were to be granted for each £3 invested in assets (much cheaper than in New South Wales and Van Diemen's Land).

In under two months, these regulations and others related to the government of the colony were drawn up, additional officials were

appointed, ships stores and finance organized, troops gathered, and Stirling made Lieutenant-governor. Such precipitate bustle ensured that there was little detailed planning or calm consideration of possible future problems in what was to be the world's most isolated colony.

The Swan River colony was novel in being the first entirely non-convict white settlement in Australia. It would develop into the city of Perth and its port of Fremantle. Stirling and the small government party arrived in mid-1829, the first private settlers soon after. All were convinced they would establish a thriving colony of free men just like those which had long flourished in North America. The dream of a single man was being realized. Without Stirling's perverse persistence and personal ambition, it is doubtful if the western third of Australia would ever have remained British. His name is today commemorated in the state in many ways.

DESPERATE DISAPPOINTMENT

Disastrously inadequate conceptions of the tasks required meant that investors harboured unrealistic anticipations, and that a grossly insufficient amount of capital was expended. Equally, most immigrants were unsuited to pioneer life, with excessively optimistic expectations. Such errors were recurring features of the history of the colonization of Australia.

Cold shock hit when the settlers were forced to spend the first few months stagnating in tents on the wind-swept dunes at the river's mouth, while the first land was surveyed. Some had brought with them the concomitants of a sophisticated European life but, as there were no roads or cartage, their treasured possessions of sideboards and pianos soon lay rotting on the beach. The first summer was torrid beyond their imaginings, their constant companions sandflies and mosquitoes. Stirling's dream was becoming a nightmare.

The surveying was painfully slow. Ridiculously large grants of land had been made with few to work them. In fact, the area of sandy soil claimed amounted to that of several English counties. Thomas Peel received about 250 square miles on condition that he bring out 300 settlers. He brought the settlers, but was soon unable to employ them.

Because of Stirling's initial glowing reports of his Swan River

paradise, new settlers arrived before the first immigrants could be assimilated, or the true state of affairs known. Moreover, as is the way of such things, the leading investors, like Peel, made sure they were allocated the best farming land. Soon there was a serious shortage of food. By the end of 1830, frustrated and bitter, the majority of labourers and potential employers had departed for Sydney and Van Diemen's Land. A dejected Peel lived out a lonely life in a stone hut on his vast but virtually untouched estate.

RELATIONS WITH THE ABORIGINES

And what of the Aborigines? We may imagine their consternation at the arrival of these strange people and their stranger vessels. After a year of peaceful coexistence with the 400 or so Aborigines who lived in the area, as settlement spread out, there were inevitable clashes.

In 1834 a small battle was fought at Pinjarra 50 miles south of Perth. It took place when a party of mounted police, soldiers, and settlers, led by the governor, attacked Aborigines in retaliation for the killing of two colonists and their livestock. Probably several dozen Aborigines were killed; several whites were wounded and one died. Afterwards, G. F. C. Irwin, the military commandant, wrote that, although the loss of life was deplorable, without it 'a petty and harassing warfare might have been indefinitely prolonged, with ultimately much heavier loss on both sides'.

But relations were also often cordial. Aboriginal beliefs about the metaphysical status of the whites seem to have had something to do with this fact. Explorer George Grey explained that the Aborigines:

> ... never having an idea of quitting their own land, cannot imagine others doing it. And thus, when they see white people suddenly appear in their country ... imagine that they must have formed an attachment for this land in some other state of existence, and hence conclude the settlers were at one period black men, and their own relations.

Wherever in the colonies such an Aboriginal belief was held it proved of deep significance for the settlers, for it meant that the whites were spared from attack before they were established.

COMING OF CONVICT EXILES

The progress of settlement remained fitful. Those who had arrived with high hopes as employers of labour had themselves to turn with their wives and children to cutting down trees and farming their own land. Only by the slowest trial and error did the colonists painfully learn how to manage the peculiarities of the climate and soil. Wheat seed needed to be soaked in brine to make it germinate and grow free from disease. The soil was best, not where the stately grey-barked Jarrah trees flourished, but where the poorer-looking clays nurtured less impressive flora.

Eleven years after the settlement had been founded, the population was still merely 2311 – a tiny dot of white people in a colony of almost a million square miles. It took decades of extreme hardship before the colony felt permanent. By 1850 the settler population was still only 5000.

Ironically, free-settler Western Australia was made viable only by becoming a convict colony. The free citizens of Western Australia pleaded with the British government to send them convicts. Nevertheless governments had learned from the experience of the east: the convicts, known as 'exiles', were carefully selected, most being men of good behaviour from English prisons. In June 1850, the first seventy-five, with their pensioner army guards, arrived in Fremantle. In the 1850s and 1860s this infusion of male convict labour (and the funds the British government sent to maintain them) gave the colony the infra-structure of wharves, buildings, and roads needed for local economic viability.

This move was extremely shocking to the other Australian colonies, which had just succeeded in their struggle to end the system of convict transportation. But some 9721 convicts, and 1191 pensioner guards together with their families, had been sent to Western Australia by the time the final convict ship reached there in 1868.

In the 1860s Perth, with some 6000 inhabitants, was still no more than a village. It would remain a small town until the 1890s when the discovery of gold in the lonely desert 300 miles east of Perth would transform the whole colony. But visitors agreed it had developed a sort

Ladies of Perth, 1868, from a contemporary photograph

of sleepy charm. Though the great city of the late 1990s is no longer sleepy, it still has the charm.

Melbourne and Victoria

Tasmania is a mountainous island. By the late 1820s the good land had been claimed. When the colonists learned from the sealers and whalers who frequented Bass Strait that the land on the strait's north side was wide and fertile, several groups decided to move their flocks of sheep and herds of cattle there – whatever the government in Sydney thought.

The first permanent settlement in what became known as the Port Phillip District, and later, Victoria, was in fact made by Edward Henty and his six strong sons, who, despairing of making a success in Western Australia, had sailed east and just squatted on land in Portland Bay on the coast 100 miles west of Port Phillip.

THE FOUNDERS: BATMAN AND FAWKNER

The most important of the Tasmanian groups arrived in 1835, their

leaders being John Batman (1801–39) and John Fawkner (1792–1869), both from the northern Tasmanian town of Launceston.

In May 1835, Batman even concluded a 'treaty' with the Dutigalla Aboriginal tribe whom he believed were in possession of the lands along the western side of Port Phillip Bay. Batman, the emissary of a fifteen-man syndicate presented these Aborigines with large quantities of items they considered useful, such as blankets, scissors, and tomahawks, the equivalent of which he promised to pay every succeeding year. In exchange he claimed to have received from them almost 1000 square miles of land stretching right along the western side of the bay.

At the head of the bay, Batman's party soon found the Maribyrnong and Yarra Rivers, and he wrote in his diary the following words about the Yarra River:

> The boat went up the large river I have spoken of which comes from the east, and I am glad to state, about six miles up found the river all good water and very deep. This will be the place for a village.

The 'village' would grow into the city of Melbourne. Because of their planning and economic involvement Batman and Fawkner are usually awarded joint credit for being the city's founders. Melbourne thus has the distinction of being the only Australian state capital founded unofficially, by individual enterprise.

To the chagrin of Batman and his syndicate, his 'treaty' was recognized by neither the New South Wales governor nor the British government.

THE COLONY MADE OFFICIAL

Sir Richard Bourke (1777–1855), the New South Wales governor, realized that there was no way of preventing these Vandemonian squatters from developing the Port Phillip District and spreading their sheep across the land. So, in 1836, he arranged for a police magistrate, William Lonsdale, to go there formally to organize the settlement. With Lonsdale came thirty-three soldiers, three constables, two customs officers, and three surveyors. Batman, Fawkner, and others were then allowed to buy land.

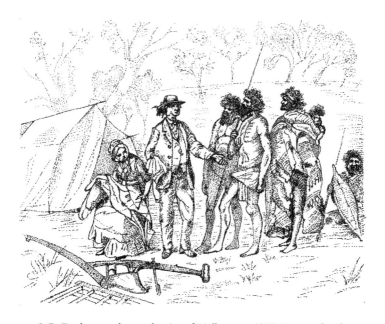

J. P. Fawkner settles on the site of Melbourne, 1835. From a sketch
by Strutt

To supply the new town, the first of the great Australian overland
movements of stock took place. Joseph Hawdon (1813–71) brought
300 of his cattle some 250 miles south from the Murrumbidgee River
in New South Wales to Port Phillip through difficult mountain
country. Others soon followed this pioneer route, within a year
bringing south about 5000 cattle and perhaps 100,000 sheep.

Governor Bourke himself visited the new town in 1837 naming it
'Melbourne' after the British Prime Minister, and the port at the river
mouth 'William's Town' after the king. Melbourne was at the time a
mere scattered collection of tents, rough wood and wattle-and-daub
huts, and a handful of small wooden houses roofed with shingles or
thatch. Bourke estimated it possessed about 500 people, in a district
holding by that date about 160,000 sheep.

POLITICAL AND ECONOMIC DEVELOPMENT

It is a fact of human nature that geographical separation engenders feelings of rivalry and different identity. By 1840, when there were 5000 people in the town and 15,000 Europeans in the Port Phillip District (and 800,000 sheep!), the first meetings were held to advocate separation from New South Wales.

During the 1840s more than 100,000 free immigrants from Britain arrived in Australia and about half of these settled in the Port Phillip District. About a third were assisted by bounties paid for by sale of Crown land. And, to the disgust of the locals, there also arrived in Port Phillip about 1700 British 'exiles' – convicts who had served part of their time and were given a conditional pardon (ticket-of-leave) if they agreed to pass the rest of their lives in the colonies.

As a centre for the pastoral industry, Melbourne grew rapidly. Bankers, merchants, builders, land and stock agents migrated into Melbourne from the other colonies and from Britain. A Port Phillip Savings Bank was opened; warehouses, storage sheds, and wharves multiplied. Many of these buildings used bluestone, the blue-grey basalt that soon became a proud and defining feature of Melbourne construction.

SEPARATION FROM NEW SOUTH WALES

Throughout the 1840s demands increased for separation. There were the usual historical factors pushing towards separate identity, others peculiar to Australia and to Port Phillip. Communication with Sydney, and with London, the source of final political authority and the destination for the region's wool, was crucial to the progress of Melbourne and the Port Phillip District. But, until 1841, London allowed mail from Britain to be unloaded only at Sydney, the source of colonial authority, even though the sea route took it right past Port Phillip Bay. Surcharged, mails then had to return to Melbourne. Dependent upon the availability of a ship, this took another week by sea. By land in the late 1830s, it took even longer – up to sixteen days. Private travel between Sydney and Melbourne was equally daunting. In 1848 it took nineteen days (including several necessary rest days) for

the newly appointed Roman Catholic Bishop of Melbourne to arrive from Sydney.

More annoying to Melburnians was the fact that Governor Gipps in Sydney refused to allow funds collected from land sales in Melbourne to be used exclusively to bring immigrants to their area, using much of it to finance migrants to Sydney instead.

Given its more recent settling, and despite the presence of a wealthy upper class among the colonists, the colony lacked the established families of Sydney and its region and the established prestige of its squatters. Thus, the politics of Port Phillip were more democratic and populist. People took an active part in associations advocating not just a separate colony and parliament but advanced democratic ideas, such as annual parliaments, secret ballots, manhood suffrage, and payment of members.

Meanwhile, thinly spread, squatters had taken up most of the rural land for sheep and cattle, and, by 1851, there were 30,000 white people in Melbourne and 100,000 in the Port Phillip District. The colony, to be called Victoria, after the queen, was to the delight of the locals, given independence from New South Wales. The new border between the two colonies was the stately Murray River. Except for funds spent on the infrastructure of government, unlike Western and South Australia, Victoria in its founding had not needed any special monetary support from the British government.

Adelaide and South Australia

The province of South Australia promulgated in 1836 was as fascinating a socio-political experiment as any that took place in the British Empire. Its inspiration was Edward Gibbon Wakefield (1796–1862), who never set foot in the place. Wakefield's spirited advocacy and self-advertising were crucial in persuading the British government to allow the establishment of another 'self supporting' colony so soon after the fiasco of Western Australia.

The area of St Vincent's Gulf on Australia's long southern coast was chosen as the site for the Wakefield experiment mainly because of the glowing (and accurate) reports by the British solider-explorer,

Captain Charles Sturt (1795–1869), who had reached there in 1829.

WAKEFIELD'S PLAN FOR SYSTEMATIC COLONIZATION

In 1826, Wakefield was thrown into Newgate Prison for abducting and marrying an heiress, a girl under sixteen. There he became interested in penal reform and had time to write his spurious book, *A Letter from Sydney*, which argued for the inefficiency of convict colonization and the superiority of his own plan for systematic colonization by free settlers, to help Britain's increasing population, and to counter crime and poverty.

Instead of grants of land or leases of large properties, as had occurred in New South Wales, Wakefield advocated selling small amounts of crown land at a 'sufficient price', a price that was supposed to ensure a proper equilibrium between land, labour, and capital. Only people of means would be able to afford to buy land, while labourers would need to work for a considerable period before being themselves in a position to purchase. The capital acquired would be used to pay for the emigration of free settlers, thus helping to reduce unemployment and poor relief in Britain. Labour would be brought to the colony in strict relation to the land sold. As a result, there would be an ideal and orderly development of close farming settlement. Wakefield's overall conception was to transplant *in toto* to the southern hemisphere a working cross-section of English society.

His ideas were taken up by the National Colonization Society and, after much debate, the British government agreed to allow a colony. There was a hybrid system of control, with representatives of a board of commissioners and of the British government. By this date the British government had changed its views of colonial governance and agreed that, when the population of the province reached 50,000, it would be granted full responsible government.

So, in contrast to Sydney, Hobart, Brisbane, and Perth, South Australia and its capital, Adelaide, owed nothing to notions either of imperial defence or convict punishment. Based on Wakefield's ideas, South Australia was officially founded as a new, free-settler, British province in December 1836. Use of 'province' rather than 'colony' was

significant – the settlers saw their community as a true extension of
Britain. So a former convict in England had prevented the convict
transportation system from being adopted in South Australia! Ever
since, South Australians have been making friendly jibes at other
Australians for the latter's supposed convict origins.

Special preparations were made to try to ensure that South Australia
would be a success. All the immigrants had to be vaccinated. Initially
the price of land was set at £1 an acre. (Wakefield believed that this was
much too low to be 'sufficient', and at that point withdrew from the
scheme!) The poorer migrants were carefully selected. Their passage
was paid, but they had to sign a declaration promising they would at
first work for wages. To avoid the notorious imbalance of New South
Wales, equal numbers of men and women were selected. The com-
missioners chose people with a wide range of skills. They ensured that
about half of all migrants fell within the energetic ages of fifteen and
thirty. Single women had to be accompanied by a chaperone. There
was to be complete religious freedom and no established religion, and
many non-conformists became migrants. The Aborigines were to be
considered, too. British government circles had by this date become
aware of the abuses perpetrated in acquisition of Aboriginal land in the
other colonies, and the matter was explicitly addressed in the planning
of South Australia.

All such principles and decisions were to ensure that, in contrast to
other colonies, South Australia would be a place of high moral tone.
Some historians have seen similarities between South Australia and the
English religious colonies established in the seventeenth century on the
eastern seaboard of North America.

As with most free immigrants to Australia during the last 210 years, the
South Australian colonists departed Britain with great optimism for their
new life, mingled no doubt with some regret at what they left behind.
Rarely, however, was this new life just what they expected. These
immigrants were the most middle-class, educated, skilled, and articulate
of all the groups who settled new regions in Australia. Despite this fact,
the early colonization did not go smoothly, partly because authority in
the colony was initially divided. Whereas the governor wielded political
power, the resident commissioner controlled the funds.

THE CITY OF ADELAIDE

The first governor, Captain John Hindmarsh, landed at what is now the Adelaide seaside suburb of Glenelg on 28 December 1836, and officially proclaimed the Province of South Australia.

Adelaide (named after William IV's queen) was laid out on the splendid plan drawn up by Colonel William Light (1786–1839), the son of the English founder of Penang in Malaysia, and today the city benefits from his foresight: its central business district is still surrounded by his wide parklands. Light was expected to survey not merely Adelaide but considerable inland areas as well.

At first, settlers lived in tents on the beach at Glenelg. For a time, Adelaide was a tent town, too. Colonel Light was literally working himself to death for he had insufficient help and was subjected to petty annoyances by governor and officials, a number of whom were more interested in their own investments than the good of the province. The settlers had to wait until their land was surveyed, and most settlers wished to stay in or near the capital anyway.

Lured by an enticing ideal, those who had planned the colony had once again underestimated the difficulty of the means. Little food was produced. Many of the labourers were unemployed and many who wanted to farm had to wait until their land was surveyed. Speculation in land was rife. By 1838, some sixty ships had arrived bringing almost 6000 people. Although the situation was not as desperate as it had been in Western Australia, there were unfortunate parallels. Shortages meant that kangaroo meat, for instance, was selling at the enormous price of a shilling a pound.

DROVERS AND DROVING

With kangaroo at that price, cattle and sheep entrepreneurs in New South Wales saw rich possibilities for profit in the new colony. Their efforts made a significant difference: South Australia was never as isolated as the Swan River settlement. In 1838 to supply South Australia with cattle Joseph Hawdon drove 340 bullocks from near Albury, New South Wales to Adelaide, on an even more ambitious expedition than his earlier one to Melbourne and, because of

the distance, perhaps the most famous of all. Contemporaries called the idea 'rash and quixotic'. (Previous livestock for South Australia had been imported from Tasmania in small sailing ships, a costly and unreliable means of supply.) To ensure his water supplies, Hawdon followed the Murray River most of the time. During the marathon twelve-week, 750-mile journey, his party had much difficulty with the sparseness of the grasses and with watering the beasts where the river cliffs were high. But Hawdon had no trouble with the River Aborigines. As these were the first cattle such people had seen, their intense curiosity overcame all other possible responses. During the next eighteen or so months many others, including Captain Charles Sturt, drove eastern cattle and sheep to South Australia.

In the Australian inland, the colloquial verb 'to drove' and its cognates 'drover', 'droving', and so on rapidly evolved from the verb 'to drive'. 'Droving' meant driving cattle and sheep over long distances. Like Hawdon, most early drovers were owners of the stock they drove, but soon contract drovers had become the majority, for considerable money was to be made. These early drovers (or overlanders) were a brave and debonair breed. Soon, droving great masses of animals from one part of the continent to another had become one of the great original outback Australian trades, which evolved its own ethos and traditions. One contemporary describes early drovers thus:

> They rode blood or half-bred Arab horses, wore broad-brimmed sombreros trimmed with fur and eagle plumes, scarlet flannel shirts, broad belts fitted with pistols, knives, and tomahawks, and had tremendous beards and moustachios. They generally encamped and let their stock freshen up about 100 miles from Adelaide and then rode on to strike a bargain with their anxious customers. The arrival of a band of these brown-bearded banditti-looking gentlemen created quite a sensation. The overlanders included every rank from emancipist to the First Class Oxford man.

By the end of 1840 drovers had introduced to the new province some 10,000 cattle and 50,000 sheep, and had persuaded many of the colonists to invest in pastoral pursuits.

EARLY PROBLEMS AND ECONOMIC RECOVERY

The second governor, George Gawler, pushed ahead with surveying. His accompanying programme of public works helped the unemployed but drained the finances. The province was then designated a normal crown colony, with greater power for the governor. So George Grey (1812–98), the next governor, made himself unpopular by tightening the budget, reducing salaries, and stopping migration. Within another two years, however, Grey's stringent measures were working. North of Adelaide, wheat farming was beginning to flourish on land close to transport by sea, and immigration was recommenced.

Recovery was boosted by the discovery in 1842 of the great Kapunda copper field, 40 miles north of Adelaide. Three years later, even larger deposits were found at Burra Burra 40 miles further inland again. For, by chance, Adelaide was the only coastal city relatively close to the vast stretches of Precambrian rock that would prove to be so mineral-rich in later decades. Within three years, Burra Burra had become the largest inland town in the continent. South Australia was beginning to supplant Cornwall as the Empire's greatest copper producer. In fact, Cornish miners were brought out to work the fields. By the time Grey departed in 1845, the province was flourishing, and Adelaide was taking on the prosperous and orderly appearance it has retained to the present day.

In hindsight we can see that the salvation of South Australia derived from local environmental factors as much as from the conceptions of Wakefield's theory or the detailed plans of the Board. The land on the Adelaide Plains and across the nearby hills was exceedingly fertile, and covered with easily cleared woodlands. Moreover, Wakefield had decided on farm lots of 80 acres to reproduce English agricultural society, and it was the fortuitous fertility of South Australian land that made possible successful farming on such a limited acreage by family labour without much need for capital. (In the other colonies the minimum was 640 acres and usually that was insufficient.)

NON-BRITISH IMMIGRANTS

South Australia was also unique in attracting in its early years large

numbers of people whose homeland was other than the British Isles. In the late 1830s some 500 hard-working German Lutherans, fleeing religious oppression, arrived from Silesia. In the following decades 10,000 more arrived. Many of these German settlers moved inland to establish the pretty townships of the Barossa Valley which soon became famous for their vines and wines. Despite strong competition from other regions the Valley remains today Australia's premier wine-producing area.

By 1850, South Australia had become that which its planners had dreamed. It was a flourishing province of 64,000 white inhabitants. By the mid-1850s, it had responsible government, was the recognized granary of Australia, was socially the most balanced, and was the greatest producer of minerals in the continent.

Excellent building stone was available, and the high proportion of brick and stone structures in Adelaide and in country areas became a defining feature of the province. South Australia in general exuded a self-satisfied sense of its own solid achievements, a state of mind still observable in the citizens of Adelaide today. The other colonies, particularly the one in the west, looked at it enviously.

WAKEFIELD'S EFFECT ON AUSTRALIAN MIGRATION

Wakefield's theory stressed that money derived from purchase of land should be used to bring out more immigrants. This was an idea of deep significance for Australia because subsidized passages helped offset the disavantages the Australian colonies suffered in comparison with North America. For it took about five times as long to reach Australia as to reach Canada; the passage cost four or five times as much; and it was clearly much easier to return to Britain from Canada or the United States should the colonial situation disappoint. But, if one's passage were paid and one's food were provided throughout the voyage, then the competition became more even.

In contrast to the policies of Canada and the United States, there thus began the general Australian policy of subsidized immigration, using monies from lands sold and leased. There were also private immigration organizations conducted by philanthropic individuals, such as Mrs Caroline Chisholm (1808–77) and the Reverend John Dunmore Lang

Farmer's hut, Gippsland (east of Melbourne) 1840

(1799–1878). The first, a Roman Catholic, tended to encourage migration from Ireland but also from England and Wales; the other, a Presbyterian, brought about migration from Scotland. Both encouraged the migration of families. Nevertheless, though more than 2.5 million people migrated to the United States and Canada from Britain between the years 1825 and 1851, only one-tenth that number sailed to Australia and New Zealand. The contrast was even greater in later periods.

To a varying extent, government help was also provided after immigrants landed: in finding them employment and in providing temporary accommodation. Following on from the government control of convict days, such services contributed to the growth of a welfare-state mentality, something that is still a contemporary feature of the Australian way of life. Assisted migration also ensured that most immigrants would be British and Irish, and so the Australian population remained relatively homogeneous – at least until after World War II.

Darwin and the Northern Territory

Between 1824 and 1849 the British government made three attempts to maintain a settlement on what is now the north coast of the Northern Territory, then a neglected part of New South Wales.

It is generally agreed that these settlements had a commercial object. They were established after the brief period of British control of the Dutch East Indies from 1811 to 1814, during which time it looked as though British and colonial traders might make substantial profits from such north Australian settlements. For they were expected to become second Singapores, which would tap the trade of the eastern half of the Indonesian Archipelago. It was expected, too, that as Thomas Stamford Raffles himself had achieved in founding Singapore, these settlements would attract Chinese and Malay farmers and traders, and also work as ports for Macassan trepang fleets. A few historians have suggested that these settlements were aimed at controlling the sea routes of the north, and that, too, can be seen as a subset of the commercial goals.

The first settlement was at Melville Island (1824–28) just north of modern Darwin. The second was at Raffles Bay (1826–29), and the third at Victoria on Port Essington from 1836 to 1849, both on the Cobourg Peninsula about 100 miles north-east of Darwin. Enervating climate, poor soils, hostile Aborigines, and the huge distances from the settled areas of Australia all took their toll. Melville Island and Port Essington were failures, and Raffles Bay was closed, perhaps prematurely.

In 1863, South Australia was allowed to annex from New South Wales what became its 'Northern Territory'. The South Australians then precipitously threw open this territory for development, and sold vast areas under land orders to investors in Britain and other parts of Australia. A centre for administration was therefore urgently needed. What is now the city of Darwin was then founded in a hurry on Port Darwin but, until 1911, was called 'Palmerston'.

In 1872 Palmerston came to take on a new role as the necessary Australian entrance point for the new telegraph line from London. Soon there occurred a short-lived gold rush in the Territory, followed

by a cattle rush – which became permanent. But Darwin would remain a small town of a few thousand people until after World War II.

A Country of Large Coastal Cities

From the earliest times of white settlement therefore, Australia became a country with a population that was in large part concentrated in five coastal cities. This fact surprises visitors, who expect the population to be spread more evenly. In the 1800s the phenomenal development of these cities surprised the Australians as well.

In time, Perth changed hands with Hobart as a member of this select list, as Western Australia boomed and Tasmanian development slowed. Throughout the twentieth century, the pattern of five has remained, for the great industrial cities of New South Wales, Newcastle and Wollongong, can be seen as part of the extended Sydney conurbation, and the large holiday resort of Gold Coast City as part of Brisbane; and, although there is now the city of Darwin, capital of the Northern Territory as a future candidate for the list, its population remains relatively small. Riding high on tax-payers' money, however, the rapid growth of the federal capital of Canberra is now adding a sixth conurbation.

Six factors led to these early concentrations of population, and in most cases have continued.

1 From the beginning, the British government and British capital generated in the upper, administrative, and business classes, a high standard of city living, initially through administrative salaries and financial subsidies for the convicts and later continued through investment in industry and markets.
2 The potential for population growth in the dry or desert inland (two-thirds or more of more of the continent) has always been small.
3 Within a few decades of 1788, Australian rural industries had become labour efficient. The labour-intensive mining industry changed the pattern for a time, but modern mining with economies in earth moving and in transport is again very labour efficient. Once suitable strains of wheat were discovered, and many local labour-saving

planting and harvesting devices had been invented, the point also applied to agriculture. Large numbers of people were not needed in the country areas.

4 With the exception of the Murray-Darling system, there were no great river systems so, until the coming of railways, costs of inland transport were prohibitive, and population remained on the coast.

5 Banking and finance were city matters, and during the second half of the nineteenth century, city companies began to take control of many outback sheep and cattle stations, and city men then made the crucial decisions, another reason for city growth.

6 Most immigrants from the British Isles, in both the nineteenth and twentieth centuries, were from cities, and so tended to stay in the great cities of their new land. The inland, 'the bush', was seen as hostile and forbidding. Moreover, the skills such immigrants brought with them were city-based skills and trades. Most preferred to scrape a living in town rather than challenge and perhaps do well in the bush.

This early tendency to cling to the coast and to live in the big cities remains to this day. Despite the legend of the tough, outback Aussie, during the last 210 years Australia always has had one of the highest proportions of urban population in the world. It was, in this more than in any other feature, that the Australian colonies anticipated worldwide trends.

Explorers and Squatters: the Demise of Black Australia

Once the Blue Mountains had been crossed, explorers, financed by the colonial governments or by prosperous pastoralists, set out to discover what lay upon the unknown map of mysterious inland Australia.

Hard on the heels of these explorers, and in some areas far ahead of them, spread pioneer settlers with their sheep and cattle. Though it had never been envisaged when the the colonies were founded, sheep and cattle rearing became the great industry of Australia.

This was not just an expansion of pastoralists into empty regions, it was also an encroachment upon Aboriginal hunting lands. Where the kangaroo had grazed now grazed sheep and cattle. But the Aborigines did not just accept the intrusion. In many areas they opposed it with all the force they could muster and, for 100 years, outback Australia became the site of racial battle.

A Mighty Inland Sea?

Many westward-flowing rivers were found on the western side of the Blue Mountains, a section of the Great Dividing Range. These rivers gave rise to vastly exciting speculation. Using the analogy of the Americas, the colonists conceived the ideas that: either the rivers flowed into some massive Australian Amazon, itself entering the sea somewhere far away on the west or northern coasts; or else they entered some equally mighty inland sea, surrounded by smiling green prairies. What marvels would await the future explorers of the inland!

By 1829, through the efforts of the explorers Hamilton Hume (1797–1873) and William Hovell (1786–1875), Major Thomas

Mitchell (1792–1855), Lieutenant John Oxley, Allan Cunningham (1791–1839), and others, the details of the map of south-eastern Australia were gradually being penned in.

Later would come the true epic journeys of exploration: of the English explorer E. J. Eyre (1815–1901) into the salt lakes of South Australia, and along the Great Australian Bight; of the Prussian-born Leichhardt (1813–48) along the Queensland and north Australian coast to Port Essington, and later into the outback, where he and his party disappeared without trace; of Major Thomas Mitchell across inland Victoria, New South Wales, and Queensland; of the tragic Robert O'Hara Burke (1820–61) and William Wills (1834–61) who perished trying, and the intrepid and successful John McDouall Stuart (1815–66), right across Australia from south to north; of Ernest Giles (1835–97) and Peter Warburton (1813–89), and Augustus Gregory (1819–1905), and John Forrest (1847–1918) and his brother Alexander (1849–1901), across the plateau wastelands of the west; of G. Grey's expeditions in the coastal Kimberleys and Shark Bay; of Captain Charles Sturt and Edmund Kennedy (1818–48). All were examples of courage and perseverance. The explorations of Sturt and Kennedy will serve as exemplars.

Epic Journeys of Sturt

No man in the continent was more fascinated by, or more determined to solve, the 'Problem of the Rivers' than Charles Sturt. Sturt was one of that multitude of nineteenth-century Britons whose professional life spanned the Empire. He served with Wellington in the Peninsular War, helped the Canadians repulse the invading Americans in the War of 1812, saw duty in Ireland, and, guarding a convict ship was sent in 1827 to New South Wales. He expected Sydney to be a long, dreary exile. In fact destiny awaited. Sturt soon fell in with a group of young Australians all eager to discover where the rivers ran.

'THE PROBLEM OF THE RIVERS'

John Oxley had tried to solve the problem in 1817, but had been thwarted by the great marshes of the Lachlan River. In 1828, Sturt set

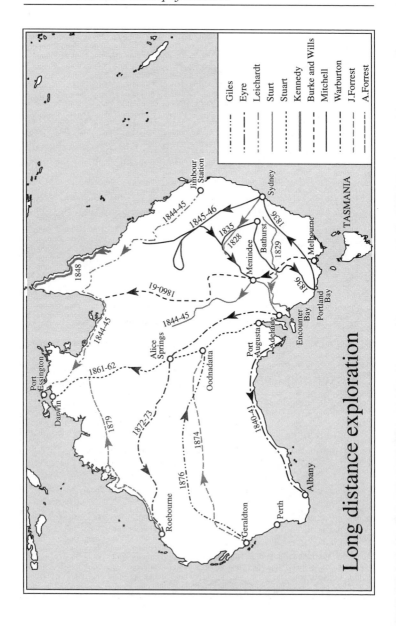

Long distance exploration

out on another attempt. This was his first expedition and he was successful, for he was able to trace the Bogan, Macquarie, and Castlereagh Rivers west through their often frustrating marshes. Early in 1829, he discovered that they all joined a fine southward-flowing river which he named the Darling, after the governor. So the problem was now partly solved.

On this journey he was fortunate to have the currency lad, Hamilton Hume, as second in command. Hume explained bush-craft and how to pass peacefully through Aboriginal lands. Modest and teachable, Sturt acquired from Hume skills crucial for all his later journeys. His next expedition in 1829 would prove to be nothing less than prodigious. The idea was to discover just where the Darling River went. Did it join another river? Did it reach the sea?

NOTES ON TOWNS SHOWN ON MAP

Towns such as Adelaide, Bathurst, and Albany mark the beginning or end of an expedition(s).

The town of Darwin is shown only for reference; it did not exist at the time of Stuart's 1861–62 journey, but grew as the ingress for the overseas telegraph cable after 1871.

Alice Springs did not exist at the time of Stuart's expedition either, but grew up once the overland telegraph line had followed his route. Repeater stations on the telegraph line became convenient sites for later expeditions: it was at the Alice Springs telegraph station that Warburton stopped in 1872–73. The town of Oodnadatta (founded in 1890) is shown merely to locate the approximate end-point of the Giles and Forrest expeditions. Jimbour Station, the starting-point for Leichhardt's 1844–45 expedition lay on the Darling Downs about 90 miles west of Brisbane. Port Essington, his terminus, existed as a settlement only from 1836 to 1849.

Menindee on the Darling River was the final area reached by Mitchell in 1835; it was in this area that Sturt built a stockade in 1844; and by the time Burke and Wills regrouped there in 1860 it had become a hamlet with a wharf, and the centre for the furthest out pastoral area.

DOWN THE MURRAY RIVER

Besides Sturt there were a currency lad, three soldiers, and three convicts. Through his strength of character and absolute trust in his fellow men, Sturt welded this unlikely group into a spirited, smoothly working team.

After a week travelling south-west, Sturt decided to follow the Murrumbidgee River to where he assumed it must join the wide, westward-flowing Murray River discovered in 1824 by Hume and Hovell. He guessed that the Darling flowed into this Murray. But no one knew where the Murray then flowed. The best way to answer such questions was by boat, so the exploring party constructed the prefabricated whale boat and smaller skiff they had brought with them. Within a week, their boats had left the Murrumbidgee and, as Sturt had predicted, entered the noble Murray.

With minimum effort on their part, the current was now carrying them far into the west. There were marvellous idyllic moments as they floated past majestic 250-foot high cliffs. There were also dangerous moments when dire threat of Aboriginal attack promised destruction. But Sturt managed to pass every test and, in doing so, injured not a single native Australian.

At longitude 42°E a broad river entered the Murray from the north. Its size and position indicated it could only be the Darling. So the problem of the western rivers of New South Wales was now partly solved. The rivers flowed into the Darling and the Darling flowed into the Murray. But where did the Murray go? Sturt's little party sailed on for another 500 miles, finally reaching their goal (in territory that, within a few years, would be part of South Australia). Here, however, was deep disappointment, for the great Murray wasted itself in vast shallow waters cordoned from the Southern Ocean by shifting sandbanks – 20-mile-wide Lake Alexandrina and its narrow, 90-mile-long lagoon, The Coorong. This was no entrance to a Mississippi: no ocean-going vessels would ever make this a water road into inland Australia.

They had to go all the way back. There were no idylls now: some 1600 miles of rowing faced them, against the stream. An unconsidered moment might cost them their lives – if they accidentally broke

through an Aboriginal fishing net, or showed signs of weakness. Week after week they rowed, with blistered hands and aching, tormented bodies. And they reached home.

MYSTERIOUS CENTRAL AUSTRALIA

In 1839 Sturt became surveyor-general in Adelaide, but still wanted to go exploring. Despite his discovery of the Murray-Darling system, even now Sturt still believed in an inland sea, but a sea much further north and west. Like a neurosis, this notion dominated these colonial minds. Central Australia was, for such men and women, a fantastic luring Atlantis.

In 1844, when Sturt was forty-nine years old, the South Australian government sent him off with a strong party to find this mystic Mediterranean: sixteen men, eleven horses, thirty bullocks, 200 sheep to eat, heavy carts, a year's provisions, and *a boat*! (Today, every person who flies from Adelaide to Alice Springs or Darwin knows precisely what Sturt would find to the north.) The party travelled up the Darling River and, near the tiny outpost of Menindie, built a little stockade before heading north-west into unknown country. From Menindie, Sturt wrote excitedly to Adelaide: 'We seem on the high road to success ... We have strange birds of beautiful plumage and new plants ... It will be a joyous day for us to launch on an unknown sea and run away towards the tropics.'

Their boat was to be a sick sarcasm: in fact Sturt was heading into a terrible desert in one of the most monstrous summers ever known. Christmas 1844 found them isolated, at a water-hole at latitude 29 south latitude. For six months they were trapped, daring to go neither forward nor back as the land dried and shrivelled around them. The temperature was 132 °F in the shade, a monstrous 157 °F outside. It cracked their combs and turned the screws from their wooden boxes. The deserts of Central Australia have their own unique beauty – but, as some modern tourists have discovered, the ferryman Death waits with infinite patience for his payment behind every red hill, along each dry watercourse.

The local Aborigines had long ago left, for 'The sun has taken the water', they said. Scurvy broke out. A man died. On 12 July 1845 rain began to fall. In this land of extraordinary extremes, the area was soon

flooding, but the water at least made it possible for them to travel to the north-west. A week later, Sturt left his men at a base he called Fort Grey, near the furthest northern corner of New South Wales – until that day a mere mark on a map – while he pushed on with a single companion.

Soon they were passing through a vast flat region whose billions of cruel stones cut into the horses' hooves; this region is now called Sturt's Stony Desert. Pressing on, Sturt became the first white person to enter what is now known as the Simpson Desert, a region he described as 'stupendous and almost unsurmountable sand-ridges of a fiery red. I saw a numberless succession of these terrific objects'. Sturt could only guess at their length. In fact, a single red Simpson Desert dune may stretch for more than 100 miles. The heat and the lack of water crushed the human spirit. In mid-August at 24.7 °S, near the present border

Burke and Wills at the start of their fateful expedition to cross Australia. Both died on the return journey

between Queensland and the Northern Territory, Sturt at last admitted defeat. By the time they had returned to Fort Grey, he and his companion were near skeletons. They had crossed 900 miles of desert. A few weeks of rest and he was off into the north-west again, on a slightly different compass bearing. They traversed another corner of the Stony Desert and, in November, arrived at a (very temporary) lake with seagulls. 500 miles from the nearest ocean!

Sturt followed a long string of linked water-holes for about 120 miles, his hopes rising all the time. Here they met a group of 400 Aborigines who explained that the watercourse did not improve from then on, but just petered out into desert. Even Sturt had had enough: there was no central Australian inland sea. Turning for home, he gave the name Cooper's Creek to this watercourse, after the leading South Australian judge. By now Sturt was well aware of the dangerous duplicity of inland Australian streams: 'I would gladly have laid Cooper's Creek down as a river, but as it had no current I did not feel myself justified in doing so'.

The return journey was a continuing torture. As they trudged south, so fierce was the summer heat, even the Darling River had ceased to flow, broken into long scattered waterholes. His muscles seized. For three weeks he could not be moved. When an emaciated Sturt finally stumbled into his home in Adelaide at midnight in mid-January 1846, his wife fainted away.

Now Australians finally knew: the western rivers flowed into the Darling, the Darling into the Murray, the Murray into the ocean. Further north and west again in Central Australia, other rivers just dried up in sandy or stony desert, or, after heavy rain every ten or twenty years, flowed into one of the vast salt lakes. Inland Australia turned out to be like the Sahara Desert. Though they were not yet absolutely sure, for there was still much to be explored in the north-west, it was likely that there wasn't even an Australian Nile flowing *through* the harsh dry heart.

Kennedy in the Tropical Jungle

In 1848 in the far north-east of the continent, Edward Kennedy proposed to track through the great tropical rainforests of vast Cape

York Peninsula, from Rockingham Bay to Cape York: over 600 miles as the crocodile crawls.

Kennedy's party was taken to Rockingham Bay at latitude 18 °S in HMS *Rattlesnake*, under the famous Captain Owen Stanley. Stanley's main task was to make precise charts of the inner passage between the Great Barrier Reef and the Queensland coast for the steamships then just coming into use. After Kennedy had mapped the route, collected plants and animals, and noted the nature and habits of the various Aboriginal tribes, his party was to be met by *Rattlesnake* at the Cape.

It was a well-equipped, well-provisioned expedition with 100 sheep for food. With Kennedy were William Carron the botanist, a naturalist, a storekeeper, a shepherd, three carters, four labourers, and very important, Jackey Jackey, an Aboriginal guide from the Hunter River. Australians were optimistic. Kennedy was a good leader with experience of outback exploration under Major Mitchell.

DIFFICULTIES

In the clammy heat, Kennedy's way was continually hindered by almost impenetrable bush, huge prickly palms, coarse rattans, climbing vines, and enormous screw pines. Air plants hung from tree forks and hanging briars grabbed at them. The party became bogged in creeks and tea-tree swamps. Continually they had to backtrack, constantly they were thwarted by rivers and torrential downpours. This was merely the first week. They were in the same country but, compared with Sturt's Stony Desert, they might have been on Mars.

A temporary member of the party during this first week was the British biologist, T. H. Huxley (1825–95), then the surgeon's mate on the *Rattlesnake*, who would become world famous years later as a pugnacious propounder of Darwin's theory of evolution. Huxley pleaded to travel the whole way with Kennedy but fate, in the form of Captain Stanley, made him rejoin the ship.

Kennedy's expedition failed to appear at the half-way rendezvous point. It failed to arrive at Cape York by the agreed date of early October, and, after waiting a month, Stanley had to continue on his voyage around Australia. This is what had happened.

The party had needed six weeks to break clear of the horrendous

swamps encountered in the very first week. The shepherd then ran away to join the Aborigines and much food was lost. The horse-carts smashed from tree to tree and had to be abandoned. Everything but life essentials was crammed into saddle bags. Struggling through the clinging undergrowth, the horses collapsed and the dogs perished from heat exhaustion. Several men came down with malaria.

It took Kennedy's party five months to cover the first 400 miles. By then, few horses were alive and the carters and labourers were themselves lugging much of the provisions on their backs. On 11 November they ate the final sheep. The situation was desperate. Kennedy left eight men under Carron at Weymouth Bay, and he, Jackey Jackey, and three others pushed on hoping to cover the last 150 miles quickly to get help. It was not to be.

DISASTER

Near Shelburne Bay one of the three men accidentally shot himself and a second became too ill to proceed. They were left, in the care of the third. Kennedy and Jackey Jackey pressed on alone. A mere 20 miles from the cape, Kennedy was speared in the back by Aborigines. Jackey Jackey's profound knowledge of bushcraft allowed him to escape by following a tortuous route around the hostile tribesmen, eight days later stumbling into the Cape rendezvous.

A rescue party found Jackey Jackey but nothing of the three men at Shelburne except their clothes. At Weymouth Bay the botanist Carron and one labourer were found, barely alive; the rest had perished. Kennedy's body was never found, merely the remains of his notes, half-chewed through. In Sydney news of the disaster and the appearance of the emaciated survivors created a sensation.

These stories of Sturt and Kennedy make it clear why Australian explorers named so many hills and mountains in their paths, Mount Misery, Mount Dreadful, Mount Deception, Mount Hopeless, or Mount Despair, and 'lakes' such as Disappointment.

The Overland Telegraph Line

Other explorers and pioneers found and performed strange and

wonderful things in the unmapped parts of the continent. There was sheer intellectual curiosity driving them all, of course, but often their treks had economic motives, too.

Despite the coming of the steamship, by 1860 the eastern and southern Australian colonies were still separated from Britain and Europe by more than two months of ocean. But suppose an electric telegraph line, that wonder of the age, could be slung across those great desert expanses, then communication could be made in hours. Despite fierce competition from Queensland, the intellectual and economic élite of Adelaide were determined that South Australia should have the honour of, and receive, the rewards from such a telegraph line. But first the harsh centre would have to be crossed and mapped.

To do this they sent John McDouall Stuart, a protégé of Sturt. In a series of expeditions financed by the pastoralist John Chambers, Stuart had already reached far into central Australia. Now he was financed by the government to finish the journey to the ocean. His 1862 marathon from near Port Augusta took Stuart and party right across Australia to the Arafura Sea and back to Adelaide in close to a year.

BUILDING THE LINE

By 1860 the first telegraph lines had joined many towns in the eastern colonies. But the construction of the overland telegraph line was of different and epic proportions. Stuart had kept meticulous records of permanent water-holes and suitable timber, and, led by Charles Todd, superintendent of telegraphs in South Australia, the builders closely followed Stuart's route. (So, too, would the later railway to Alice Springs; and, in the twentieth century, the monotonously straight cross-Australia Stuart Highway from Adelaide through Alice Springs to Darwin.) The workers were good at improvisation: when a tree was close enough to the route it was just topped off and used instead of a pole.

By 1872, the continent was crossed by this 1975-mile telegraph line between Adelaide and Palmerston (Darwin), poles strung out sixteen or twenty to the mile. At vast intervals of about 200 miles sat the three or four operators and maintenance men at the repeater stations tapping out the short, expensive messages to be faintly received at the next

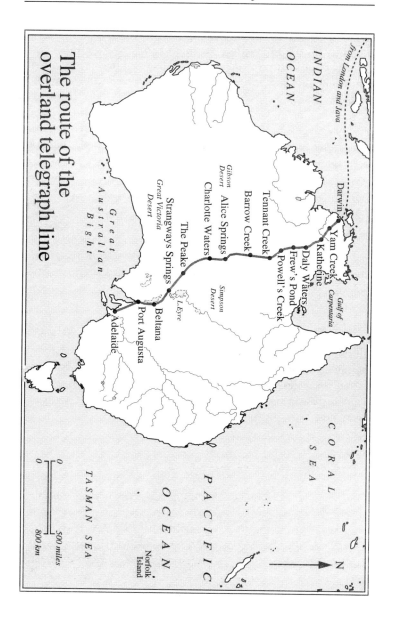

The route of the overland telegraph line

station and so repeated on down the line. Thus began the Northern Territory towns of Katherine, Tennant Creek, and Alice Springs.

A track of sorts grew up beside the line to bring provisions and telegraphic supplies to these almost-marooned men. They had more problems than just heat and isolation. The first wooden poles were eaten by termites and had to be replaced by iron ones. The insulators on the poles often went missing, too: they made splendid cutting tools and spear-heads for the local Aborigines, who also occasionally speared a telegraph operator to death.

ULURU (AYERS ROCK) AND THE GREAT SANDY DESERT

This lonely line and its supply track became a base for further exploration. In 1873 W. C. Goss (1842–81) with his camels, was going west from the tiny overland telegraph station at Alice Springs.

Pushing through the harsh, corrosive-green brush of this spinifex country, he saw ahead a low hump which, as he crested the rise slowly grew into 'one immense rock rising abruptly from the plain'. This was the 1200-feet-high, mysterious 'Ayers Rock' (after a South Australian premier) or 'Uluru' (the name used by the local Aborigines for this mighty inselberg). A week later Goss returned to gaze again upon its glory. Seen by few non-Aborigines until the mid-twentieth century, in recent decades millions of visitors have watched its continuum of colour changes. Goss was the first to express the common sentiment in English that, in his own words 'This rock appears more wonderful every time I look upon it'.

Uluru (Ayers Rock)

Ernest Giles went into the great unmapped northern half of Western Australia three times between 1872 and 1876. With even less justification, he shared the dreams of earlier men, such as Sturt, for in such a vast area he said:

> There was still room for snowy mountains, an inland sea, ancient river, and palmy plain, for races of new kinds of men inhabiting a new and odoriferous land, for fields of gold and golcondas of gems, for a new flora and a new fauna.

Again all he found was desert or semi-desert, not sea but sand. But, in the twentieth century, in this region known now as the Great Sandy Desert, mineral discoveries would be made, and in the adjoining Kimberley District, Giles's fields of gold and golcondas of gems would become a reality.

Squatters Squatting

LAND OF SHEEP

Inland Australia was ideal for sheep. They flourished on the great grasslands partly created by the Aborigines' eons of 'fire-stick farming'. The climate having no protracted cold winter as it does in Europe, there was no need to spend time cutting hay and storing it. And the only predatory animal was the native dog, the dingo which, with care, could be kept at bay though never really beaten.

When it became clear that the mills of Yorkshire could take as much wool as Australia could produce, enterprising men took their sheep further and further inland. Good-quality wool was one of the high-priced commodities of the world, so that it was possible for wool to be transported slowly hundreds of miles by dray to a coastal port, shipped to the other side of the earth, and still make a profit for the woolgrower. Sheep were prolific in the Australian climate: 500 at the beginning of a year might be nearly 1000 by the end.

Life was far from easy. These men, and the very occasional women who went with them, had few amenities. They had to battle the extremes of the inland Australian climate: drought and bush-fires,

blistering heat and occasional flood, snakes and myriads of flies and other insects, Aboriginal attack, and not least, mind-shattering loneliness. The sheep suffered from scab, catarrh, foot-rot, and fluke.

LIMITS OF LOCATION

This unanticipated, unplanned, and uncontrolled settlement worried the authorities in Sydney. It was not merely that the further men were from the capital, the more difficult were they for the government to control; it was also the case that there were continual bloody clashes with the native inhabitants of the land. In 1829, Governor Darling marked a line on the map of New South Wales in an approximate semicircle about 150 miles from Sydney enclosing 'the nineteen counties', beyond which settlers were forbidden to go. This would put a stop to the taking of Aboriginal land.

The sheep men ignored these 'limits of location' as the line was called. They drove their sheep wherever the grass was good, and just *squatted* on land to which they had no legal right under British law, or moral right in relation to the Aborigines. So these sheep farmers began to be known by the amusingly accurate word, 'squatters'. Risking all, such squatters pioneered the expansion of settlement. By the early 1830s, half the stock in the colony was owned by squatters beyond the limits of location.

Whatever the British Government might have wished or done, the pastoral expansion in Australia had a life and logic of its own. Even had Britain sent out 100,000 troops to prevent its spread, it would still have continued – and there would have been a rebellion as well. The tiny colonial government had even less chance of stopping, and probably less will to control the pastoralists.

By the time of Governor Gipps (1791–1847) in the 1840s, many recognized that it would be economic suicide to try to limit the squatters for, by then, their wool formed the key export of New South Wales. As Gipps elegantly wrote to a London friend, it would be as futile:

> to confine the Arabs of the Desert within a circle traced upon their sands, as to confine the Graziers or Woolgrowers of New South Wales within any bounds that can possibly be assigned to them; and as certainly as the Arabs

would be starved, so also would the flocks and herds of New South Wales, if they were so confined, and the prosperity of the Country be at an end.

This expansion, which continually looked for 'good land farther out', would continue into the 1880s, and eventually encompass in sparse pastoral settlement much of far-northern Australia as well.

A VAST ACHIEVEMENT

In 1821, some 175,400 pounds of wool had been sent to Britain; by 1830, it was 2,000,000; and, with an area of grassland as large as Ireland newly grabbed in most years during the 1830s, this rate of increase continued. Some 24,000,000 pounds were exported in 1845. By the early 1840s, squatters had occupied a great curve of territory stretching from the Darling Downs, in what became Queensland, through the inland all the way to South Australia. There were then 718 squatters' stations, employing 7000 people including 2600 convicts.

For the first twenty years of this expansion, the squatters did little to raise permanent buildings because their hold on the land was tenuous. For both squatters and their shepherds life was tough. The only 'roads' were the tracks marked out by the bullock drays, and the bush itself provided the rough materials of their huts and sheepfolds. To survive, a man had to depend on his 'mates', his fellow workers, and on his own ability to work hard and improvise. Everything was concentrated on the task of becoming established. Weeks or months distant from the government in Sydney, authority meant little. Solace was found in the 'mateship' of the few around him, and when it was available, in strong drink.

During the squatting era, overland transport was expensive and slow and would remain so until the building of the railways. So, to supply squatters' needs, numerous tiny townships eventually grew, separated by a day or two's travel by bullock team.

After 1830, to gain some measure of control, New South Wales had issued squatting licences of £10 – the same for all regardless of the area squatted. (One squatter leased about 8000 square miles – the size of Wales!) Later, more realistically, the cost of a licence was scaled in accordance with the amount of land held and its proximity to settled

areas. Licences gave the squatters legal right to use the land of their stations for a given period, but not freehold. This allowed for the possibility that, in the future, such land might be needed for agriculture. The Waste Lands Act of 1846 gave greater security of tenure, with leases of fourteen years.

THE MEN THEMSELVES

Who were these squatters who first made much of inland Australia what it is today? They were the sons of successful colonists; canny publicans and traders; former station managers; professional and rural middle-class people from Britain, including a disproportionate number of Scots; army officers from Britain and India as military establishments were reduced. All either possessed, or had to borrow, considerable amounts of capital, and had to be prepared to dispense with the comforts of civilized life.

At first, the squatter's 'house' – even the word 'hut' scarcely describes it – was of timber slabs with a sheet of bark for the outside door, its bottom hinge perhaps the broken end of a bottle, its upper a piece of stirrup leather. And there were wool-packs for partitions. 'Furniture' was equally *ad hoc* made, without additional expense, from local bush materials tied together with strips of greenhide: beds of saplings and bags, boxes for chairs, tables, and books – squatters always had books. Books kept them human and formed a fragile but essential link to civilization. Soap was made from animal fat, using a lye produced by pouring water through the ashes of cooking fires. In lawless or frontier districts, there might be loopholes in the slab wall for shooting at marauding bushrangers or attacking Aborigines.

SHEPHERDS, SHEARERS, AND OTHERS

What of the men who worked for the squatter? First were the shepherds. Originally they had been serving convicts. With the end of transportation, they were mostly emancipated convicts – 'old lags', as they were called. It was such emancipists who herded the flocks from Van Diemen's Land and New South Wales into Port Phillip, and from New South Wales to the Darling Downs. Death from thirst, or snake-bite, or Aboriginal spear continually threatened. These dangers,

coupled to the exquisite loneliness, made for eccentricity and in some cases madness. During the 1850s' gold rushes, shortage of labour brought about fencing of station runs, and shepherds were gradually replaced by that Australian trade, the boundary rider, to keep the fences repaired.

Once each year, the shearers would arrive on the station for the annual clip. This was men's work. (Nowadays there are some women shearers.) Bending all day, holding sheep between one's legs, and using hard-to-operate hand shears was a back-breaking and painful business. It remained back-breaking even after the introduction of the first machine-driven shears in 1881.

Bullock drivers were crucial, too. Once a year they were needed to take the bales of wool slowly to the nearest port, and return with supplies to last another year. Each way they might be months on the 'road'. This work, too, was lonely, and drivers became men of few words, except in their manifold and colourful profanities to their bullocks. But most squatters found them reliable. Bullocks were the long-distance engines of Australia. Even after railways had spread across the outback, bullocks were widely used until they were replaced by the truck.

There were other workers on stations, in trades that became more specialized and important as time passed and the rough edges went from station life: sawyers, carpenters, fencers, blacksmiths, and ten or more trades based on the needs of horses. As free migration increased and many ex-gold diggers sought bush employment, men grew more dependable and more independent, and there occurred the first stirrings of bush trade unionism.

And in the desert areas of the continent's centre, there were those key outback animals, the camels, imported from 1840 onwards from British India for transport and exploration. The cameleers were mainly from Baluchistan (now in Pakistan) though they quickly acquired the universal description, 'Afghan'. Some camels escaped. And, with the arrival of railways and trucks in the 1920s and 1930s, most of those remaining were turned loose: perhaps 100,000 feral camels now range across the outback. Modern camel farms also export camels to the Middle East (!) and to the United States, bringing in several million dollars a year.

SOCIAL CHANGES IN THE BUSH

Just as the native born were different from immigrants, so the people of the inland subtly changed as well. Though important social differences remained between the squatters and their employees, social distance also lessened.

At the barn dances, or at hotel dances in the nearest town held after picnic race meetings, there was social mixing on a level impossible in contemporary Britain. Squatters were workers as well as organizers of their stations, and their wives worked at a wider range of duties than did their British counterparts. Work and the lack of domestics meant the curtailing of some of the social niceties, most obviously in the new patterns of eating. English afternoon tea and dinner were collapsed into one meal, 'tea' at sundown, combining the tea drunk at the first with the meal eaten at the second. This 'tea' remains a pattern widely observed across Australia.

There were disaster years when wool prices were so low sheep could only be boiled down for their tallow. But, by the 1860s, many squatters were prospering. Their houses changed accordingly. Splendid two-storied structures built in English or Scottish architectural styles would be set in lawns and gardens. The house would often be surrounded by a wide Australian veranda. Were an approach tree lined, it would be as often of eucalypts as of imported poplars. Squatters began to send their children to boarding schools in the cities, or brought out British governesses to educate them at home on the station, often under the auspices of the newly founded Female Middle Class Emigration Society. Gentility was descending on the inland.

In the 1870s the novelist, Anthony Trollope (1815–82), out from Britain to visit his squatter son wittily demarcated the several levels of squatter thus:

A hundred thousand sheep and upwards require a professional man-cook and a butler to look after them; 40,000 sheep cannot be shorn without a piano; 20,000 is the lowest number that renders napkins at dinner imperative. Ten thousand require absolute plenty, plenty in meat, tea in plenty, brandy and water, colonial dishes in plenty, but do not expect champagne, sherry or made dishes.

Black versus White

THREAT FROM THE PASTORAL INDUSTRY

With the amazing spread of the pastoral industry west of the Great Dividing Range, racial problems were exacerbated. This rush of squatting was not just a nuisance for the Sydney authorities. It was a matter of life and death for the Aborigines. Soft kind wool had become the most decisive threat to the very existence of Aboriginal civilization.

So, as with the settlers and natives of the Americas, on and off for a century there were clashes. Squatters and their stock occupied black tribal land without recompense, unknowingly and knowingly let their animals destroy venerated areas, and pursued and shot Aborigines. Aborigines killed sheep and cattle, stole from shepherds' huts, and murdered shepherds and people alone in the bush.

ATTEMPTS TO HELP

Many settlers thought that, for their own good the Aborigines should be kept separate from the whites. Many others thought they should be absorbed into white society. Governor Macquarie tried the latter but failed. Observers were impressed with the ease with which Aboriginal children could learn. Mostly, such adaptation to white ways was merely expedient. Many a cleric, pleased with the progress of his new Aboriginal parishioners, appeared at service the following Sunday to find that his flock had entirely disappeared into the bush.

A Select Committee of the Colonial Office in 1836–37 noted that, in the founding of the Australian colonies, the 'territorial rights' (as the Committee described them) of the Aborigines had not been considered, and that this 'omission' 'must surely be attributed to oversight'. So the British government was concerned to end the fighting.

The institution of Protectorates was established – white men who tried to look after the interests of the Aborigines. Perhaps the best known was the Port Phillip Protectorate, in existence from 1838 to 1850. But Britain and the British Aboriginal Protection Society were too far away, the squatting expansion continued, and the natural rights

of black people continued to be ignored. The squatters' arrogance is well summed up in the following words of 1840 from G. A. Robinson, one of the Protectors of Aborigines:

> Many of the squatters with their twenty and forty square miles of country absurdly imagine that a ten pound licence to squat confers on them the power to expel the primitive inhabitants from the land of their forefathers.

So, despite the goodwill of these men, all protectorates abjectly failed, because most squatters just refused to co-operate.

The further the squatters roamed from Sydney, the less was the law able to control them. Though spears were no match for muskets and rifles, the Aborigines fought back. Because squatters were so far from the reach of the law, callousness and murder became all too common. In 1838 the Faithfull brothers, of ironic name, while droving their cattle in central Victoria fought a pitched battle with the local Aborigines, killing perhaps fifty. Vicious deeds escaped undetected but, after the Myall Creek massacre in 1838 in which twenty-eight Aborigines were murdered, Governor Gipps determined to set an example: eleven white men were brought to trial and seven hanged. This judicial interference was much resented by the outback white community and, within a few years, such settlers closed ranks and the earlier confrontations and murders resumed largely unabated.

Robinson complained to Earl Grey, the Secretary of State for the Colonies, in London. Grey's reply, sent in an 1848 despatch to the governor of New South Wales, pointed out that the granting of pastoral leases was never intended to deprive the Aborigines of their former right to hunt in such districts, or to wander across them searching for sustenance from foods spontaneously produced by the soil. They could be excluded only from land actually cultivated or fenced for that purpose. Earl Grey implied that all future settlement in Australia was to be governed by these principles, and they were, in fact, embodied in all leases for pasture acquired in Queensland, Western Australia, and the Northern Territory in the second half of the nineteenth century. What this meant essentially was that Aborigines had the right to come and go as they might desire and to follow their traditional way of life. Grey's principles should have achieved an equitable and

mutually tolerant period in race relations. In practice, in the dry out-back or far north, 500 or 1000 miles from the capital city of the colony, his ruling was honoured by the settlers mostly in the breach, and dispossession and bloodshed continued. The fact that with the granting of responsible government in the 1850s Crown land came under the jurisdiction of the various colonial governments reinforced this trend. For instance, in Queensland the colonial parliament was largely controlled by pastoral interests.

Moreover, in many areas, influenza, smallpox, and measles were once again more deadly to the Aborigines than overt fighting. Such diseases penetrated even where Europeans had never reached. And, in places where race relations were amicable, alcohol often took over as a destroyer of the black man and his way of life, for the alcohol of the outback was not beer, but the less-perishable, more addictive spirits and rum.

Of course, there were always settlers who struggled for the rights of the Aborigines. Besides the Aboriginal Protectors, all across the continent and throughout the century compassionate men and women were appalled at the treatment often accorded the native people, and fought to stop it: ex-convicts, humble bushmen, selectors, miners, journalists, clergymen, missionaries, government residents. But, in fact, only some kind of reservations or protectorates across vast areas of the country could have saved Aboriginal civilization and, under the inexorable momentum of the pastoral industry and the vicious ethics of frontier life, there was no will to do this until late in the century. It was only in the final decades of the nineteenth century that this was achieved in a very inadequate form, when special government reservations and church missions were established to protect Aborigines. For many outback Aborigines this remained official policy until after World War II. In recent years this policy has been harshly criticized by Aboriginal and white commentators for its paternalism and destruction of Aboriginal culture.

Proper consideration of Aboriginal land rights had to wait upon another age with another attitude. It would be more than 130 years after 1848 before large areas of Australia came under Aboriginal control once again; and Grey's humane principles have become

significant legally in Australia only in recent years as a source for Aboriginal claims.

THE NATIVE POLICE

The most bizarre development of Aboriginal-white relations in nineteenth century Australia was the several colonial native mounted police forces. The first was founded in 1842 in the Port Phillip District. The aim was initially an educational one. It was believed that specially trained Aboriginal men, inducted into the discipline of the police, and controlled by white officers, could function as exemplars to wean the Aboriginal people away from their nomad life and help assimilate them into the white community. Attracted by the striking uniform of green jacket, green and red caps, opossum-skin trimmings, sword, and short carbine, numerous young males were tempted to join. In the 1850s, such police were used in the gold escorts from the various fields to

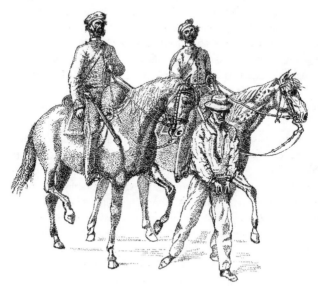

Native mounted police bringing in an offender from Ballarat, after a drawing by Strutt

Melbourne. Though it had not been envisaged in the original conception, the bush skills of such native police immediately neutralized the main advantage ordinary Aborigines possessed in conflict between whites and blacks.

For much of the rest of the century, the original purpose was lost and, especially in Queensland, such police gained a reputation for taking matters into their own hands and creating, rather than solving, problems. By driving the remnants of local tribes from their lands, the native police forced them to spear cattle and sheep to live. Recruited from tribes in the southern colonies, they showed no compassion for the Aborigines of Queensland and, in fact, much increased Aboriginal hatred of whites. Often unrestrained by their white officers, they kidnapped and raped local Aboriginal women, and were eager to fight and kill local Aboriginal men.

MASSACRES OF AND BY ABORIGINES

The cycle of killing and revenge became endemic in almost every area of outback Australia, as the white pastoral frontier was continually pushed west and north during the nineteenth century. The following four examples are representative of dozens, and show just what a complex recipe for tragedy the encounters of the two cultures continually provided.

In 1840, while sailing from Hobart to Adelaide, the ship *Maria* was wrecked off the Coorong. Twelve passengers survived to struggle ashore. At first, the local Aborigines helped the whites by carrying their children in the direction of Adelaide and giving them fish and water. When the boundary of their tribal territory was reached, in accordance with the strict Aboriginal rule of reciprocity, the blacks asked for clothes and blankets in recognition of their help. The Europeans, unaware of the rule, and perhaps unsure of their future needs refused but promised that, when they reached Adelaide, they would send such items back. The blacks began to help themselves. The whites resisted. Only the Aborigines had weapons, and all the whites were killed. In judicial retaliation, two Aboriginal men were hanged.

The enlightened squatter, Daniel Cameron, had pioneered the Dawson River district of Central Queensland and established harmo-

nious relations with the Aborigines who hunted on the lands where he had made his station. This state of affairs failed to survive the arrival of other squatters and the Native Police – by now notorious for the enthusiasm with which they massacred people of their own race. Spearing of sheep and shepherds and killing of Aborigines in retaliation brought about a massacre of eleven whites on a moonlit night in 1857 at Hornet Bank Station: the owner, Mrs Fraser, seven of her children, the tutor, hut-keeper, and shepherd. The tutor was castrated, the females all raped – this latter probably to repay earlier rapes of Aboriginal women. Posses of settlers and Native Police retaliated and, it is believed, massacred at least 150 Aborigines. Clearly, what little law existed on the frontier was being entirely ignored. For some years afterwards, William Fraser, the eldest son, who at the time of the massacre had been away bullock driving, took indiscriminate revenge on individuals.

The story of the largest massacre of whites in Australian history is equally poignant. The genial Horatio Spencer Wills, son of an English convict, had been a successful editor and publisher in Sydney and a successful squatter in Victoria. Wills had been elected to the newly established Victorian Legislative Assembly in 1856 but wanted to set up an even larger station in the north. In January 1861 he sailed to Brisbane and, with his eldest son, Thomas, and his party of men, bullock dray, and sheep, set out on the long, tiring, 500-mile journey to his great adventure, a new station he called Cullin-la-Ringo, some 250 miles west of the young port of Rockhampton, and about 150 miles north-west of Hornet Bank. Since the Hornet Bank attack, Native Police in central Queensland had been acting without regard for the law, perpetrating a string of massacres. Wills seems to have been unaware that the Aborigines were planning revenge.

One hot afternoon at the just-completed homestead, Wills and his people were taking their midday siesta when the Aborigines suddenly attacked. Wills was bludgeoned to death and eighteen of his white employees killed. Thomas Wills survived, being absent on an errand. He bore no grudge towards the Aboriginal people, but several groups of Native Police and a number of posses of settlers took fierce revenge. In a report to the Colonial Office, the Queensland governor claimed

that seventy Aborigines had been killed by the Native Police. How many were killed by the settlers is unknown, but it may be guessed at least as many.

Matters were often problematic in the more closely settled areas as well. For instance, in 1846, Brisbane's *Moreton Bay Courier* reported that no person 'ventures to trust himself unarmed beyond the precincts of the town'. For a decade in mid-century, the white inhabitants of isolated towns, such as Maryborough in Queensland and Port Lincoln in South Australia, went in fear of their lives, and these towns came close to being abandoned.

COMPLEXITIES

Race relations were always immensely complex. There were tribes which pleaded with settlers to help fight their own traditional enemies. Friendly Aborigines often used their unmatched bushcraft to help white settlers and lawmen to discover water-holes and creeks, to track bushrangers, and to find lost white children. Many exploring expeditions took Aboriginal guides. Shipwrecked sailors were killed by Aborigines but, just as often, kindly treated: James Morrill in the Bowen region of Queensland, and Norman Fersen in the Gulf of Carpentaria both lived for seventeen years as respected members of local tribes. There were squatters, such as Daniel Cameron and G. S. Lang, who treated the tribespeople of their areas as their extended family. Thomas Wills, mentioned above, helped promote an excellent team of Aboriginal cricketers. At the Melbourne Cricket Ground in 1866, in a match billed as 'Australian Natives v. The World', Wills played on the side of the Aborigines. In Queensland many Aboriginal tribes quickly became absorbed into the cattle industry, their bush skills a great boon, with most showing a natural ability to ride horses. By 1886 they represented approximately half the total workforce involved. The pastoral industry in the Northern Territory and Western Australia later followed a similar pattern. In many places this Aboriginal contribution has continued to the present day.

NUMBERS

So, long-isolated Australia had now joined the other continents of the

world in this dismal business of blood spilled in a cultural and racial struggle for land. During some 100 years of strife, probably 3000 white settlers were killed by Aborigines, with an equal number wounded. It is not accurately known, but the most knowledgeable estimate suggests that at least 20,000 blacks perished at white hands and many more tens of thousands from disease. More died in intertribal fighting as blacks were forced back into the lands of their neighbours: because the Aborigines had developed no organization that possessed central authority, the mayhem of their ancient custom of pay-back then ran bloodily out of control.

To keep this issue in perspective, it should be mentioned that the death rate in centuries *prior to* the arrival of the settlers probably equalled or exceeded that during the racial conflict of the nineteenth century. A single warrior from each tribe, killed in intertribal fighting each year, would have produced many more than 20,000 deaths per century. Moreover, the numbers killed directly as a result of white settlement in Australia are miniscule in contrast to those of most other conquests, such as the estimated forty million deaths of people conquered by the Mongols in the thirteenth century; or even the several hundreds of thousands killed in Russia's eighteenth- and nineteenth-century colonization of eastern Siberia and Alaska. Nor was the Australian racial violence as fearsome as occurred in Native American-white confrontations in the Americas, where the numbers killed over the whole period of conquests by the United States, the Spanish, and the Latin American countries (not counting deaths from disease) are estimated in the millions. But death on this scale was still significant in the small Aboriginal and settler populations of Australia.

Had Australia not been colonized by British settlers, some other European or Asian nation or nations would certainly have taken their place. The French clearly indicated this – prior to the French Revolution, they were planning to establish a convict settlement of their own. For the Aboriginal lifestyle was an open temptation to occupation from the rest of the world, especially once the industrial revolution had begun.

So the demise of Aboriginal society and culture continued throughout the nineteenth century. By the end of the century, the

considered anthropological opinion was that full-blood Aborigines would probably die out. Around 1920 it was discovered that they, as well as mixed-blood Aborigines, were actually increasing in numbers, and this increase has continued to the present day.

Economic Development: 1850–1900

The most crucial period for the development of Australia, both economically and politically, was the second half of the nineteenth century. Gold was discovered in massive quantities in New South Wales and Victoria in 1851, and much of the world suddenly learned there was a land called Australia. The middle-class and professional people among the gold seekers altered the political and economic outlook of the eastern Australian colonies, of Victoria most of all. From being a mainly pastoral economy the eastern Australian colonies were transformed.

With a larger population, Australians began manufacturing many of their own requirements. The pastoral industry maintained its expansion, and crop farming was encouraged in the inland by government incentives and through creative technical innovations. Immigration continued. River steamboats and thousands of miles of government railways knitted the country together, coastal and overseas shipping improved, and vast mineral wealth was discovered. In the final decade of the century, except in Western Australia where gold was found again, large-scale droughts and industrial troubles slowed these exciting developments.

Gold Glorious Gold

'Put it away Mr Clarke, or we shall all have our throats cut!' Governor Gipps is reported to have said in 1842 to a religious gentleman who was excitedly showing him some gold found not far from Sydney. Gold had been discovered by the odd convict shepherd or squatter in small

amounts in widely dispersed areas of rural New South Wales for several decades before that date. The reaction of the government had always been to ignore or suppress such information, because gold and convicts were radically incompatible.

By mid-century, the situation had changed. Pressure from the Australasian Anti-Transportation League, and penal reform in Britain, had ended transportation. The native-born population continued to increase and, during the 1840s, more than 100,000 free settlers arrived. The number of convicts and ex-convicts was now small in comparison to the total population. The final development, a result of the others, was the clamour for greater self-government and, in 1850, Britain gave all the colonies (except Western Australia) a system of Legislative Councils, in which two-thirds of the members were elected by popular vote.

These developments meant that, when gold was discovered in mid-century, the political situation was very different from that of earlier decades.

HARGRAVES'S GOLDEN OPPORTUNITY

From 1848, the Californian gold-fields were attracting Australians in such numbers that colonial administrations became alarmed. By early 1851, more than 3000 men had left from Sydney alone for the other side of the Pacific. Through the energetic activities of one of them, the English-born Edward Hammond Hargraves (1816–91), the situation would change in Australia.

While mining in California, Hargraves learned the prevailing methods of panning for gold. On returning to Australia, his intuitive geological knowledge convinced him that gold must exist not far to the west of the Blue Mountains, and gold was soon found near Bathurst on 12 February 1851. And the first Australian rush began. Other fields were quickly discovered within a 50-mile radius. *The Times* in London reported 'This is the Arabian nights over again'.

BOUNTIFUL BALLARAT

In 1851, the Port Phillip District was separated from New South Wales to become the colony of Victoria. In Victoria, just months after

Edward Hargraves 1851, the man who began the Gold Rushes

Hargraves's find, even more fabulous fields were found. The gold was struck at Castlemaine, Bendigo, and, most famous, frenetic, and fantastic of all – at glorious Ballarat, two days' ride, a week's walk, and today an unhurried 100 minutes' car drive from Melbourne. Here were the richest gold-fields the world had ever known! No country in the last 500 years has begun a new half-century in such pandemonium.

In Geelong, the nearest port to the gold-fields, the whole town was in 'hysterics', said the Melbourne newspaper the *Argus*. By October 1851 it was reporting:

> The police are handing in their resignations daily ... the custom house hands are off to the diggings; seamen are deserting their vessels. Contractors' men have bolted and left expensive jobs on their hands unfinished. What are the contractors to do? Why, follow their men; and off they go.

Though the drastic regulations of the masters and servants acts forbade such behaviour, rules were powerless when even the police were deserting. The women were left behind to carry on the businesses as best they could. Describing Melbourne, Governor C. J. La Trobe (1801–75) wrote 'Cottages are deserted, houses to let, business is at a standstill, and even schools are closed. In some suburbs not a man is left.' Most diggers walked to the fields.

When gold-seekers from overseas began arriving in late 1852, they were joined by the crews of the ships that brought them, and all headed for the fields. The ports of Geelong and Melbourne became forests of deserted ships.

People feared that the lawlessness of the Californian rush would be repeated. The *Sydney Morning Herald* predicted 'calamities far more terrible than earthquakes or pestilence'. It did not happen. Even though there were substantial numbers of Tasmanian ex-convicts on the diggings (called 'Vandemonians'), the Australian gold-fields were mostly law abiding. Unlike in California, the Australian discoveries occurred close to established centres of government authority, and the New South Wales government enforced at the very beginning the rule of law on the fields. Victoria was less well established and so less prepared, and was invaded by many more diggers, but managed to maintain law and order with some touch-and-go improvisation.

Moreover, most diggers belonged to the same racial stock of British and Irish, and were accustomed to the rule of law. Sensible regulations also helped: so that everyone had a chance, the colonial governments allowed diggers to peg out claims only about the size of today's Australian bedroom. As a result, the gold fell into many hands, and the rushes were essentially democratic.

Almost every day in 1853, a great sailing ship crammed with fortune-hunters left British ports. Sailing by the fastest (the great circle) route down the middle of the Atlantic and then far south towards the Antarctic continent, the passengers saw no land for the next 13,000 miles. Not all reached Australia. Some sank in storms or were crushed by mighty Antarctic icebergs, golden hopes perishing in the ice-blue waters.

Gold-seekers also came from the United States and, in smaller

numbers, from almost every European country. The number of free immigrants in the first two years exceeded the total number of convicts to Australia in all eighty years of transportation. By decade's end, Victoria's population had increased seven-fold, Australia's had more than doubled. Prices rose enormously. By 1853, land in down-town Melbourne was bringing £200 a foot: five times that in central London and New York.

Some 40,000 Chinese also arrived, to become the butt of racial antipathy, and occasional anti-Chinese riots. Finally, all colonies enacted legislation to prohibit further Chinese immigration. This anti-Chinese feeling has often been decried by modern Australians. But it should be remembered that antipathy to foreign cultures was then a worldwide phenomenon. One may speculate on the Chinese government's reaction had 40,000 white Australians entered China to dig for gold.

It was as if King Midas himself had walked in erratic fashion hundreds of miles through the Australian bush touching here, touching there. Men found gold in all sorts of terrain: tracks, farms, forests, river valleys. Gold was a great leveller: servants became masters, men without means were suddenly riding in splendid carriages. Other things being equal, hard work paid. Cornish copper miners sank their shafts several times as fast as city slickers. For once in history, wealth was more easily accessible to the poor than to the rich.

Women were arriving: by 1856 there were more females than males in the city of Sydney – the first such imbalance in Australian history.

Culture in its various forms came, too. Renditions of Shakespeare's plays by competent British actors were surprisingly popular on the fields. In 1855, there appeared in Ballarat the notorious Lola Montez, mistress of the King of Bavaria, with her famous troop of dancers.

Within a month, a promising new field might suddenly have 20,000 or 30,000 men living in a tent city, and, if the diggings proved poor a few months later, it might have no-one. The topography of a field looked like some jumbled moonscape of chopped trees and holes in the ground. Of all the inexplicable actions performed by white men, it was this destruction of the land that seemed most incomprehensible to the local Aborigines.

Many diggers did well. A number did astronomically well. Nevertheless, some of the latter spent all they had won in a few months. One might see a poor soul egged on by his fair-weather friends lighting his cigar with a £5 note, or playing skittles with bottles of French champagne. But about one in three diggers abandoned their quest empty handed, worse off than on arrival.

SHOPKEEPERS AND DROVERS

The first people to win small fortunes were the publicans, shopkeepers, and carters, not the diggers; and doctors and lawyers also did well. Even more, the New South Wales and Victorian squatters, who had feared ruin when most of their shepherds fled to the diggings, made tidy fortunes from supplying mutton and beef and breeding horses for transport. To feed the diggers, great herds of cattle were overlanded from New South Wales and South Australia, and the drover again became the man of the hour.

The first person to realize the potential 'gold' to be had from overlanding cattle to the fields was James Tyson (1819–98), one of the greatest cattlemen of Australian history. He and his brother established a butchering business in the other great gold-mining city, Bendigo, and James drove the cattle there from the Tysons' station in New South Wales ('only', as the Tysons said) 200 miles to the north. When their own cattle were all sold, James travelled as far north as Queensland to buy sufficient cattle for the miners. In a decade the Tysons made a fortune and, with the money, James set up a string of sheep and cattle stations, one to tap the Melbourne market, the others stretched across the outback. Ever fit, Tyson worked well into his eighties and died a multimillionaire.

By the time Tyson brought his first cattle to the fields, through experience and trial and error, the droving 'plant', as it was called, had become well established. It consisted of the boss–drover, a dray or cart, several drovers to control the herd, and sufficient spare horses. The cart would be loaded with bags, tents, food, cooking gear, camp ovens, shoeing tools, and a calico strip and stakes for making a temporary 'yard' if sheep were being moved. For a large mob of 10,000 sheep or several thousand cattle, the boss–drover would, in addition, need several extra

drovers, a cook, twenty or thirty spare horses, and a horse-tailer to look after them. Care was taken not to overload the cart lest it become bogged down in wet weather. For this reason some drovers preferred to use many pack-horses.

BATTLE OF THE EUREKA STOCKADE

At first the diggers took the easily available gold by panning in creeks and rivers. But, by the end of 1852, Ballarat and Bendigo diggers were having to probe more deeply in holes lined with timber in search of the deep gold leads. Work was dangerous, and diggers began to band together in groups of eight to twelve. Ballarat and other important gold towns then took on an appearance of permanence. Within a few years of its founding, Ballarat had banks, churches, libraries, schools, a newspaper, and a population of 50,000 including 15,000 women and children. Many of the elegant Victorian buildings erected in the 1850s and 1860s in these cities remain to this day.

But all was not well in Ballarat. The average winnings of £390 per head in 1852 fell to less than half that in 1854. To pay for the administration of the diggings, Victoria and New South Wales had made it law that, to dig for gold, a miner had to buy a licence. But, by

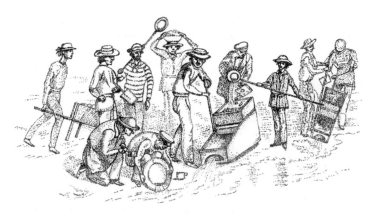

Panning and washing for gold, Ballarat 1851, after a drawing by Strutt

1854, all but the most successful miners were finding the outlay of £3 for a two-months licence too expensive because the time required for success had lengthened. The Victorian government remained largely unaware of the significance of these difficult new conditions. Discontent was continually fanned, as one observer put it, by the brutal manner, 'the Russian sort of way' in which the mounted police, many of them former convicts, rode into the diggings on licence hunts. Most miners were vehemently anti-convict. A series of annoyances and frustrations produced a temporary following for the political radicals. Led by an educated middle-class Irishman, Peter Lalor, and with a disproportionate number of Americans and Irish, many miners burned their licences and began organizing a revolt.

On a hill-top overlooking the road to Melbourne, perhaps 700 diggers erected their rude wooden 'Eureka Stockade', where they raised a handsome home-made blue-and-white southern cross flag, and did no less than proclaim the Republic of Victoria! They were determined to resist any further arrests over licences.

On the Saturday night of 2 December, three-quarters or more departed, leaving perhaps 130 of their more determined mates behind the barricades. Meanwhile, Sir Charles Hotham, the recently appointed governor of Victoria, and his Executive Council, were well aware of the mounting tension but failed to understand its nature and determined to stamp it out. At 4.30 on Sunday morning a contingent of soldiers and police stormed the stockade. Within half-an-hour it had fallen, as had twenty-two diggers and six soldiers. Though the leading surviving rebels were captured, all were later acquitted, for the feeling of the general populace was certainly with them. Lalor lived to become a bastion of state authority in Victoria, as speaker of the lower house of parliament.

A monument erected in 1923 by the citizens of Ballarat on the place of battle reflects the ambivalent attitude of Australians to the event (and to constituted authority). It reads:

> To the honoured memory of the heroic pioneers who fought and fell, on this sacred spot, in the cause of liberty, and the soldiers who fell at Duty's Call.

A commission of enquiry agreed that the rebels had legitimate grievances, and recommended that the hated licence be replaced by a duty on gold exports, and a 'miner's right'. This cost £1 a year and gave the right to vote and to help make mining laws for each district. Eureka had been in part a symptom of the profound economic changes that were occurring, for large amounts of capital were increasingly needed to dig for the deep gold. In the Victorian elections of 1856, only about an eighth of the miners bothered to vote. This strongly suggests that their grievances had been mainly personal and economic rather than political, and that, with a little more common sense and compromise on the part of the government, Eureka would never have happened.

ECONOMIC AND CULTURAL RESULTS OF THE RUSHES

Statistics show that about a quarter of all arrivals during the 1850s were skilled tradesmen and professional people, several times the number in these categories of preceding decades. The social, political, and economic outlook of Australia changed, Victoria most of all. Many such men came, not to dig, but to take advantage of the new business opportunities. After the first period of panic when their book-keepers and seamen deserted to the fields, city merchants and shipping firms waxed prosperous on the increased business. Secondary industries grew to provide for the much larger population. Farming increased to supply foodstuffs. Because of the labour shortage, sheep stations were fenced, and squatters found this was actually better and cheaper than having shepherds fold the sheep each night.

Soon also, the American, Freeman Cobb (1830–78), had established his fast coach line between ports and gold-fields – the famous Cobb & Co. Cobb used American-type coach cabins and suspensions – more suitable to outback Australian 'roads'. Within two years, he had a large number of staging posts for fresh horses strung across the land, about 10 miles apart, and Cobb & Co. moved people and mails on a tight timetable. Cobb's twenty-two-horse *Leviathan*, running between Melbourne and Ballarat, became legendary, carrying its near-100 passengers. By the 1870s, Cobb & Co. routes covered such far-flung regions as the Gulf Country in north Queensland. Their last coach ran in 1923.

Melbourne went through a building boom: hotels and hospitals, warehouses and wharves went up. Schools were needed for the young, teachers had to be trained. A great public library was founded, as well as an art gallery and a museum. Colonists, hungry for culture, began mutual-improvement and philosophical societies. Ballarat, Bendigo, and other large country towns built mechanics institutes and schools of arts, and naturally enough, a School of Mines of world class grew up in Ballarat. In 1854, Melbourne also founded a university which included Australia's first school of medicine in 1860. The original proud stone buildings adorn the central campus to this day, a reminder of a frenetic but architecturally more gracious age. Gracious, too, were many of the new churches and cathedrals that grew upon commerce and gold, including the Sacred Heart Cathedral at golden Bendigo, still perhaps the most elegant religious building in the continent.

Some historians argue that the arrival of so many British migrants also slowed the growth of Australian nationalism as distinct from a more generalized British Empire loyalty. On the other hand, life on the diggings clearly encouraged Australian democratic and egalitarian sentiments, which reinforced earlier tendencies.

Rivalry of Victoria and New South Wales

FREE TRADE OR PROTECTION?

Each colony wished to maximize its economic growth, but which economic policy was best? The two largest colonies developed opposed economic schemes: Victoria protection, New South Wales free trade, and each too readily attributed its prosperity to its economic system. The other colonies developed mixed systems.

In Victoria, David Syme, the editor and chief shareholder of the Melbourne newspaper, *The Age*, took up the idea of protection as the paper's personal crusade. Because of his eventual profound influence over populace and government, Syme earned the sobriquet, 'King David'. He said manufacturers as well as industrial workers would profit from tariffs. As a result of such agitation, from 1879 almost complete economic protection became the accepted policy. To the frustration of

travellers, customs houses were set up at the chief border crossings, and smuggling was rife.

Victoria soon placed import duties on many British products!

In New South Wales, promoted by British-born Henry Parkes (1815–96), the most famous politician of the second half of the century, the opposite economic policy of free trade became the norm. It is probable that her vast coal-fields and larger areas of undeveloped land made free trade a better option for this colony, though some cynics claimed it occurred for no better reason that that Victoria was protectionist.

During the give and take of this debate about protection or free trade, the notion of a reasonable standard of living for all became an accepted part of Australian political and social rhetoric. It was also assumed in all colonies that governments should accept some responsibility for bringing this about.

The 1870s and '80s were periods of great material expansion. Exports, especially wool, were flourishing, and London-based finance was granted readily to the various colonial governments for their railways, roads, and telegraph lines, to the private enterprise of colonial banks and building societies, and, in the 1880s, to the telephone companies. In the early part of this period the colonies were importing each year capital of £20 million, that is, several billions in modern terms, and in the latter years £175 million. Though smaller than the amounts of British capital being invested in North America, these were enormous figures for a total population of only a few million.

Cheap money brought careless financial management. When floods hit Queensland and droughts hit New South Wales and South Australia, some banks failed, and the governments of these colonies were forced to economize. Victoria, the financial centre of Australia, did not learn from these salutary experiences of others and its boom continued, with an inevitably even larger crash later.

MELBOURNE V. SYDNEY

From the 1850s, there developed increasing rivalry between Melbourne and Sydney. It became intense, much more so than today, for each was then the capital of its own proud and separate colony. By

the early 1860s, booming Melbourne had surpassed Sydney as Australia's largest city.

One unexpected but exciting event in this period was the visit of the American Confederate ship *Shenandoah* to Melbourne in 1865, to take on supplies and make repairs.

In 1879, Sydney held an International Exhibition – the first ever in the southern continents – in its vast 'Garden Palace' in The Domain. It was completely destroyed by fire three years later. So, in 1881, Melbourne staged an even larger International Exhibition. A certain *nouveau riche* ungraciousness was detected by *The Australasian Sketcher*. It complained that Victoria had been given 'a preposterous amount of frontage' at the very heart of the main artery, with the exhibits of the United States, Italy, and other nations 'sent off to the remote ends of the avenue'.

In the great Exhibition Hall, which still stands, Melbourne's Centennial International Exhibition in 1888 was even more prodigal. Over the arched doorway to the displays, the motto read: 'Victoria Welcomes all Nations'. This was the peak year of the economic boom. That year, prices of land in the main thoroughfare, Collins Street, soared higher than they would for another fifty years. With its elegant Victorian edifices for business and society, this was one of the world's great boulevards. Heights of buildings soared, too. One office block was thirteen storeys – taller than any building in Europe. On Saturday mornings, fashionable Melbourne society 'did the Block', taking tea, showing off the latest styles, bowing and chatting to friends, and cutting their business enemies dead.

The gold-rushes had made Melbourne the financial capital of the continent, the headquarters of most businesses and banks. Trading on the Melbourne stock exchange exceeded that in the rest of Australia combined. Significant amounts of London capital were being used in speculation in central-city land and buildings. Although such great mines as Broken Hill and Mount Morgan lay in other colonies, Melbourne controlled the wealth that flowed from them. To celebrate their success in conspicuous consumption, the wealthy built grand Italianate mansions in fashionable suburbs such as Toorak.

Less-ostentatious suburbs also spread. The limitless countryside

began to be filled with detached houses set in their own 'yards', with about 40 per cent being owner-occupied by the end of the century (the comparable British figure was about 10 per cent), a proportion which long continued to increase. This was not uncontrolled sprawl. The original surveyors had not forgotten the importance of parkland, and later city fathers ensured that central Melbourne was surrounded by elegant parks and gardens.

The circulation of *The Age* grew larger than that of any other newspaper in the Southern Hemisphere. And, just like London, Melbourne had an *Illustrated Melbourne News* and a *Melbourne Punch*. The first Tuesday in November, the date of Australia's greatest horse race, the Melbourne Cup, first run in 1861, replaced Sydney's Regatta Day as the chief day in the Australian sporting calendar. By 1883, about 100,000 people were attending – almost one in four of the city's population.

In the 1890s, Melbourne constructed a wonderful network of cable tramways, considered a scientific marvel at the time. Other Australian cities followed this example. Later, these became electric tramways. Of the great cities, only Melbourne has retained the whole system to this day – much to its advantage in an age of pollution, and a pleasant means of travel for locals and tourists.

Books published locally, extolling the city's virtues, could claim without hyperbole that Melbourne and its facilities compared favourably with any city in the world excepting they said 'only the great metropolis itself', namely, London.

A negative feature of Melbourne life (and of Sydney's too) was the growth in the final decades of the century, of gangs known as 'pushes', the members of which, 'larrikins', some dressed like dandies, belittled and frightened respectable citizens, created havoc for the police, and beat up one another. Even such larrikins exuded a certain cocky colonial *savoir faire*. It is little wonder that Australians, and especially Victorians, gave the city the title of 'Marvellous Melbourne'.

GROWTH OF SYDNEY

It is true that Sydney was temporarily outshone, but Sydneysiders were determined to compete.

By 1873, Anthony Trollope could already write of the attractions of the harbour and its headlands, that it might be worth while to move to Sydney just so that he could look at it 'as long as he could look at anything'. And Sydneysiders, perhaps more than any other Australians, were already developing a zest for life, a deliberate pleasure-seeking. In contrast to the less climatically blessed, more religious, more work-obsessed cities of Britain and North America, there was already a very different communal ethic. It remains today.

Nevertheless, in 1852, Sydney had established a university two years ahead of Melbourne, and Sydney's narrow streets, with their sandstone baroque and rococo fronts, showed panache. The grand town houses lining Macquarie Street looked out at the very English park of the Domain and the Botanical Gardens on the other side. Steam trains went out to Parramatta.

In 1857, H. G. Smith, a rich emigrant from seaside Sussex, had a vision. Just north of North Head, on the spit between ocean and harbour, stood the fishing village of Manly. During the following decade, Smith's efforts began to turn Manly into the sort of model seaside town it still is. It set the pace for the multitude of other Australian seaside suburbs and towns which would spring up during the following 100 years. Because of a law which prohibited bathing in daylight, however, the popularity of ocean swimming lay forty years in the future. Ocean bathing, for which Sydney is now one of the world's Meccas, began in October 1902 when the proprietor of the Manly newspaper challenged the absurd law and, with the greatest publicity, entered the surf at noon dressed in his neck-to-knee costume. He went unprosecuted and was soon followed by multitudes who turned the law into a laughing stock and began Australians' love affair with their ocean beaches.

Sydney was always the hub of New South Wales farming and grazing. After the engineering marvel of the great Lithgow Zig-Zag was cut through the Blue Mountains in 1869, steam railways spread across the New South Wales inland to tap this wealth. Industry of all sorts sprang up in the city and suburbs.

In the 1880s, the city built a new city hall, an Anglican cathedral, a new government house, a great post office, and grand buildings for the

Treasury and the Lands Department. But, most spectacular of all was St Mary's Roman Catholic Cathedral, finished in 1882 and, at that time, probably the largest structure erected by British people in their overseas empire. To match St Mary's, by century's end there was also Rookwood Cemetery, by then one of the largest in the world. Trains twice a day plied from Central Station picking up at stations en route mourners, clergy, and corpses – the corpses travelled free.

In 1888, huge celebrations and ceremonies were held in the city to mark the 100 years of settlement. The people of New South Wales even considered renaming their colony 'Australia' until they were stopped by an outraged chorus of protest from the other colonies.

In competition with Melbourne, Sydney established its own *Illustrated Sydney News* and *Sydney Punch*.

In the 1880s and '90s, Sydney was the great port for the magnificent wool clipper ships. Sometimes, eight or ten would be in port at the same time. The most famous of them all were the *Cutty Sark* and the *Thermopylae*, which would often sail together through the heads on their long race round the Horn and back to Britain. In the harbour itself, elegant, tall-funnelled steam ferries took passengers from Circular Quay to Manly, and to a dozen other coves. Some of these ferries had actually sailed out all the way from British shipyards, 'under their own steam'.

All the details of Victorian decorum prevailed among the middle and professional classes and among the wealthy squatters who kept houses in town. The best shops consciously modelled themselves on London: W. H. Soul, the chemist, which was painted in blue and white and had an heraldic crest on top, and David Jones, the draper, which later grew into the great department store, nowadays still one of the world's most elegant. Towards the end of the century, Sydney, matching Melbourne, developed an extensive and efficient system of double-deck steam tramways which sometimes frightened passengers by rounding corners at rakish angles.

'Sydney or the bush', meaning 'everything or nothing' became a catch-phrase of Sydneysiders, and of many other Australians, too.

FURTHER IMMIGRATION

Meanwhile, from the mid-1830s, more free immigrants than convicts

had been arriving from the British Isles. From the 1840s, many were on passages subsidized by the sale of Australian Crown land. In many years, half the revenue from land sales was used. The White Star Line and the Black Ball Line and others carried passengers safely around the world from Liverpool to Melbourne in about eighty days.

But there were also problematic shipping and ill luck. Some emigrants drowned scarcely out of sight of the English Channel. In 1866, the overloaded steamer, *London*, bound for Melbourne, foundered in the Bay of Biscay and 223 passengers went to the bottom. Some were eminent: from the leader of the Melbourne Methodists, to a Shakespearean actor much loved on his previous tours of the South Land. In the several hours it took *London* to sink, extraordinary heroics were done, and gallant men and women tried to save one another. In contrast, others died almost in sight of Melbourne. In 1845, the *Cataraqui* ran on to a reef on King Island in Bass Strait. Nine men survived; 399 people drowned or were broken on the rocks. There were other hazards. In 1852, the clipper *Ticonderoga* arrived in Melbourne. Of its 742 migrants, ninety-six had perished from typhus; another eighty-two died in the quarantine station. Such disasters were a sad loss of good people to the young colonies.

As the century progressed, stricter regulations were enforced. Unless a woman arrived at the embarkation port with clothes sufficient for the tropical and for the Antarctic sections of the voyage, she was prevented from sailing. Nevertheless, on most voyages someone died, infants and young children being particularly vulnerable. Continual sea-sickness and storms were often so traumatic that many migrants decided never to go to sea again in their lives.

Those who helped organize such emigration believed that the deserving poor of Britain and Ireland could improve their lot in the colonies. Because women were outnumbered in Australia, immigration officers tried to bring servant girls and other young women of marriageable age. Thousands of orphans from Irish work-houses arrived. By 1880, most immigrants were travelling in steam-ships. By using the new British-French-controlled Suez Canal, the voyage now took only seven weeks.

'Unlocking' the Land for Farming

By the late 1850s the surface gold had mostly gone, and many ex-miners now saw their future in farming. The idea of a block of land upon which a man might make a living for himself and his family in hard work and independence beckoned enticingly, and matched the developing democratic temper of the times. Many politicians, and business and professional men, saw advantages in the establishment of thousands of prosperous farms. But most of the good land had already been taken up in the grazing leases of squatters – who also had considerable influence in the upper houses of parliament. By 1860, a large majority of Australians believed that the squatters' privileges should be reduced by reclaiming much of their land for farming.

'FREE SELECTION' IN NEW SOUTH WALES

The confrontation began soon after Premier John Robertson (1816–91) ('Jack' to his followers) of New South Wales, introduced his so-called free-selection laws into the colonial parliament. Robertson had an earthy eloquence made more piquant by his lisp. His new laws allowed what was called 'Free Selection before Survey'. A potential farmer was given the right to select between 40 and 320 acres out of the leases of the squatters, and to begin farming immediately, that is, even before the surveyor had arrived to mark out the boundaries months, or even years, later. Given generous terms to pay for the land, the farmer was expected to build fences and barns within a reasonable time. Such farmers became known as 'selectors'.

The squatters were also given pre-emptive rights at the same price over the block of land on which they had built their homesteads, and over any other one-twenty-fifth of their leased lands. Selectors and squatters were supposed to co-exist. All around the colony the ballad was chanted,

> Come all you Cornstalks the victory's won.
> Jack Robertson's triumphed, the lean days are gone.
> No more through the bush we'll go humping the drum,
> For the Land Bill has passed, and the good time has come.

But the squatters resisted, and the hostility that developed between squatter and selector prevented the kind of co-operation that might have sorted out which areas were best suited to agriculture and which left to unchallenged pasturage. For twenty years, though there was little bloodshed, the Australian countryside became the scene of bribery, blackmail, and violence between white Australians the like of which has rarely been seen.

ABUSES THAT HELPED THE SQUATTERS

Simple to understand, the laws were equally easy to outwit by squatters using ruses such as 'dummying' and 'peacocking'. Dummying occurred when a squatter used his friends or children, or men specially hired for the purpose, to free select land and then make it over to him. On one sheep property in the Liverpool Plains, north-west of Newcastle, no fewer than 108 out of 112 selections were dummies acting in the interest of the squatter. 'Peacocking' or, 'picking the eyes' out of a sheep property was also an easy victory for the squatter. Knowing well the nature of his own leased property, he would merely select the land that lay around his creeks and water-holes, and the remainder of the acreage would be useless.

SELECTORS FIGHT BACK

The reverse also occurred. Some selectors peacocked to blackmail squatters with exorbitant prices. Some stole the squatters' sheep and cattle, or abused the improvement clauses. Those honest selectors who persevered showed remarkable endurance fighting flood, bushfire, drought, plagues of insects, crop disease, soil deficiency, and, not least, the hostility of nearby squatters. To supplement the family income, the husband might take on cattle droving or seasonal shearing of sheep – for the squatter, too, needed labour. Meanwhile, the wife and children would do what they could to raise the crops.

The selector's house hardly deserved the name. It repeated more permanently the crudity of the early accommodation of the squatters themselves decades before, but for longer: walls of roughly hewn timber, floor of pounded dirt, outside oven. Poverty became the pattern in the farming areas of Australia – battered barns, broken fences,

corrugated iron sheds, tumble-down houses. The human suffering of the selection era was immense.

RESULTS

Although some 10,000 selections were taken up by farmers in New South Wales, perhaps only about one in five became permanent. Twenty years after the introduction of the laws, it was the squatters and large pastoral companies who had triumphed, and had been able to change much leasehold into freehold. Of 24,000 square miles sold, only a few thousand were cultivated.

The ballad, *Eumerella Shore*, in poignant contrast to the earlier *Jack Robertson's Triumphed*, dates from this period. To the tune of the contemporary song, *My Old Kentucky Home*, it ran:

> To Jack Robertson we'll say,
> You've been leading us astray,
> And we'll never go a-farming any more.
> For it's easier duffing [stealing] cattle on a little piece of land,
> Free selected on the Eumerella shore.

SELECTION IN OTHER COLONIES

The New South Wales selection laws affected the largest numbers of people, but the other colonies passed similar legislation, leading to similar abuses. In Queensland, where fewer people were involved and the land was in the main more suited to cattle than to agriculture, selection was even less successful. In Victoria, a colony of more congenial conditions, the acts were more effective. There the area under cultivation increased by more than 1600 square miles in the same twenty years. Nevertheless, wide areas of potentially rich agricultural land in the Western District of Victoria passed into the hands of squatters, much of which they, or pastoral companies, still hold today. It was in South Australia that the laws had most success, and selections were taken up with little strain on the social fabric. For population and power were more evenly balanced, and men were willing to compromise.

CREATIVE INNOVATIONS IN FARMING

There were also many positive developments during this period of rural

conflict and disaster, developments that would make farming more economic in later decades. Of most importance was the discovery that repeated ploughing of fallow land conserved nitrates and moisture. This so-called 'dry-farming' was significant for Australian conditions for, together with the arrival of railways, it made possible the eventual movement of grain farming into what are today the great inland wheat belts.

Australian inland regions produced smaller yields per acre than the wheat fields of other countries and they needed larger areas, thus increasing costs. This situation stimulated the invention of labour-saving devices: technology has had an honourable place in the development of rural Australia. John Ridley, a South Australian, invented the 'stripper' in 1843, and its use was becoming widespread in the 1860s. In time, it was changed into a complete harvester, by the nineteen-year-old mechanical and farming genius H. V. McKay (1865–1926). By the end of the century, McKay had developed a great mechanical harvester industry at Sunshine near Melbourne, producing the 'Sunshine Harvester' and exporting to places as far away as Canada, Argentina, and Siberia. The 'stump-jump plough' of Robert Bowyer Smith, an ingenious series of wheels in place of the traditional plough-share, invented in the Mallee district of western Victoria, allowed farmers to grow crops even though the land had not been fully cleared of tree stumps.

The further development of wheat growing waited upon the results of scientific research. During the final decades of the century, yields of wheat in South Australia declined. The research of John Custance at the colony's agricultural college explained how the soils were losing their phosphates, and he advised the use of soluble superphosphates as fertilizer. Like their brethren throughout history, Australian farmers were slow to change but, when they heeded Custance's advice, results were striking.

It had long been realized that sheep needed to be bred for Australian conditions, but it was late in the century before it was seen that the same point applied in agriculture. English and South African wheats had been used, and some degree of evolution by natural selection had taken place in the new conditions. But William Farrer (1845–1906),

from Cambridge University, was the first scientifically to breed new strains of drought-resistant and quickly ripening wheat for Australian conditions. His kind of work has gone on ever since. By 1914, wheat growing was rewarding thousands of farmers in country that had once been thought too dry and suited only to pasture. Free selection had been about fifty years too soon.

In dry north-western Victoria the government, learning from Californian practice, introduced irrigation from the Murray River and, through the use of the new fertilizers, vast citrus-growing areas developed around the towns of Mildura and Renmark in what had been semi-desert.

Trade and Industry

PADDLE-STEAMERS ON INLAND RIVERS

The first two shallow-draught paddle-steamers, operated by two different companies, appeared on the Murray River in 1853. Their captains, with the quaintly complementary names of Cadell and Randell, had managed with difficulty to encourage their small ships across the sand bar at Lake Alexandrina. They were the first of hundreds more, most of them built inland at the river ports.

There is only one river system in the continent capable of navigation far inland, the Murray and its tributaries, the Darling and Murrumbidgee. A pygmy in comparison to those of other, wetter continents, it is most precious in water-starved inland Australia. Still, the system had a massive navigational problem: it was often too shallow for vessels drawing even a few feet; often too narrow, where overhanging trees could damage parts of the ships or cargoes; the Murray was navigable only from June to December even in normal years, the other rivers for even shorter periods; steamers sometimes stuck in the Darling mud for a year, waiting, as one historian puts it, 'for the river to arrive'; sandbanks shifted dangerously; driftwood accumulated on bends. And the rivers so meandered that, to progress a straight-line mile, a steamer travelled 3 miles of river.

Nevertheless, some 4000 miles were navigable at one time or

Barge of wool bales drawn by a paddle steamer c. 1860

another. The most southerly port of Goolwa was only a mile from the Southern Ocean; the most northerly, Walgett, lay on the dry plains near the Queensland border. Trade grew rapidly and, by the 1880s, these rivers carried a vast volume of wool and wheat. Stations as far as 100 miles from a river sent their produce and received their stores that way, for water transport was usually a tenth of the cost of transport by bullock dray.

As the railways pushed further into the inland, they reached many of the river towns, and quickly began to capture the river trade. The first railway to reach the river far upstream ran 156 miles from Melbourne to the river port of Echuca, which then siphoned off trade that would have gone down to the river mouth. Soon Echuca was the main depot for the whole system. Within a few years most of the paddle-steamers began to sink in the mud, not for a year but forever.

THE RAILWAY AGE

The reason for the early success of the South Australian wheat-growing

areas was their proximity to the sea and so to cheap transport to market. But the potential inland wheat areas of New South Wales, Victoria, Queensland, and Western Australia were far from the sea. They had to await the coming of railways before they could be brought under cultivation.

The story of the growth of Australian railways is another epic. Australia's first working railway was built from Melbourne to Port Melbourne and, soon after that, one from Sydney to Parramatta and in Queensland one from Ipswich to Grandchester. The early railways of these gold-rush years were begun by private companies, and did not spread far from the capital cities. Colonial governments entered the game only to bail them out. Though the building and running of railways quickly became a responsibility of the colonial governments, certainly there was no motive of doctrinaire socialism. Governments were drawn in because of Australia's small population and vast distances – factors uncongenial to private enterprise. Nevertheless, great hopes were held. Many politicians believed the railways would turn Australia into a second United States of America.

Victoria, with its greater capital, larger population, and smaller area, led the way in railway building. Its railways reached the New South Wales border in 1879, and the South Australian border in 1885. It was beside such lines that the free selectors of Victoria were able to make a success of farming. As part of the evolving political philosophy of full employment and a reasonable standard of living for all, it became accepted that Australian railways should exist, not for profit, but as a public service: uneconomic freight charges worked as a hidden subsidy to rural agricultural and pastoral communities.

The great railway age was the period 1870 to 1890, beginning with just 1000 miles of line and ending with 11,000. This was a vast achievement, albeit with the help of huge amounts of British capital.

When the railways of New South Wales and South Australia reached the Victorian border, and those of New South Wales and Queensland met, a remarkable fact stood revealed. The different colonial railways had been constructed with different gauges! New South Wales used 4 ft 8½ in, Victoria 5 ft 3 in, South Australia three different gauges. Busy stations grew up on the Victoria–New South Wales border at Albury,

and the New South Wales–Queensland border at Wallangarra, where passengers and goods changed trains.

Blame for the confusion has usually been laid at the feet of two young engineers. An Irishman Wentworth Shields, planning Sydney's first railway, rejected the advice of the British government that all Australian railways should be constructed on the British gauge of 4 ft $8\frac{1}{2}$ in, and planned to build the first New South Wales railway using the Irish gauge of 5 ft 3 in. Victoria and South Australia then agreed to the same gauge. Shields soon resigned and his English successor persuaded New South Wales to use the 4 ft $8\frac{1}{2}$ in gauge. By that time, the other two colonies had begun construction and would not change. They would eventually go on to build the largest network of Irish gauge in the world.

Historians have often criticized this situation as one lacking in foresight. One of them has suggested that, on the contrary, such critics lack hindsight. His point is that, unlike the integrated British economy which needed an equally integrated rail network, colonial Australia was many widely separated little economies, each with a port and its own hinterland. Most communication and trade between them went by sea, so the point of railways was to link each inland area with its nearest port. Separate railway systems thus made good colonial sense. Such scant importance was given to uniformity of gauge that when Queensland began building railways, it used another gauge again, the narrow gauge, more suited to sharp curves and so needing fewer cuttings and excavations. It was thus much cheaper to build across the long distances of that huge colony. Larger Western Australia and smaller Tasmania (because of its mountains) also adopted 3 ft 6 in.

CITIES OF SILVER AND GOLD

In far-western New South Wales, near the South Australian border, the Barrier Range rises ragged from the monotonous semi-desert salt-bush plains. The explorer Charles Sturt passed this way in his 1844 expedition and named a specially craggy eminence 'Broken Hill'.

In 1883, Charles Rasp, a boundary rider for a nearby sheep station, found silver on Broken Hill. Rasp and six others from the station formed a syndicate and pegged out some 300 acres. Five years later their

£490 investment was valued at £6,500,000, for Broken Hill proved to be the world's largest silver–lead–zinc lode, though projections see it terminating around the year 2020.

The Broken Hill Proprietary Company (BHP) was formed in 1885 and, within a few years, bringing water from the Darling River, a town of 20,000 people blossomed in the wilderness. Soon a railway connected 'The Hill' to Adelaide, for the South Australian capital and that colony's ports were much closer than their New South Wales equivalents.

BHP continued to expand. It first invested capital from the sale of ore in a smelting works at Port Pirie in South Australia. In 1900 it opened iron mines in South Australia and began to build a new port town nearby at Whyalla on Spencer's Gulf. By the time of World War I, it had laid the foundation of an Australian iron and steel industry. It became Australia's largest commercial enterprise, and it still is, although it withdrew its stake in Broken Hill in 1939. Within ten years of the Broken Hill discovery, prospectors in Western Australia, in particular 'Paddy' Hannan, found vast quantities of gold in the desert more than 300 miles east of Perth. This time most of the diggers arrived from the eastern Australian colonies. One of the few overseas' personnel was the young and ambitious mining engineer, Herbert Hoover (1874–1964), later to become president of the United States (1929–33).

The rush began first at Coolgardie, and then even larger reefs of gold were discovered at Kalgoorlie. The city of Kalgoorlie rose from the sands of the desert. Its main mining area was soon known to all Australia as 'the Golden Mile' and, within a few years, the population of Western Australia had trebled. A great feat of engineering by C. Y. O'Connor (1843–1902), the man who had constructed Fremantle Harbour and much of Western Australia's railways, helped make Kalgoorlie possible. For years, water on the goldfields had been almost as precious as champagne. O'Connor solved the shortage with one of the wonders of the age, a 340-mile pipeline, with steam pumping houses at intervals, bringing life across the desert from Mundaring Weir near Perth.

A year before Broken Hill, another great mountain of gold and

copper was discovered at Mount Morgan, 800 miles to the north-east, and inland from the central Queensland port of Rockhampton. The man who put Mount Morgan on the map was not an initial discoverer, but William Knox D'Arcy (1860–1917) an Englishman who had migrated to Rockhampton as a sixteen-year-old. He became the major shareholder in Mount Morgan Mines, and a multimillionaire. Mount Morgan was the earliest Australian company to pay £1,000,000 in a year's dividends. In 1908, D'Arcy became, as one historian has it, the most influential man in Middle Eastern history since Muhammad. For, from 1901, D'Arcy had been using a hunch and his fortune to search for oil in Iran, and, after seven years, his money almost gone, became the first man to find it.

As had happened on the Victorian gold-fields, the rugged outback activity of droving was again crucial in the establishment of Broken Hill and of Kalgoorlie. The legendary figure of Sidney Kidman (1857–1935) began his rise by droving cattle and sheep to the hungry miners of Broken Hill. By the first part of the twentieth century, Kidman was the largest land controller in Australia, his vast string of adjoining cattle stations stretching more than 2500 miles across the continent. In a similar manner, 'Charlie' Smith brought cattle to feed the Kalgoorlie miners, and made his fortune.

On their stations such men risked their money in sinking bores to tap the deep, underground waters of what came to be known as the Great Artesian Basin. If water were found the whole district benefited. Outback districts might have had to wait twenty years before a reluctant colonial government did the same job.

Kalgoorlie was the greatest of these later finds, but gold was found all across eastern Australia during the forty years between the end of the Victorian rushes and the end of the century. This was particularly so in Queensland, first at Gympie in 1867, which rescued the near-bankrupt Queensland treasury, then in an anticlockwise direction, at famous Charters Towers inland from Townsville (for decades Charters Towers was the second largest city in the colony), at Cooktown and the Palmer River in the Cape York Peninsula, at Croydon in the Gulf Country, and at numerous other places.

Lodes of silver and lead almost as extensive as at Broken Hill were

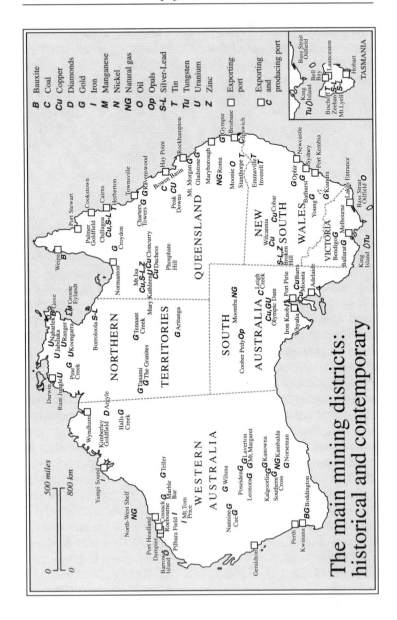

The main mining districts: historical and contemporary

KEY

B Bauxite
C Coal
Cu Copper
D Diamonds
G Gold
I Iron
M Manganese
N Nickel
NG Natural gas
O Oil
Op Opals
S-L Silver-Lead
T Tin
Tu Tungsten
U Uranium
Z Zinc

□ Exporting port

□ Exporting and producing port

discovered at Mount Lyell in Tasmania. There were many other great finds. These mineral discoveries in Australia have been termed 'the rush that never ended', and rich discoveries have continued throughout the twentieth century.

DEVELOPMENT OF QUEENSLAND

The state of Queensland occupies almost a quarter of the continent. Though the capital, Brisbane, is subtropical, more than half of the vast state lies in the tropics. As a result of this geography, Queensland developed a subtly different way of life. In the heat people even began to walk more slowly. It is the most decentralized state, with substantial cities all along its east coast. Nineteenth-century accounts often referred to it as, 'the country of Queensland'.

Because of climatic similarities with India, many Queensland ideas probably came from British experience in the subcontinent: the wide verandas around the houses; the waving cloth punkahs in the communal rooms of the best hotels; the pith helmets, and white clothing worn by gentlemen and by bank and clerical workers; sleeping under mosquito nets; in high summer the departure of Brisbane's élite for respite to Toowoomba, 2500 feet up on the edge of the Great Dividing Range.

To meet its needs, Queensland developed its own styles, too. To defeat the termites, to catch the breeze, and for coolness, many houses were built on stilts or stumps 5 or 6 feet high, with protective metal plates between the house and the stump. (In the twentieth century the under-house area has often served as a garage.) Because imported slates cracked in the torrid sun, and to collect rainwater, roofs were built of corrugated iron. Until the 1960s, most houses in Queensland followed this style. To decorate their verandas many houses also made imaginative use of wrought iron-work.

To maintain a regular direct intercourse with Britain, the Queensland government subsidized the Queensland Royal Mail Line steamers. These sailed monthly north from Brisbane to London by way of the inner passage along the Great Barrier Reef, through Torres Strait, then via Batavia (Djakarta), Aden, and Suez. The steamers stopped at each little tropical port and helped engender a Queensland consciousness.

Queensland's thousands of assisted immigrants arrived by the same route in reverse, thus preventing any temptation to remain in the southern colonies.

Most of all, Queensland was different in its industries. As early as 1860, cotton was being grown, and it flourished while the American Civil War raged. At war's end the cotton industry collapsed, though it has been revived from time to time. (In the 1990s, the mechanized industry is again thriving, and again exports to, and processes its product in, the United States.) Queensland's cheap virgin lands for mixed and dairy farms attracted not merely Britons but Danes and Germans as well. As already mentioned, its minerals were discovered in an unending stream, but beef cattle and sugar cane were the kings. In the last forty years of the nineteenth century, the Queensland pastoral industry prospered. Virtually all land suitable for flocks had now been taken up in leases and, as has often been said, 'Australia rode on the sheep's back'. In contrast, on the great tropical and subtropical plains of Queensland and other regions in north Australia, it was the cattle industry that became far more important.

As a further boost to the beef industry, in 1877, Thomas Mort (1816–78) established a freezing works at Lithgow in New South Wales on the western side of the Blue Mountains, and great refrigerated warehouses on the Sydney docks. There were similar developments in Queensland at Brisbane, Rockhampton, and Townsville. Thus began Queensland's massive frozen-meat trade to Britain.

In this far north of Queensland, and in what became the Northern Territory, the cattle stations were larger than ever: Alexandra Station on the Barkly Tableland covered 11,000 square miles; Victoria River Station more than 14,000 square miles; the first almost as large as, the second considerably larger than, Belgium.

Pastoral expansion and such huge cattle stations of course meant that further Aboriginal land was taken, with little or no concern for Aboriginal ways or welfare, and the racial struggle and bloodshed of earlier years were repeated across the north. For more than a decade, the most famous, belligerent, and daring of all Aboriginal resistance was offered by the Kalkadoons of north-west Queensland. The Queensland Native Police helped the settlers to destroy that resistance

in the last recorded Queensland battle, fought in 1884 at Battle Mountain. Perhaps hundreds were killed in this, the Kalkadoons' 'last stand'.

On the hot, wet, tropical coast plain, Queensland also excelled in the production of sugar. The first cane was grown in 1862 by Louis Hope on the coast just north of Brisbane. Growers found it more economical to send their cane to be crushed at a central mill, and the industry was soon dominated by the Colonial Sugar Refining Company (CSR), established in 1855. By the early twentieth century, CSR was second only to BHP among Australian industrial giants. Soon it moved into shipping, collecting the sugar from the same little ports serviced by the mail steamers, and it developed a huge commercial empire of its own in the South Pacific.

Sugar-cane planting and cutting needed labour. Even in this Queensland was different: because the British government of India refused to send Indian coolies, and the other colonies opposed the idea of convicts, Queensland growers resorted to labour from the Pacific islands such as New Caledonia and the New Hebrides (Vanuatu). The cane farmer, Robert Towns, after whom the city of Townsville is named, brought in the first party of islanders in 1863. The trade became a scandal, for many of the 47,000 who eventually arrived failed to understand the agreement and were in effect kidnapped. In 1901 half of the crop was still produced by such men. Because the new Australian federal government agreed to subsidize sugar growing, quickly the whole industry changed to the labour of white Australians, and most of the islanders were repatriated, some against their will.

THE CRASH

Following the 1880s boom in the Australian economy, the inevitable crash began in 1889 when income from exports fell drastically, coinciding with a tightening of London money. Confidence disappeared and thus began Australia's greatest depression until that of the 1930s. Victoria, with the most intricate and developed economy was hit hardest, comparatively underdeveloped Western Australia least. In 1892, across Australia, dozens of land and building companies failed and, by mid-1893, half the banks had either collapsed or gone into

The arrival of a water train in a drought-stricken area

reconstruction. Tens of thousands of small depositors lost their life savings, and hundreds of thousands of family men their jobs. To add dismay to despair, two years after the crash there occurred the worst drought in Australian history, and thousands of farmers were forced off their land. The drought was to last until 1902, this last year the worst of all. Two-thirds of the country's livestock perished. The fact that between 1880 and 1890 the population of the city of Melbourne increased by 200,000, but in the next decade by a mere 6000, gives some indication of the devastation.

In the final decade of the century, Australia's share of immigration was paltry as well, and hope of expansion from that source died. In fact, during the long period of depression and drought from 1891 to 1906, Australia received only 8000 migrants, mostly British. In contrast, during the same period, about seven million European and British migrants poured into the United States.

Progress Overall

Despite the final slump, the fifty years covered by this chapter saw the greatest changes in Australia's history. Australia was no longer just a pastoral country with maritime interests. The 400,000 white people in the colonies at the end of 1851 were near 4,000,000 by 1900. At the beginning of 1851 there was not a mile of railway or telegraph line in the entire continent; by 1900 there were some 12,000 miles of rail and 20,000 miles of telegraph. Cultivated land had grown from 780 square miles to about 15,600 square miles, with 23,400 square miles of sown pasture. The seventeen million sheep were now 106 million. Proportionately, secondary industry and manufacturing had grown even more; some 2000 employees had become 400,000. Despite the slump of the 1890s, overseas trade showed a tenfold increase in real terms. And the Australian colonies were now among the world's great mining countries.

The main cities had also changed out of all recognition. Sydney's 50,000 and Melbourne's 30,000 were now half-a-million each, matched by nothing in the Southern Hemisphere at that time except for Buenos Aires and Rio de Janeiro, and comparable to great Northern Hemisphere cities such as Rome, Manchester, and Philadelphia.

Despite their small total population, the Australian colonies, with their large areas, their infrastructure of communications, their local manufacturing, and vast agricultural, pastoral, and mineral production, if taken as a whole now formed a country of significance.

Democracy and Nationalism: 1820–1900

The fundamental economic changes described in previous chapters made it inevitable that there would have to be changes in the ways the Australian colonies were governed. Controlled by benevolent despots during the first decades of the nineteenth century, by its end the colonies had progressed to take their place among the most democratic countries in the world, with political parties in the modern sense, and a powerful and growing movement of organized labour. In the final decades of the century, these developments were matched by growth in national feeling. By 1900, Australians were about to formalize this awareness in a federal union.

The Coming of Responsible Government

AUTOCRATIC RULE OF THE EARLY GOVERNORS

Until the conclusion of Macquarie's tenure in 1821, New South Wales and Van Diemen's Land were governed autocratically by men appointed by the British government. Because both were primarily convict colonies, most of the regulations the governors promulgated were restrictive, having to do with control and discipline.

As men such as Lord and Macarthur became successful in business and in the pasturage of sheep and cattle, they and other free settlers found the governor's regulations increasingly frustrating. As shown in the actions of Macarthur, however, early opposition to the governors was less constitutionally constructive than personal: the Exclusives

relied on the influence of powerful friends in Britain to frustrate or defeat policies they disliked.

The British government was aware of the problems of the settlers. In 1817, Lord Bathurst wrote:

> The settlers feel a repugnance to submit to the enforcement of regulations which, necessarily partaking much of the nature of rules applicable to a penitentiary, interfere materially with the exercise of those rights . . . which as British subjects they conceive themselves entitled.

Bathurst had the Exclusives in mind, but his point might equally have applied to the Emancipists, the convicts who had served their sentences. They, too, wanted clarification of their status so that, once again, they might act as free men and women.

MOVES TOWARDS SELF-GOVERNMENT

Commissioner Bigge recognized these grievances and, besides his recommended economic and disciplinary changes, he called for some curbing of the powers of the governor. So, in 1823, Britain established a nominated council of from five to seven colonists to advise the governor. In the same year came trial by jury in civil cases. Though the governor held absolute authority, he was wise to heed the opinions of council members. The council was enlarged in 1828, and some of the legal disabilities suffered by Emancipists were removed. Criminal trial by jury had to wait until 1839.

Meanwhile the governors were also having difficulties. They had several masters back in Britain, and they were expected to implement British policy that might be unpopular in the colonies, in which case they would be violently attacked in the free colonial press which had existed from the early 1800s.

In the mid-1820s, William Charles Wentworth, who had been in the first party to cross the Blue Mountains, became the chief agitator for self-government. He began his efforts in the era of the martinet, Governor Darling (1825–31) and, born of a convict mother and a doctor father was the first great Australian democrat. All his life he stood for the new man: Australian-born, self-reliant, opponent of governors. He began a newspaper, *The Australian*, to push his ideas. When

Governor Darling departed in 1831, he held a monster celebratory party for 4000 guests, the climax of which was a fireworks' display that spelled out in huge letters the words 'Down with the Tyrant'. Like most people of his era, all his life Wentworth thought of Australia as 'a new Britannia in another world' as he described it in a youthful poem. Indeed, he believed that, sometime far in the future, Sydney might replace London as the centre of the Empire.

By the 1840s, the governors and the council were continually quarrelling over land policy. The press was flourishing, newspapers free from the taxes that were still levied in most European countries. The time for granting responsible government to the colonies was at hand.

At this point the squatters began their own agitation. Their ideal was a society, not only based upon the pastoral industry, but equally led by this 'aristocracy' of large land-holders, a 'squattocracy' as it pejoratively came to be called. Viewing the actions of the governors as those of the British government at one remove, and frustrated in their desires for greater security of tenure, the squatters, like the other free settlers, also saw their salvation in self-government.

RESPONSIBLE GOVERNMENT

In the nineteenth century, events and ideas in the various parts of the British Empire ramified and interrelated in multiple ways. In the matter of responsible government, it was the Canadian provinces which were the pace-setters, and the Australian colonies benefited from developments there. As a result, within a year of the first gold discoveries, the Legislative Councils of the Australian colonies with their burgeoning new free and prosperous population, had been authorized by the British government to draw up constitutions for full responsible government, including control of Crown land.

In nineteenth-century Britain, the new middle class working for political change had to take into account the opposition of the aristocracy and the House of Lords. In Australia in the 1850s, when the new colonial constitutions were being drawn up, the new men of the middle class had to accommodate to the closest colonial equivalent – the old colonial officials and the squatter class. For the next few years, one of Australia's most intense periods of political debate began as the

squatters tried to ensure their control of the new parliaments, and the middle class of the capital cities opposed them.

The squatters saw themselves as the Australian aristocrats who had struggled against the Aborigines and pioneered the spread of settlement into the inland, who had been given wardship over the land, and who carried with them the practical political wisdom of the past. So they desired disproportionate representation for rural districts and special powers for the upper houses to check the radical democracy of the lower. But the trend in the West has been inexorably towards the rule of the many, and so it was in colonial Australia. The opponents of the squatters, the city merchants and the radical democrats among the tradespeople, argued that virtue and political wisdom are spread throughout the population and talk about the wisdom of property merely a ploy to retain privilege. Some had read the English Utilitarian theorists, Jeremy Bentham and John Stuart Mill, who believed politics should promote the greatest happiness of the greatest number.

Argument became personal, and invective reached a superb level which modern Australian laws of libel would forbid. But though argumentative, in a typically Australian way, the demands of the democrats were not revolutionary. They wanted a wider sharing of the good things, not the destruction of classes and the overturning of the world. It was in these fierce, anti-squatter debates that Henry Parkes (1815–96), later Sir Henry, Australia's greatest nineteenth-century statesman, first became well known. Leonine-headed, provincial-born Parkes had come to Sydney as a poverty-striken assisted migrant. He had a chequered business career, but his political abilities could not be denied, and he became premier of New South Wales five times. Such a career for a man of his class would have been impossible in Britain. But the compromise of the times is also shown in Parkes's emphasis that people of whatever station in life had duties to others. This included the duty of the employee to the employer. Certainly he, like most Australians, wanted no republican government.

All colonies except Western Australia were given full responsible government in the years 1855–56. They produced similar constitutions, with bicameral legislatures, in which the powers of the

Sir Henry Parkes in old age, 'The Father of Federation'

squatter class had been limited. Because the working class was not yet a political power in the land, the Australian colonies were governed by middle-class business and professional people. As one English visitor neatly observed, Australian society was 'English with the upper class left out'. The executive was drawn from members of parliament and headed by the premier, himself normally a member of the lower house and responsible to it. The governors, appointed from Britain, now became advisers and figureheads representing the British Crown, and, except in political crises, were expected to acquiesce in all legislation. Judges were appointed by the colonial governments, not elected, and they and the public service kept office through changes in government. This procedure has continued to the present day. As a result the Australian judiciary and public service have remained largely independent of political bias.

All these colonial constitutions allowed for new democratic techniques such as the secret ballot (this was an Australian creation, and in some parts of the world is still called 'the Australian ballot'), regular elections and three-year parliaments, and universal manhood suffrage. Although for several decades the upper houses were elected by men of some property or of the professions, such constitutions allowed a wider franchise than applied in Britain at that time. In the most powerful colonies, New South Wales and Victoria, most Aborigines had the right to vote but, understandably, as they had little interest in such a practice, almost none took advantage of this right. Later, having ignored it, and with new paternalistic attitudes in governments, most full-blood Aborigines lost the right and remained in political limbo until 1948.

The Australian colonies had perhaps the most democratically advanced constitutions in the world at the time. Even today, except for further democratization of the upper houses and the giving of votes to women, the Australian states are still governed under rules similar to those drawn up in the 1850s. Australia is one of the three or four oldest *continuous* democracies in the world.

Though the colonial governments were allowed almost complete economic autonomy, in general, foreign policy remained the right of the British government.

Australian government and politics evolved peacefully and changed as need arose. Unlike the American colonists, Australians never formally rejected their heritage, but accepted it, valued it, and adapted it to their own circumstances. Democracy came to Australia democratically.

EDUCATION

As in all pioneering societies, Australian life had a practical bent and valued practical skills. Nevertheless, from earliest times, there had been people concerned to develop education and the more cultural aspects of life. For instance, in the 1830s and 1840s, the town of Hobart was an isolated centre of endeavour, next stop Antarctica. Yet it established a philosophical society that took general scientific enquiry as its mission but emphasized discovery in things Australian. It soon became the

Royal Society of Tasmania and still thrives, the oldest such Royal Society outside Britain.

The gold-rushes saw an upsurge in interest in education and, when Sydney University was established in 1852, it offered scholarships for the talented offspring of poor parents. In general, prior to the gold-rushes and for some time after, most colonial governments subsidized the schools of the major denominations – Anglicans, Roman Catholics, Presbyterians, and Wesleyans. The exception was South Australia whose respectable middle class believed religious activity should stand on its own feet.

Henry Parkes in New South Wales and men of similar mettle though of only moderate education themselves understood its value and worked fiercely to bring primary education to all. Such men believed education provided the means by which ordinary people could assert their rights as individuals, and promote democracy.

For decades there was ceaseless conflict between advocates of church education and of secular education, as successive waves of immigrants brought with them the related issue of Irish–British sectarian bitterness. But, with increasing population, the churches were unable to cope and, in each colony, there developed the so-called 'dual system' of church schools and national schools.

The final outcome, so far as government funding went, was the principle of so-called, 'free, compulsory, and secular' education, first adopted in Victoria in 1872, quickly followed by the other colonies. In Western Australia the premier, John Forrest, silenced the opponents of compulsory schooling with the wry statement, 'Do you want these children in the bush to grow up as if they are kangaroos?' State-provided schooling was to be free (except for books), so even the poorest could benefit from it; compulsory, to force reluctant parents into sending their children, and reluctant governments into building schools for the scattered inland population; and secular, in the hope of avoiding religious controversies. As a result, most colonial children attended these state schools. All the while, however, even after subsidies were withdrawn in the 1870s and '80s, the churches retained their own schools, of which the Roman Catholics had by far the largest system, and still have today. In 1964 the federal government

began again to subsidize science education in private and church schools.

The weakness of local government meant that education was in the control of departments run by the colonial governments. This inevitably brought bureaucratization and centralization. But it also brought equal educational standards to even the most isolated bush areas: the curriculum was the same and, to staff the schools, state teachers were transferred anywhere within the enormous distances of a colony – for instance, the 667,000 square miles of Queensland. An especially Australian institution, which formed a crucial part of this splendid enterprise, was the one-teacher school. The same teacher taught all ten or twenty children of a bush district, covering every primary grade. Dotted throughout the countryside, these tiny bush schools existed in their hundreds until about twenty-five years ago.

What did the children learn in these colonial state-run schools? Sterile in many ways with rote learning, as were most nineteenth-century schools, they also had some admirable features. They provided a curriculum that was very similar in each colony, and this created a common culture for the future federated country. Excerpts in the reading books drew upon the great prose and poetry of the English-speaking world. Shakespeare and Longfellow rubbed shoulders as did Dickens and Twain. Children read something of other literatures, too, such as translations from *Don Quixote*. In the 1860s, H. Kendall (1839–82) and A. L. Gordon (1833–70) produced poetry praising the bellbird and the golden wattle respectively and, in so doing, helped develop more positive attitudes to the bush. Theirs and later similar poetry was learned by heart by thousands of Australian schoolchildren. There was: the history of the British Isles and the Australian colonies, and something of the other countries of the Empire from Canada to India; basic geography of Australia and much of the world; elementary arithmetic and geometry; and nature study, which provided an awareness of Australian flora and fauna. Despite sectarian disputes and much truancy when children's work was needed on the farm, schooling worked. By century's end, the Australian colonies were among the world's few countries with more than 90 per cent literacy. To this day Australia has one of the world's highest literacy rates.

The Australian Ethos

The physical environment of Australia was exceedingly different from the green-grass isles of Great Britain and Ireland, and, as already suggested, very early, native-born Australians became aware that they were different.

INDIVIDUALIST SENTIMENTS

William Westgarth, who had been chairman of the enquiry that examined the Eureka disturbances wrote,

> The social equalities of colonies give them an aspect of rudeness to eyes that are fresh from the mother country ... the necessary result of a general prosperity that brings all classes to some similar degree of independence and consideration ... A labourer in Australia is indeed a very different personage from one in the mother country, and he is not long of knowing the fact.

A few years later, when manhood suffrage was granted in Victoria, Westgarth aptly suggested this was merely, 'the adjusting of the political to the social constitution'.

The newly enfranchised voters used their power further to democratize their colonies, and shape them after their own self-conception – that of the egalitarian, independent man. In an unformed way, such people were already aware of the key ideas that would guide the political struggles for the rest of the century and beyond. These ideas were not doctrinal. They were those which democratic common sense believed proper for ordinary men and women: secure employment and a reasonable standard of living, to be achieved with a modicum of independence.

A NATIONAL CHARACTER?

The fact is acknowledged the world over that many Australians are interestingly distinct from other English-speaking peoples. The most famous description of the Australian character comes from the historian, Russel Ward, in his book *The Australian Legend*. Ward says that the Australian is a practical man who decries affectation; he does not exert himself unduly except in a good cause, swears and gambles a lot, and

periodically drinks to excess. The Australian is a man of few words, sceptical of intellectual pursuits and religion, independent and a hater of pomposity, who enjoys disparaging success unless this is physical or in sport. Believing he is just as good as his superiors, probably better, he dismisses pretensions, and dislikes authority as typified in military officers and police officers. He is very hospitable, and will support his close friends (his mates) even when they are in the wrong. Ward probably would have claimed that, with some modification, such as omitting the swearing and drinking to excess, much of the description would fit Australian women also.

But, even for the nineteenth-century population, this description requires modification. There always have been many Australians to whom few of these characteristics apply: there are, after all, teetotallers, religious Australians, Australian police officers, and military officers, too. Nor have Australians ever been as unintellectual as Ward suggests. The early Tasmanian philosophical society, the presence of books in the squatters' huts, and the establishment of universities in Sydney and Melbourne, when they were towns of only about 50,000 people, were mentioned earlier. Even in the shearers' bush camps during the great strikes of the 1890s, libraries were organized. There is no evidence to suggest that Australians are more philistine or less interested in ideas than people of similar countries, such as the white Commonwealth countries or of the United States. And, for 150 or so years, Australians have purchased more books per head than have Britons. Still, Ward is not describing a mere stereotype – there are many Australians who do fit his picture. They still believe in 'a fair go' for all. Perhaps more interesting, true or not, Ward's description is exactly how many Australians like to see themselves.

It is often suggested that the source of the characteristics Ward emphasizes was the inland, that which Australians call 'the bush'. It is said that there, during the nineteenth century, encouraged by the lack of amenities and the absence of women and clergy, these qualities were consolidated. Squatters, farmers, labourers, itinerant workers, were always facing some test: a drought to be got through, supplies to be waited for, a fire or flood to be fought, a pest to be put down, a job to be found. It was in the inland that both owners and workers necessarily

perpetuated the radical egalitarian convict values of mateship, fraternity, and, though modified in the employer class, derogation of superiors. And, it is said, it is there that such qualities can be most easily found today. One still hears remarks that 'It's in the outback that the real Australians live'. There is truth in these views, as long as we remember that such attitudes and values were *initially* formed by the convicts, the Irish, and the native born in and around Sydney.

Moreover, in nineteenth-century Australia the contrast in way of life between city and bush was not precise either in appearance or in life-style. It was common for families to supply much of their own food such as eggs and bread, and sometimes milk. Something like a rural pattern of living was possible on the large quarter-acre blocks surrounding the family home in many towns and cities: the bush ethos did not end at the town boundary. And the convicts, the Irish, and the native born developed egalitarian and fraternal values *wherever* they lived.

The nineteenth-century cities were also sites of considerable egalitarian trade-union activity, so there was much levelling and democratic sentiment felt and promoted in the Australian cities, too. The cities were also the locations of influential newspapers and parliaments, and, by the end of the century, such parliaments had made the Australian colonies world leaders in egalitarian social legislation.

Though the city may not have provided as much of the essential inspiration, it was the city folk who perpetuated the inspiration, shaped it to their prejudices, and gave it permanent verbal and literary form. It was in the cities that the great *self-consciously* Australian movements in art and literature occurred.

'AUSTRALIANISM'

In the 1870s, for the first time in Australia's history, the number of people of European extraction born there exceeded that of people born overseas. This situation contributed to the growth of national feeling and, in the last two decades of the nineteenth century, the Australian character became conscious of itself through the work of a remarkable generation of painters, writers, poets, and cartoonists.

It had been common for nineteenth-century immigrants to claim

that Australia was a country where the flowers had no scent and the birds no song. This claim was untrue, but we can understand why it came about. For immigrants brought with them not only their European attitudes and values, but European ways of seeing and sensing, too, so that naturally they failed to observe much that was obvious to more accustomed eyes and ears. It was for similar reasons that, even into the twentieth century, so many Australians continued to call Britain and Ireland, 'home'.

Such people made it more difficult for the unique qualities of the Australian landscape to be appreciated for their own sake. Even so, though the majority saw the land as merely something to be mastered, from the early 1800s there were always people who saw beauty and worth in the Australian environment. As the proportions of native born increased, the legend of Australia and Australianism grew from the land itself. Gradually the different beauty of Australia came to be seen, not through European eyes, but in its own terms. And, for perhaps the first time, large numbers of people began to imagine some kind of common destiny, and to think about the form the future country might take.

Nevertheless, the first great painter of Australian landscape in more clearly Australian terms was an immigrant not a native born, the French-Swiss painter, Louis Buvelot (1814–88), who arrived in Melbourne in the wake of the gold-rushes. Though he did not entirely rid himself of European notions of what was romantic and worthy of representation, he began to see through Australian eyes: Buvelot talked about 'learning the landscape'. This was crucial for in every country and era, artists see what they paint as much as paint what they see. Buvelot became a teacher of landscape painting, and soon his influence was to have great and permanent results. It woke the talents in a generation of gifted artists who interpreted Australia anew, names now revered in the pantheon of Australian art: the so-called Heidelberg School of Tom Roberts (1851–1936), Arthur Streeton (1867–1943), Charles Conder (1868–1909), and Frederick McCubbin (1855–1917). Such men taught Australians to love their land not so much despite its differences, difficulties, and idiosyncracies, as because of them. Paintings such as McCubbin's *Down On His Luck*, and Roberts's *Shearing the Rams* remain national icons.

The influence of these painters was widely acknowledged and, in hindsight, looks crucial in the rise of Australian national sentiment. Their labours were complemented by those of the writers.

AUSTRALIAN LITERATURE AND *THE BULLETIN*

Once the first tasks of pioneering had been accomplished, writers began to put on paper their impressions of, and experiences in, their unique, old/new southern land. Three periods are usually distinguished in the history of Australian literature. The first, 1788–1880, involved mainly descriptive writing. The second, 1880–1940, mirrored and helped produce the growing national feeling and greater diversification of society. The third, since 1940, has reflected the great changes brought by war and by vast post-war immigration and national development.

The first Australian novel is said to be H. Savery's *Quintus Servington* (1831), the prototype novel about convicts. Marcus Clarke's (1846–81) *For the Term of his Natural Life* (1874) indicted the brutal convict conditions in Tasmania. Convictism has been one of the five inter-related themes of Australian literary preoccupation, taken up in modern times in such books as Hal Porter's *The Tilted Cross* (1961) and Thomas Keneally's *Bring Larks and Heroes* (1967). The other four have been: the complex relationships with Britain; the conditions of life in the bush and the cities; the bushrangers; and the Aborigines.

The second period of writing was created by what might be called '*The Bulletin* school' who did much to develop an Australian ethos. *The Bulletin* was the brainchild of J. F. Archibald (1856–1919). From its first issue in 1880, it aimed at being a *national* newspaper, and quickly achieved this. During the next forty years it probably had a greater influence on Australian writing, values, and opinion than any other Australian paper before or since.

It had a mission to make Australians consider their country anew. The inspiration and orientation of *Bulletin* writers was that of the bush man and woman not the city dweller, the shearer rather than the squatter, the labourer rather than the businessman. The great moral principle which ran through all was admiration for authenticity, for character wherever it be found, for an egalitarian independence unimpressed by social station. This emphasis on the common man and

woman and on the commonplaces of the bush was inevitable for Australian literature at that date, for it was the complex of egalitarianism and outback life that first distinguished Australia from the Old World of Britain and Europe.

Rarely anywhere in the world at that period did such eye-catching prose, poetry, and pictures grace a weekly newspaper. *The Bulletin*'s editors had the discernment to discover and encourage bold new writers and artists. Henry Lawson (1867–1922), A. B. (Banjo) Paterson (1864–1941), Joseph Furphy (1843–1912), Steele Rudd (A. H. Davis), the poet Mary Gilmore (1865–1962) and many others, had their first successes between the red-pink covers that were its symbol until the 1960s: Lawson's short stories and poetry, which immortalized the struggles of the selectors; Paterson's outback poems, such as his *The Man from Snowy River*; Furphy's vision of authentic country life, as in his *Such is Life*. Rudd's stories of Dad and Dave *On Our Selection* on the Darling

Henry Lawson, the writer, from a cartoon by Low

Downs, have become central to the Australian literary canon. From that time on, literature in Australia was increasingly written, not from a British point of view or for a British readership, or with one eye upon what British critics might think, but about life in Australia from an Australian point of view for Australian readers.

The Mystery of the Hansom Cab (1886) by Fergus Hume, set in East Melbourne, was one of the world's earliest detective novels. The popular Rolfe Boldrewood achieved classic status with his bushranger epic, *Robbery Under Arms* (1888), a theme returned to more recently in Joy Chambers's *Mayfield* (1992). Pioneer virtues were celebrated in Miles Franklin's *My Brilliant Career*, and white–Aboriginal encounter in Mrs Aeneas Gunn's *We of the Never-Never*, a theme to be taken up later in Katherine Susannah Prichard's *Coonardoo* (1929) and Xavier Herbert's bitter *Capricornia* (1938). The classic of the new emphasis on realism was Henry Handel Richardson's trilogy, *The Fortunes of Richard Mahoney* (1917–29), which considers the varying fortunes of the immigrants who developed urban Australia in the late nineteenth century.

By the end of the nineteenth century, there had also evolved a distinctive style of Australian humour. Complementing the Australian character described by Ward, it was sardonic and cynical, irreverent, and disrespectful of office. It infused Australian writing and was the essence of Australian cartooning, again best represented perhaps in the pages of *The Bulletin*. Paradoxically, in Australian writing this cynical humour was mixed with the romantic notion that Australia, the continent last discovered by Europeans, should produce a society free from the injustices of the Old World – a notion which, while ignoring the plight of the Aborigines, was widely accepted in the general community. Extravagant that notion may have been but, protected by the Royal Navy from the rest of the world, the colonists did succeed in creating a country (again excepting the Aborigines) with greater free-dom for the ordinary person, more equality of opportunity and material well-being, and less social and political violence than was the case in most other countries in the nineteenth and twentieth centuries. With the harrowing experiences of twentieth-century wars and depressions has come a more realistic appraisal of what is politically possible in

Australia. Nevertheless, the belief that Old World restrictions have no place still affects the national psyche.

And, today, though Australian cities have continued their inexorable and disproportionate growth, Australians as a whole are more conscious than ever of their inland and their open spaces, and identify with them. More than ever before, more than in the hey-day of *The Bulletin*, the Australian city dweller can today experience something of the bush, for inland tourism is a giant industry. The modern Australian city dweller now finds in the inland a sense of space, of psychic roots, and perhaps catharsis. The most popular Australian television serial in the 1990s is set in the bush.

The Bulletin helped create Australian nationalism, and such nationalism had its first peak around the turn of the century. It is therefore important to point out that this period co-existed with widespread loyalty to the British Empire. Queen Victoria's jubilee of 1887 was eagerly celebrated in all the Australasian colonies, her diamond jubilee in 1897 with even greater enthusiasm. 'Banjo' Paterson was Australia's most popular poet, and the author of its most popular song, *Waltzing Matilda*. But almost as popular was Rudyard Kipling, the poet of the Empire. The two were personal friends. So, while people such as Henry Lawson were dreaming of a utopian republic of the common man, the great majority, though seeing Australia as unique, held a vision of a unified Anglo-Saxon or Anglo-Celtic 'race'. Many Australians believed the Empire would always exist, being held together by common democratic values, belief in parliamentary self-government, the sharing of a great world-girding enterprise, and common feelings of loyalty to the crown.

BUSHRANGERS

There has always been a rebellious aspect to the Australian democratic ethos. It will be recalled how the first bushrangers were 'bolters', escaped convicts who preyed upon farmers and lonely travellers. There was a revival of bushranging during the gold-rushes. All that gold carried across the countryside by coaches and isolated travellers was too much temptation for some unsuccessful diggers. Robbery seemed preferable to digging, as *Jack LeFroy*, a bush-ballad of the time agrees:

> But I swore I'd not be found, hunting nuggets in the ground
> When the biggest could be picked up in the bank!

The third generation of bushrangers, those of the 1860s and 1870s, came from the less-successful free selectors, for there was little difference between cheating the squatter of his land and stealing his sheep and cattle. A further move and such men had become full-scale outlaws. They held the belief that their own antisocial behaviour was justified: by their ill fortune contrasted with the success of those squatters who they believed had used unethical methods to become prosperous.

Attitudes of this kind were widespread in the rural areas of Victoria and New South Wales. They made the tasks of policemen and schoolmasters doubly difficult. When most of the district's population connived at the bushranger's activities, capturing bushrangers became problematic. There were many in the cities who held similar sentiments.

Their names matched their brashness: Captain Moonlight (A. G. Scott), Captain Thunderbolt (F. Ward), Mad Dan Morgan, The Wild Scotsman (J. McPherson). Daring deeds won admiration and aid from those country people who shared the bushrangers' origins or values. Taken for trial in the cities, bushrangers were sometimes given heroes' welcomes. The anti-authority strain in Australian democracy is shown in the fact that public hangings were ended in Australia a decade earlier than in Britain because of the popular sympathy for the condemned.

A specially brazen act of bravado was the bailing up in 1863 of the town of Canowindra for three days by a gang led by Ben Hall who entertained the populace with free food and drink. Two years later, at the age of twenty-eight, Hall was ambushed and shot by police. That was comparatively old, for most bushrangers met even earlier deaths from shooting, or dangling from a rope.

The shooting in 1870 of Captain Thunderbolt, who played out his adventures around the town of Uralla in the New England District of New South Wales, was almost the end of white bushranging except for a few sporadic outbreaks in the 1870s – the one described below being especially notable. The ambivalent attitudes to these antiheroes is symbolized in a striking equestrian statue to Captain Thunderbolt,

standing today in the main street of Uralla – for it was erected as a local project during the 1988 Australian bicentenary celebrations!

When the anti-authority ethos was supported by Irish free-selector families who imaginatively believed that all government representatives were British oppressors, the scene was set for some very successful outlawry. Such was the context for the legendary deeds of a young man named Ned Kelly, from north-eastern Victoria – the most famous of all. Son of an Irish emancipist father and an immigrant Irish mother whose family was ever in scrapes with the law, Kelly grew up with rebellious blood. In his teens he turned to stealing horses and cattle from the local squatters, as much acts of rebellion as need. A personal vendetta between Ned and a local Irish constable brought matters to a climax when Ned was accused (probably perjuriously) of attempting the constable's murder.

Kelly ambushed three police and shot them dead. Outlawed, he, his brother, and two others took to the bush for a successful twenty months, holding up banks at Euroa in Victoria and Jerilderie in New South Wales. They took particular delight in destroying all the deeds of mortgage on the small farming selections in these regions. Their last stand was in the township of Glenrowan in north-east Victoria where, in a battle with the police, all but Ned were killed. Public imagination has been fascinated ever since by the fact that Kelly had protected his head and body with a set of armour he forged from plough-shares. This worked until he was shot in the knee. Kelly was a victim of a changed world, for the police who came to arrest him had arrived by railway, and his whereabouts were flashed along the telegraph.

Kelly was hanged in Melbourne, to the satisfaction of that half of the country who valued the propriety of law and order, and to the chagrin of the other half who saw in him an exemplar of pluck. Today he lives on in folklore, commemorated in the morally opposed statements of common wisdom, 'as game as Ned Kelly' and 'Ned Kelly prices', and in ballads, plays, poetry, and painting.

Then there were the black bushrangers. They harboured motives similar to those of the white rebels, fuelled by racial antipathy towards the whites who were taking their ancestral lands. During the second half of the nineteenth century there were many: the Governor brothers

in New South Wales; the Dora-Dora brothers and Johnny Campbell in Queensland; Captain, Major, and Pigeon (Jundamarra) in Western Australia. They could be a serious threat, not only to further expansion of white settlement, but also to the stability of well-established country districts. Their backgrounds were similar: experience of their own culture with its subtle bushcraft; early work with whites as trackers, stockmen, or mounted police, where they acquired knowledge of European outback skills; and a working knowledge of English; all marvellous training for their future 'profession'.

Jundamarra (Pigeon to the whites) was a member of the Bunuba tribe of the Kimberley region of far-north Western Australia, growing up during the period when the region was being settled by pastoralists in the 1880s, following the explorations of Alexander Forrest. His family worked on one of the new pastoral stations and, very young, he had become a good stockman, could break horses and shear sheep, and was a phenomenal shot with a rifle. At fourteen, Jundamarra departed for the hills, to shoot the white-men's sheep. Captured in 1889, he served a period in prison after which he became a tracker for the police. While helping a policeman bring in fifteen Bunuba tribesmen accused of sheep spearing, Jundamarra switched sides again, shot the policeman, freed the prisoners, and, with rifles and ammunition, fled into the hills. Within a week, he had ambushed settlers taking cattle through Windjana Gorge, shot them all, acquired their firearms, and halted the pastoral expansion into Bunuba lands. At the end of 1894, a considerable police action was organized from far-away Perth. It encountered Jundamarra and his group high up in a cave in the Gorge. After a fierce dawn-to-dusk gunfight, Jundamarra was seriously wounded and presumed dead. In fact, he survived to harass the settlers and police until 1897 when he was tracked and killed by another Aborigine.

SPORTSMEN AND SPORTSWOMEN

Greatly encouraged by the sunny climate and ample open spaces, as well as considerable weekend leisure time for city dwellers, sport has long mirrored Australian values and attitudes, for what was required in carving out a continent were, of course, practical virtues. By the 1840s,

British visitors were remarking on the colonial devotion to horse-racing, boxing, watersports, and cricket.

During the first 100 years of settlement, sport was also one of the few endeavours upon which national feeling could focus. Sporting achievements were physical like mining, shearing, and exploring, but they had the added attraction of potential or actual national competitiveness. By the last three decades of the century, sport was perhaps of greater importance to the Australian imagination than it is even today.

Horses were central to the life of nineteenth-century Australia. Horse-racing was immensely popular. In 1843, the free settlement at Brisbane was less than a year old when the penchant for sport and gambling was evidenced in the first-ever race meeting – in a town with a population still less than 1000. As Anthony Trollope put it in the 1870s, 'there is hardly a town to be called a town which has not its racecourse, and there are many racecourses where there are no towns'. The most famous Australian poem, Paterson's *The Man from Snowy River*, celebrates a gallant man-horse combination.

By the 1870s cricket rivalled horse-racing. (The first Australian cricket team to tour England actually consisted entirely of Aborigines.) Soon the main cricket grounds in the colonies were larger than those in England. At the Melbourne Cricket Ground in 1877 the visiting English cricket team was defeated by an Australian eleven by forty-six runs. This match has come to be regarded as the first official 'test match', as they are now called. Series of such test matches between the two countries have continued on a regular basis ever since. Remarkably, the 'Centenary Test', held on the same ground in 1977 to commemorate 100 years of such Australia-England games, ended with precisely the same result. The part played by Australian cricket teams in the creation and strengthening of Australian national feeling in the last quarter of the nineteenth century and throughout the twentieth century can hardly be exaggerated. Here was an area of endeavour in which Australians could compete with the mother country (or at least the chief part of it) on an even footing from the beginning. Over the decades Australians have identified closely with such great bowlers as F. R. Spofforth, W. J. O'Reilly, R. R. Lindwall, and D. K. Lillie, and with equally great batsmen such as A. Bannerman, V. C. Trumper,

The Australian Cricket XI of 1880

W. H. Ponsford, D. G. Bradman, and G. S. Chappell. Similar points can be made with respect to other sports with international competition: athletics, swimming, tennis, rugby union, and rugby league.

The second half of the nineteenth century was a generally prosperous period. People therefore had money with which to gamble, and gambling became a permanent part of many popular Australian sports. The numbers at spectator sports were boosted by the popularity of sport among Australian women, helping to make Australia perhaps the first part of the world to attract spectators in such large numbers. The largest funerals in the colonies were also those of sporting heroes.

Australian Rules Football (nowadays called Australian Football), a hybrid of soccer, rugby, and Gaelic football, played on a much larger, oval ground, was invented in Victoria in the 1850s, possibly on the gold-fields. Despite the fact that no other country plays this code, so that Australians have not been able to test their abilities internationally, it became easily the most important winter game in all the southern colonies and Western Australia, and still is. Such well-loved clubs as Melbourne (1858) and Geelong (1859) are older than most football clubs in Britain or Europe. The early development of Australian

Football may explain why, in Australia, soccer has failed to become the main winter sport.

Cycling, too, became immensely popular, not only as a convenient form of transport, but as a sport, with huge cycling clubs and Australia-wide competitions. Though most Australians could swim, it was not until the turn of the century that they developed the efficient stroke known as the 'Australian Crawl', soon to be adopted by swimmers the world over. As already mentioned, only after 1902 did surfing become popular. Throughout the twentieth century, the combination of sunshine, sand, and surf, has drawn multitudes of Australians to the splendid ocean beaches – they possess more than any other country. Beaches provide an environment where a number of Australian ideals can come gloriously together. There is a marvellous chance to worship the cult of youth, to show off, and to display one's body; there is complete equality of opportunity and (un)dress; and there are the attractive alternatives of absolute idleness or extreme physical activity, separately or in combination.

THINKERS

Some nineteenth-century Australians chose to explore the secrets of nature.

In 1852, attracted by the wealth of the golden colony, the German-trained, Danish botanist, Ferdinand von Mueller (1825–96), was made Victoria's first government botanist and remained so until his death in 1896. In all that time he rigorously pursued his aim of classifying Australia's flora. He did his own exploring, securing, for instance, the first known alpine plants from the top of Mount Buller. There were thousands of letters to other men of science, which reminded the world of Australia's botanical uniqueness. His work had practical applications, too, which was important in a developing country: Maram Grass to anchor the sandy soil of the southern coast; Paspalum Grass, for which dairy farmers have thanked him ever since; Insignis Pine trees in the bare areas of provincial towns. Pompous and pedantic he was, but his work for his adopted land changed its self-image.

The possibility of outdoor activity in a new country attracted Edgeworth David (1858–1934) to Sydney in 1882 as the government's

assistant geological surveyor. His early work mapped the potential coalfields of the Hunter Valley, providing experiences which taught him the importance of general theory in science. When David became professor of geology at Sydney University, he was able to inspire generations of students with his ideals. His continuing interest in the ancient glaciation of Australia led to new geological insights and made him a key member of the British Shackleton expedition to Antarctica in 1908–09 when, with his student Douglas Mawson (1882–1958), he mapped the southern magnetic pole. His fifty years in geology did much for Australia's future development.

There were great amateurs, too. John Tebbutt (1834–1916) never attended college but was taught astronomy by his bush schoolteacher in the Hawkesbury Valley farmlands. Tebutt made himself a master through self-study, and became one of the nineteenth century's greatest discoverers of new comets. Helped by being in the southern hemisphere and having the clean, clear night skies of the countryside, in May 1861, in his mid-twenties, he discovered Tebbutt's Comet, perhaps the most brilliant of all the century's new comets. Another amateur, Alfred Biggs of Launceston, Tasmania, and a regular correspondent of Tebbutt, maintained a lifetime interest in astronomy and meteorology, and, by reading overseas' reports, built his own telephone. In 1877 he may have made (the date is disputed) the first long-distance telephone call in Australia between Launceston and Campbelltown. But his greatest fame came from his lonely, continuing pioneering efforts to measure earthquakes.

Lawrence Hargrave (1850–1915) migrated from England at sixteen. In 1883 he left his secure job at Sydney Observatory to experiment on the problem of flight. Independently of workers in Europe and North America, he made monoplane models and developed a crude compressed-air rotary engine. He discovered that curved wing surfaces have maximum lift, then used them in box kites, a series of which in 1894 lifted him 16 feet from the ground – which, in principle, could have been 1000. He discovered that adding a vertical tail improved stability. In 1899, he visited Britain and presented papers discussing his findings. It remains unclear whether his efforts helped other pioneers such as the Wright brothers, but their own work clearly paralleled much of his.

Political Developments

The second half of the nineteenth century, and especially the last two decades, saw many far-reaching developments in Australian politics.

GROWTH OF POLITICAL PARTIES

During the early decades of responsible government, colonial politicians described themselves as 'Conservative' or 'Liberal'. Real parties were slow in developing, and such designations meant little for there were few politicians, even in the upper houses, who seriously believed in a traditional, hierarchical society, and issues such as free trade and protection might be supported by politicians of either designation.

In Victoria, party organization and passion were a decade or more ahead of the other colonies. In New South Wales and the others, parties, in the modern sense of relatively permanent groups and leaders who espoused an accepted platform, had constituency associations, and conformed to parliamentary discipline, did not exist before the last ten or fifteen years of the century. Before then government was controlled by factions. Members clustered around leaders who could form a majority in the house only by joining for the time being with one or more other leaders of factions. As in most human endeavours, experience counted, and practised leaders might enjoy a longer success.

In the changing economic circumstances of the 1880s and the depression of the 1890s, government by unstable coalitions ceased to be viable, and organizations resembling modern political parties evolved. In 1889, Henry Parkes, for instance, became leader of the new Liberal Party in New South Wales. In time, party discipline became stronger. By the the 1920s, party discipline in Australia was perhaps the tightest in any democracy, and it became increasingly rare for members of parliament to vote against the general policy of their political party, except on 'matters of conscience'.

GROWTH OF UNIONS, SOCIALISM, AND THE LABOR PARTY

It was during these years that Australian trades unions also developed into a mighty power.

Early Australian unions had been guild-like in so far as they were concerned to provide benefits for their members and to prevent unskilled men from joining. Most also believed that unions should stay out of politics. But, by the 1870s, ideas of 'the new unionism' were spreading and, in principle, this new unionism sought to enlist all workers, skilled or not. In most western industrial countries the new unionism developed first among miners and transport workers such as railwaymen and seamen. This happened in Australia, too, with the formation in 1874 of the Amalgamated Miners' Union, and, in 1876, the seamen's unions. But, in Australia, bush workers in the pastoral industry, such as the shearers, soon played an even more important part. At the same time, in the cities the old crafts unions became more militant.

Bush unionism began in 1886, with the Amalgamated Shearers Union led by W. G. Spence. Its spread was extraordinarily rapid. By 1887, the shearers of Victoria, New South Wales, and South Australia had merged and were co-operating with those of Queensland. Shearers went on strike more often than all other unionists combined, and squatters were forced to pay them at the then high rate of £1 per 100 sheep shorn.

The depression of the 1890s helped bring about the greatest series of strikes in Australian history. It began, not with a dispute by manual workers, but with a strike by an association of ship's officers who wished to affiliate with the Melbourne Trades Hall. Within weeks, tens of thousands of unionists, from waterside workers (dockers) to shearers, were on strike and, as is the way of such things, the reason for the initial dispute had been largely forgotten. The issues were many and specific, but a common thread ran through them all. This was the clash of principle between the employers' insistence on being able to employ whom they pleased, that is, on 'freedom of contract', and the unions' insistence on the employment of union members only, and the claimed right of the union to bargain on behalf of such members, that is, on 'the closed shop'. The struggle raged on and off until 1894. Perhaps the most bitter disputes occurred on the docks where, in solidarity with striking shearers, cargoes of wool were even set on fire. Finally came a victory for the employers – for the time being. By the turn of the

century, however, unionism was stronger than ever, and more powerful in Australia than in any other country.

In the Queensland inland, shearers flew the Eureka flag over their large camps of strikers, and persuaded, cajoled, or physically forced into the union men who were reluctant – men they called 'scabs' and the squatters called 'free labourers'. The almost magical potency of the term, 'scab', prevented men from disagreeing with the union. It still does. Many unionists justified their militancy as a way of achieving a working man's utopia in this new land of the south. Thus, Australian unionism was accompanied by a millennialist conception of the power and righteousness of organized labour and of socialism.

Unionism gained an added revivalist fervour through popular books such as US author, Edward Bellamy's utopian *Looking Backward,* set in the year AD 2000, and by the work of the socialist, William Lane (1861–1917), writing in the Brisbane papers, *Boomerang* and *Worker.* Lane was read widely, especially among bush workers, and reprinted *Looking Backward* in instalments. His socialism was not of the revolutionary variety, but involved a less doctrinaire notion of workers' solidarity. In his slogan, 'socialism is just being mates', we can see the connection between this political ideal and the Australian bush ethos. The bush ethos was absorbed, indeed commandeered, by the new unionism.

Utopianism was shown in its most extreme form when, in 1893, a disillusioned Lane departed Australia's shores to pursue his socialist dream elsewhere. He and about 300 followers purchased a schooner and sailed across the Pacific and round the Horn. In the savanna lands of far Paraguay he established a socialist colony, 'New Australia', where everyone would be mates sharing all their worldly goods. It failed. Human nature, Australian or otherwise, does not change with change of location.

Out of the initial defeat of the strikes and the devastation of the depression the belief grew that there ought to be a political party to represent organized labour directly. This idea first saw success in New South Wales and Queensland, as Labour Parties formed, the first in 1891. Payment of MPs, which had occurred in all the colonies prior to federation, also made it easier for members of such parties to enter

parliament. The discipline required to create the unions carried over into the parliamentary behaviour of these new Labour (soon to be spelled the American way) Parties, from whose solidarity the parties of the right also learned.

These colonial Labor Parties were influenced by British working people who migrated. Two men who arrived in the 1880s would become the most successful of all Labor politicians before World War II – prime ministers Andrew Fisher (1862–1928) and W. M. Hughes (1864–1952). In 1899, the youthful Andrew Dawson, leader of the Labor Party in Queensland, formed a government. Though it lasted for just four days, it was the world's first democratically elected social democrat government.

From early in the century, Irish Catholics had formed a large section of the working class, and they, too, saw the possibility of greater political power through the Labor Party. Moreover, from 1884, Cardinal Patrick Moran (1830–1911) of Sydney brought to Australia the Irish tradition of priestly political pressure and encouraged an alliance between Catholics and the Party. Moran worked unceasingly to keep the Party reformist rather than revolutionary. By 1910, perhaps 90 per cent of Australian Catholics were Labor supporters. Because Moran also encouraged Catholics to become Australians rather than to hold on to their British Isles identities, this Catholic influence was to be of lasting importance in the growth of national feeling.

NINETEENTH CENTURY WARFARE

The last British military garrison had departed Sydney in 1870, and national feelings had been stirred when European powers began pressing claims in the Pacific. Queensland, led by Sir Thomas McIlwraith, feared German ambitions on its doorstep. Perhaps seeing it also as a source of cheap labour, Queensland annexed eastern New Guinea in 1883. This move was refused by a Britain worried about additional expense. When Germany did finally take north-east New Guinea in 1884, to Queensland's relief Britain agreed to annex the south-east (Papua). French annexation of New Caledonia also caused concern, and there were several Russian scares. Such events focused the

colonial mind on military matters and, by the final decade of the century, each colony had tiny military and naval establishments. In his 1889 report on defence, the advice of General Edwards, recommending unification also gave food for thought.

In fact, the first foe faced by Australians was in Africa. In 1885 Britain was fighting in Sudan against the slave-trading Muslim fanatic, the Mahdi. When his followers massacred the populace of Khartoum and killed General Gordon there was a flood of Imperialist sentiment throughout the Australian colonies, and the acting premier of New South Wales, a man of Irish convict descent, organized a voluntary expeditionary force of 750 men. In 1900, another voluntary contingent of 500 naval personnel from several colonies helped Britain, the United States, and other allies to put down the Boxer uprising in Beijing.

The departure of the Australian contingent for the Sudan (detail after a painting by Arthur Collingridge)

At the same time, some 16,000 volunteer horsemen from all colonies were fighting as part of the British army against the rebel Boers in South Africa. Much of South Africa was similar to outback Australia, which complemented the Australians' fighting efficiency. Their most famous engagements were at Sunnyside and the Elands River. In both the Australians beat the Boers at their own tactics.

So there had been some intercolonial co-operation on military matters before federation. In fact, many an enthusiast was able to use defence as a powerful weapon in favour of federating the colonies.

Federation

At the end of the nineteenth century, the six colonies decided to form a federation known as the Commonwealth of Australia. In the pompous phraseology of the time, Australians would have 'a continent for a nation and a nation for a continent'.

As with most great political changes, federation was the work of actively moving minorities, minorities who felt passionately about federation and worked hard at persuading the masses to agree. Indeed, it was people outside the official political system who most promoted federation, through organizations such as the Australian Natives' Association, and various federal leagues. But, if one man is to be given credit above all others, that man must be Sir Henry Parkes, for his tireless efforts. As early as 1867, Parkes and others were discussing publicly 'some federal bond or connection'.

A National Convention in 1891 began more detailed planning. Interest then waned for some years, to be renewed from 1896. Parkes himself was to have no share in the final achievement for he died in that year. Probably economic self-interest as much as Australian patriotism proved decisive. One Tasmanian politician offered the following splendid mixed motives for federation:

> Gentlemen, if you vote for the Bill you will found a great and glorious nation under the bright Southern Cross, and meat will be cheaper; and you will live to see the Australian race dominate the southern seas, and you will have a market for both potatoes and apples; and your sons shall reap the

grand heritage of nationhood, and if Sir William Lyne [a staunch advocate of protection in New South Wales] does come back to power in Sydney he can never do you one pennyworth of harm.

The common interests and values of Australians made a unification of the colonies good common sense, and Australians had always moved from one colony to another with little sense of difference. In fact, there already existed areas of co-operation such as intercolonial organizations of unions, pastoralists, employers, athletes, cricketers, and intercolonial conferences. The continent was already linked by telegraph lines, railways, and shipping routes.

The upshot was that, after two decades of debate, several colonial conventions, and referendums in the various colonies with some closely run results, it was agreed that the five mainland Australian colonies and Tasmania would form a federation of states. New Zealand and Fiji had taken part in federation conventions, but decided to remain separate. Had New Zealand been a little less prosperous at this time, it would probably have joined. The Australian constitution still lists New Zealand as a potential state. The 'Commonwealth of Australia Constitution Act' was passed by the parliament of Great Britain and received the assent of Queen Victoria in September 1900. The new nation came into being on the first day of the twentieth century, 1 January 1901.

Western Australia had been reluctant, and was the last to join. Without the favourable votes of the gold miners who had come from the other colonies, Western Australia might have remained independent and, in the twentieth century, the Australian continent would then have been the home of two separate nations. Separatist sentiments still remain in the west: in fact, in 1932, at the height of the Great Depression, that state voted overwhelmingly to secede but, because of the unclear constitutional position and British reluctance to intervene, nothing came of this.

The period when the Australian colonies federated coincided with the period of the greatest power and prestige of the British Empire. Despite federation, and despite being self-governing, Australians were still British subjects. Several kinds of patriotism existed in Australia at

that time. People might consider themselves Britons. They might consider themselves Australians but British, too – as the majority did at least until World War II: R. G. Menzies (1894–1978), Victorian-born Australian prime minister 1939–40 and 1949–65, though proudly Australian, always claimed to be 'British to the boot heels'. Or they might think of themselves as Australians only. By the mid-1950s, after federal parliament had passed the 1948 Australian Citizenship and Nationality Act, in a changing political and economic world, this latter orientation was becoming the overwhelming one.

The Early Federation, the Great War, the 1920s and '30s

While the 1880s and 1890s were seminal, the decades from 1901 to the end of World War I in 1918 were also important. Australians created a federal union and further developed democratic social and political policies. For the first time, they also became aware of the full horror and meaning of war. From the end of World War I to the outbreak of World War II, many Australian events and attitudes were broadly similar to those experienced and felt in other Western countries, but took on special Australian emphases determined by the country's political needs and geographical position. The Great Depression of the 1930s deeply affected Australia. Australian foreign policy in the '30s, though broadly in agreement with that of Britain, was more concerned with the growth of Japanese militarism than with Nazism in Germany.

Federal Structure and Early Legislation

STRUCTURE OF THE FEDERAL GOVERNMENT

The new federal nation was to be a constitutional monarchy and a parliamentary democracy, as the six colonies already were. The Constitution of this new federation tried to combine the best elements of the democratic systems of Britain and the United States. It established two houses of parliament, a lower house (the House of Representatives), and an upper house (the Senate). It also created the new office of governor-general as head of state, to represent the monarch, to be the final source of authority in the nation, and to be

guardian of the Constitution. There was also a High Court to interpret the Constitution and the laws, with powers similar to that of the US Supreme Court. As interpreters of the Constitution, the judges of the High Court had enormous potential powers and in recent decades the court has been able to arrogate to itself some of the rights of parliament.

The House of Representatives was modelled on the British House of Commons, with members representing electorates· of roughly equal population. The Senate had almost the same authority as the lower house in making laws and was modelled on the Senate of the United States. To ensure that the small states, such as Tasmania, were not dominated by the large, such as New South Wales, each state irrespective of population returned the same number of senators.

The conventions of parliamentary responsible government, and of the public service, which had applied in the various colonies since the mid-1850s now applied in the federal sphere. But the founding fathers of the Constitution explicitly mentioned neither responsible government, nor the offices of prime minister and cabinet, nor the public service. Nor did they mention the functions of the official opposition. They preferred to write into the Constitution only the formal mechanisms of decision making, leaving the actual functioning of government to the unwritten customs and conventions that had evolved in Australia and in Britain.

There was a division of authority between Commonwealth and states. The colonies (now the states) transferred to the federal government those powers that affected the whole country, such as defence, immigration, currency, postal services, and so on. As in the United States, all other powers not explicitly mentioned, such as education and health services, remained the responsibility of the state governments.

SOCIAL ISSUES

The Liberals under Alfred Deakin (1856–1919) had recovered their nerve lost during the strikes and depressions of the 1890s. Their ideal of Australia differed only in detail from that of the youthful and growing Labor Party. Indeed, in the early years of the century the Liberals (who now called their party 'Protectionist'), supported in office by Labor,

carried through much innovative social legislation. For the first ten years of federation Labor exerted pressure out of office but, at times, in a special agreement with the Protectionists, Labor also formed governments with clear majorities between 1910 and 1913 and again from 1914. It is not surprising, then, that with no established aristocratic or conservative party or class to moderate reforms, these were achieved faster than anywhere else in the world, with the possible exception of New Zealand. Compared with the rest of the world, these were good days for most Australian workers.

South Australian women had been enfranchised in 1894, and all women in Australia were given the vote in 1902, a decade or two ahead of most democratic countries. During the last two decades of the 1800s Australian women struggled to win the vote, but did not have to fight for their political rights in the same militant way as would the suffragettes in Britain and America.

Thus matters of ordinary livelihood mostly absorbed the energies of the new federation between 1901 and the outbreak of war. In 1908 the Commonwealth government adopted protection as Australia's economic policy, in a further development of the earlier conception of protection. Alfred Deakin, Australia's second prime minister, was a man of intellect and committed social concern. As he explained, the earlier protection had been concerned with making good wages a possibility for ordinary men, the new was concerned to make them actual. In 1909 came federal old-age and invalid pensions, and, in 1912, a system of maternity allowances. Many Australians saw their country as a sort of antipodean social laboratory, a country to show the world the nature of the good society. In the same year, to much scepticism from traditional thinkers, the federal government's Commonwealth Bank was established. Ably led by Denison Miller (1860–1923), it would soon prove crucial in financing Australia's part in the Great War, and in economic development after the war.

The thinkers among the politicians and administrators, men such as Deakin and H. B. Higgins (1851–1929), saw further than the obvious utilitarian tasks of development, and hoped that a material standard once obtained would lead on to greater things in the arts and sciences. Like all politicians in that era, they had no conception of the fact that

affluence would bring its own problems, or that greater social security might reduce the incentive to succeed.

As a result of the dislocation caused by the great strikes, arbitration of industrial disputes by independent government-supported bodies had been accepted in the colonies during the 1890s, and an Arbitration Court (today the Conciliation and Arbitration Commission) was set up in 1904, to become a body of crucial importance in the nation's social and economic life. Higgins was appointed president of the Court in 1906. He led it to nationwide significance under two principles: that industrial conflicts should be subject to the rule of law; and that such law should not just reflect currently accepted ideas, but have a positive social content.

Out of the reflections by the Arbitration Court on the case of H. V. McKay's harvester factory came the first great decision, one that has been fundamental to Australian society ever since. It involved the conception of a 'basic wage' – which was implemented in Australia before anywhere else in the world. This was a wage based upon 'the normal needs of the average employee, regarded as a human being living in a civilized community', which was the minimum to be paid regardless of the employee's degree of enthusiasm. In short, economic considerations had to reflect social justice.

IMMIGRATION

Other early legislation was to institute controls under the Immigration Restrictions Act of 1901. There were several reasons for this Act. It was considered desirable to determine the nature of the future population of the new country. Australians had experienced Protestant-Catholic sectarian strife from the early 1800s, and did not wish to introduce some ethnic equivalent. To prevent the conflicts which, throughout history, had dogged countries with mixed populations, and which had already occurred in Australia in Aboriginal-white frontier violence, it was planned to keep the Australian population overwhelmingly Caucasian. Chinese already living in Australia were allowed to remain, new immigrants were discouraged. A second reason for wishing to keep out Chinese, Japanese, and other Asian migrants was the desire to prevent the 'fair and reasonable' standard of living for all Australian citizens from

being lowered through cheap labour. Thirdly, the word 'racism' had yet to be created because the world's values were different, but what we would now call racist reasons were acting as well, though even these were complex. Deakin argued, for example, that the Japanese were not inferior, merely different, and probably in quite a few qualities superior to Europeans as well. Lacking any official name, this migration policy gained the unofficial name White Australia Policy, and it remained in force until the 1960s. So the new Anglo-Japanese Treaty of co-operation of 1902 was not welcomed in Australia, for Britain thereby appeared ready to place the Empire's strategic interests ahead of Australia's cherished domestic policies.

The policy damaged Australia's reputation in Asia. Perhaps this was undeserved. From the late nineteenth century, the United States, Canada, and New Zealand also had racially based immigration laws. Moreover, it is difficult to name a contemporary country that did not hold xenophobic views about race, religion, and culture. And it is usually forgotten that China and Japan did not welcome foreigners.

INDUSTRY AND AGRICULTURE

Despite, or because of, the cordiality between Australia and Britain, there was fierce competition in business. Brands with distinctive Australian names were becoming more popular: Billy tea, Boomerang brandy, Cooee tomato sauce, Goanna salve, Kangaroo ropes, Southern Cross pumps and windmills. British-owned banks were losing some of their business to Australian banks.

The industrial scene into which the Arbitration Court came was itself developing fast. There had been small foundaries for forging iron from early times, but the iron and steel industry moved to a new level of production when a modern blast furnace was constructed on the Lithgow coalfield some 80 miles west of Sydney in 1905. At the same time, some Australians were creating new industrial techniques. F. J. Lyster, a foreman at Broken Hill, worked out the selective-flotation process which is now used in metallurgy throughout the world. The Melbourne engineer, A. G. M. Michell, invented the thrust bearing, without which the huge battleships of the Great War would have been impossible.

In the years between the crash and the Great War, agriculture expanded, supported by more new railways. More wheat lands were opened in the south-west and the south-east, more sugar-cane was grown in Queensland. In Tasmania, a great temperate fruit industry developed. British merchant ships filled their holds with Tasmanian apples and pears and sailed to Empire destinations such as India, Malaya, South Africa, and Egypt. Or they would take the non-stop great-circle route back to Liverpool. Also in their holds might then be tins of the cleverly named IXL jams produced in Hobart, and first made popular by the British army in the Sudan. Both types of fruit trade would continue until world trade patterns began to change a decade or so after World War II.

THE FEDERAL CAPITAL CITY

In 1911 the federal government took responsibility from South Australia for the administration of what became the Northern Territory. The Territory developed slowly, depending almost entirely on its beef cattle industry. The other territory administered by the Commonwealth government, the Australian Capital Territory and its federal capital city of Canberra, also developed slowly.

Last-minute bargaining in drawing up the Constitution had agreed that the national capital should be situated in New South Wales, at least 100 miles from Sydney. During the first ten years many sites were examined and great excitement reigned in New South Wales country towns at the prospect of future glory. The almost virgin Canberra region was finally chosen, and an area of 939 square miles resumed from New South Wales to become the federally controlled Australian Capital Territory. Though it is widely believed that the Aboriginal word 'Canberra' means 'a meeting place', there is also evidence for other interpretations.

An international competition was staged for the best plan for the pristine capital. Judges were to submit recommendations for prizes to the pugnacious Minister for Home Affairs, King O'Malley. Because this competition failed to meet the rules for such events established by the bodies to which professional Australian and British architects then belonged, many outstanding architects did not take part. An American,

W. B. Griffin (1876–1937), won the prize. His innovative, futuristic, original plan, based upon sets of concentric circles linked by long axes and vistas, made imaginative use of the local landforms. His plan was considerably modified over the years, however.

Until 1927, when the new federal parliament house was ready, parliament sat in Melbourne. Until well after World War II, Canberra, delayed in its development by two world wars and the Great Depression was more promise than reality. It boomed in the 1960s and 1970s.

Modern Canberra is beautiful, more like clusters of striking buildings set here and there in some graceful park than like a city, but its political Achilles heel is its artificiality. Canberra is artificial in the sense that, unlike Paris or London or Melbourne, but just like Washington D.C., it is insulated from the real working life and daily difficulties of the nation.

MILITARY MATTERS

In the pre-war years, consideration was also given to defence. To protect the European population of Australia, two military principles were evolved: Australia must support Britain in military matters so that she would always come to Australia's aid, not merely from 'family', racial, and imperial sentiment, but also from self-interest; Australia must build up its own army and navy.

Another early action by the Commonwealth parliament was to create a national Department of Defence, under Major-General Sir Edward Hutton. Hutton wanted the new army to be uniquely Australian. Drawing upon bush tradition and skills, it emphasized the horse soldier, under two categories: the Light Horse to scout, skirmish, and fight on foot and on horseback; and the Mounted Infantry for whom the horse was primarily a means of transport. In 1909, the British General Horatio Kitchener was invited by the Commonwealth government to comment upon the adequacy of this new army. He was generally impressed, but recommended the establishment of an officers' school and a small arms factory. In 1911 the Royal Military College was founded at Duntroon in Canberra, and in 1912 a small arms factory at Lithgow. Almost all small arms carried by Australian soldiers since 1912 have been made at Lithgow.

The Japanese defeat of the Russian Grand Fleet in the Straits of Tsushima in 1905 was a shock to the whole world, but hardly more so in Russia than in Australia. For the first time in modern history an Asian nation had humbled a European one, and Australians were thus reminded of their vulnerable geographical position. In complementary contrast, the goodwill visit of the US Navy ('The Great White Fleet') to Sydney in 1908 was a spontaneous and resounding success. Both incidents helped focus the Australian mind mightily. (Sydney must have seemed an attractive place, too, because thirty American sailors 'jumped ship'.) A navy seemed imperative. Rather than contribute towards the costs of the Royal Navy, an option taken by New Zealand, the federal government established a Royal Australian Navy. But its model and its first officers came from the Royal Navy, and, until 1978, it flew exactly the same white ensign.

At a time when conscription was favoured by neither Britain nor the United States, compulsory military training was introduced by the Labor government. This policy produced the greatest regimentation Australians had experienced since convict times. Many young men and their families, raised on a value-diet of radical individualism, objected, not because of the *military* training but because of its *compulsory* nature. Thousands were prosecuted for evading service, most fined, a quarter imprisoned. The most obvious example of the principle behind the protests involved the imprisonment in a military jail of the two Size brothers from Adelaide. The true nature of their protest stood revealed at the outbreak of war a few months later when they immediately *volunteered* for overseas military service.

The Great War

In August 1914, into this prosperous, socially aware, relatively calm Australia burst the Great War, or World War I as it later became known. Even before Britain had actually declared war upon Germany and Austria-Hungary, the Australian Labor prime minister, Andrew Fisher, had pledged Australia's support; as he so patriotically put it, to 'the last man and the last shilling'. He was nearly right. By war's end, out of an Australian population of under five million, 417,000

volunteers had enlisted of whom 324,000 served overseas; more than 60,000 died and over 155,000 were wounded; and the federal public debt rose from £6 million to £325 million.

In 1914, though Australia and Britain had their own separate democratic governments, they were in many respects a single polity. The decision to support Britain did not need to be *made*: it had been there in most Australian hearts for decades. Self-interest pointed the same way, for Britain kept Japan contained and prevented German and French intrusion into Australia's Pacific sphere of influence.

At first the logistical restrictions on sending men across the world limited the Australian Imperial Force (AIF) to 20,000, though this was radically increased later. Conscription before the war had been for the defence of Australia, not for service overseas. So AIF troops were all volunteers. They came from every walk of life, and joined up with determination and brio. Four brothers from their cattle stations in the Hunter Valley enlisted, bringing their own teams of horses. One Queensland grazier with his horses rode 460 miles to the nearest railhead (in South Australia) and took the train to Adelaide only to find that the South Australian quota had been filled. He took ship to Tasmania where the same thing occurred. So he sailed on to Sydney and there was accepted at last, as a private – after a journey of some 2000 miles.

EARLY NAVAL ACTIONS

Australia's early action took place close to home. A few hours after war had been declared, a German merchant ship, the *Pfalz*, tried to escape from Melbourne but was turned back when a gun of Fort Nepean at the heads of Port Phillip laid a shell across her bows – this may have been the first shot of the entire Great War. In late 1914, off the Western Australian coast, the light cruiser HMAS *Sydney* sank the German raider *Emden*, that had been damaging merchant shipping in the Atlantic and Indian Oceans. This was a small battle but the first wholly Australian one, and the country took considerable pride in the victory. Early in the war, an Australian Naval force of 2000 captured the powerful German radio transmitter in Rabaul and then all of German New Guinea, together with the radio transmitter on Nauru in the western Pacific.

THE FIRST GREAT BATTLE – GALLIPOLI

Joined by the New Zealanders, Australian troop-ships crossed the Indian Ocean and sailed up the Red Sea to their training grounds in Egypt – the acronym ANZACS (Australian and New Zealand Army Corps) was coined to describe the combined force. They had been escorted all the way, not just by the Royal Australian Navy but by a Japanese cruiser, for Japan was an ally in the Great War.

Because Egypt was relatively close to Turkey, which had recently allied with Germany, these ANZAC troops were chosen for a famous campaign that, while strategically excellent, was destroyed by poor luck and insufficient planning, and was allowed to continue for too long. Traditionally, Britain had used its navy to land and supply expeditionary forces at vulnerable places on an enemy's flank. The idea was to capture the Gallipoli Peninsula in Turkey so as to gain control of the narrow strait of the Dardanelles and send supplies through to support wavering Russia on the Eastern Front.

Just before dawn on 25 April 1915, the first of 75,000 British, French, and ANZAC troops landed at several places on the peninsula, but strong winds forced them into the wrong landing areas and they had to claw their way through monstrously rugged, easily defended terrain. Led by Mustafa Kemal (after the war he became the head of the new Turkish republic), the Turks also displayed that bravery which had made them the terror of Europe in the past, and the ships' guns could not match the Turkish shore batteries. In the months of close fighting the Australians acquired a grudging admiration for their enemies, these stolid peasant soldiers. Eventually, after some 20,000 British and 7000 Australians had been killed for no substantial military gain, the troops were withdrawn in a successful and sophisticated night-time manoeuvre. Australians, using cricket terms, preferred to see the Gallipoli campaign as a gallant draw rather than as a defeat.

Because this was the first great battle fought by Australians on the world stage and because they fought so gallantly, an Australian legend was born – that of ANZAC. A famous London war correspondent claimed there had 'been no finer feat in this war than this sudden landing in the dark', and John Masefield, later British Poet Laureate,

described the Australians as 'the finest body of young men ever brought together in modern times'. Thenceforth Gallipoli was seen as the baptism of fire of Australian military forces, and, true or not, a moral victory and the embodiment of all that was worthy in the Australian character. After the war, the anniversary of the landing, known as ANZAC Day, became celebrated in Australia each year as the national day solemn above all others, one embodying a sort of secular religion. As the decades passed and other wars were fought, ANZAC Day would absorb their meaning too.

MIDDLE EAST

After Gallipoli, while the bulk of Australian troops was sent to fight in France, some remained as the Australian Light Horse in Palestine to continue fighting the Turks, part of the force commanded by the British general, Field Marshal Allenby. These troops had mostly brought their own horses with them from their cattle and sheep stations in the inland and so developed a special *esprit de corps*.

Social conditions in the Middle East were an eye-opener. Possessors of strong democratic beliefs, the Australian troops were disgusted by the slave gangs they observed in Muslim countries.

The Australian Light Horse successfully repelled the brunt of the Turkish attack on the Suez Canal. They then played a significant part in the advance through Palestine and Syria and the defeat of Turkey, performing some of the last great cavalry charges in the history of warfare, as at Beersheba. Their part in the capture of Nazareth, Bethlehem, and Jerusalem (in Christian hands for the first time since 1189) provided memorable moments.

THE WESTERN FRONT

In April 1916 the Australian forces took up their positions in the northern section of the Western Front, where the greatest contribution of, and the greatest slaughter of, Australians occurred. In the horror and filth of the trench warfare of 1916, 1917, and 1918, the Australian experience mirrored that of all the other troops, Allied and German. In one devastating thirty-hour period of fighting around the village of Pozières, the Fifth Division suffered more than 5000 casualties, and

soon afterwards the First Division suffered almost as many. Of the 3000 men who advanced at Bullecourt, 2339 were killed, wounded, or captured. Amiens, Ypres, Fromelles, Mouquet Farm, Mont St-Quentin, Messines, Passchendaele, Menin Road, Polygon Wood, Broondseinde, and other places witnessed heroism, pain, and death, and would become moving and familiar names on the hundreds of memorials across Australia after the war.

By late 1917 the leading military officers in the Australian army were no longer permanent army but civilians. The Australians were now led by General Sir John Monash (1865–1931), the most able military figure the country has ever produced. Plucked from civilian life to lead the Fourth Brigade of the ANZACS at Gallipoli, Monash was different from most generals in history. He believed that total preoccupation with military matters was stultifying. Though he had been a part-time soldier, he was by profession a civil engineer, regarding his military activities as his civic duty.

He was a master of tactics. His leadership at the battle of Hamel was so superb that his orders and battle plans were published by General Headquarters to provide a model for the whole British army. Indeed, his offensive of August 1918, 'Ludendorff's Black Day', when he commanded 200,000 troops including Americans, was a turning point. The leading British authority on the war wrote later that, if the war had lasted another year, Monash 'might even have risen to Commander-in-Chief [of the Allied armies]. He probably has the greatest capacity for command in modern war.'

THE AUSTRALIAN SOLDIER

Complementing Monash was the ordinary Australian soldier whom he led. All soldiers were volunteers: the training introduced before the war did not entail compulsion for overseas service. Such men stood squarely in the individualist outback tradition. Their antipathy to class distinctions had even made it difficult to recruit officers' batmen, and grooms. Although these troops accepted army discipline as an evil necessary to win the war, they were never really reconciled to the rule book. Their independent and egalitarian spirit ran great risks for things thought worthwhile, such as grabbing an unusual souvenir, making a trip to

Paris without leave, saving a wounded comrade under fire, or taking the initiative during an advance. They cherished a democratic loyalty to their mates, to Australia, to Britain, and to the Allies – that, after all, was what mateship was about. And because this mateship encompassed the officers (unless they were arrogant or incompetent), such men were easy to lead even in the most trying circumstances. Their story has been captured in the massive official history of the war by C. E. W. Bean (1879–1968).

Of the 324,000 Australians who embarked to fight overseas, more than 215,000 became casualties. This was the highest proportion of any country in the war. It happened because of the Australians' recognized fighting abilities: the great majority was used as front-line, attacking troops.

THE HOME FRONT AND CONSCRIPTION

Early in 1916, the new Labor prime minister, W. M. ('Billy') Hughes, went to Britain to observe the war for himself. London born of Welsh parents, Hughes was the most extraordinary political figure ever produced by Australia. He had played a significant part in the rise of the Labor Party and the early union movement. Wizened, gnome-like, mischievous, partly deaf, misogynist, his numerous early jobs had ranged from itinerant outback worker, to umbrella salesman. To the delight of the British press, he made belligerent speeches on the theme of 'Win the War'. Hughes returned home convinced that the rest of the Empire must contribute more, and to do this Australia should, like Britain, introduce conscription for overseas' service.

Hughes's acerbic style and his dogmatic opinions caused much misunderstanding and bitterness, and his two referendums recommending conscription were narrowly rejected, the campaigns creating social division unequalled at any previous time in Australia's history. On this issue, Hughes had many opponents in his own party, particularly from the Catholic Irish parliamentarians and supporters, such as Archbishop Daniel Mannix of Melbourne who, recently arrived from Ireland and as dogmatic as Hughes, advised Catholics to vote 'No'. As a result, the Australian Labor Party was torn asunder, and Hughes was forced out of the party. No laggard at looking after Number One,

Hughes quickly cemented an alliance between the rump of his party and the Liberals, and remained prime minister. The fighting troops also voted in these referendums, with almost half voting against.

By 1917 some working people were beginning to feel that the war sacrifice was being borne too much by their section of the community, and there were several bitter strikes. With the troubles in Ireland, many Irish Catholics felt increasing alienation from the Allied cause.

WAR EFFECTS ON INDUSTRY

The closing of European markets, the shortage of shipping, the ships sunk by German U-boats, and the sheer uncertainty of war dislocated many Australian industries. British investment in Australia ceased. Wool, Australia's main export, had to be stockpiled. The pearling industry was suspended. Gold-mining declined. Timber cutters and other bush workers were laid off. Stock markets closed for the duration of the war. Before the war, lead, zinc, and copper had been sold to Belgian and German smelters. Now this was impossible.

On the other hand, war shortages actually helped some industries – for instance, the BHP smelters at Port Pirie were enlarged to meet the higher demand for Australian product. The war forced Australians to manufacture other items previously imported: carbide and copper cable; plastics from phenol-formaldehyde had a humble beginning with the production of buttons for the greatcoats of the soldiers; because salicylic acid was no longer available from Germany, a young Melbourne pharmacist produced his own aspirin; chlorine, hydrogen, and caustic soda were made from the electrolysis of brine. Thus the war was important in forcing the establishment of new Australian secondary industries. From 1915, the construction of the huge BHP steel works on the Newcastle coalfields was easily the greatest wartime industrial development. Drawing on its own generated capital, together with capital from Britain before and after the war, the rise of BHP to industrial supremacy in Australia was rapid, with more steel works at Port Kembla (Wollongong) south of Sydney. Nowadays, to transport all the coal, limestone, iron, dolomite, manganese, and so on, used in making steel, BHP operates one of the world's largest private shipping fleets. Its ships are never empty. They carry iron ore east around the

southern coast to the company's New South Wales steel mills, and return west full of coal for its South Australian mills. Economic historians usually agree that, during the war, Australia experienced the 'take-off point' into full industrialization.

VERSAILLES

At the Peace Conference at Versailles, the Australian delegates were Sir Joseph Cook and 'Billy' Hughes. To the deep satisfaction of the people at home, in the debates dealing with Germany and the shape of the post-war world, Australia like Canada, though part of the British Empire, was accorded the status of an independent nation, and Australia signed the peace treaty separately from Britain.

Australia was given a League of Nations' mandate over German New Guinea, and a share in the island of Nauru, rich in phosphate rock. Hughes more than held his own with the great Clemenceau of France, Lloyd George of Britain, Woodrow Wilson of the United States, and others. The latter, riled by Hughes's aggressive debating methods, called Hughes 'a pesteriferous varmint'. A long-time leader of men in tough outback wool sheds and city factories, and a man who would sit in parliament for fifty-eight years, Hughes was not impressed by patrician Wilson. When Wilson observed that *he* spoke for a nation of 100 million, Hughes, knowing that the total Australian battle dead exceeded those of the United States, retorted that he Hughes spoke for 60,000 dead.

Even these figures fail to show an immensely greater loss. The 60,000 were the very flower of Australia, the best and bravest, the most altruistic. In every field they would have been the next leaders – and equally important the fathers and role models of a new generation. Had they not died, Australia's future might have taken a different path. In King's Park, Perth, there is a memorial to the Western Australian dead in the Great War. It is not some grand granite monument, but long rows of simple metal name plates at the foot of gum trees lining the drive around the park's grassy centre: Alexander Dixon, aged 19; Harold Bleakley, aged 18; Alfred Smith, aged 19; Shaun Anderson, aged 19; Michael Kelly, aged 20 . . .

Hughes, who remained prime minister for four more years, was

determined to have a say in any British policies that affected Australian interests. For instance, he insisted on a separate Australian signature to the 1922 Washington Naval Limitation Treaty, which was the real successor to the Britain-Japan Treaty of 1902.

Roaring Twenties

After World War I, there was a worldwide epidemic of influenza. In 1919, in Australia alone, 12,000 people died of influenza. Then came the years which in Australia as in other Western nations have been called 'The Roaring Twenties'.

It was as though the youth of Australia, and many of the women who had done men's jobs during the war, were collectively rejecting the ideas of their fathers. Like other great cities of the world, Sydney and Melbourne were booming. Women began to smoke in larger numbers. Buying on credit was a sign of economic confidence.

Nevertheless, though Australia itself had not been physically touched by the war, the massive death toll inflicted in the killing fields of France had a profound effect. The exuberance of the 1920s did not entail the confidence in the future that had characterized pre-war decades. That had gone forever. Australia never quite regained its ideals and innocence. The twenties were an odd mixture of insouciance and ennui.

NEW FORMS OF COMMUNICATION

To everyone's intense excitement, aeroplane flights brought the far-flung parts of the world and the Empire ever closer. In 1919, two young brothers, Ross and Keith Smith from Adelaide, achieved the first Britain–Australia flight in twenty-eight days. Overnight they became national heroes in both countries. In 1930, Amy Johnson, as befitted the new mood, became the first woman to fly solo from Britain to Australia, and was greeted in the skies over Sydney by six female pilots in their own biplanes. And in the same year the first telephone calls could be made between Sydney and London. Mighty new ships, of famous lines such as P&O and Cunard, plied the Australia route from Britain.

With such great distances to span, it is not surprising that, from the beginning, Australians took a keen interest in aviation. In 1920, the world's first regular, long-distance air service, Queensland and Northern Territory Aerial Services (QANTAS) was established in the Queensland outback. Planes soon became a significant factor in Australian transport, with passenger and mail services steadily increasing. In 1935, a ten-seat QANTAS Empire Airways passenger plane inaugurated the London-Sydney service, the world's longest commercial air route. The journey took nearly thirteen days and the plane landed forty-two times. After World War II QANTAS would become a major overseas airline.

'The Flying Doctor' was another Australian aerial innovation. Inaugurated in 1928 through the tireless efforts of the Reverend John Flynn (1880–1951), it brought medical care to isolated cattle and sheep stations as much as 500 miles from the nearest city. The airlines, the Flying Doctor, and other enterprises were quick to adopt the new invention of wireless (radio). Soon many families also had their radios, served by a growing number of radio stations.

The hundreds of thousands of new cars for the average person, required better roads and automatic traffic lights. Drownings were soon exceeded by deaths in car accidents. Ever-increasing dependence on motor vehicles meant that Australia was no longer self-sufficient in transport for, unlike in the era of horse- and bullock-drawn traffic, it had to import most of its motor vehicles and all of the petroleum to run them. Imported Model-T Ford cars and various makes of British vehicles transformed life in the cities and had an even greater impact in outback Australia.

NEW POLITICAL PARTIES

Setting a new style in politics was the Communist Party of Australia, founded in Sydney in 1920. It was led by men and women already powerful in trades unions and in industry, such as the secretaries of the New South Wales Trades Hall and the Australian Seamen's Union. Soon to be taking orders direct from Moscow, they were dedicated to the overthrow of Australia's economic and political system. At their

most powerful in the 1930s and 1940s, Australian Communists would prove adept at industrial disruption for the next seventy years.

In contrast, the strength of rural Australia was demonstrated in the founding of the Australian Country Party (renamed the National Party in 1974) which, since 1919, has usually formed coalition governments with the other rightist party – since World War II, the Liberals. The Country Party helped promote the well-being of farmers and pastoralists through programmes of government subsidy and protection. In so doing it also strengthened the historical tendency of Australians to rely on governments to solve their economic problems, rather than on self-help.

NEW FASHIONS AND WAYS OF LIFE

There were novel electrical appliances, such as vacuum cleaners and refrigerators, though, for the time being only for the well off. Crazes from the United States and Britain hit Australian shores: jazz, and controversial new dances, such as the Charleston, the Bunny Hug, and the Turkey Trot; and many middle-class homes had a pianola or at least a piano. New fashions proliferated, such as flat chests and cloche hats. There were new styles in houses. A significant Australian film industry had developed before the war, and some of the world's earliest feature films had been made in Australia – such as *The Story of the Kelly Gang*, in 1906. The industry went into decline in the 1920s, being unable to compete with the greater financial resources of Hollywood. In 1927 the first sound films, 'the talkies' arrived. Each week millions of cinema-goers could escape mundane lives for threepence at the local picture palace. Bathing-beauty contests became fashionable. In 1923 in a backyard lab, 'Vegemite', Australia's all-time favourite sandwich spread, was created, and the same year began Australian children's continuing love affair with the confection the 'Violet Crumble'. Religion had its fashions, too, as American evangelists, such as Billy Sunday, hit Australian shores with their hot gospelling.

From the 1890s onwards, temperance advocates had hoped for a complete ban on the sale of alcohol. Failing in that aim, they achieved what was for them the next best thing, the early closing of hotel bars and pubs. Because most people finished work at five or six in the

Inter-war Australian suburban house: 'The Californian Bungalow'

afternoon, social drinking was seriously affected. By the end of 1916, 6 o'clock-closing was the law in New South Wales, Victoria, South Australia, and Tasmania. Naturally, men tended to drink quickly during the short time available. Forced on the nation by philistines, the '6 o'clock swill', at it became known, was an unedifying feature of the Australian social scene for decades. Men were drunk by six, sober again by eight or nine. Victoria and South Australia maintained this pattern much longer than the other states, Victoria until 1966.

The leaders of the 1920s wanted Australia to develop. Under the prime minister, S. M. Bruce (1883–1967), the slogan 'Australia Unlimited' was popularized and a search was begun for 'men, money, markets'. The men and women were Britons, the money was mainly from London, and the markets were British and Imperial, through government-arranged preference schemes for Australian primary produce. Some money also came from the United States.

After the war, the federal government tried settling ex-soldiers on the land. Some soldiers succeeded; most failed. In the 1920s, as a condition of their passage, many immigrants were also encouraged to go farming as the 'men' to grow products for the 'markets'. These schemes were inadequately planned and again the majority of farms, many in only marginal farming areas, failed leaving much frustration and heartbreak. Once more the problematic nature of inland Australia for farming stood revealed.

So beneath all the surface gaiety of the 1920s, lay pain and doubt, and much unevenness of success and failure.

Depressing Thirties

The economic confidence of the 1920s could not last and, after the US stock market contracted suddenly in 1929, the Great Economic Depression descended on Australia in 1930. The shock was all the greater because of the preceding long period of growth, before and after World War I.

Like other countries, Australia tried to protect its industries and monetary reserves by raising tariffs against imports: that is, against other countries' exports. But, by beggaring their neighbours, countries were also beggaring themselves. The value of Australia's exports fell faster than the value of imports, and the ability of people to buy was hit by the cessation of overseas' loans and the burden of paying interest on loans contracted before the Depression. Primary producing countries such as Australia suffered drastically. Wool prices dropped to a seventh or eighth of 1920s' values. In country areas there were rabbit plagues and droughts. Nearly a third of the work-force was unemployed. The only parts of Australia which were truly prosperous were gold-mining towns, such as Kalgoorlie, because gold actually increased in value.

In the United States many unemployed moved south; in Southern-hemisphere Australia they travelled north – at least a man could sleep rough in a warmer climate. Shanty towns and soup kitchens appeared in the great cities. Thousands of 'swaggies' (tramps) jumped the trains or plodded along the outback roads in search of work or a meal. In their mateship, they helped one another: a stone placed on top of a gate post signified to the next arrival a good place to get a free 'feed'. Niggardly government doles and relief work gave sporadic help.

CONFUSED ATTEMPTS TO HELP

From 1929 to 1934, as well as the federal government, every state government was voted out of office by the electors to be replaced by their political opponents. James Scullin (1876–1953), the new Labor prime minister, was a devout Catholic Irish-Australian, near the middle

of Party opinion. Labor Party ideas on what should be done to mitigate the effects of the Depression varied from abolishing the whole capitalist system, through the ideas of the federal treasurer, E. G. Theodore, for development programmes to provide work for the unemployed, to implementing to the letter the deflationary policies of Sir Otto Niemeyer, who had been invited from the Bank of England to give his advice. The federal government mostly vacillated.

Into this atmosphere of crisis strode one of Australia's most extraordinary politicians, the imposing figure of the Labor premier of New South Wales, Jack Lang (1876–1975), who denounced Niemeyer's plans as a sinister plot of overseas' capitalists. Lang proposed to end unemployment through a programme of public works, the state meanwhile halting payment on or repudiating all overseas loans. Hundreds of thousands of suffering unemployed were convinced by his ideas and, across Australia, were heard the slogans 'Lang is Right', 'The Lang Plan', and even, because of the strength of Communists in the trade unions, 'Lang is Greater than Lenin'! Lang cut by 10 per cent the salaries of public servants. He generated immense opposition from the other political parties and from more moderately minded people. A compromise plan of state premiers in 1931 reduced interest rates, increased taxes, and forced a 20 per cent cut in pensions. Though Lang was dismissed from office by the governor of New South Wales, and eventually expelled from the Labor Party, in the hindsight of Keynesian economics, it is clear that at least the first part of his proposals, as well as some of Theodore's plans, were sound.

SOME DISTRACTIONS

One bright star of the 1930s was the extraordinary ability of the New South Wales cricketer Donald Bradman (1908–) (Sir Donald after 1948) who at one time held most of the world's important batting records, and still holds many of them. Bradman's enormous success stimulated Australian national feeling. Seventy years after his debut, Bradman remains Australia's greatest sporting legend. In 1932, to restrict his prodigious scoring rate, the visiting English cricket team employed an aggressive new form of 'bodyline' bowling. England won the Test series and reduced Bradman's average scores by 50 per cent.

The profound importance of sport for most Australians was demonstrated when the uproar over bodyline almost brought about a rupture in British-Australian relations. A second star in these distressing years was the construction of the splendid Sydney Harbour Bridge, designed by an Australian, built by a British firm, and opened in 1932. Jack Lang was about to cut the ribbon to open the bridge, when a dedicated opponent spurred forward on a white horse and slashed the ribbon to thwart him. A third was the establishment in 1932 of the Australian Broadcasting Commission (ABC). It rapidly developed into one of the world's quality radio systems with a diversity of excellent programmes. It also supported good music, in 1937 setting up orchestras in each capital city.

Sydney Harbour Bridge under construction 1930, completed 1932

GENERAL EFFECTS

Even without the Depression, the rise of larger companies and trades unions had made industrial relations less personal and, in economic planning, abstractions such as labour and capital took the place of flesh-and-blood people. There developed a more doctrinaire mood in Australian political life. Nevertheless, Australia did not produce the extremes of many other countries during the 1930s: though the Communists increased in numbers, there was little support for fascist ideas.

The positive effects of all the pain were that inefficient industries went bankrupt, and those that survived learned more circumspect ways. Australians came to produce more manufactured products themselves and, in the tough 1930s, industrial expansion actually exceeded that of the twenties.

In the period 1931 to 1935, the total population of Australia declined by about 30,000! The Depression deeply affected Australian economic thinking until the mid-1960s, and many politicians decided that the hardships and insecurity of the 1930s should never be allowed to occur again.

INTERNATIONAL POLITICS

The prime minister, S. M. Bruce, represented Australia at the 1926 Imperial Conference in London. The most important agreement from this conference of Empire prime ministers was the Report made by the committee under Lord Balfour. It declared that:

> The United Kingdom and the Dominions [i.e., Australia, New Zealand, Canada, etc.] are autonomous communities within the British Empire, equal in status, in no way subordinate to one another in any aspect of their domestic or external affairs, though united by a common allegiance to the Crown and freely associated as members of the British Commonwealth of Nations.

These international relationships were later made formal and legal in the Statute of Westminster passed by the British parliament in 1931; they were not ratified by Australia until 1947.

In a sense, both Report and Statute merely made formal that which was already actual, for Australia, though sharing the same monarch, was politically already quite independent. This was despite much

Empire fellow feeling, as when loyal Sydneysiders described their home town as 'the Second City of the Empire'; and, despite the fact that *realpolitik* still gave Australians a vested interest in a close-knit Empire. Though unrecognized at the time, the Report and Statute also implied that, unlike say, the case of the then forty-eight American states, there was now nothing practical to hold the self-governing British dominions politically together. There were merely shared values and sentiment.

ANTARCTICA

Because of their position in the Southern Hemisphere, Australians had long taken greater interest in the seventh continent than had most people in the Northern Hemisphere. In 1936, for scientific but also strategic reasons, Australia formally claimed a huge slice of Antarctica, to be called the Australian Antarctic Territory. The claim has not been generally recognized internationally.

The earliest Australian activity had centred on the seas around the offshore islands which provided whales and seals in large numbers. Interest was renewed when several European pre-1880s' sea-going exploring expeditions provisioned in Hobart and Sydney. The Australian geologists, Edgeworth David and Douglas Mawson, took an important part in the English Shackleton expedition to Antarctica in 1908–09. In 1911 came the first full Australian Antarctic expedition, under Mawson. It sailed from Hobart, spent many months ashore, discovered new territories that it called King George V Land, and claimed these for the British Empire. Mawson also explored Adelie Land, found the first Antarctic meteorite, and made the first long-distance radio call from the continent. In 1929 Mawson returned with the British, Australian, and New Zealand Antarctic Research Expedition which explored MacRobertson Land. By this date, the significance of Antarctica for scientific understanding of Australia's and the world's weather and climate was becoming clear. The first permanent research base, 'Mawson', was established in 1954.

JAPANESE AND GERMAN MILITARISM

Throughout the 1930s most Australians, like most Britons, watched

warily the events in Europe. Many trusted that the internationalism of the League of Nations would prevent war. In 1935, when Mussolini invaded Ethiopia, the Australian government immediately applied the sanctions on Italy recommended by the League. The great majority of Australians also hoped that Hitler would cease making further territorial claims, and, appalled by the horror and waste of the Great War, prayed that somehow war could be averted. In 1938 they, like most of the world, sighed with relief when Chamberlain returned from his meeting with Hitler in Munich with the famous promise of 'peace in our time'.

More worrying for Australians were the industrial and territorial ambitions and expansion of Japan, and the fact that many Japanese coveted the British Empire in the Far East. It was also recognized that in the minds of some Japanese militarists these ambitions included Australia. The Japanese annexation of Manchuria in 1931 and invasion of China proper in 1937 were in some ways reassuring because they involved expansion to the west. Britain's completion in 1938 of the mighty naval base at Singapore at the tip of the Malayan Peninsula was greatly welcomed. Privately, during the late 1930s, Australian governments unsuccessfully tried to arrange a commitment of military support from the United States.

Meanwhile, steps by Scullin's Labor government to avert the effects of the depression had resulted in internal Labor Party divisions and a trouncing in the 1931 Australian election by the newly formed United Australia Party (UAP). The UAP was led by a former Labor man, the Tasmanian, Joseph Lyons (1879–1939). Like its rightist predecessors, the UAP was dedicated to anti-Communism, private enterprise, and traditional social values.

Lyons's government had been slow to realize that war was coming, and the Labor opposition harboured numerous isolationists. But, in the elections of 1937, defence became the main issue. Lyons and the UAP stressed naval expansion, while John Curtin (1885–1945), the Labor leader, wished to strengthen the air force. The UAP again triumphed and Lyons was to remain prime minister until his death half way through 1939.

World War II and Post-war Changes to 1972

In late 1941, aware that Britain was fighting for its life in Europe, the Australian prime minister appealed to the United States for help, and Australian military forces were placed under US command. The Japanese continued to move south and were halted on Australia's doorstep by resolute Allied action. During and after the war, the Labor government exerted strong controls over the economy and introduced further social-democratic legislation.

Under the Liberal-Country Party the 1950s and 1960s were general boom times. Population grew and, through large-scale immigration, Australia changed from being a nation of mainly British-Irish descent to one with a large, growing, and increasingly assertive multicultural minority. Secondary industry expanded.

Meanwhile, politically and culturally, Australia moved further from Britain and more under American influence, made defensive alliances with the United States, became more conscious of Asia, and fought in the Korean and Vietnam Wars. Trade with Asia also became ever more important – already by the mid-1960s, the wartime enemy, Japan, was Australia's best customer, and would remain so.

World War II

On Sunday, 3 September 1939, all Australia was listening to the radio as Neville Chamberlain, the British prime minister, reported that Britain was now at war with Germany. R. G. Menzies (1894–1978), who had become Australian prime minister on the death of Lyons, spoke next. In spirit and fundamental values, Britain and Australia were still one,

just as they had been during World War I – as the Great War now became known. Menzies explained that in consequence of Britain's decision: 'It is my melancholy duty to inform you officially that … Australia is also at war'. Almost all the country agreed with Menzies's decision. Australians realized that much would have to be done to secure their own defence in case of Japanese involvement, but the first thought was to send help to Britain.

WAR AT A DISTANCE

Menzies suggested that Australia form a National Government, but the Labor Party rejected this. Menzies then travelled to Britain to discuss strategy. Australians apprehensively watched developments in Europe as Hitler's Nazis conquered country after country.

Meanwhile, two different land forces were established. A Second AIF was raised by volunteer enlistment for service overseas, and a militia of conscripts was created for the defence of Australia. Australia contributed about a third of its forces to the war in Europe and the Middle East. This decision made perfect practical sense. Australia wanted to preserve its trade through the Suez Canal, and to ensure that Britain was not defeated – for (if the United States were not in the war) that would surely mean the defeat of Australia, too.

In the twelve months between the fall of France in June 1940 and Hitler's invasion of Russia in June 1941, Australia, Britain, and Canada were Hitler's three chief remaining opponents. Australian airmen were transferred to Britain; Australia sent RAN ships to fight in the Atlantic and the Mediterranean; AIF troops of the 6th, 7th, and 9th Divisions joined the British and other Empire forces fighting the Germans and Italians in Greece, Crete, and North Africa, and the Vichy French in Syria.

The Australian troops fought their first battle at Bardia in Libya in January 1941 against the Italians. In an amazingly successful action, the 6th Division captured 40,000 Italians. In this battle, part of the first British victory of the war, the Division lost only 130 killed and 326 wounded. Later that month the 6th Division took the seaport of Tobruk in Libya, captured 27,000 more Italian prisoners and 130 tanks, and lost only forty-nine killed. In a mere six weeks the Australians

Australian Prime Minister, Robert Menzies at the outbreak of
World War II

pushed the Italian army 500 miles across the desert and destroyed it.
When the Germans under Field Marshal Erwin Rommel entered the
North African war and laid siege to Tobruk, the Australians held out for
242 days before evacuating. Before returning to defend Australia
against the Japanese their service in the Middle East ended famously
with the 9th Division as the spearhead of Field Marshal Montgomery's
(1887–1976) attack on Rommel in the Battle of El Alamein in Egypt in
1942. The Australian attacks were crucial in the British victory – itself a
turning point in the war.

In French Syria, which had declared for the Vichy collaborationist
government, the Australians defeated troops of the French Foreign
Legion and again captured Damascus as they had done in World War I,
this time by themselves. After that loss, the French general sought an
armistice.

Meanwhile, in Australia, a drive to produce all sorts of munitions was led by Essington Lewis, the head of BHP. The war effort was hindered by Communist-inspired strikes on the New South Wales coalfields (until the USSR entered the war) as well as some early reluctance on the part of the Australian populace to give up their good life for the emergencies of wartime. By war's end, in a rapid industrialization, more than 200,000 Australians were producing a variety of war material, from aircraft and anti-aircraft guns, to tanks and warships.

In August 1940 three cabinet ministers and the chief of general staff had all been killed in an RAAF plane crash in Canberra. In the following election Menzies lost his clear UAP-Country Party majority and was forced to depend on the support of two independents to stay in government. So he had to spend as much time on party politics as on the war effort. In October 1941 the independents switched sides and Labor, under John Curtin, formed a government. It would remain in power for the remainder of the war.

FALL OF SINGAPORE

The startling successes of Hitler in the first two years of war were repeated by the Japanese during the following year.

In December 1941, without declaring war on either the United States or Britain, Japan attacked. On the day the Japanese bombed the US naval base at Pearl Harbour, they also attacked British Malaya and began bombing the British stronghold at Singapore. Wake Island (USA), Hong Kong (Britain), and the Philippines (USA) were quickly overrun. By 19 January 1942, the Japanese had conquered the Dutch and British in Borneo, and were planning to take the key Dutch island of Java. They were succeeding beyond their wildest dreams, and approaching ever closer to Australia. Thousands of European refugees from these colonies fled to sanctuary in Australia.

In seven weeks early in 1942, the Japanese captured the whole of Malaya. In the fighting retreat down the peninsula, Australians of the 8th Division played an important role, especially in the early Battle of Gemas, which involved a superbly executed attack led by Lieutenant-Colonel F. G. 'Black Jack' Galleghan. In what was perhaps the most successful ambush of World War II, some 800 Japanese were killed and

only about eighty Australians were killed or wounded. But many undertrained Australian troops had also been sent to Singapore, with inadequate weaponry, and such things contributed to the eventual defeat. Personal rivalries among the British and Australian military leaders hindered the effort in Malaya and Singapore, and the numerous Indian troops were incompletely trained.

Soon Singapore lay before the Japanese who quickly attacked across the Strait of Johore. They had to be quick. The British were unaware that the Japanese general, Yamashita, was bluffing, and short of provisions, weapons, and ammunition. The British commander, General Percival, made some crucial strategic and tactical mistakes and, on 15 February, he and 90,000 troops surrendered to a force about half that size in the greatest-ever defeat of British arms. Of these, some 15,000 were Australians of the 8th Division. The Australian commander, General H. G. Bennett, and a few hundred Australian troops escaped to fight another day.

Australians had lived for 154 years protected by the British imperial umbrella and had never imagined the possibility of having to defend their country without the contribution of British military forces. The Fall of Singapore was a profound shock. It is impossible to convey the depth of dismay felt right across the country.

Many Australian troops, taken prisoner at Singapore and interned in Changi Prison and in other places in south-east Asia, were to die terrible deaths – not counting those who, when captured, were immediately shot, bayoneted, or burned alive. In Burma and the Dutch East Indies (Indonesia), to carry out Japanese plans Australian prisoners were marched until, from fatigue, starvation, disease, and beatings, they died in their thousands. The survivors were used as forced labour on Japanese railways, roads, and bridges. Those who showed any sign of slowing were clubbed or bayoneted to death, or beheaded. Tools for beating prisoners included baseball bats, split bamboo canes, horsewhips, hammers, and iron bars. Recaptured prisoners were either bayoneted or beheaded. Of the 22,000 Australian prisoners captured by the Japanese during the war, more than 8000 died in captivity. In contrast, of the 8184 troops captured by the Germans, only 265 died.

AUSTRALIA AND THE PACIFIC WAR

'The fall of Singapore opens the Battle for Australia', said Prime Minister Curtin. The military knowledge of Curtin's government was minimal. One cabinet minister had served in World War I. Three others had served in the Second Boer War (1899–1903). Before becoming Leader of the Opposition, Curtin's greatest claim to fame had been as a fervent anti-conscriptionist, jailed during World War I. It was by these men that the decisions were taken as Australia faced the threat of invasion for the first time since white settlement. Fortunately, Curtin and his colleagues were quick learners.

BOMBING OF AUSTRALIAN TOWNS

Just three days after Singapore surrendered, the town of Darwin in the Northern Territory suffered the first attack on Australian soil by a foreign power. At 10 a.m. Japanese bombers from 14,000 feet dropped their bombs in a pattern. Next, dive-bombers and fighters from four aircraft-carriers bombed and machine-gunned ships in the harbour, the airport, the RAAF base, and the town hospital. The American Kitty-hawk aircraft, assigned to protect Darwin, were mostly shot down soon after take-off, and the anti-aircraft batteries were ineffectual. Five merchant ships and three warships were sunk, including a US destroyer with its guns still firing, and a hospital ship. When the planes departed after some forty minutes, most of the town and the harbour had been obliterated. At 11.45 a second wave of fifty-four land-based bombers attacked, destroying in about twenty minutes the little that was left, and razing the RAAF aerodrome – though many of the aircraft escaped, hidden under camouflage in the jungle. Darwin had been unprepared. This was Australia's Pearl Harbour: in fact, most of the Japanese commanders and the four aircraft-carriers had been involved in the attack on Pearl Harbour! Curtin's government in Canberra was in deep shock. To keep up morale, it censored the news, reporting that seventeen people had been killed and twenty-four wounded. In fact, the figures were 243 dead and approximately 350 wounded.

During the following years the rebuilt Darwin was bombed again many times, including May 1943 when the RAAF defended the town

with thirty-two Spitfires that had been acquired from Britain. Other bombed towns included Wyndham, and Broome in Western Australia several times, and briefly, Townsville in north Queensland. In the initial, Broome raid, more than 200 civilians, including many Dutch refugees about to evacuate, died in the destruction of flying-boats and land planes waiting to take off in and near the harbour. By mid-1942 the Japanese had taken all the Dutch East Indies, Dutch New Guinea, the Australian-controlled Mandated Territory of New Guinea, and were crossing the Owen-Stanley Ranges into Australian-controlled Papua planning to capture the capital, Port Moresby.

In northern Australia a special commando force of regular army men and local Aborigines was formed in mid-1942. It used horses and canoes and Aboriginal bush skills to patrol the coastline and swamps, ready to report on Japanese landings and movements. Meanwhile civilians prepared for the worst. Slit trenches were dug in back-yards as a precaution against air raids. In Queensland and Western Australian towns long lines of reinforced concrete communal air-raid shelters appeared in central streets, or were dug in public parks.

AMERICAN AID

In different ways, Menzies and Curtin had the difficult task of reconciling Australian needs with the wider strategic concerns of Britain and the United States. From the last months of 1941, Britain, stretched to the limit in Europe, North Africa, the Atlantic, and the Mediterranean, and expecting a Japanese attack on Burma and India, was unable to guarantee Australia's safety from Japanese invasion. On the other hand, Australia, now threatened with invasion, could no longer give Britain the help it needed. Australians realized this and, on 27 December 1941, prime minister John Curtin made a direct appeal to the United States for help.

In March 1942, General Douglas MacArthur (1880–1964), under orders from President Roosevelt, escaped from the Japanese attackers in the US-controlled Philippines and reached Melbourne. It had been decided that it was to America's great advantage to use Australia as the base from which the US counter-attack should proceed to recapture the Philippines. In fact, four days before Curtin's appeal, the first US naval convoy, originally intended for the Philippines, sailed up the

Brisbane River. The American decision perfectly matched Australian desires. Curtin placed the Australian forces under MacArthur's control and, with British prime minister Churchill's agreement, MacArthur became Supreme Commander of Allied forces in the South West Pacific, with headquarters in Melbourne.

The relationship between the very different personalities of Curtin and MacArthur worked well. Nevertheless, Curtin probably felt overwhelmed by MacArthur and by the American military presence. He tended to discount Australian military advisers such as the Commander-in-chief, General Thomas Blamey (1884–1951), and gave way to MacArthur in almost every aspect of war plans.

By mid-1942, MacArthur had shifted his HQ further north to Brisbane where he lived in the best suites in the best hotel in the city. Most Americans were unaware that the majority of troops under MacArthur's control were, at least until the end of 1943, Australians. In mid-1943, Australian forces serving in the south-west Pacific numbered 446,000. The Americans numbered only 111,000 but, during the next year-and-a-half, had increased to 500,000 and by war's end to almost a million.

Most of these American troops passed through Brisbane, then a city of about 300,000, on their way to the great battles in New Guinea, the Solomons, and the Pacific. Public parks and race-courses became vast tented US army camps. In north Queensland, the town of Townsville, population 30,000, had some 90,000 American troops camped in and around it. These soldiers injected millions of pounds into the Australian economy. The effect of so many well-paid American servicemen on the Australian civilian population, especially the young women, may be imagined. More than American troops came. In 1944 *The Readers' Digest* began an Australian edition and Coca-Cola went on sale. These were merely the beginning of what would be increasing American commercial inroads into the Australian economy and way of life in later decades.

Curtin had welcomed the Americans as 'visitors who speak like us, think like us, and fight like us'. This was partly true but, in fact, Americans and Australians had different ideas and values, which became increasingly obvious as time passed. The 'friendly invasion' of these US

alter egos gave Australians much to think about, and a greater awareness of their own culture. Australia's farms fed the United States army and, at war's end, the US government was in debt to Australia – in contrast to Britain which remained enormously in debt to the United States.

Brawls between American and Australian servicemen were one inexorable byproduct of the presence of so many US troops. The World War I aphorism of the British that the Americans were 'over-paid, over-sexed, and over-here' was widely repeated in Australia. The Catholic Archbishop of Brisbane even demanded a ban on marriages between Australian women and American soldiers, but, by the end of the war, over 12,000 Australian brides had departed for the United States, and few returned – another significant loss.

OCEAN AND JUNGLE WAR IN THE SOUTH PACIFIC

On 4 May 1942, the naval battle of the Coral Sea began, and Australian government foreboding reached its height. If the Americans and Australians lost this fight, then every eastern Australian port lay open to Japanese attack. This was the first naval battle in history in which the two fleets did not fire upon each other. It was fought by planes launched from carriers, from Japanese island bases, and from Allied bases in Australia. Though Allied losses were marginally greater than those of the Japanese, this proved to be an Allied tactical victory. It prevented a naval invasion of Port Moresby and forced Japan to fight an extended land campaign in New Guinea from the north coast; Japanese plans for invading Fiji, New Caledonia, and Samoa, and thus isolating Australia, were thwarted; and there was a powerful psychological effect – for the first time in the war the Japanese had been stopped. In fact, the battle was a turning point in the Pacific war, and contributed significantly to the US victory in the crucial Battle of Midway a few months later.

As it was, in Australian waters 1942–45, Japanese submarines still managed to sink twenty-nine merchant vessels, including important iron-ore carriers and the hospital ship *Centaur*. Japanese ships briefly shelled Sydney and the industrial city of Newcastle, and a number of midget Japanese submarines entered Sydney Harbour and achieved some damage.

In mid-1943, the AIF 9th Division, which had shared the honours at El Alamein, returned to Australia. They were eulogized by the press, marched through Brisbane in triumph, and were significant in helping Curtin and Australians in general to maintain something more like a balance in the relationship with their powerful American ally.

In the attitudes and actions of the AIF and the conscript Militia in New Guinea, the Australian ethos of mateship was displayed once again. It was in late 1942, first at Milne Bay, then along the Kokoda Trail in the Owen-Stanley Ranges, that the Japanese were at last defeated on land in a series of relentless battles over seven months. The Australian-made Owen light machine-gun played a decisive role in the close fighting. Finally, in early 1943, Kokoda was recaptured, as well as the coastal villages of Buna and Gona, and the Japanese were driven into the sea. The Australians were supported by supplies air-dropped by US and Australian planes or carried on the backs of tireless and courageous Papuans.

Apparently to protect himself, during the early stages of the Kokoda Trail battle General MacArthur despatched messages to Washington that cast serious doubt on the Australians' fighting ability. From far away in Brisbane he ordered the Australians to close 'the pass' through the Owen-Stanley Ranges with explosives. 'The pass', the Kokoda Trail, was actually irregular bits of jungle track, loosely linked, in places accessible only by crawling over a jumble of precipitous ranges and deep valleys. His impossible order was ignored.

By late 1943, MacArthur had developed a shrewd strategy of 'island hopping'. Important Japanese bases and islands were bombed and left, bypassing and isolating the Japanese troops who, without possibility of reinforcement or resupply, could later be attacked or left to rot in the jungle until peace came. United States forces monopolized these advances. Meanwhile, the Australians were left to do the less-glamorous but equally murderous 'mopping up' in northern New Guinea and adjacent islands. The north New Guinea coast had been recaptured by September 1944, the Australians having advanced more than 1500 jungle miles in a year, and destroyed or captured some 200,000 Japanese.

Jungle warfare was horrendous. Illnesses, such as malaria and dengue

fever, were rife as troops fought on ridges and in swamps, were attacked by clouds of mosquitoes, tortured by ulcers and sores, and existed on tinned food. Sometimes a brigade could hardly muster a battalion. But medical advances such as penicillin and sulphonamide drugs saved many lives.

Though its airforce was inadequately prepared when war arrived, the record of Australian airmen was astonishing. As volunteers in the Royal Air Force (RAF) early in the war, as Royal Australian Air Force (RAAF) men fighting within units of the RAF, and as members of the RAAF by itself, or as RAAF in conjunction with the Americans, they fought in most theatres of war: in Coastal Command in the Battle of the Atlantic, escorting Allied ship convoys, attacking enemy convoys and submarines, rescuing torpedoed seamen, and patrolling east and west from Iceland; escorting the dangerous Arctic convoys to Murmansk and Archangel in Russia; supporting the British and Australian army in North Africa; doing reconnaissance in the Adriatic and the Greek Islands; ferrying planes from West Africa across the desert to the Nile then north to Egypt; supporting the invasions of Sicily and Italy; bombing oil fields in the Balkans and dropping mines in the Danube River; flying in supplies from Brindisi, Italy, to support the Warsaw Uprising; supplying troops in the south Sudan, and Ethiopian tribesmen rebelling against the Italians; in Iran and Iraq, protecting the oil fields and frustrating the pro-German shah of Iran; defending the Middle-east-Persian Gulf-India supply line; based in Ceylon (Sri Lanka) protecting Ceylon–Australia shipping, and mapping Sumatra and nearby islands; based in India and attacking the Japanese in Burma; ferrying planes across Australia; flying from Townsville, Queensland to take part in the Battles of the Coral Sea, the Kokoda Trail, and other battles in New Guinea; flying missions in the Solomon Islands; aiding in the evacuation of Timor and the later Allied invasion of Borneo; and these were not all.

The record of the Royal Australian Navy was almost as complex: cruisers escorting the troop-ships across the Indian Ocean to the Middle East, and round the Cape of Good Hope to Britain; attacking the Vichy French navy off Dakar in West Africa; attacking the Italian navy in the Mediterranean and the Red Sea; destroying Italian mines off Alexan-

dria; sinking the first Italian ship of the war off Libya; taking part in the Battle of Calabria off southern Italy – the first fleet action in the Mediterranean since the Napoleonic wars; defending British Somaliland; transporting troops for the Greek campaign; supporting the Australian army's invasion of Vichy Syria; engaging the German *Kormoran* off Western Australia; fighting around Singapore Island; protecting convoys in the Persian Gulf; supporting the Dutch in the East Indies in battles such as that of the Java Sea; resisting the Japanese air attacks on Darwin; fighting near Ceylon (Sri Lanka); supporting the American fleet in the Battles of the Coral Sea and the Solomons; taking part in the recapture of Borneo; sustaining Japanese suicide attacks in Leyte Gulf in the Philippines.

THE HOME FRONT

In the emergency of wartime, the federal government was able to centralize and direct the national work-force and restrict non-essential production in a manner unthinkable in peacetime. Women took the place of men in the military, working in factories and on the land.

The prime minister adopted some features of a presidential style, directed policy without regular consultations with cabinet, and, in rejection of Australian tradition, made use of experts outside parliament and the public service. Other ministers – F. M. Forde as deputy prime minister and minister for the army, H. V. Evatt (1894–1965) as attorney-general, and J. B. 'Ben' Chifley (1895–1951) as treasurer – became powerful in their own right.

The threat to democracy made life more precious and, at the height of the war, the Australian government was planning for a better post-war society: in February 1943, the government formed the Ministry of Post-War Reconstruction, and Chifley announced the twin post-war policies of national welfare and a high level of employment.

Rationing and price controls limited what could be bought, and diverted the workers' excess wages, which Chifley called 'the unspendable margin' into bonds and bank savings to fund the war effort. A huge change in federal-state relations occurred when Chifley, supported by the High Court, managed to end state income tax and to make the federal government the sole taxing agency.

In 1943 Curtin showed great diplomacy and subtlety in persuading the Labor Party to agree to its great anathema, military conscription for fighting outside Australian territory – limited however by the Equator. Given the way in which the conscription issue had sundered the Australian social fabric during World War I, this was a considerable achievement. At the time, the decision was justified as necessary for the defence of Australia. Documents now available show it to have been a master stroke of diplomacy with the United States. For the US government, persuaded by its diplomats in Canberra, had complained of what it misinterpreted as Australians' lack of concern and effort for their own defence, the crucial evidence being the absence of military conscription – and such American criticism was becoming more vehement as time went on. Curtin's action silenced it.

In August 1943, Curtin and Labor, having brought Australia through its most life-threatening national crisis, were returned overwhelmingly at the general election. Soon after, Menzies, defeated but not broken, called together the leading figures and organizations on the political right to form a new and dynamic party, the Liberal Party of Australia. At this time on both sides, ideas were crystallizing that would determine the main lines of Australian political debate for the next three or four decades. Labor emphasized social justice and the belief that material security could be achieved only collectively through governmental and increasingly bureaucratic initiatives. As an alternative, the Liberals stressed that social justice could best be achieved through national economic progress based on free enterprise and the rights of individuals; they would argue, moreover, that government and collective action were always a potential threat to freedom and individual rights.

Just before the end of the war, Curtin, like Roosevelt in the United States, died in office. Curtin's profound success in leading the war effort was acknowledged by political allies and opponents alike. Indeed, for his own party, his achievement and his modesty turned him into a sort of secular saint. He was succeeded by J. B. Chifley, who almost immediately had the responsibility of informing the Australian people that the war in the Pacific had ended with the dropping of atomic bombs on Hiroshima and Nagasaki. Emotional relief burst forth. Never

since have Australia's churches been so crowded. There had been 105,900 casualties, of whom 39,300 died.

Despite separate Australian and combined British Commonwealth protests, the new US administration of Harry S. Truman refused to hold formal discussions with its allies about the Japanese terms of surrender. Australians thought the American terms much too lenient, and wanted Hirohito to be tried as a war criminal. The terms were imposed on Japan without the name of Australia even being mentioned. It may be significant that the Australian government assessed its military and economic contribution to the total Allied effort in the war against Japan at 28 per cent. The US assessment of it was only 8 per cent. It was only because of stubborn insistence by Britain and Australia that a British Commonwealth contingent, which included Australians, was allowed to be a part of the occupation forces in post-war Japan.

Post-war Developments at Home

Demobilization of the troops and their integration into civil society were achieved with little dislocation. In 1946 in the first post-war election, though Chifley appeared pedestrian in comparison with the increasing brilliance of the Liberal leader, Menzies, Labor again triumphed, achieving its greatest peace-time victory since 1910.

War had exposed Australia's vulnerability as a nation with a small population and low birthrate. The Labor government response to the perceived need for a larger population for defence and for accelerated national development was therefore to implement large-scale immigration.

NON-BRITISH IMMIGRATION

At first, Arthur Calwell, the immigration minister, hoped for ten British migrants to every foreign one, but soon recognized that this source would be insufficient for the growth envisaged. Thus, the Labor Party rejected its traditional antipathy to non-British-Irish immigration. At the same time it reduced trade union worries about immigration as a threat to working-men's jobs. For it believed its

wartime experience of controlling the economy had showed it how to ensure social welfare, and prevent any repetition of the despair of the Great Depression.

Labor's implementation of these policies of welfare and migration made the period from 1941 to 1949 especially significant. Because of the complex changes thereby begun, which continue to the present day, the new policy on immigration was probably the most important social-political decision in the whole of the twentieth century, perhaps in the whole of Australian history.

Soon after the war, thousands of displaced refugees from Europe were admitted for humanitarian reasons, just as several thousand immigrants fleeing Nazism had been admitted prior to the war. This new immigration plan at first aimed at bringing in 70,000 migrants per year, but the depressed economic conditions of post-war Europe made possible an intake of 150,000 a year by 1950. Begun in 1945, it brought in more than two million immigrants by 1970. Consistent with Australia's history, more than 80 per cent of these people benefited from assisted passages. Such population increase, and the willingness of migrants to accept the tougher and less-attractive factory jobs, made possible the industrial growth and the great development projects of subsequent decades.

This wave of immigration was reminiscent of that of the gold-rushes. But unlike that first great wave, this one also changed the ethnic basis of Australia – not without some misgivings. In fact more than half the migrants were non-British. In the early years the largest numbers were from the Baltic countries; later they were from Scandinavia, Germany, Greece, the Netherlands, Italy, and Yugoslavia. The largest groups have been Italians and Greeks and, by the same date, some 900,000 had arrived. More than half lived in Melbourne and in other parts of Victoria.

As had occurred during the gold-rushes many immigrants brought important skills, some entirely new, and immigration once again produced sustained economic growth. There were absorption pains, of course, and mutual tolerance was required (and largely achieved) between Australians and these 'New Australians' as they came to be called.

NATIONAL DEVELOPMENT

People and government wanted to move rapidly to peacetime development. But shortages of power and essential materials at first hindered the building of new houses and the construction of new industries. The long-term power solution was the vast Snowy River Project, one of the world's greatest engineering projects during the last fifty years, and the largest ever undertaken by an Australian government. The fast-flowing Snowy River in the Australian Alps on the NSW-Victorian border spent its waters in a rush to the ocean. Constructed over a period of fifteen years, a series of mighty dams and tunnels diverted its flow inland through hydro-electric power-generating stations, then into the Murray River so that the water could also be used for inland irrigation. Besides Australians, the work-force included many thousands of the migrants.

The Chifley government also contributed considerably to the prosperity of primary industry by organizing boards to aid the marketing of wool, meat, dried fruits, and other products. Even more

Prime Minister Benjamin Chifley inspects the first Holden car in 1948; the earliest motor vehicle of wholly Australian manufacture

important was the decision to retain the wartime arrangements for marketing wheat. The concerns of many farmers at what looked like creeping socialism dissipated as the new arrangements greatly lessened the effects of bad seasons.

RESPONSE TO INDUSTRIAL PROBLEMS

Although the Commonwealth Arbitration Court had awarded employees a forty-hour working week, and the needs of an expanding economy provided full employment and rising wages, such benefits were reduced by inflation. Trades union leaders took advantage of discontent to bring about a series of strikes. The situation was exacerbated by the control of crucial unions, such as those of waterside workers, electricians, and coal miners, by members of the Australian Communist Party and its sympathizers within the Labor Party.

In 1948 a quite unjustified strike by the coal miners occurred in New South Wales. After seven weeks of increasing bitterness, the Labor government under Chifley despatched troops to work the opencast mines and load the coal. Communists tried to turn this action into an additional *casus belli* but rank-and-file unionists were, by this time, so tired of confrontation and loss of pay that, widely supported by the general community, they rejected any further disruption. This was a major set-back for the Communists.

In its desire to strengthen the hand of government over the economy, the Labor Party made several partly successful attempts to control not only the state-owned Commonwealth Bank but also the private banks. Chifley then planned to nationalize all banking. It was this last move, and its concomitant spectre of socialism, that finally brought Labor's defeat at the 1949 election and ushered in a record twenty-three years of Liberal-Country Party control in the federal parliament. During the election campaign, Menzies demonstrated his understanding of the point of view of Australian women concerned at the threats to domestic life posed by strikes and shortages. Labor, with its male workers' traditions, had forgotten this fact. Some of the success of Liberal-Country Party governments derived from the good relationship between Menzies and the Country Party leader, Arthur Fadden (1895–1973), who remained treasurer until 1958.

Soon after the next (1951) election, Chifley died. He had been a man of great ability, rising from the job of train driver to prime minister of his country. His place as opposition leader was taken by Dr H. V. Evatt, a much more controversial personality.

THE PETROV SPY AFFAIR

To organize counter-espionage in Australia, Chifley had established an Australian secret service modelled on Britain's MI5, the Australian Security Intelligence Organization (ASIO). Its most spectacular coup came with the defection, in 1952, of the Soviet KGB spy, Vladimir Petrov, the most senior Soviet agent to defect to the West since General Krivitsky in 1938. Petrov brought with him documents proving Soviet espionage. Twisted allegations by the USSR and its East European Communist colonies, such as Poland, rapidly followed. After much diplomatic protest, the Soviets withdrew their embassy, expelled the Australian envoys in Moscow, broke all diplomatic relations, and announced that they would buy no more wool.

These events took place a few weeks before a general election won by Menzies. It may be that the Petrov scandal helped the Liberals. Many Labor supporters believed (erroneously) that the affair had been stage managed to that purpose, and held that view for decades. The opposition leader, Dr Evatt, launched a bitter attack in parliament claiming precisely that. As evidence, Evatt disingenuously argued that he had been in touch with the Soviet foreign secretary, V. M. Molotov (1890–1986), who had assured him that Petrov's documents were forgeries. Interrogated by ASIO and British secret-service personnel, Petrov revealed the structure of the KGB, and the names of some 500 Soviet spies worldwide. Five years later the USSR renewed diplomatic relations.

COMMUNISTS AND CATHOLICS

Australia was now a part of worldwide political and economic society and was deeply affected by the doctrinal battles of the Cold War. And, though most Australians continued to follow parliamentary principles and values in resolving their political differences, the Liberal-Country Party government was convinced this merely played into the hands of

the Communists. After all, Communists did believe in revolutionary class struggle and the undermining of all liberal-democratic governments, and had been involved in many of the industrial disputes. Though many Australians thought Menzies overreacted, Soviet archival materials show that the strategies of the Australian Communist Party were indeed being orchestrated by Moscow. Moreover, Menzies knew that no national Communist government had ever come to power through free popular election, but through internal subversion and/or rigged elections.

So in 1951 Menzies brought in a bill to outlaw the Communist Party 'for the safety and defence of Australia' and to prevent 'declared' Communists from employment in the federal public service and the unions. This bill worried many Australians because it threw the onus upon the accused to disprove such assertions. People also feared that despite the precise wording of the bill, precedents might be set for future governments to ban other political groups.

The Labor Party used its majority in the Senate to delay the bill, then passed it, but it was soon declared unconstitutional by the High Court. Menzies then held a referendum on the issue to change relevant sections of the constitution but this, too, was rejected. This was not the end of the matter. Differences over Communism were to have a disastrous effect on the Labor Party.

Since the days of Cardinal Moran, the Labor Party had been strongly supported by the Catholic Church. Many of Chifley's ministers had been Catholics of Irish descent. From 1937, groups known as Catholic Action had been working to counteract Communist influence in Australian organizations, especially in the trades unions. By the mid-1950s, such groups were not only promoting Catholic interests and points of view in every facet of Australian life but becoming increasingly concerned with Communist infiltration of the Labor Party.

In late 1954, the Labor Party leader, Evatt, his own position under threat, made a bitter attack upon what he called the 'tiny minority of Catholics' who were, he said, trying to undermine the Labor movement. This allegation annoyed many Catholic Labor voters, already worried by Evatt's seemingly pro-Communist behaviour during the Petrov case. Some Catholic Labor MPs alleged that Evatt was trying to

split the Labor Party. As 1955 progressed, there developed an unbridgeable rift between Catholic Action and their supporters, and the rest of the party. So for about twenty years there were two Labor Parties, the official party, the ALP, and a smaller rebel party, mostly Catholics, known variously as the Anti-Communist Labor Party or the Democratic Labor Party (DLP), or the QLP (in Queensland). Each claimed to embody the true spirit of the historical party. The Catholic vote was split and much bitterness engendered at parish level. For instance, Calwell, the Catholic deputy leader of the ALP, was denounced from the pulpit of his own parish church.

The DLP gradually lost its influence and became politically null, the longest-lasting branch, Victoria, going into liquidation in 1978. Meanwhile, this dissension played into the hands of the Liberal-Country Party, the DLP vote helping to keep Labor out of power in many state and federal elections.

ECONOMIC DEVELOPMENT

Menzies was a profoundly effective prime minister. During the long years of Liberal-Country Party government in the 1950s and 1960s, Australia prospered. Because of Australia's enviable political stability, American and British investment was strong. In 1964, the London *Financial Times* proclaimed the Australian economy the world's healthiest. The country's population grew, much more through immigration than by natural increase. In their efforts to integrate into the community and give themselves security, the New Australians strengthened the economy through their hard work. Secondary industry was expanding. In the general prosperity strikes were less common. What has been called 'people's capitalism' was growing as many of the middle-class and some working-class people bought shares. The cities further invaded the bushland. The great Snowy Mountains scheme came into production and, with its water, new irrigation areas were opened.

Mineral discovery continued. In 1802, during his circumnavigation of Australia, Matthew Flinders had noticed the great red cliffs of Weipa which stretched for 100 miles along the west coast of Cape York Peninsula in the far north. More than a century later these red cliffs were recognized as being composed of aluminium ore, bauxite, and in

1956, mining began there at one of the world's greatest deposits. This was just one of many mineral finds in this and the following decades, all of which helped continue the boom. By this time, too Mount Isa in north-west Queensland, one of the world's largest silver-lead and zinc lodes, also finally came into full production after some decades of problems.

Post-war Developments: Foreign Policy

THE UNITED NATIONS

Labor's success with its wartime economic planning encouraged it to hope that the world might also be made a more predictable and safer place. So, from the very first meeting in 1944 during the war, it wholeheartedly supported the United Nations Organization, and Australia was one of the original signatories. Dr Evatt, in particular, worked for the strengthening of this world body and, for a session, was president of the General Assembly.

RELATIONS WITH BRITAIN

In a speech, delivered shortly after he became prime minister in 1939, R. G. Menzies emphasized that, although in its approach to European affairs Australia depended on the advice given by Britain, in the Pacific region Australia had 'primary responsibilities and primary risks'. Given its geographical position, Australia's international perspective was, he said, necessarily different because, 'what Britain calls the Far East is to us the Near North'.

The Menzies government realized that Australia now needed its own diplomatic representation in its own region and, in 1940 ambassadors were appointed to Japan, China, and the United States, the first such appointments in Australia's history. Diplomatic relations of this kind were to be greatly expanded after the war.

In 1939 Menzies still believed, as did most contemporary Australians, that the unity and continuation of the British Empire were of utmost importance. Nevertheless, he was aware and his words implied, that the governments and peoples of the dominions might legitimately look at

the events of the world from different perspectives and so have different emphases on how the various parts of the Empire might best be preserved and defended. As events showed, this did occur during World War II when, after the entry of Japan, Australian troops were brought home from fighting the Italians and Germans to defend their own shores. After the war, this trend in Australia to regional thinking, and to a concomitant slow separation from Britain became more obvious with the passing of each decade.

DEFENCE AND SECURITY

In 1947 in South Australia a base and a town for developing guided missiles were established at Woomera, named after the ancient Aboriginal spear thrower. Here, Australian and British scientists co-operated to design, produce, and test missiles.

The elongated triangle of the guided-missile range extended across 1200 miles of desert into Western Australia. During the following years several thousand miles of dirt road had to be surveyed and bulldozed to be used for recovery and research. Today, some of these roads provide access to desert Australia for adventurous tourists, the main one being known as The Gunbarrel Highway. Later, Woomera became the base for testing British atomic weapons some 500 miles further into the desert at Emu and Maralinga. Hydrogen bomb tests were also conducted on the Monte Bello islands off Western Australia. At this date relationships between Britain and Australia were close and personal, and the large majority of Australians took pride in the fact that their country was involved in military research of such significance. A later, less pro-British generation held an inquiry into the radio-active side-effects of the tests and this suggested that Britain should pay for the clean-up.

BRITAIN AND EUROPE

Britain's application to join the European Common Market in 1964 confirmed that it, too, was beginning to understand that in a changing world its own interests must take first place over British Common-wealth interests. Although the French president, Charles de Gaulle (1890–1970), vetoed that application, and a second one in 1968, the

signal had been given. When Britain was at last allowed to join, in 1972, Australians and their government accepted the fact relatively calmly. In 1964, however, many Australians were dismayed that Britain should plan to desert them by joining a politico-economic organization that included former enemies. But, over the years, Australians, just as much as the British, had allowed the politico-economic link to dissolve. The chance of Australians to cement a permanent economic relationship with Britain had really been lost long before, in the 1880s and 1890s, when Australian statesmen would have nothing to do with Empire federation.

THE KOREAN WAR

The events of World War II had forced Australia into the American orbit. After the war, this continued on political and on cultural fronts. When China was taken over by the Communists in 1948, it seemed to many Australians that the defeated Japanese in their region had now been replaced by an equally threatening and much larger menace. When Communist North Korea invaded the South in June 1950, shortly to be massively supported by China, Menzies had a patent example of Communist aggression, and an opportunity to show the United States that Australia remained a reliable ally.

Initial support came from the Australian navy which acted in concert with the British and, when the UN appealed for assistance, some 17,000 Australian ground troops (all volunteers) were also sent. Perhaps the most extraordinary Australian engagement occurred in October 1950, when at the Battle of the Broken Bridge (Kujin), a bayonet charge killed 270 North Koreans, captured 239, and lost only 8 killed and 22 wounded. But the overwhelming military effort in the war was supplied by the United States.

By the time the war ended in stalemate in 1953, after long-drawn out negotiations, the importance of the Australian government's efforts at pressing for a defence relationship with the United States had been demonstrated. This relationship had been made formal with the signing of the 1951 ANZUS Treaty (Australia, New Zealand, United States). ANZUS was vague regarding specific commitments but showed that Australians valued US support.

Communist China remained problematic in Australian defence thinking, not so much for any direct threat it might pose, but for its encouragement of Communist aggression in south-east Asia. Australia, paralleling US foreign policy, strictly refused diplomatic recognition to the Communist government, claiming such recognition would weaken the resolve of the non-communist nations of south-east Asia, and harm the Australian relationship with the United States. The second claim was certainly true for America resolutely refused such recognition until 1972. But contact with China was never entirely lost and, during the 1950s and '60s, the Australian Wheat Board pragmatically organized huge sales of wheat to that country.

SUEZ AND HUNGARY

In 1956 two international crises had important effects on Australia. When Colonel Nasser of Egypt seized the British-French-owned Suez Canal without compensation, Menzies was in the United States on a post-election tour. He immediately conferred with Eisenhower and the Canadian prime minister, and also contacted the leaders of India, Pakistan, and Ceylon. Menzies also led the delegation of canal-user nations, which tried, unsuccessfully to persuade Nasser to withdraw.

With Menzies's approval, Britain and France sent in troops and recaptured the canal but, opposed by the UN and most of the world including the Russians and the Americans, after two months withdrew their forces. The UN policed the canal area in the interim prior to Egyptian control. Perhaps the final indignity for Australia was the destruction by an Egyptian mob of a splendid memorial to the Australian Light Horse which had defended the canal during World War I. Meanwhile many Australians were left wondering just how the US would have reacted had Panamanians seized the US-controlled Panama Canal.

To the disgust of most Australians, Khrushchev's Soviet tanks crushed the freedom revolt in Hungary in October 1956, while the world looked on. Australians were provided with another instance of clear Communist aggression. An Australian migration officer was immediately despatched from Vienna to the Hungarian border, and some 15,000 Hungarian refugees migrated to Australia. They became another

Anti-communist election pamphlet of 1966

cohesive, strongly anti-communist ethnic group. Menzies and Calwell, the latter soon to be opposition leader, vigorously condemned the Soviet action. In the otherwise excellently managed Olympic Games held in Melbourne in December 1956, in the water polo final, the Soviet and Hungarian teams bloodily fought one another in the pool.

Despite the lack of US support for Suez, Menzies agreed to purchase American troop-carriers and fighters for the RAAF, a move that determined future air-force development. Changes in defence plans were also announced. These reduced the numbers of Australian troops and concentrated on developing a smaller, better-trained, élite corps, able to move quickly to trouble spots in the region.

THE VIETNAM WAR

In 1954 the South East Asia Treaty Organization (SEATO) was established as a (weaker) imitation of the North Atlantic Treaty Organization. Besides an enthusiastic Australia, its other members were Britain, New Zealand, the United States, Thailand, and the Philippines, its intention to show a united front against Asian Communism. When SEATO met in Australia in 1957, strong anti-Communist feelings were expressed, the delegates agreeing that the main threat to peace was the presence of Communist subversion within south-east Asia. Though SEATO as such was not formally involved, by the mid-1960s, the worst fears of its members were realized with the outbreak of the Vietnam War, which followed the French loss of North Vietnam to Ho Chi Minh's Communists. On one side were the North Vietnamese Communists supported by the Southern Communist Vietcong; on the other, South Vietnam supported by the United States, and much smaller commitments from US allies with an interest in the region, including Australia (from 1966) and South Korea.

This ever-worsening war opened the question of how far Australians should concede their political initiative to secure US protection. Involvement polarized Australian opinion. For seven years, increasingly massive street demonstrations, led mostly by Labor politicians such as J. F. Cairns, marched in capital cities. They voiced their opposition to Australian participation in the war and the call-up of young national-service men, and sometimes supported the Communists. For the first

Australian soldier on patrol in the Vietnam war

time ever, returning soldiers were not uniformly regarded as heroes. Some were vilified by the left.

In all, more than 47,000 Australians served. They fought in Phuoc Tuy province south-east of Saigon, a difficult jungle area. The Australian approach to the war was completely different from that of the Americans' huge firepower and, per individual, resulted in much greater success. As in New Guinea in World War II, the Australians used small patrols moving quietly through the jungle. As one officer put it: 'Conventional soldiers think of the jungle as being full of lurking enemies. Under our system, *we* do the lurking.' The most memorable Australian battle was Long Tan in August 1966. In response to a Communist attack on their base, 108 troops advanced into a Vietcong trap set by more than 2500. The Australians formed a circle in the jungle and beat back waves of suicidal attackers. Together with an artillery bombardment from the Australian base, a careful attack on the

Vietcong rear was organized. Three hours later, the Vietcong retreated leaving at least 245 dead for the loss of seventeen Australians.

With his slogan, 'All the way with L.B.J.' (Lyndon B. Johnson, the American president), Harold Holt (1908–67), Menzies's successor as Liberal prime minister, was a pugnacious supporter of American policies. After he was mysteriously drowned off a beach south of Melbourne in 1967, the support for Australian involvement in Vietnam rapidly declined. So, when it became clear that the United States intended to withdraw from the war, Australia also withdrew.

NEW RELATIONS WITH JAPAN

During the 1950s and '60s, as relations and trade with Britain lessened in importance, they reciprocally increased with the wartime enemy, Japan. In 1957, though opposed by the returned servicemen's association, Australia signed a trade agreement with Japan and, in a sense, set aside wartime hostility. With respect to economics, this move was far-sighted. With its almost insatiable thirst for coal and metals, Japan soon became Australia's best customer. By 1966–67 Japan was already buying more Australian goods than was Britain, some 21 per cent of Australian exports going to Japan, 14 per cent to Britain, and 13 per cent to the United States.

In later decades the Japanese connection would continue to increase. Japanese tourists would come to Australia in increasing numbers, with Japanese companies providing much of their accommodation in hotels and tourist resorts. Japanese capital would also be invested in mining and retail outlets.

ASIAN NATIONALISM

World War II had shown that, despite the shared values, Australia could not base its security on loyalty to Britain. Asian nationalism, though not produced by the war, was made viable by it, through the encouragement of the Japanese once they realized they were losing the war. Australians had to accept this new reality.

To show its willingness to be a good neighbour to Asian countries, in 1950 Australia joined the Colombo Plan. Over the next decade the equivalent of half-a-billion dollars was spent on projects technically to

assist Asian countries, and to offer thousands of scholarships for Asian students to study in Australian universities.

Australian policies towards the new nation of Indonesia, which succeeded the Dutch colonial regime, were another sign of new conceptions. For the first time in its history, Australia now had a near neighbour not only controlled by Asians but with an overwhelmingly Muslim population. During the Indonesian struggle for independence from the Dutch, however, the Australian government and many Australian organizations, such as the waterside workers (dockers), had consistently supported the Indonesians. The Labor government established these policies and the Liberal-Country Party governments which followed tried to continue them. The intransigence of the Indonesian leader Achmed Sukarno, at times made this difficult as, for example, during the campaign the Indonesians called 'Confrontation', when Indonesia tried to annex Malaysian territories in Borneo. Australia sent 4000 troops who, together with those of Britain, ended the Indonesian aggression.

Alongside British and other British Commonwealth forces, from 1950 to 1960 Australia had also helped Malaya (now Malaysia) to suppress a Communist insurgency. This was the world's first example of the successful elimination of Communist guerillas.

RESPONSIBILITIES IN NEW GUINEA

Papua had been annexed in 1884 but German New Guinea first came under recognized Australian control as a mandate from the League of Nations after World War I and was converted into a UN trusteeship after World War II. Dominant Australian sentiment upheld the idea of an ultimately independent New Guinea.

Many facts made problematic the attempt to develop Papua-New Guinea into a parliamentary democracy and a single nation: the thousands of different tribes and languages; their ancient antipathies; their physical separation by vast impenetrable ranges and jungles; the Stone-Age state of the highland peoples; bizarre beliefs, for example that dreams are coterminous with reality; and the fact that people in Bougainville Island identify with the Solomons rather than with Papua-New Guinea. To complicate matters, UN committees tried to force

Australia's hand into granting precipitate independence. Independence was granted in 1975 although Australia has continued to give this new nation significant financial help.

In the 1960s, the other half of the island of New Guinea, Dutch New Guinea, became a source of concern for Australians, when Indonesia led by President Sukarno, moved to annex it. Australians believed that all the Melanesian New Guineans should become one nation. But supported by an inconsistent United Nations and not opposed by the United States, the West New Guineans were forcibly incorporated into Indonesia in two stages, in 1962 and 1969. It was a sign of Australia's now very limited leverage in international affairs that the Australian government simply had to accept the situation. In recent years, refugees from the guerilla war which has resulted, have attempted to enter Australia.

Politics, the Economy, and Culture since 1972

During the last three decades, Australia has shared the same economic problems such as unemployment and 'stagflation', as other Western nations. The economy continued to change; investment was opened to overseas' capital, and privatization became common; entrepreneurs took Australian products and ideas to the world. In a global economy, Australian business and government found decreasing room for decision-making. Trade with Japan and other Asian nations expanded. In the 1980s and '90s, the two main political parties in turn enjoyed long periods in federal government, their implemented policies differing mostly in degree.

Australian nationalism was boosted in the late 1960s and during the short-lived Whitlam Labor government (1972–75), and this trend continued irrespective of party. Culturally and socially, Australia continued to diversify, with radical changes in attitudes; with the 1980s came increasing numbers of Asian immigrants, and astonishing changes in Aboriginal policies. The special relationship with Britain continued to diminish and, as the end of the century approached, the question of republicanism intensified.

The 1970s and their Labor and Liberal Governments

Coming in the wake of changing Australian social attitudes, the election of Labor late in 1972 is often seen as one of the watersheds of Australian history. Labor and its leader, E. Gough Whitlam (1916–), were determined to make up for twenty-three years in the federal

wilderness. Though they continued some initiatives begun by the Liberal-Country Party in its last two terms of office, they developed many new programmes.

THE LABOR GOVERNMENT OF GOUGH WHITLAM, 1972–75

Whitlam was one of the great phenomena of Australian politics, large in size, large in ideas and abilities. He implemented many Labor policies even before the cabinet was appointed, claiming that the new government would lose its impetus if he waited until members for his cabinet had been selected by the Labor Party Caucus some weeks later. Thus, in the early days, he personally took charge of thirteen portfolios and, with the help of the deputy prime minister, Lance Barnard, who held fourteen, and the accommodating governor-general, Paul Hasluck, made decisions touching most areas of policy.

In a breathtaking first few months, decisions large and small were taken. Full diplomatic relations were opened with Communist China and North Vietnam, and the salacious book, *Portnoy's Complaint* was released from the censors; the last troops were withdrawn from Vietnam, and free rice was sent to Indonesia; wheat sales to rebel Rhodesia (now Zimbabwe) were banned, and sales tax was removed from the contraceptive pill; military national service was abolished, and the excise duty was removed from wine; Whitlam's Labor friend, Sir John Kerr (1914–90), chief justice of New South Wales, was appointed the new governor-general, and South African sports teams were prevented from touring Australia.

In its three short years in office, Labor behaved as though money could solve all problems, and it was used lavishly.

An Australian Council for the Arts had been established in 1968 by John Gorton's (1911–) Liberal-Country Party government (1968–71) to fund the arts. The Whitlam government converted this into the Australia Council which dramatically increased contributions to drama, ballet, literature, and other arts and crafts. A National Film and Television School was established. FM radio and colour television were introduced. The new government had its own conception of high culture, and, through a points system, forced this upon the television

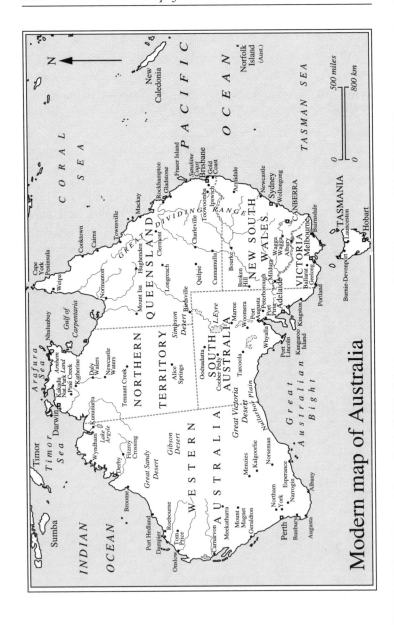

Modern map of Australia

channels at the expense of forms of entertainment ordinary citizens preferred.

In education, university fees were abolished, and academics received large pay rises. An Australian Schools Commission was established to give the federal government some direct influence in primary and secondary education, previously an entirely state matter. Special schools for Aborigines were set up.

The place of women in national life was encouraged. Women were at last given the same wages as men. A special adviser on women's matters was appointed. A new Family Court was established to deal with divorces and related matters. Divorce was simplified so that an unsatisfactory marriage could be terminated after a year's separation. Such simple divorce necessarily lessened the significance of marriage as an Australian institution, and brought changes in social relationships.

Huge areas of the outback were set aside for national parks, large grants were made to preserve historic buildings, and plans put into motion to concede large areas to Aborigines in the Northern Territory, the only region besides Canberra in which the federal government then had some direct influence. The high point of social legislation was the establishment in late 1975, after strong opposition from the medical associations, of a universal health scheme. Called Medibank, it paid most of the costs of medical services. The government boasted, rightly, that it had introduced more legislation than any previous administration.

For the first time in a quarter-of-a-century, under pressure from the left of the Labor Party, Australian foreign policy had a leftward lean. Besides the diplomatic recognition of Communist countries already mentioned, Australian troops were withdrawn from Singapore and participation in SEATO ended. The 1941 Soviet annexation of the three Baltic countries of Estonia, Latvia, and Lithuania was recognized. Australia was the only Western nation to do this, and it brought permanent antipathy to Labor from most Baltic immigrants. Protracted but ineffective protests, including an action in the World Court, were made against the French atomic tests in French Polynesia but nothing was said about similar tests, a similar distance away, by Communist China. The political views of immigrants were no longer made a criterion of admission.

AUSTRALIAN NATIONALISM

Whitlam and his colleagues believed that Australian mores and Australian national feeling had been insufficiently promoted by previous governments. As the core of the new policy, a system of honours, the Order of Australia, was devised to replace the imperial system of OBEs and knighthoods. Final legal appeals to the Privy Council in London, the last constitutional link with Britain, were formally ended. No longer was there to be special treatment for British migrants or special attempts to attract them to Australia. After a referendum, *God save the Queen* was discarded, and a new national anthem, *Advance Australia Fair*, adopted. In strengthening Australian nationalism, Whitlam began a trend that has continued.

In government buying, preference was given to Australian companies. Complex plans were made by the energy minister, Rex Connor, to buy back large sections of foreign-owned Australian land and industries, and to develop alternative energy sources within Australia. These plans unwisely involved very unorthodox ways of raising huge sums of money from Middle Eastern sources. Although to Connor's chagrin the money was never actually borrowed, in the accompanying scandal damage was done to the government's image.

ECONOMIC PROBLEMS

The government's economic policies, however well intentioned, weakened the Australian economy at a time when the world economy was in difficulties. Prices of houses increased by more than 30 per cent in two years. The previous McMahon [Sir William McMahon (1908–88)] Liberal government (1971–72) had experienced, and now Whitlam's government was experiencing, a condition for which the world's economists had to coin a new term, 'stagflation', a combination of stagnant economic growth and increasing unemployment, but also with accelerating inflation – a problematic context for change and experiment. Stagflation put Whitlam in a difficult position because of the strong expectation of change that brought his party into office.

During the first year, in attempting to achieve economic order, the government cut tariffs by 25 per cent, and revalued the Australian dollar

upwards three times. Business confidence plummeted. Whitlam also failed to consult sufficiently with the trades unions, Labor's traditional supporters. His difficulties were compounded: in October 1973, the Organization of Petroleum Exporting Countries (OPEC) cut oil production and, within a few months, oil prices had trebled; on Christmas Day 1974 Darwin, capital of the Northern Territory, suffered severely from a cyclone; and a few days later, the great bridge in Hobart, Tasmania, was severed by a massive ore-carrying freighter.

Meanwhile, there was damaging intra-party conflict with numerous ministerial sackings. Whitlam had to resort to using the final authority of the governor-general to dismiss two such ministers who refused to resign: J. F. Cairns and C. Cameron. Perhaps he failed to notice the constitutional precedent being set.

Because of trouble with the opposition-controlled Senate, Whitlam called an election in May 1974 and his government was returned, but with a smaller majority. Some fiscal constraint was introduced towards the end of Whitlam's period by the sound work of the new treasurer, W. G. Hayden (1933–) who, himself, later became leader of the Labor Party, and then governor-general. But people were becoming disturbed by all these changes and by the series of scandals. At the same time, the opposition Liberal-Country Party still had a majority in the Senate.

WHITLAM'S DISMISSAL AND CONSTITUTIONAL CRISIS

Drilled into line by the Liberal Party leader, Malcolm Fraser (1930–), descendant of an old squatter family in western Victoria, the Liberal-Country senators refused to pass the money bills necessary for the running of government. This tactic precipitated the greatest constitutional crisis in Australia's history. Though within the letter of the federal constitution, such action was neither within its spirit nor within the working parliamentary conventions that had grown up over the decades. For weeks the two houses of parliament were deadlocked. Without money, government ground to a halt. Meanwhile, many Liberal supporters were unhappy with the situation that Fraser had provoked for it was setting a bad precedent. (The first small precedent for the Senate to dispute the budget had occurred in 1967. Labour

senators in combination with the DLP rejected the Liberal-Country government plan to increase postal charges.)

On 11 November 1975, Sir John Kerr, the governor-general, and Whitlam's own nominee, resolved the impasse with an unexpected and unprecedented move. He judged that parliament had become unworkable. To the anger of Labor supporters and the acquiescence of the Liberal-Country Party, Kerr invoked his prerogative and dismissed Whitlam. Kerr then appointed the opposition leader, Malcolm Fraser, acting prime minister to pass the supply bills through the Senate. And he ordered a general election of both houses of parliament so that the impasse could be finally solved by the votes of the people. In Britain, the Queen would not have dared to do such a thing. It was in fact some 200 years since the closest precedent had occurred there. Understandably, Whitlam was outraged and promised a dire future for Kerr. Labor firebrands spoke of mass civil disobedience and revolution.

The governor-general's action has been debated ever since, passionately at first, more calmly later. The consensus has become that the letter of the constitution allowed him to dismiss Whitlam but the spirit did not, or at least, not so quickly. Had Kerr enquired, he would have found several wavering Liberal senators who, with a little persuasion, might have deserted Fraser. In Kerr's favour, it can be said that, while normally the position of governor-general is ceremonial, a key reason for the existence of the office is to resolve crises and impasses which the politicians themselves cannot, and, in Kerr's judgement, this is precisely what he did. Whitlam, too, could have acted differently. He seems to have had no contingency plans. In treating Kerr as a mere figurehead he had made a fatal mistake. Acting immediately, he might have had his ministers in the Senate withdraw the money bills, leaving Fraser as acting prime minister to get them through the House of Representatives against a hostile Labor majority.

The majority of Australians are conservative people. They have to be forced into radical change by active minorities or arrogant governments, and they do not like it. Though it was a surprise to Whitlam it was no surprise to students of the Australian character that a majority of Australians were tired of his government and, in the subsequent election, Fraser triumphed with the largest margin in Australian federal

history: ninety-one out of 127 seats in the lower house and a workable majority in the Senate. The dire threats uttered by some Labor supporters remained just that. The Australian political process had once again shown its resilience and its rejection of violence. Very soon the normal carping political calm descended on Canberra and on the continent in general.

Instead of resigning immediately after the election, as good manners and political perception recommended, Kerr remained in the governor-general's position for eighteen months, bitterly resented by Labor supporters.

THE LIBERAL-COUNTRY PARTY GOVERNMENT OF MALCOLM FRASER: 1975–83

Like Whitlam, Fraser was large in size and, while perhaps not as profound a political thinker as his Labor opponent, he was equally confident of his own abilities. In the one brain, Fraser combined an odd mix of the conservative and the radical, and forced this mix on his government. He spoke individualism but increasingly implemented collectivism and, in fact, further developed many of Whitlam's initiatives.

In sharp contrast to Whitlam, however, he tried to create business confidence, his economic policy was based on cuts in government spending, and he came to be remembered for his aphorism, 'Life was not meant to be easy'. He encouraged mining by reducing the compulsory Australian-owned proportion in companies from 50 per cent to 25 per cent, so attracting overseas' capital. And he persuaded the mining sector to present a united front in bargaining with overseas' interests, such as the Japanese steel-making consortiums. Despite determined opposition, uranium mining, banned by the Labor government, was also allowed to be resumed under strict controls. Interestingly, the trades unions which had given Whitlam trouble calmed considerably under Fraser.

Economic recovery was difficult, however, because Australian manufacturers were experiencing increasing competition from Japan and from south-east Asia. Although in 1958, for instance, half of all new cars sold were Australian-made Holdens, by 1979, this proportion

had fallen to a quarter while Japanese vehicles had risen to a half. Thus, most of the worst unemployment occurred in industrial cities such as Wollongong and Newcastle.

Several years of drought at the end of the Fraser period, and in 1983, and some of Australia's worst bush-fires in forty years caused further problems. In 1980, Fraser established a royal commission to enquire into the actions of the ship painters and dockers' union (FSPDU), a union known for its violence and questionable practices. The findings revealed major criminal activity including murder but, at the same time, uncovered systematic tax fraud that involved not just that union and other unions but numerous public companies, and apparently implicated many prominent individuals.

Personally aloof (known in his own party as 'the Prefect'), Fraser had a legalistic conception of morality and expected an unpractical rectitude on the part of his ministers, dismissing several of them for peccadilloes so very minor they would go unnoticed in most of the world's governments.

A policy known as the 'New Federalism' was proclaimed, its objectives a clearer definition of the respective powers of the federal and the state governments but, despite the talk, the balance of power remained substantially the same. One exception was the delegation to state governments of rights in offshore mineral exploration.

Fraser was able to replace Kerr with successive appointees to the office of governor-general who brought more sensitivity to the post, and began reconciliation with the Labor Party: they were Sir Zelman Cowen and Sir Ninian Stephen. In 1980, in an important development, a new party, the Australian Democrats, was established under the leadership of the erstwhile Liberal, Don Chipp. This was a deliberately middle-of-the-road party which, since that time, in association with independents and environmentalists (Greens), has held the balance of power in the Senate.

In foreign policy, Fraser often recognized oppression for what it was. He rejected apartheid in South Africa and Communist dictatorship in the USSR, especially when it invaded Afghanistan, and he supported the emergence of the new black-majority nation of Zimbabwe. So he opposed sporting contacts with South Africa, and Australian

participation in the Moscow Olympic Games – though a team did attend. Meanwhile, Whitlam's policy of recognizing China had improved Sino-Australian relations, and they remained generally amicable under Fraser. He also extended Whitlam's multiculturalism, and established an ethnic television channel in all states.

Social Changes

As in other Western countries, the 1960s and '70s were marked by substantial changes in values, attitudes, and behaviour, especially among the young.

From the early 1960s attendance at churches had steadily declined, first in the several Protestant denominations, later among Roman Catholics. At the same time, less-mainstream religion grew, with small numbers being attracted to Indian religions and large numbers to fundamentalist Christian sects. So, as with many other aspects of Australian culture, American religious attitudes were imported. Islamic adherence also increased, with the immigration of people from the Middle East.

Overall decline in church attendance was related to new, rebellious attitudes in the young, encouraged by contemporary scientific developments such as the contraceptive pill. Anti-authority actions by American and European students were imitated in Australia. Suddenly, Australian college authorities had to concern themselves with unprecedented disruption and subversion from within – sometimes with larger political motives. This pressure achieved significant student control in institutional government.

As part of the challenge to traditional values, the consumption of illegal drugs increased. Senior personnel in the New South Wales police force were involved in drug trafficking, and there was probably corruption at a high level in state government. The federal government thought it prudent to take over some of the nation's anti-narcotics work.

Censorship of sexually explicit matter in books and films was challenged, and governments withdrew many regulations. Some of this liberalization was a response to social pressure, some was originated by

governments themselves: particularly that of Don Dunstan (1926–) in South Australia, in 1970 the first state to legalize abortion. There were regional differences, too. After South Australia introduced the nation's most liberal pornography laws, for the next two decades it experienced a dramatically higher incidence of rape than did Queensland which retained Australia's most restrictive pornography laws.

Feminists and homosexuals began to be heard, and organized protests – one of the most logically argued books on women's liberation, *The Female Eunuch* (1970), was written by the Australian, Germaine Greer (1939–). Changing attitudes to marriage meant that illegitimate births rose from 8 per cent in 1966 to 18 per cent in 1986, and provision of government-subsidized child-care centres facilitated the entry of married women into the workforce. As well as the extremism always present in such efforts, there was good common sense in much of this pressure for change. Until the mid-1970s, it had remained difficult for Australian women to obtain bank loans without the backing of a male family member; until 1972 most women had been paid less than men for doing the same job; and, until the changing attitudes of the 1970s, homosexuals had been persecuted, and policemen had undue control of public sexual morals.

At the same time, despite all the challenge to traditional ways, family values remained cherished by the substantial majority of the population, and many people were very satisfied with their lives. A thoroughly researched study in 1977 found that Australia was 'not a terribly dissatisfied society', with just 7 per cent of the sample saying they were very dissatisfied about the family financial situation, and only a quarter saying they were somewhat dissatisfied.

Sport changed in the 1970s, too. Television began to pay large fees for rights to cover major sports such as the rugby league and Australian football finals, and players demanded much higher payment. Even cricket, that very Australian sport, changed. The media magnate, Kerry Packer (1937–) secretly signed up most leading Australian and overseas' players and promoted cricket specially arranged for his television channel, with night matches, modified rules, and players in garish coloured uniforms instead of the traditional elegant white –

'pyjama games' journalists called them. Such games began to capture larger crowds than did traditional matches. Australian sport was becoming 'professional' in the sense that players could now earn their livings, or even make fortunes, 'unprofessional' in the sense that some players no longer valued the game intrinsically. In 1997, to much disillusion, there was a threat by cricketers to go on strike.

Nevertheless, the fact that so much Australian effort continued to be channelled into sport was perhaps a cause for pride, if it meant that it diverted aggression away from those banes of history, militarism and internal political violence, and so made Australia a good neighbour and a safe place to live.

The 1980s and 1990s, and their Labor Governments

'BOB' HAWKE AND PAUL KEATING

Meanwhile, just before the 1983 election, there had been a palace revolt within the Labor Party and, despite his successes, Hayden was replaced by R. J. L. 'Bob' Hawke (1929–). Under this new leader Labor regained power. Though a relative newcomer to parliament, Hawke had been an aggressive and effective General Secretary of the Australian Council of Trade Unions (ACTU) for more than a decade. His treasurer was Paul Keating (1944–), a professional politician since his early twenties, later to oust Hawke from the prime ministership. Because the Democrats held the balance of power in the Senate, and promised never to use the Senate to force an election, Hawke was free from the threat that had destroyed Whitlam. In their following fourteen years of record Labor rule, controversial initiatives by these two men would change the face of the Australian economy and of land ownership.

Hawke had learned much from his ACTU experience, and mini-mized Labor Party in-fighting by awarding each party faction impor-tant cabinet positions. 'Consensus' was to be one of his key words. He achieved business and union co-operation by calling 'The Accord', a national economic summit of union leaders, leading business people, and leading politicians. To stress the significance of the occasion, this gathering met in Parliament House – the first non-parliamentary use in

the building's history. 'The Accord' helped achieve some six years of reasonable industrial calm. Unions agreed to curb their wage demands, and business leaders to moderate their dividends.

THE PROBLEMATIC ECONOMY

In contrast to the frenzy of the Whitlam Labor years, Hawke advocated 'a sense of gradualism'. This signalled a different approach from previous Labor Party governments and was widely approved by the community. Indeed, with the possible exception of Curtin during the war years, Hawke achieved greater popularity than any other prime minister. At times his approval rating was an amazing 70 per cent – owing to his enduring populism, for Australians are a nation of levellers; and Hawke's nasal accent and craggy smile exuded a down-to-earth Australianism.

Another characteristic which endeared Hawke to the electorate was his support of sport. He reinstituted the cricket tradition begun by Menzies of a 'Prime Minister's XI' playing against visiting national teams. Fortuitously, during his first year of office, an Australian syndicate, led by the Western Australian tycoon Alan Bond, managed to wrest the America's Cup, the world's most prestigious yachting trophy, from the New York Yacht Club – the first non-American win in 132 years. All Australia cheered and Hawke identified closely with this success.

Australian federal governments stand or fall by their management of the economy and, for the first few years, happily aided by the breaking of the long drought and the consequent boost to farming, Hawke and Keating acquired a reputation for soundness. The national rate of economic growth was comparable to the leading OECD (Organization for Economic Co-operation and Development) nations.

Encouraged by these good relations with business and with labour, overseas' investors began to look again to Australia. In an attempt to make Australia economically more competitive, Hawke then made two unprecedented moves, which Fraser had merely considered. That a Labor government should adopt them was astonishing. The Australian dollar was allowed to 'float' on foreign-exchange markets, and regulations on stockbroking and banking were removed. In the next three years the dollar fell in value by about a third. By July 1986, it had

reached its lowest level ever: US 57.3 cents. Suddenly, the four main banks – the government-owned Commonwealth Bank and the three large private banks – were beset by competitors from Britain, the United States, and Asia. Within a single year more trading banks established branches in Australia than had been set up in all the previous years since federation. In 1984 a tenth of all companies were taken over. The rich did better than the poor: in 1986 the number of millionaires increased by about 10 per cent, the number of new unemployed by a similar percentage. It was a sign of a changing economic environment that the figures for unemployment among the young remained higher than for the rest of the population. Gradually it became clear that the first half of the traditional Australian vision of full employment coupled with social security was gone, perhaps for ever.

These radical moves did little to strengthen the economy. Competition made the banks incautious. Huge debts were incurred by state government instrumentalities, by corporations, and by entrepreneurs. A significant part of this money was used in take-over bids and other news-making actions that did little to improve productivity.

During these years of Labor rule, the opposition tried five different leaders: John Howard, three others, then Howard again. Howard and most Liberals admired the free-enterprise successes of Margaret Thatcher in Britain and Ronald Reagan in the United States, but were unable to find a precise Australian version of their policies that might capture the imagination of the electorate. In any case, what would normally be viewed as Liberal Party policies had been introduced by Hawke's government. Nevertheless, the Liberal defeat in 1990 was unexpected. Their further defeat in 1993 was due largely to the miscalculation by the new leader, John Hewson, who showed his limited parliamentary experience by advocating a goods and services tax. This move played into the hands of the canny new Labor prime minister, Paul Keating. For meanwhile, in another party revolt, Keating had replaced Hawke whose popularity had plummeted.

In the state governments, despite promises of reform and the appointment in 1990 of the first-ever female premiers, Carmen Lawrence (1948–) in Western Australia and Joan Kirner (1938–) in Victoria, Labor was rejected for its financial mismanagement, and the

opposition Liberals and Nationals (formerly the Country Party) elected. These new state governments then made drastic cuts.

ENTREPRENEURS

In large part owing to the deregulation of financial markets, the 1980s became the great age of Australian tycoons, whose names were on everybody's lips and whose take-overs included anything small or large, as in 1987 when John Elliott and Robert Holmes à Court attempted to gain control of BHP, still Australia's largest company. But such ambitions also took in Britain, the United States, and other parts of the world. In 1987, for instance, as well as much of the Golden Mile in Kalgoorlie, and Kerry Packer's Channel 9 TV Network, Alan Bond acquired a huge American brewery, and a half control of the telephone network of Chile.

Kerry Packer, the man who revolutionized Australian cricket, a big man with big business ideas, inherited the radio and television companies of his father, Sir Frank, in 1974. During the following decades his hard-hitting style gained him a business empire, and he became Australia's richest man.

Rupert Murdoch (1931–　) inherited his family newspaper business in Adelaide in 1952, then developed it in his own way on four continents, acquiring a flamboyant reputation reminiscent of that of the British 'press barons' of the turn of the century. In 1964 he established the first Australia-wide daily newspaper *The Australian* and, within a decade, he had become the owner or major controller of newspapers and magazines across the English-speaking world. He developed a foolproof formula for boosting circulation, involving sex, scandal, crime, human interest, sport, huge headlines, and in general, conservative editorials. In 1981 he bought the prestigious *Times*, in London. In 1973 Murdoch entered the US market with the purchase of papers in New York and other big cities. Back in Australia he acquired a half share in Ansett, one of the two most important domestic airlines. To facilitate expansion of his American assets, in 1985 he took US citizenship. In the following years Murdoch further diversified into television, books, cinema, and related activities around the world, to become more influential than most prime ministers and presidents.

The quiet success of these years was the self-made television entre-

preneur, Reg Grundy (1923–). Through quizzes and game shows he became a household name, then moved into drama and was out-standingly successful. Later he developed internationally, to become the world's leading independent television provider. His persistence over many years broke into the tough corporate world of American television, prised open the British television system, and began producing in many European, North and South American, and Asian countries – thus pioneering the way for other Australian television producers and film-makers. Grundy's Australian-made *Neighbours* became Britain's top-rating programme, and equal success occurred in France, Germany, Spain, and Italy, with locally made shows. According to sociologists and linguists, *Neighbours* even began to affect the pronunciation of British teenagers. Grundy shows played in almost all countries of the world, on screens as culturally separated as Tokyo and Timbuktu. His success had nothing to do with inflationary borrowing, but was due to inventiveness and careful business sense.

These tycoons achieved wide media coverage and, Bond in parti-cular, became figures of considerable admiration. If some of them scarcely merited adulation, at least it was an exception to the traditional Australian attitude of denigrating 'tall poppies'.

The vast amount of overseas' borrowing and the corresponding interest had a disastrous effect on the balance of payments, and the usual international economic confidence in Australia deteriorated. Many tycoons eventually crashed, the Bond corporation with debts of $9,300,000,000, John Spalvin's Adstream with debts of $9,200,000,000, and John Elliott's Elders-IXL & Harlin with debts of $7,900,000,000. For a time even Murdoch's News Corporation Limited was estimated to have $11,000,000,000 in liabilities, but was sufficiently powerful and diversified to continue in business. Some tycoons went to gaol for malpractice, the most notable being Bond. The same happened to two state premiers who had unwisely dabbled in business.

NEW ECONOMIC DIRECTIONS

In 1989, in an effort to dampen demand, the Hawke government allowed lenders to charge the highest interest rates in fifty years: 20 per cent. For many, the traditional goal of average Australians to own their

own houses was no longer realistic. In the same year, the most serious challenge to the government's incomes policy came from an unlikely source, the middle-class federation of airline pilots who sought up to 39 per cent salary increases. Hawke fought them tooth and nail. With RAAF support the airlines were able to break the strike, but the economy and tourism were affected, particularly that of the island state of Tasmania. By 1994 strikes were at their lowest for thirty years.

Paralleling the economic changes of the early 1980s, in the early 1990s the Labor government made three serious, interrelated changes in economic policy. There was an intensified search for trade in the Asia-Pacific region; the government radically reduced the scale of protection for Australian industry; and it privatized many government enterprises. The last two changes were in direct opposition to traditional Labor Party beliefs and, indeed, to the policies broadly supported by all parties in Australia for about 100 years. The sacred cow of protection, so dear to the hearts of pioneers like David Syme, of early leaders of the Labor Party, and of Australians in general, was sacred no more. In retrospect, these changes can be seen as the culmination of a developing free-enterprise political philosophy, in government and in the community, which began in the latter years of the Fraser government and has continued to increase in influence to the present time. Labor Party support for such ideas seems to have derived from the belief that, otherwise, funding for government, in particular for the welfare services, would have to be seriously reduced.

The first move was really an increase of already developed policy. While about 55 per cent of Australian exports in merchandise went to Japan, China, and other east Asian countries, the Australian share of Asian imports was declining. The government wished to reverse this decline and also to diversify such exports. For Australian trade to Asia was dominated by minerals, understandably perhaps, as in the late 1970s and the 1980s, the discovery of new mineral deposits continued. The world's largest deposit of diamonds was opened in the Kimberley region of Western Australia and, a few hundred miles to the west, the undersea reserves of the north-west continental shelf provided massive quantities of natural gas and some petroleum. Soon a monster pipeline was pumping gas to Perth and its nearby alumina refineries, and semi-

frozen gas was being shipped to Japan. Booming prices for gold encouraged the development of new fields and novel methods for reworking old ones. In the Pilbara of Western Australia, the world's largest iron ore field had been opened in the 1960s by Lang Hancock (1909–92). In the 1980s, to meet Japanese needs, the world's largest open-cast mine was developed there at Mount Newman. This mineral bonanza was still insufficient to pay for all the imports or for the capital borrowed during the years of the entrepreneurs.

Tariffs were steadily reduced into single figures. These reductions may have made Australian industries more competitive, but they were still unable to keep pace with low-wage production and prices of other countries. A flood of cars, textiles, transistors, tyres, and other goods entered Australia from Japan and from the other so-called east Asian 'tiger economies' such as South Korea. This destruction of protection had deep social consequences, for it killed off many factories which gave work to migrants and to school-leavers, and whose workers traditionally voted Labor. It was also a sign of the times when, in the early 1990s, a Japanese rather than a British consortium constructed the tunnel under Sydney Harbour.

In the early 1990s, too, Keating, as treasurer, sold a third of the Commonwealth Bank to private buyers; Telecom was opened to competition; and QANTAS was partly sold to British Airways. In 1995, with Keating now prime minister, all of QANTAS and the Commonwealth Bank were sold. Labor policy had come full circle since 1949 when Chifley tried to nationalize all banking. Meanwhile, municipalities and state governments also privatized – from prisons, to electricity supply, to capital city airports.

Government also encouraged more deregulation of the work-place, and it became more common for agreements to be negotiated between firms and employees rather than, as in most of the twentieth century, between employers and a unionized industry as a whole. Workers felt an insecurity not known since the Great Depression. There was a growth in American-inspired management and productivity strategies, which were supposed to increase efficiency.

Climatic change has also affected the economy. Since 1979, Australia has experienced the eleven hottest years on record. In the same period,

inland Australia has suffered from massive dust storms, and in Queensland and New South Wales from 1993 to 1995 one of the nation's worst-ever droughts, which forced thousands of farming families from the land.

BICENTENARY

The Fraser government had established a Bicentennial Authority to plan the celebration in 1988 of 200 years of white settlement. Hawke continued this idea. Numerous bicentennial projects – national, state, and local – were instituted, the most important being that which upgraded many major roads and achieved for the first time an asphalted Highway 1, all the way around the Australian continent.

Some Aboriginal Australians, recently made aware by white archaeologists and scientists of the profound antiquity of their culture, saw 1788 as the beginning of their troubles and suggested that, far from a day of celebration, 26 January 1988 should instead be a national day of mourning.

Overseas' governments brought gifts: the United States a wing to the National Maritime Museum; Britain the sail training vessel *Young Endeavour*. Following the original route, splendid, full-size replicas of the First Fleet sailed all the way from Portsmouth and, after entering Botany Bay a few days earlier, tied up at Farm Cove near the Sydney Opera House on the morning of 26 January.

Every state capital experienced a brilliant summer's day. And every city and town in Australia held its own ceremonies and celebrations. Only Aborigines remained unimpressed, though many of them seemed caught up in the enthusiasm of the day as well. Appropriately, Sydney Harbour was the scene of greatest commemoration, and the national epicentre for the memorable day. The Opera House was the formal centre, and a large survey ship of the Royal Australian Navy served as a base for Hawke, other government dignitaries, and from Britain Prince Charles representing Queen Elizabeth II.

Led by *Young Endeavour*, some 200 tall ships from every significant seagoing nation joined the festivities and sailed in double line down the harbour, escorted by many thousands of smaller craft. Celebrations and parties continued into the small hours.

At the same time, in the largest Aboriginal demonstration in Australian history, more than 20,000 Aboriginal Australians and sympathizers marched under their own black, red, and gold flag and banners of protest, and converged on Mrs Macquarie's Chair, the stony outcrop across Farm Cove from the Opera House. Some of them had even crossed the continent in coaches from Port Hedland and Darwin. Although these were the largest protest marches since the demonstrations against the Vietnam War, and passionate speeches were made, except for one or two whites given bloody noses for sarcastic comments, there was no violence either by the marchers or by the police. As the day wore on, the Aboriginal groups settled down to observe the scene on the harbour and to listen to the celebrations and music reaching them from the other side of the cove. The Aboriginal protests were given wide and favourable coverage in the media. Indeed, in its editorial of the day, the *Sydney Morning Herald* had argued for recognition of Aboriginal grievances and for reconciliation, as had papers in other capital cities.

It was cause for pride that such divergent interpretations of the national day could take place in the same great city without significant violence. This fact itself demonstrated how deeply embedded in the modern Australian psyche, black and white, were the peaceful political processes brought to the continent by the Anglo-Celtic settlers. Thus it was appropriate that the construction of a striking and massive new parliament house in Canberra was also a bicentennial project. Begun in 1983, it was opened by the Queen in May 1988.

Great Cultural, Social and Political Changes

During the last three decades, profound cultural, social, and political changes, have been occurring in life styles and in the arts, in immigration and Aboriginal affairs, and in relation to the Constitution.

MULTICULTURALISM AND CHANGES IN MIGRANT POLICY

In the immediate post-war period government migration policy had been that of assimilation, migrants being expected to blend into the

mass and to adopt the values and mores of the host country. From the early 1970s, with the policies of the Whitlam government and its commissioner for community relations, Al Grassby, assimilation was rejected for a policy that Grassby called 'multiculturalism', which encouraged migrants to keep a pride in their ethnic heritage. In many ways this approach was admirable. Countless migrants were working hard in factories, restaurants, and corner shops, saving to put the next generation through university. They were proud of their ethnic origins, but they did not allow this to stop themselves becoming good citizens of their new land. Promisingly, many also adapted easily to democratic public life, exemplified in 1988 when N. F. Greiner (1947–), of Hungarian parentage, became premier of New South Wales.

But, by the early 1980s, multiculturalism had developed into an ultra-liberal policy which, through education and community initiatives, strongly encouraged migrants to retain their ethnic identity, too. Australia was in danger of forgetting the significance of shared values for national cohesion. Critics pointed out that the fundamental Anglo-Celtic heritage was being undervalued. They also argued that tolerance of diverse cultures, though admirable as a general principle, might also work against fundamental Australian moral and political values such as tolerance and equality themselves, as manifested, for instance, in the suppression of women in Muslim and Greek communities in Australia.

A situation was developing in which many immigrant groups felt deep antagonism: Muslims and Jews showed antipathy; for years Croatian terrorists trained in outback New South Wales to fight against other ethnic groups in Yugoslavia; soccer matches between ethnically based teams sometimes needed heavy policing; graffiti appeared on places of worship; immigrants formed their own suburban enclaves, such as Asians in Sydney's Cabramatta and Melbourne's Springvale; and Australia's first ever political assassination took place when the New South Wales state member of parliament for Cabramatta, a staunch opponent of the drug trade in his electorate, was murdered. Substantial numbers of immigrants themselves have complained that multiculturalism reduced both the economic opportunities of their children, and their chance to participate as Australians in the wider culture.

A considerable rate of immigration remains a platform of all political

parties. In the 1970s, and 80s, in a reversal of policies implemented for something like 100 years, Asian immigrants were allowed into Australia in increasing numbers. And in the 1990s, over 40 per cent of immigrants were Asian. This followed from the belief that there ought to be considerable Asian immigration because of the importance of Asian trade to, and investment in, Australia. For by the 1980s there was an official reluctance to admit that Australia could continue to have a largely European and English-speaking population without losing its economic lifeline to Asia. Critics argued that trade and investment are one thing, immigration policy another. From 1996, with the election of the Queenslander, Pauline Hanson, to the federal parliament, those who wished to reduce Asian immigration and also reverse the multi-cultural trend found a political voice. In 1997 she formed the One Australia Party, which began to acquire a following.

So despite their undoubted successes immigration and multicultural policy were also bringing problems. Nevertheless this is Australia, and Cabramatta and Springvale are enclaves, not slums or ghettos: for instance, despite its drug problem, Cabramatta's population is energetic and the suburb generally clean. Historically Australia has always absorbed its immigrants and turned them into locals. It may be that within a generation, these Asians too will be talking 'Strine' (broad, informal Australian speech) and barracking at the cricket.

LIVING WITH ASIA

The view that Australia ought to cultivate good relations with her nearest neighbours, the south-east and east Asian countries, in diplomacy and trade, was agreed to by almost all Australians, and federal governments have tried hard to achieve this. Despite misgivings over the treatment of the Timorese, Australia was among the handful of countries to recognize the Indonesian annexation of East Timor; and agreement was reached in 1995 with Indonesia over the potentially divisive issue of shared rights to prospect for oil in the Timor Sea. But Asian nations are quick to anger when Australian journalists, business people, or politicians criticize their actions or regimes. When, in 1996, Paul Keating described the Malaysian prime minister as 'recalcitrant', indignation broke loose in the Malaysian media. Because Australians

habitually criticize their own politicians, such happenings continually remind them how politically very different their country is from its nearest neighbours. Meanwhile, Australia continued to cultivate good relations with the USA.

Cultural Developments

Until after World War II, Australian cuisine had been characterized by its ordinariness: bacon and eggs for breakfast, steak or chops for the evening meal, a leg of lamb or roast beef for Sunday; and for casual eating the commercial, hand-sized meat pie. Australian restaurants (except Chinese) offered much the same fare. The millions of European (and later, Asian) migrants changed all that. A diversity of new dishes was introduced by Greeks, Italians, Lebanese, Indians, Vietnamese, Thais, and others, and delicatessens and specialist food stores multiplied. By the 1990s restaurants were offering something called 'Modern Australian': a multicultural mix drawing upon any or all of the above.

The first substantial wine-producing area was the Hunter River Valley of New South Wales in the late 1830s, using grapes brought from France and Spain by James Busby (1801–71). South Australian wines from the Barossa Valley were praised at the Paris Exhibition as early as 1854, but only from the late 1960s, did most of the world learn just how good Australian wines are. In recent decades vineyards have increased and diversified. Every state has its own wines. Shiraz and Cabernet Sauvignon grapes produce excellent reds, with Semillon and Chardonnay prominent among the whites. Australia has no real need to import. Despite the increasing popularity of wine, Australians remain committed to beer. For more than 100 years beers were top fermented, in the manner of British ales and stouts, but these have in time been replaced by bottom-fermented lagers, more suited to the hot climate.

The deference of Australians to the supposed superiority of the arts in Britain, Europe, and North America, the so-called 'cultural cringe', is no more. Australians now recognize that their most talented artists produce work of world standard. The rebirth of the Australian arts was marked by the opening in 1973 of the Sydney Opera House, sixteen years after the Danish Architect, Jan Utzon had won the international

Sydney Opera House

competition with his unprecedented design. The Opera House, with its roof of spherical sections like billowing sails, rapidly became a symbol of the new cultural confidence – exemplified when the great Australian coloratura soprano, Joan Sutherland (1926–), performed there. Soon it had eclipsed the Harbour Bridge to become not just a symbol of Sydney, but an icon of Australia. It was the most striking example of the attempt since World War II to find an Australian architectural style suited to the country's climate and open spaces. Further examples are the National Library (1968), several other structures completed in Canberra in the 1980s, such as the National Gallery and the extraordinary New Parliament House designed by the firm of Mitchell, Giurgola and Thorp, and the Victorian Arts Centre in Melbourne (1968).

Since the heyday of the Heidelberg School, Australian painting has had its own distinctive approach, which takes note of overseas techniques and trends but converts them to something essentially Australian. After World War II the painters continued to evolve this Australian style. In their youth, Ian Fairweather (1891–1974), Russell Drysdale (1912–81), Sidney Nolan (1917–92), and Arthur Boyd (1920–) experimented with expressionism and surrealism. As Australia's most famous portrait painter, William Dobell (1899–1970), had done before the war, many such painters travelled to London immediately after the war to make their reputations. But nowadays Australian artists do not have to depend upon overseas patronage. Painting became increasingly abstract,

with a rapid succession in the 1960s of variants of pop art, colourfield abstraction, minimalism, and conceptual art; but most Australians still preferred landscape paintings, albeit in a modernist form, by such people as John Olsen (1928–) and Fred Williams (1927–82). Drysdale and Nolan became famous for their evocations of the outback, with Nolan (noted for his Ned Kelly series) probably the best-known internationally.

The first notable Aboriginal artist was Albert Namatjira (1902–59), whose richly coloured landscapes of central Australia were produced in the Western tradition. But until the mid-1970s, Aboriginal art proper was almost ignored outside anthropological museums. By the 1980s a thrilling renaissance had occurred, with Australian galleries, and private collectors at home and abroad, buying the best, and dealers who sell to tourists taking the remainder. Today several thousand Aboriginal artists live entirely on the proceeds of their painting, using traditional motifs but working in modern media such as acrylics. Internationally, Aboriginal art is the best known form of Australian art. By the mid-1990s the first acknowledged masters, Emily Kame Kngwarreye

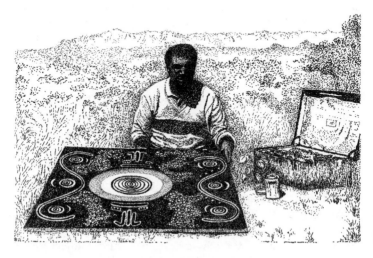

Modern Aboriginal artist at work

(1910?–96) and Rover Thomas (1926–88), had emerged. Their work hangs in the most prestigious galleries and commands top prices.

Despite the decline in film production since the 1920s, a handful of films on Australian themes continued to be produced, such as: *40,000 Horsemen* (1940), *The Overlanders* (1946), and *Jedda* (1957) (the first to star an Aborigine, Robert Tudawali). With funding from state and federal governments, the industry burgeoned in the 1970s, producing some 150 feature films. *Picnic at Hanging Rock, Sunday Too Far Away, My Brilliant Career, Caddie*, and *The Last Wave*, dealt with Australian themes such as the landscape, shearers, mateship, life in the bush and in country towns, and the Aborigines. But under directors such as Bruce Beresford (1940–) and Peter Weir (1944–), this was achieved in a striking, new, and sophisticated manner, which took the attention of international audiences. The 1980s were more commercial, with the war film *Gallipoli, Mad Max* films, and the most successful of all, the satirical *Crocodile Dundee* films by Paul Hogan (1940–). In the 1990s tastes have again changed, with a spate of outlandish film comedies, such as *Priscilla Queen of the Desert*, and *Babe*.

Television, first broadcast in 1956, soon became the key form of entertainment. The government-funded Australian Broadcasting Corporation (ABC) has channels in all capital cities and many regional areas, and produces much of its own content; since 1979 there has also been a government multicultural channel, the Special Broadcasting Service (SBS). The three nationwide commercial television channels attract larger audiences, produce many of their own programmes, but draw upon the successful independent companies such as those of Reg Grundy (mentioned above), Hector Crawford and, recently, Southern Star.

During the 1930s and '40s and after World War II, descriptive writing remained important but, from the 1950s, writers became more allusive and speculative. Eleanor Dark's *The Timeless Land* was a classic trilogy of Australian settlement. From the 1930s on, Ion L. Idriess produced thematic outback tales, as did Frank Dalby Davison. Christina Stead examined disrupted lives. Brian Penton questioned the motives of the 'glorious pioneers'. Patrick White (1912–90), the *eminence grise* of Australian writers, was the most influential of the post-1950 novelists, with books such as *Voss* (1955), *The Solid Mandala* (1966), and *The*

Twyborn Affair (1979). Through analysis and symbolism and the motif of people's loneliness in their attempts to communicate, he explored key themes of historical and contemporary Australia. In 1973 he won the Nobel Prize. Other novelists who have examined Australian themes since World War II are Martin Boyd, George Johnston, Colin Johnson, Randolph Stow, Morris West, Elizabeth Jolley, David Malouf, Peter Carey, and Thomas Keneally (1935–　), many of whom also dealt with non-Australian subjects. Keneally is usually acclaimed Australia's greatest contemporary novelist. Some of the best critical examination of Australian life has been produced by playwrights such as Douglas Stewart (1913–85), Ray Lawler, and David Williamson. And in Judith Wright (1915–　), Kenneth Slessor, and A. D. Hope, twentieth century Australia has had poets of world class.

ABORIGINAL RIGHTS AND STATUS

It was in relation to the Aborigines that the largest shift in Australian attitudes occurred. Developments during the last two decades have been so extraordinary and so counter to most of Australia's history since 1788 that 'revolution' is hardly adequate to describe them. Change began slowly both in Aboriginal consciousness and in white Australian attitudes, and it was several decades after World War II before the real changes began. The right to vote varied from state to state, and some Aborigines had to wait until 1962.

Gradually Aborigines came to be more important in public life. In 1944, Reginald Saunders became the first Aboriginal army officer; in 1971 the Queenslander, Neville Bonner (1922–　), the first Aboriginal senator. In 1976 Pastor Sir Douglas Nicholls (1906–88) was made governor of South Australia, the first Aborigine to hold a vice-regal position; and Patricia O'Shane became the first barrister. In 1985 Canon Arthur Malcolm became the first bishop, in 1986 Ernie Bridge the first cabinet minister, and in 1996 Gloria Shipp the first female Anglican priest. In 1965, following American precedent, Charles Perkins (1936–　), one of the first Aboriginal university graduates organized a 'freedom ride' through New South Wales country towns to protest against treatment of Aborigines. Increasingly, black political activism in the USA has provided a model for the more militant urban Aborigines.

From the late 1960s, as Aborigines have become more vociferous and whites more socially conscious, in various ways the errors of the past have been redressed. A wide range of special government services, payments and privileges for Aborigines have since been introduced, at the same time as Aborigines have been encouraged to keep and recover their culture.

Following intense scrutiny by parliamentary committees, in 1989, a powerful Aboriginal body, the Aboriginal and Torres Strait Islander Commission (ATSIC), was established. ATSIC administers a government funded billion dollar budget, and coordinates sixty regional councils. Leading members of the Commission, such as the already well-known Charles Perkins, Lois O'Donoghue, Noel Pearson and others, became figures of national importance. Some leading Aborigines have lost no opportunity to deride the early settlers and past and present Australian governments for sins of omission and commission.

Accompanying the increasing public face of Aborigines there erupted the issue of Aboriginal land rights. An early activist chairman of the Aboriginal Northern Land Council was Galarrwuy Yunupingu (1948–). Yunupingu negotiated the first agreement between Aborigines and a mining company, the Ranger Uranium Mine in the Northern Territory, and stressed the significant link between Aborigines and the land. In 1982, based upon the federal signing of an international covenant on civil rights, the High Court found in favour of the federal government against the Queensland government in the case of Cape York Aborigines, the Koowarta. The federal government then allowed the Koowarta to buy land previously held in a pastoral lease.

During the 1980s in much of northern Australia, the federal government purchased former government Aboriginal reserves, religious missions, and pastoral properties, and allowed them to be administered by land councils controlled by local Aborigines. In the first large transfer, in 1984, 28,000 square miles of land (larger than Tasmania) at Maralinga in South Australia were returned to Aboriginal ownership. In 1985 Uluru (Ayers Rock) was handed back to the Aboriginal people who have lived for eons in its shadow. (At the same time, increasing thousands of tourists were arriving. Typical were whole jet-loads of Japanese who came directly from Tokyo to Brisbane and Sydney, before

flying to Uluru to view the Rock's majestic changes of colour.) This trend accelerated. By the early 1990s, through legislation unprecedented in the history of the world, some 450,000 square miles (the equivalent of France, Spain, and Portugal together) stretching from the Southern Ocean to the Northern Territory coast, had been returned by the governments of the descendants of the settlers to descendants of the indigenous peoples – to Aboriginal trusts and groups. This 15 per cent of the whole country was now controlled and owned by about 2 per cent of its people. Though much of this was semi-desert, its actual and potential mineral and tourist wealth was enormous.

The most controversial and revolutionary change, one which will reverberate for decades, was introduced by the High Court, in a finding now known to Australian history as 'Mabo'.

In 1992, after some years of deliberation, a majority of the High Court found that Eddie Mabo (1937–92) and other residents of an island in Torres Strait had demonstrated that they and their ancestors had worked the land continuously and so possessed 'native title', a concept not previously recognized in Australian law. In fact, native title entailed rights explicitly rejected in earlier court cases. If this ruling had been confined to the crop-growing people of Torres Strait, little comment would have resulted. But, controversially, the High Court also found that native title could be applied to the nomadic, hunting-and-gathering Aborigines of the Australian continent as well. In effect the Court argued that all earlier judges had misunderstood the common law.

It will be recalled that something similar to 'native title' had been acknowledged by the British government in the nineteenth century as shown, for instance, in the documents establishing South Australia, and in the 1848 instructions by Grey, the Secretary of State for the Colonies. In fact, Aboriginal rights to access were usually included in pastoral leases in the second half of the nineteenth century. But *in practice* such enlightened conceptions were mostly ignored by the colonists and their governments. In 1992 it seemed Australian history had come full circle. Some Aboriginal groups stoked the fires of controversy by making legal claims to the central business districts of Brisbane and Sydney (including the Opera House), the Kosciusko National Park, the whole of Canberra, and so on.

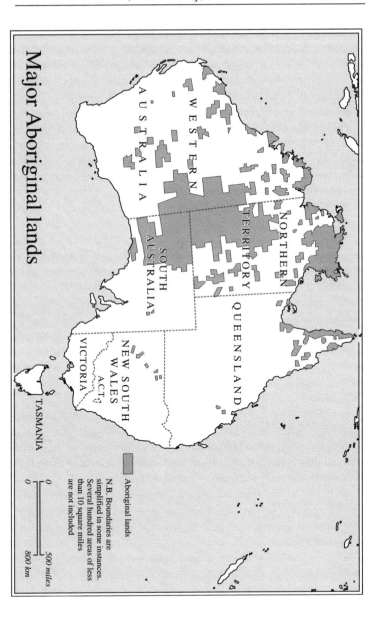

Major Aboriginal lands

WESTERN AUSTRALIA

NORTHERN TERRITORY

SOUTH AUSTRALIA

QUEENSLAND

NEW SOUTH WALES

A.C.T.

VICTORIA

TASMANIA

Aboriginal lands

N.B. Boundaries are
simplified in some instances.
Several hundred areas of less
than 10 square miles
are not included

0 500 miles
0 800 km

Labor prime minister Paul Keating gave the Mabo decision legislative teeth. His Native Title Act, which operated from the beginning of 1994, established tribunals to decide which lands should be returned to Aboriginal claimants. This legislation, though headline-catching, was in essential features ambiguous, badly drafted, and, as has been shown since, difficult to implement, with potential to cause unending conflict. For instance, in respect to Aboriginal lands it remained unclear whether governments or Aboriginal groups had the right to control essential services such as water pipelines, telecommunications, roads, sewerage, and the airspace above. Foreign and Australian investment in mining, plummeted.

In principle, the Keating legislation established that about 79 per cent of all the land in Australia might be claimable as Aboriginal land. By early 1998, more than 700 new claims to Native Title had in fact been lodged. This meant that more than half of the total area of Australia was now either already owned by or claimed by Aborigines. But, because of problems in the legislation, few claims were being settled. Present-day Aborigines, the descendants of the original Aboriginal occupiers, are through miscegenation, in many cases only half, a quarter, or an eighth black. This situation is, however, consistent with the logically circular notion of 'Aborigine'. For entitlement to rights and benefits, official government policy says that any person who is of Aboriginal descent, who is recognized as such by other Aboriginal people, and who recognizes himself or herself as Aboriginal *is* Aboriginal. On this definition, projections from the 1991 census estimate the 1999 Aboriginal population at about 350,000.

The most extreme Aborigines now advocate separate legal and political institutions. Today there exist many formidably articulate, university-educated, well-read, talented Aborigines, fiercely proud of their heritage. Far from all Aborigines agree with confrontation, however. Many believe that there has been too much polarization. They want to see less Aboriginal aggression, and more concessions and conciliation.

Keating's successors, the Liberal-National government of John Howard elected in 1996, had the unenviable task of trying to work out how the demands of Aborigines and existing, and potential future, land

users such as pastoral and mining companies, could be equitably reconciled following Mabo and the Keating legislation. To make the job more complicated, a second High Court ruling, that concerning the Wik people in a remote part of north Queensland, found in a 4–3 judgment that the existence of a pastoral lease did not extinguish any Aboriginal right to the same land – such title could co-exist. This ruling increased the scope for Aboriginal claims, and created economic uncertainty for sheep- and cattle-rearing pastoralists.

In 1997, the Howard government introduced a ten point bill to clarify the ambiguities in the earlier legislation and in the Mabo and Wik judgments, and to produce a more workable system for claims. The Senate in which the government did not command a majority, twice rejected the bill by a single vote. Opinion in Australia polarized. In July 1998, following the longest debate in the Senate's history, the legislation, with amendments meeting Aboriginal concerns, was passed. To process land claims, the Act provided for tribunals within each state, to be established by the respective governments. Though some Aboriginal groups remained critical, it was generally agreed that the legislation would provide reasonable security for pastoralists and miners while at the same time respecting native title. Significantly, the Labor opposition in parliament was prepared to accept the Act, promising, when next in government, to amend it only on the basis of case law.

As is the way of such things, by the early 1990s, from the education system to the attitudes of the churches, all things Aboriginal had become the new fashion. Taking advantage of this mind-set, many white Australians, especially in the arts, discovered they could be more successful by pretending to be black. In 1996, for instance, a supposed autobiography by an Aboriginal woman won a national prize for a first book by a female, and became stipulated reading in the English syllabus of New South Wales secondary schools. It was later discovered that the author was a white male Sydney taxi-driver.

Meanwhile, there have been significant areas of racial co-operation, initiated by private organizations and by government. White pastoralist groups and Aboriginal representatives have begun to work out compromises on land use acceptable to both sides. In many parts of the continent, archaeologists and local Aborigines have discovered that

co-operation brings important advantages for both parties. Another important but little-known example of co-operation is the three army reserve commando units of Norforce, a continuation of those of World War II, based in the Kimberleys, the Top End (Northern Territory) and far north Queensland, which guard and patrol Australia's far northern coastal frontier. These units consist of white troops and volunteer Aborigines from local tribes, or men sent by the tribal elders. They practise the latest military techniques but they also live off the land, eating berries, kangaroo, and snake. In some communities Norforce is well into its second generation, with fathers and sons sometimes serving in the same unit. The paradoxes of cultural fusion are shown, however, in the recent comment of an Aboriginal private in Norforce who, while stressing that all his people recognize the power of sorcery, said that Norforce is very important and no amount of sorcery can stop an enemy bullet: 'That's reality'.

In recent decades in relation to its Aborigines, Australia has been experiencing immense problems of readjustment. These involve all the excesses, pro and con, that occur when a nation reorients its fundamental values.

ENVIRONMENTALISM AND TOURISM

Concern for conservation began with early twentieth-century bushwalking clubs. Before World War I, the first national parks to preserve native flora and fauna had been reserved. After World War II, a National Trust was established to protect colonial buildings, and the Australian Conservation Foundation was set up in 1965. In the last twenty-five years these sources have merged to form a powerful environmental movement. Environmentalists have been significant in the extension of national parks over large areas of rural Australia, and have supported the Aborigines in their campaign for land rights. They have fought successfully against some egregiously short-sighted economic developments, such as the planned destruction of parts of the unique wilderness areas of the Daintree tropical forest in north Queensland and the sublime cool-temperate rainforest of south-west Tasmania. They have raised people's awareness of environmental issues. A number of seats in the federal Senate and state upper houses have

been occupied by 'Green' members, a position in which they some-
times hold the balance of power. In the mid-1990s, the Queensland
Labor government planned to build a toll road from Brisbane to the
Gold Coast through bushland that contained one of the largest colonies
of koalas in the continent. At the ensuing election, the government lost
every parliamentary seat along the proposed route, including that of the
Minister for the Environment. The road plan was discarded. Never-
theless, Green opposition to important industrial projects is sometimes
difficult to justify, as in the rejected 1987 plan for a futuristic
commercial spaceport near Weipa in Cape York Peninsula.

During the same period, Australian tourism has enjoyed a boom as
travel has become more rapid and less expensive, and as the world has
become more aware of the unique experiences Australia can provide –
especially on the Great Barrier Reef, in the tropical north in areas such
as Kakadu and the Kimberley, and in the inland with attractions such as
Uluru (Ayers Rock). Several of the areas fought for by the envir-
onmentalists have become important for tourism, as have numerous
places that have been returned to Aboriginal ownership. Eleven
Australian regions are now on the World Heritage List.

As the crown on its first 100 years as a federated nation, and a great
tourist occasion, Australia looks forward to welcoming the world to the
Sydney Olympic Games in the year 2000, in elaborate, newly
constructed facilities at Homebush in western Sydney.

REPUBLICANISM

The end of a century and, more so, of a millennium focuses the national
mind on issues of identity and meaning. So it has been in Australia. In
the 1990s, republicanism again became an issue as it had done a century
earlier, but with much wider support. Prime minister Paul Keating saw
political capital in the idea and wanted a republic by the year AD 2000,
the year of the Sydney Olympic Games.

Disputes broke out in the republican ranks over the nature of any such
republic. Waters were muddied by extremist ideas, such as Hawke's
suggestion that, concomitantly, the state governments should be
abolished. This idea forced people who valued state rights to reconsider
just what a republic might entail. Keating also saw a more general attack

on Britain and things British as a vote winner for his government and for the republican cause. Among other things, and based upon a personal interpretation of history, he lambasted Britain for what he claimed as inadequate concern for the defence of Australia in 1942.

Meanwhile, the main pro-monarchist organization, Australians for a Constitutional Monarchy, began a strong campaign in favour of the status quo. For perhaps most remarkable was not the fact that there were strong republican leanings but that, in the 1990s, there remained such large popular support for the monarchy. After all, Australia is a nation on the opposite side of the world from London; about half of the population in the 1990s was derived from non-British nationalities; Australia has always had a large population of Irish stock; and there is a strong tradition of organized labour.

The new Liberal prime minister, John Howard, though a monarchist himself, acknowledged the strength of republican feeling and organized a constitutional conference in early 1998. Some 152 partly nominated, partly elected delegates discussed the best structure for any future republic. Their debates recommended that the governor-general, as Queen's representative, be replaced by a president elected by a two-thirds majority of both houses of federal parliament. Presidential candidates would be chosen by the prime minister and opposition leader from a list drawn up by a committee of state parliamentarians, councillors, and public. The president would have powers similar to those of the current governor-general. The parliamentary system would remain the same. It was planned to hold a referendum in 1999 to decide whether Australia should change to this recommended republican model or remain a constitutional monarchy, so that the constitutional future would be clear by the centenary of federation in 2001 and the beginning of the new millennium.

Australia Today and Tomorrow

Australia is more important in the world than its comparatively small 19 million population would suggest.

Its large area and the changes wrought on its face in the last 210 years are responsible for this fact. For, though the tiny population of

indigenous inhabitants lived in harmony with their environment, they also allowed its massive potential to lie dormant and useless to the rest of the world. Since the arrival of the British in 1788, Australia's vast mineral wealth has been mined and its sleeping pastoral and farm lands brought into production. The settlers developed their colonies and made a nation. As a result, besides its own population, Australia through exports now manages to feed and clothe about 100 million other people on every other continent. Its manufactured goods, from opal jewellery to modern ferries, are in high demand overseas. Its wool clothes many foreign millions, its uranium warms and lights the population of Britain. Its coal, iron, and bauxite fuel the great steel and aluminium mills in Japan and other Asian countries. Its technical services and knowledge are in demand in many developing countries; its tourist facilities minister to millions of foreign vacationers. All these achievements look likely to continue far into the future.

The last fifty years have seen radical social changes. The question, 'What is an Australian?' was easier to answer in 1901 than it will be in 2001. The next fifty years will show whether the multicultural experiment has been a success, the degree to which a harmonious relationship has been achieved between Aboriginal and other Australians, and with what success Australia has engaged with the nations of Asia and the Pacific.

Just how economically and politically independent Australia can remain is perhaps the key question that will be answered in the same period. In economic matters, many of the crucial decisions which affect the daily lives of Australians have for years been made in government offices, boardrooms, and stock exchanges in other parts of the world by people of other nationalities.

As the economy of the world becomes more integrated, further world economic and political changes that will affect Australia, must come. Perhaps the next few decades will witness as much change as has occurred since 1788.

Notes

Notes

Notes

Adaptation of the Red Kangaroo to the Environment

Red kangaroos stand well over six feet and are the largest of the several kangaroo species. Though they evolved later, their special adaptation to the arid conditions of the far outback has given them dominance. (Only the males, the bucks, are red, the much smaller females, the does, are mainly a blue-grey colour.)

Red kangaroos are basically sedentary and territorial, and males establish territories of about four square miles each, which are generally no further than about ten miles from a reliable source of water. For years at a time they make use of the same favourite resting sites, under trees or bushes. They understand their territories intimately, including where to find the best grasses, plants and shrubs to eat, and where they can avoid predators such as dingoes.

In drought years, poor patches of dry grass remain their sole sustenance. Because such food consists almost entirely of cellulose and lignin, it cannot be broken down by the enzymes of normal digestion, so red kangaroos, like other herbivorous mammals have evolved a specialized digestive system. Their large foreguts contain special microorganisms, bacteria, fungi and protozoa, which cause the vegetable matter to ferment. Such material may count for 10 per cent of the animal's total weight. With little oxygen in the gut, such microorganisms extract only a very small amount of energy from the vegetable matter. The excreted remainder which consists of fatty acids is reabsorbed and metabolized by the animal. From such scant fare the digestive system can produce the required vitamins and proteins, and break down the many toxins found in desert vegetation.

Red kangaroos have the ability to excrete salts through their urine, so losing little water. Urea is also absorbed from the urine and transferred to the foregut, to be recycled into protein. An elongated large intestine and rectum help produce dry feces. Such adaptations together with their lower metabolism and economical method of travel enable them to drink much less often than other large mammals. They are also adept at selecting greener, moister vegetation. Whereas sheep in the same outback regions need to drink twice a day in summer, red kangaroos drink only about once a week. Some may drink every

three days, but others can exist for two weeks between drinks. During the cooler part of the year they may get most of their water from the plants they eat. In the hot, dry, outback environment in which a human being would need eight quarts of water daily, the perfectly adapted red kangaroos require only two or three quarts a week.

Movements, habits, and physiology of red kangaroos also conserve energy and water. In the hot summer months they feed at night, and make sure that by sunrise they are lying in the shade, where they spend much of the day. When they rest their metabolic rate is low. They also stop perspiring immediately movement ceases. By crouching under a tree or shrub with their long tails drawn up between their legs, the animals also reduce the surface area exposed to the sun. To cool the body, red kangaroos drop saliva on to and lick their forearms where there is little hair, and close to the surface a network of blood vessels which efficently dissipate heat. They also pant while resting (panting is much more energy-efficient than perspiring) which allows them to lose heat while expending a minimum of water.

With successive leaps of up to thirty-three feet, adult red kangaroos can move at a 'cruising speed' of between fifteen and twenty-five miles per hour for some miles. Hopping involves a more efficient use of energy than 'walking' – when red kangaroos have to use their tails as an extra 'leg'. At their 'cruising speed', using their tails as a counterbalance, red kangaroos expend less energy than most animals do when running. It is believed that they are even more energy-efficient when hopping at high speed, and for short bursts may approach forty m.p.h. Such high efficiency probably derives from something akin to a coiled spring – by which energy is stored in the elastic recoil of the powerful tendons and ligaments which strengthen the animals' backs, tails, and legs. By reducing the need to use the muscles for breathing, even hopping improves efficiency – the up and down movement of the gut effortlessly contracts and expands the chest cavity.

Reproduction takes advantage of food supplies while they last. Females are ready to mate two days after giving birth. The fertilized egg quickly develops to a blastocyst (a cluster of cells which lies dormant in the uterus) while the new-born kangaroo, the joey, sits in the pouch being suckled. When the joey leaves the pouch (after about 190 days) and suckling lessens, the hormonal changes allow the blastocyst to resume growth. Females (which may still be breeding in their twenties) can at the one time have a blastocyst in the uterus, a joey in the pouch, and another at foot. Outback conditions however take a heavy toll. Except when a sequence of rainy years has produced relatively lush vegetation, the majority of infant kangaroos die, and during prolonged drought almost all perish before being able to climb into the pouch to wean. Even in good years the majority do not survive for long after weaning. Nevertheless the reproduction system operates well while there is sufficient food, and populations can increase rapidly. Those kangaroos who manage to survive infancy may live a

surprisingly long life – some up to thirty years. But if drought persists, the reproductive sequence comes to a halt. With food scarce, females cease coming into oestrus, and males become sterile. Equilibrium between population and environment remains.

Why Boomerangs Return

Aboriginal males learned the complex skills of how to shape and hurl various sorts of boomerang. They knew that the shapes must follow tradition, that boomerangs spin in flight, and that the returning boomerang turned over as it flew, so that it came back with the curved side underneath. But, like all pre-scientific cultures, they knew absolutely nothing about why such dynamics occurred. The explanation, an aspect of the theory of flight, is that the boomerang returns because the air flows across the aerofoil shape of the cross-section of the arms at different rates, and because the boomerang spins continuously.

In relation to a right-handed thrower the physics, in more detail, are as follows.

The aerofoil provides aerodynamic lift in the direction of the curved side, the spin provides stability. Because air passes across the curved top of the aerofoil faster than across the flat bottom, it creates lower pressure on the top which, as with an aeroplane wing, results in lift. The torque due to the lift also causes a precession of the boomerang's spin plane – which brings about the curved flight path. This precession occurs because, at the high point of every turn, the upper arm of the boomerang is moving in the same direction as the boomerang is travelling, while the lower arm is moving in the opposite direction. Thus, the air passes the upper arm faster than it passes the lower, resulting again in lower pressure and so in greater lift on the upper arm. Because the upper arm has greater lift, it has greater torque and thus provides a rotation of the spin plane about a vertical axis. This effect occurs throughout the flight, resulting in a leftward precession of the flight path which not only slowly turns over the spin plane but also returns the boomerang to the vicinity of the thrower.

Governors-General, Governors, and Premiers

Governors-General of the Commonwealth of Australia since Federation in 1901

Earl of Hopetown, 1900 (appointed prior to federation)
Baron Tennyson, 1902
Baron Northcote, 1904
Earl of Dudley, 1908
Baron Denman, 1911
Sir Ronald Munro Ferguson, 1914
Baron Forster, 1920
Baron Stonehaven, 1925
Sir Isaac Isaacs, 1931
Baron Gowrie, 1936
Prince Henry, Duke of Gloucester, 1945
William J. McKell, 1947
Sir William Slim, 1953
Vicount Dunrossil, 1960
Vicount De L'Isle, 1961
Baron Casey, 1965
Sir Paul Hasluck, 1969
Sir John Kerr, 1974
Sir Zelman Cowen, 1977
Sir Ninian Stephen, 1982
William G. Hayden, 1989
Sir William Deane, 1997

Governors of Colonies to Responsible Government, and Premiers of Colonies/States since Responsible Government

Governors of New South Wales

Capt. Arthur Phillip, 1788
Major Francis Grose (administrator), 1792
Capt. William Patterson (administrator) 1794
Capt. John Hunter, 1795
Capt. Philip G. King, 1800
Capt. William Bligh, 1805
Maj. George Johnston (administrator), 1808
Lt.-Col. Joseph Foveaux (administrator) 1808
Col. Willliam Paterson (Lt-Gov.), 1809
Lt-Col. Lachlan Macquarie, 1809 (takes office 1810)
Lt-Gen. Sir Thomas Brisbane, 1821
Lt-Gen Ralph Darling, 1825
Maj-Gen. Sir Richard Bourke, 1831
Sir George Gipps, 1838
Sir Charles FitzRoy, 1846
Sir William Denison, 1855

Premiers of New South Wales

Stuart A. Donaldson, 1856

301

Charles Cowper, 1856
Henry W. Parker, 1856
Charles Cowper, 1857
William Forster, 1859
John (Jack) Robertson, 1860
Charles Cowper, 1861
James Martin, 1863
Charles Cowper, 1865
James Martin, 1866
John (Jack) Robertson, 1868
Charles Cowper, 1870
Henry Parkes, 1872
John (Jack) Robertson, 1875
Henry Parkes, 1877
Sir John Robertson, 1877
James S. Farnell 1877
Sir Henry Parkes, 1878
Alexander Stuart, 1883
George R. Dibbs, 1885
Sir John Robertson, 1885
Sir Patrick Jennings, 1886
Sir Henry Parkes, 1887
George R. Dibbs, 1889
Sir Henry Parkes, 1889
George R. Dibbs, 1891
George Reid, 1894
William J. Lyne, 1899
John See, 1901
Thomas Waddell, 1904
Joseph H. Carruthers, 1904
Charles J. Wade, 1907
James S. T. McGowen, 1910
William A. Holman, 1913
John Storey, 1920
James T. Dooley, 1921
Sir George Fuller, 1921
James T. Dooley, 1921
Sir George Fuller, 1922
John (Jack) T. Lang, 1925
Thomas R. Bavin, 1927
John (Jack) T. Lang, 1930
Bertram S. B. Stevens, 1932
Alexander Mair, 1939

William J. McKell 1941
James McGirr, 1947
John J. Cahill, 1952
Robert J. Heffron, 1959
John B. Renshaw, 1964
Robert W. Askin, 1965
Terence L. Lewis, 1975
Sir Eric Willis, 1976
Neville K. Wran, 1976
Barrie J. Unsworth, 1986
Nicholas F. H. Greiner, 1988
John J. Fahey, 1992
Robert Carr, 1995

Governors of Victoria
Charles J. La Trobe, 1851
Sir Charles Hotham, 1854
Sir Henry Barkly, 1856

Premiers of Victoria
William C. Haines, 1855
John O'Shanassy, 1857
William C. Haines, 1857
John O'Shanassy, 1858
William Nicholson, 1859
Richard Heales, 1860
John O'Shanassy, 1861
James McCulloch, 1863
Charles Sladen, 1868
James McCulloch, 1868
John A. McPherson, 1869
James McCulloch, 1870
Charles G. Duffy, 1871
James G. Francis, 1872
George B. Kerferd, 1874
Graham Berry, 1875
Sir James McCulloch, 1875
Graham Berry, 1877
James Service, 1880
Graham Berry, 1880
Sir Bryan O'Loghlen, 1881
James Service, 1883
Duncan Gillies, 1886

James Munro, 1890
William Shiels, 1892
James B. Patterson, 1893
George Turner, 1894
Allan McLean, 1899
Sir George Turner, 1900
Alexander J. Peacock, 1901
William H. Irvine, 1902
John T. Bent, 1904
John Murray, 1909
William A. Watt, 1912
George A. Elmslie, 1913
William A. Watt, 1913
Sir Alexander Peacock, 1914
John Bowser, 1917
Harry S. W. Lawson, 1918
Sir Alexander Peacock, 1924
George M. Prendergast, 1924
John Allan, 1924
Edward J. Hogan, 1927
Sir William McPherson, 1928
Edward J. Hogan, 1929
Sir Stanley Argyle, 1932
Arthur A. Dunstan, 1935
John Cain, 1943
Arthur A. Dunstan, 1943
Ian Macfarlan, 1945
John Cain, 1945
Thomas T. Hollway, 1947
John G. B. McDonald, 1950
Thomas T. Hollway, 1952
John G. B. McDonald, 1952
John Cain, 1952
Henry E. Bolte, 1955
Rupert J. Hamer, 1972
Lindsay H. S. Thompson, 1981
John Cain, 1982
Joan E. Kirner, 1990
Jeffrey G. Kennett, 1992

Responsible government was instituted immediately Queensland became a separate colony in 1859.

Premiers of Queensland

Robert G. W. Herbert, 1859
Arthur Macalister, 1866
Robert G. W. Herbert, 1866
Arthur Macalister, 1866
Robert Mackenzie, 1867
Charles Lilley, 1868
Arthur Palmer, 1870
Arthur Macalister, 1874
George H. Thorn, 1876
John Douglas, 1877
Thomas McIlwraith, 1879
Samuel W. Griffith, 1883
Sir Thomas McIlwraith, 1888
Boyd Morehead, 1888
Sir Samuel Griffith, 1890
Sir Thomas McIlwraith, 1893
Hugh M. Nelson, 1893
Thomas J. Byrnes, 1898
James R. Dickson, 1898
Andrew Dawson, 1899
Robert Philp, 1899
Arthur Morgan, 1903
William Kidston, 1906
Robert Philp, 1907
William Kidston, 1908
Digby F. Denham, 1911
Thomas J. Ryan, 1915
Edward G. Theodore, 1919
William N. Gilles, 1925
William McCormack, 1925
Arthur E. Moore, 1929
W. Forgan Smith, 1932
Frank A. Cooper, 1942
Edward M. Hanlon, 1946
Vincent C. Gair, 1952
George F. R. Nicklin, 1957
Jack C. A. Pizzey, 1968
Gordon Chalk, 1968

Johannes Bjelke-Petersen, 1968
 (Sir Johannes from 1985)
Michael J. Ahern, 1987
T. Russell Cooper, 1989
Wayne K. Goss, 1989
Robert E. Borbidge, 1995
Peter D. Beattie, 1998

Governors of South Australia

Capt. John Hindmarsh, 1835
Lt-Col. George Gawler, 1838
Capt. George Grey, 1841
Maj. Frederick H. Robe, 1845
Sir Henry Fox Young, 1848
Sir Richard MacDonell, 1855

Premiers of South Australia

Boyle T. Finniss, 1857
John Baker, 1857
Robert R. Torrens, 1857
Richard D. Hanson, 1857
Thomas Reynolds, 1860
George M. Waterhouse, 1861
Francis S. Dutton, 1863
Henry Ayers, 1863
Arthur Blyth, 1864
Francis S. Dutton, 1865
Henry Ayers, 1865
John Hart, 1865
James P. Boucaut, 1866
Henry Ayers, 1867
John Hart, 1868
Henry Ayers, 1868
Henry B. T. Strangways, 1868
John Hart, 1870
Arthur Blyth, 1871
Sir Henry Ayers, 1872
Arthur Blyth, 1873
James P. Boucaut, 1875
John Colton, 1876
James P. Boucaut, 1877
William Morgan, 1878
John C. Bray, 1881

John Colton, 1884
John W. Downer, 1885
Thomas Playford, 1887
John A. Cockburn, 1889
Thomas Playford, 1890
Frederick W. Holder, 1892
Sir John Downer, 1892
Charles C. Kingston, 1893
Vaiben L. Solomon, 1899
Frederick W. Holder, 1899
John G. Jenkins, 1901
Richard Butler, 1905
Thomas Price, 1905
Archibald H. Peake,1909
John Verran, 1910
Archibald H. Peake, 1912
Crawford Vaughan, 1915
Archibald. H. Peake, 1917
Sir Henry Barwell, 1920
John Gunn, 1924
Lionel L. Hill, 1926
Richard L. Butler, 1927
Lionel L. Hill, 1930
Robert S. Richards, 1933
Richard L. Butler, 1933
Thomas Playford, 1938
Frank H. Walsh, 1965
Donald A. Dunstan, 1967
R. Steele Hall, 1968
Donald A. Dunstan, 1970
James D. Corcoran, 1979
David O. Tonkin, 1979
John C. Bannon, 1982
Lynn M. F. Arnold, 1992
Dean C. Brown, 1993
John Olsen 1996

Governors of Western Australia

James Stirling, 1829
John Hutt, 1839
Lt-Col. Andrew Clarke, 1846
Lt-Col. Frederick C. Irwin, 1847
Capt. Charles Fitzgerald, 1848

Arthur E. Kennedy, 1855
John S. Hampton, 1862
Frederick A. Weld, 1869
Sir William Robinson, 1875
Sir Harry Ord, 1877
Sir William Robinson, 1880
Sir Frederick Broome, 1883
Sir William Robinson, 1890

Premiers of Western Australia
John Forrest, 1890
George Throssell, 1901
George Leake, 1901
Alfred E. Morgans, 1901
George Leake, 1901
Frederick Illingworth, 1902
Walter H. James, 1902
Henry Dalglish, 1904
Cornthwaite H. Rason, 1905
Newton J. Moore, 1906
Frank Wilson, 1910
John Scaddan, 1911
Frank Wilson, 1916
Henry B. Lefroy, 1917
Hal Colebatch, 1919
James Mitchell, 1919
Philip Collier, 1924
Sir James Mitchell, 1930
Philip Collier, 1933
John C. Willcock, 1936
Frank J. S. Wise, 1945
Duncan R. McLarty, 1947
Albert R. G. Hawke, 1953
David Brand, 1959
John T. Tonkin, 1971
Charles Court, 1974 (Sir Charles
 from 1980)
Raymond J. O'Connor, 1982
Brian T. Burke, 1983
Peter M'C. Dowding, 1988
Carmen M. Lawrence, 1990
Richard F. Court, 1993

Governors of Tasmania
Col. David Collins, 1804
Maj. Thomas Davey, 1811
Col. William Sorell, 1817
Col. George Arthur, 1824
Sir John Franklin, 1837
Sir John Eardley-Wilmot, 1843
Sir William Denison, 1847
Sir Henry Fox Young, 1855

Premiers of Tasmania
William T. N. Champ, 1856
Thomas G. Gregson, 1857
William P. Weston, 1857
Francis V. Smith, 1857
William P. Weston, 1860
Thomas. D. Chapman, 1861
James Whyte, 1863
Sir Richard Dry, 1866
James M. Wilson, 1869
Frederick M. Innes, 1872
Alfred Kennerley, 1873
Thomas T. Reibey, 1876
Philip O. Fysh, 1877
William R. Giblin, 1878
William L. Crowther, 1878
William R. Giblin, 1879
Adye Douglas, 1884
James W. Agnew, 1886
Philip O. Fysh, 1887
Henry Dobson, 1892
Sir Edward Braddon, 1894
Neil E. Lewis, 1899
William B. Propsting, 1903
John W. Evans, 1904
Sir Neil Lewis, 1909
John Earle, 1909
Sir Neil Lewis, 1909
Albert E. Solomon, 1912
John Earle, 1914
Sir Walter Lee, 1916
John B. Hayes, 1922
Sir Walter Lee, 1923

Joseph A. Lyons, 1923
John C. McPhee, 1928
Sir Walter Lee, 1934
Albert G. Ogilvie, 1934
Edmund J. C. Dwyer-Gray, 1939
Robert Cosgrove, 1939
W. Edmund Brooker, 1947
Robert Cosgrove, 1948
Eric E. Reece, 1958
Walter A. Bethune, 1969

Eric E. Reece, 1972
William A. Neilson, 1975
Douglas A. Lowe, 1977
Harold N. Holgate, 1981
Robin T. Gray, 1982
Michael W. Field, 1989
Raymond J. Groom, 1992
Anthony M. Rundle, 1996
James A. Bacon, 1998

Prime Ministers of the Commonwealth of Australia

Edmund Barton (Protectionist) 1901
Alfred Deakin (Protectionist) 1903
John C. Watson (Labor) 1904
George H. Reid (Free trade) 1904
Alfred Deakin (Protectionist) 1905
Andrew Fisher (Labor) 1908
Alfred Deakin (Fusion) 1909
Andrew Fisher (Labor) 1910
Joseph Cook (Liberal) 1913
Andrew Fisher (Labor) 1914
William (Billy) Hughes (Labor) 1915
William (Billy) Hughes (National) 1916
Stanley M. Bruce (National-Country) 1923
James H. Scullin (Labor) 1929
Joseph A. Lyons (UAP/UAP-Country) 1932
Earle Page (Country-UAP) 1939
Robert G. Menzies (UAP-Country) 1939
Arthur W. Fadden (Country-UAP) 1941
John Curtin (Labor) 1941
Francis M. Forde (Labor) 1945
Benjamin Chifley (Labor) 1945
Robert G. Menzies (Liberal-Country) 1949
Harold E. Holt (Liberal-Country) 1966
John McEwan (Country-Liberal) 1967
John G. Gorton (Liberal-Country) 1968
William McMahon (Liberal-Country) 1971
E. Gough Whitlam (Labor) 1972
J. Malcolm Fraser (Liberal-National [formerly Country]) 1975
Robert (Bob) J. L. Hawke (Labor) 1983
Paul J. Keating (Labor) 1991
John W. Howard (Liberal-National) 1996

Chronology of Major Events

B.C

c. 53,000	Arrival of first wave of Aboriginal settlers.
c. 53,000–8000	Aboriginals settle Sahul (Australia, Tasmania, and much of present-day continental shelf).
c. 16,000	Oceans begin to rise; Sahul reduces in size.
c. 12,000	Tasmania has separated from mainland.
c. 6000	Torres Strait has formed.

A.D.

1606	Spaniard, L. V. de Torres, passes through Torres Strait.
1644	Dutch captain, Abel Tasman, charts southern coast of Van Diemen's Land (Tasmania).
1688	Englishman, William Dampier, lands in north-west.
1697	Dutch explore Swan River.
1770	Lieutenant James Cook charts most of east coast, discovers Great Barrier Reef, claims eastern Australia for Britain.
1788	First Fleet, commanded by Captain Arthur Phillip, of British convicts arrives; settlement made at Sydney Cove; first farming at Parramatta; settlement on Norfolk Island.
1790	Colony close to starvation; Second Fleet of convicts and New South Wales Corps arrive.
1791	First land grant to ex-convict; whaling and sealing begin.
1792	Phillip departs; NSW Corps begins trade monopoly.
1793	First few free settlers arrive.
1797	Coal found north and south of Sydney.
1798	Bass and Flinders prove Tasmania is an island.
1801	Baudin's French expedition explores southern coast.
1803	Bowen settles Hobart Town in Van Diemen's Land (Tasmania); joined by the Collins party from Port Phillip. Matthew Flinders completes first circumnavigation of Australia.

1804	Flinders first uses the name 'Australia'.
1806	Governor William Bligh arrives in Sydney with explicit instructions to suppress rum trade.
1808	'Rum Rebellion' by NSW Corps against Bligh.
1810	Governor Macquarie arrives; Napoleon advises the governor of Mauritius to 'capture the English colony at Port Jackson'.
1813	Successful crossing of Blue Mountains.
1817	Bank of NSW, first Australian bank; term 'Australia' becomes more common.
1818	J. Oxley explores inland NSW.
1821	First general meeting of emancipists for redress of grievances.
1823	Oxley explores Brisbane River; Commissioner Bigge reports.
1824	Convict settlement at Brisbane; first civil jury in Australia; Australian Alps seen by Hume and Hovell; formation of Australian Agricultural Company; Fort Dundas settlement on Melville Island; Hume and Hovell travel overland to Port Phillip.
1825	Van Diemen's Land given separate government.
1827	Cunningham traverses the Darling Downs; pressure for legal and constitutional rights.
1829	Legislative Council to advise governor of NSW; foundation of Perth and colony of WA; Sturt sails down Murray River.
1831	*Sydney Herald* weekly newspaper, later called *Sydney Morning Herald*.
1835	Settlement made at Port Phillip Bay, later called 'Melbourne'.
1836	Province of SA founded, with capital at Adelaide; Sydney Gaslight Company; American consul appointed to Sydney.
1838	Settlement at Port Essington, northern Australia; end of assigned convict system in NSW.
1839	End of convict system at Brisbane; New Zealand annexed by Britain, under NSW jurisdiction.
1840	Convict transportation to mainland Australia abolished; first municipal election (Adelaide).
1841	New Zealand made separate colony from NSW.
1842	First municipal elections in Sydney and Melbourne; copper discovered at Kapunda in SA; Brisbane opened to free settlers.
1843	Representative government in NSW; T. Ridley invents stripper for wheat harvesting.
1844	Sturt begins exploration of central Australia; Leichhardt begins exploration of north-east Australia.
1849	Australian Mutual Provident Society formed.

1850	Representative government granted to SA; foundation of Sydney University; convicts arrive in WA.
1851	Victoria becomes separate colony; gold discovered in NSW and Victoria.
1853	End of convict transportation to Tasmania; Melbourne University founded; first paddle-steamers on Murray River.
1854	First Australian railway, Melbourne to Port Melbourne. Eureka Stockade rebellion; Crimean War – forts are built by colonies and volunteers train.
1856	Responsible government in all colonies except WA; SA and Victoria pioneer secret ballot.
1858	Telegraph lines between Sydney, Melbourne, and Adelaide; Australian Rules Football becoming popular in Melbourne.
1859	Queensland made separate colony.
1861	Aboriginal massacre of whites at Cullin-la-Ringo, and white retaliation; Burke and Wills expedition disaster; first Melbourne Cup horse race.
1862	McDouall Stuart crosses Australia from south to north; first sugar production in Queensland.
1863	Northern Territory annexed to SA.
1867	Gold found in Queensland; conference of colonies – Henry Parkes suggests a confederate-type union.
1868	Last convict arrives in WA.
1869	Steam ships to Australia begin using Suez Canal.
1870	Last British garrison departs, Royal Navy remains.
1872	Overland Telegraph Line completed – Australia connected to London; gold at Charters Towers in Queensland.
1877	Telegraph communication between Adelaide and Perth; first Test Cricket Match v. England.
1879	First artesian well sunk; International Exhibition in Sydney.
1880	*The Bulletin* begins publication; first frozen meat arrives in Britain.
1882	Gold and copper at Mount Morgan, Queensland.
1883	Broken Hill discovery of silver; annexation by Queensland of Papua repudiated by Imperial Government; gold and copper at Mount Lyell, Tasmania; steam train links Melbourne and Sydney.
1884	British protectorate established over Papua; H. V. McKay invents combine-harvester for wheat.
1885	Broken Hill Proprietary Company (BHP) formed; Federal Council of Australasia formed; NSW military contingent sent to Sudan; gold found in the Kimberleys.
1886	Birth of Amalgamated Shearers Union.

1887	Colonial Conference in London, first Naval Defence Agreement.
1888	Centenary celebrations in NSW; International Exhibition in Melbourne; three eastern colonies take responsibility for costs of administering Papua.
1889	Financial difficulties begin in Victoria.
1890	Responsible government in WA.
1891	First Labour Party; colonies join Universal Postal Union; federal convention in Sydney; arrival of auxiliary British naval squadron.
1893	Financial panic, banks close; gold discovered at Kalgoorlie.
1894	Votes for women in SA.
1897	Sessions of Federal Convention in several cities.
1899	First troops sent to Boer War.
1900	Australian naval contingent to Boxer Rebellion, China.
1901	Federation of six colonies; first Federal parliament meets in Melbourne; Immigration Restriction Act passed.
1902	All-British Pacific cable links Australia and Canada; Anglo-Japanese Treaty causes misgivings.
1903	Federal High Court established; end of disastrous seven-year drought.
1904	Federal Conciliation and Arbitration body established.
1906	Administration of Papua taken over by Commonwealth.
1908	Canberra site chosen for federal capital; US 'Great White Fleet' visits Sydney; Australian, W. K. D'Arcy discovers first Middle-Eastern oil.
1909	Compulsory military training; first successful Australian heavier-than-air flight.
1910	First ships of Royal Australian Navy arrive; first federal bank notes issued; Australian High Commission established in London.
1911	First federal census; federal government takes control of Northern Territory; penny postage links all parts of British Empire.
1912	Foundation of Commonwealth Bank (federal bank); Douglas Mawson explores and claims King George V Land in Antarctica.
1913	Foundation of Canberra.
1914	World War I begins; HMAS *Sydney* sinks German ship *Emden*; Australian navy captures German New Guinea.
1915	Australian troops (ANZACS) land on Gallipoli Peninsula; opening of BHP steelworks at Newcastle.
1916	Australian troops in France.

1917	Trans-Australian Railway completed.
1918	End of World War I; first direct radio message from Britain to Sydney; trade commissioner appointed to USA.
1919	Australia plays prominent role at Peace Conference; joins League of Nations; first Britain–Australia flight (28 days).
1921	Australia given mandate over former German New Guinea; Labor Party adopts socialism as policy.
1922	First regular air service (QANTAS), in Queensland.
1926	Imperial Conference agrees Britain, Australia, and other self-governing dominions in Empire have equal status; foundation of Council for Scientific and Industrial Research (later, CSIRO).
1927	Federal government transferred to Canberra; opening of first parliament there by Duke of York (later George VI).
1928	First flight from USA to Australia.
1931	Great Depression hits Australia; Statute of Westminster legalizes 1926 Imperial decisions; D. Mawson explores Antarctica.
1932	Opening of Sydney Harbour Bridge; Imperial Conference in Ottawa; worst year of Depression; 'Bodyline' cricket series.
1933	WA votes to secede from federation.
1935	Japanese goodwill mission to Australia; trade commissioners to China, Japan, Dutch East Indies.
1936	Death of King George V; abdication of King Edward VIII; Hume Dam opened; Australian Antarctic Territory claimed.
1938	Iron ore exports to Japan halted; R. G. Menzies leads mission to Germany.
1939	Outbreak of World War II.
1940	Ambassadors to China, USA and Japan, High Commissioner to Canada.
1941	Prime Minister Curtin appeals to USA for aid against Japan.
1942	Singapore falls; Battle of the Coral Sea; Darwin bombed by Japanese; Allied Works Council established; Australians repulse Japanese in New Guinea Battles of Milne Bay and Kokoda Trail.
1945	End of World War II; General Blamey accepts Japanese surrender on Morotai; Australian judge presides at trials of Japanese war criminals; B. Chifley becomes PM.
1948	Most wage earners gain 40-hour week; the Holden, first mass-produced Australian car.
1949	Election of Liberal-Country Party Government under Menzies; Indonesia becomes independent.
1950	Australian armed forces fight in Korean War.

1951	Signing of ANZUS Treaty (Australia, NZ, USA) and peace treaty with Japan.
1952	Beginning of British atomic tests in Australian desert.
1954	Soviet spy, Petrov, defects; SEATO Treaty.
1955	Labor Party divided over Communists; Australian troops leave Korea, go to Malaya.
1956	Melbourne Olympic Games; TV in large cities; renegotiation of preferential trade agreement with Britain; Menzies mediates in Suez crisis.
1957	Australia-Japan trade agreement.
1958	QANTAS inaugurates world's first around the world scheduled air service.
1959	Snowy Mountains hydro-electric power comes into operation; Antarctic Treaty signed in Washington.
1961	Beginning of iron-ore mining in Pilbara (WA); Indonesia invades Dutch New Guinea.
1963	RAAF orders supersonic bombers; Indonesian confrontation; Soviet diplomats expelled; Menzies-Kennedy talks; US-Australia Naval Communications Station agreed for North West Cape.
1964	Federal aid to church schools; Australian advisers in Vietnam.
1965	Australian battalion sent to Vietnam.
1966	Menzies retires, H. Holt becomes PM; oil found beneath Bass Strait; Japan overtakes Britain as best Australian customer.
1969	Arbitration Court accepts equal pay for women.
1970	Demonstrations against Vietnam War, Australian troops begin withdrawal.
1971	Australia joins OECD.
1973	G. Whitlam leads first Labor government for 23 years, establishes diplomatic realtions with China; boundary agreement between Indonesia and Papua-New Guinea.
1973	Sydney Opera House opened.
1974	Cyclone devastates Darwin.
1975	Papua-New Guinea given independence; Whitlam dismissed by governor-general; Liberal-Country Party under Fraser wins ensuing election.
1976	Aboriginals granted large sections of Northern Territory; Treaty of Friendship with Japan.
1979	Kakadu National Park proclaimed (World Heritage site 1981).
1982	Dampier and Port Headland ship more tonnage than Sydney.
1983	Australia and New Zealand move towards a common market; Labor under R. Hawke wins election.

1984	Financial deregulation; foreign banks allowed into Australia.
1985	Uluru (Ayers Rock) formally given to Aborigines.
1988	Bicentenary celebrations; New Parliament House opened by Queen Elizabeth II.
1990	Entrepreneurs fail.
1991	Keating replaces Hawke as Labor PM.
1992	Recession; unemployment over 10 per cent.
1994	Native Title Act makes 79 per cent of Australia potentially Aboriginal land.
1996	Liberal–Nationals under Howard win election.
1998	Constitutional Convention recommends Australia become a republic with a president to replace the governor-general, and a referendum to be held on this issue in 1999; Native Title Amendments Bill passed by Senate; Liberal–Nationals under Howard win election with much reduced majority.

Further Reading

General Histories

BLAINEY, GEOFFREY, *A Shorter History of Australia* (Melbourne 1994/1996).

BLAINEY, GEOFFREY, *The Tyranny of Distance* (Sydney, 1966/1983).

BOLTON, GEOFFREY (gen. ed.) *The Oxford History of Australia* (5 vols) (Melbourne, 1988–96).

BURGMANN, Verity, and Lee, Jenny (eds) *People's History of Australia* (4 vols) (Melbourne, 1988).

CLARK, G. M. H., *A History of Australia* (6 vols) (Melbourne, 1962–88).

CRAWFORD, R. M., *Australia* (London, 1970).

CROWLEY, FRANK (ed.) *A New History of Australia* (Melbourne, 1974).

FITZPATRICK, BRIAN, *The British Empire in Australia 1834–1949* (Melbourne, 1949/1971).

RICKARD, JOHN, *Australia: A Cultural History* (London, 1988/1996).

Aborigines, Convicts, Settlers, Cities, Etc.

ALEXANDER, FRED, *From Curtin to Menzies* (Melbourne, 1973).

BELL, PHILLIP and BELL, ROGER. *Implicated: The United States in Australia* (Melbourne, 1993).

BLAINEY, GEOFFREY, *Triumph of the Nomads* (Melbourne, 1975).

BLAINEY, GEOFFREY, *The Rush that Never Ended: a History of Australian Mining* (Melbourne, 1963/1994).

CARROLL, JOHN (ed.) *Intruders in the Bush: The Australian Quest for Identity* (Melbourne, 1982/1992).

CHAMBERS, CORAL, *Lessons for Ladies: a Social History of Girls' Education in Australasia 1870–1900* (Sydney, 1986).

DAVISON, GRAEME, *The Unforgiving Minute: How Australia Learned to Tell the Time* (Melbourne, 1993).

FITZPATRICK, CATHLEEN (ed.) *Australian Explorers* (London, 1958).

FLOOD, JOSEPHINE, *The Riches of Ancient Australia: a Journey into Prehistory* (St Lucia, 1990).

FROST, LUCY, *No Place for a Nervous Lady* (Melbourne, 1984).

HILL, ERNESTINE, *The Territory* (Sydney, 1951/1995).

HUGHES, ROBERT, *The Fatal Shore: A History of Transportation of Convicts to Australia 1787–1868* (London, 1987).

INGLIS, K. S., *The Australian Colonists* (Melbourne, 1974).

KOCIUMBAS, JAN, *Australian Childhood: A History* (St Leonards, NSW, 1997).

LOWENSTEIN, WENDY and LOH, MORAG, *The Immigrants* (Melbourne 1977/1991).

MULVANEY, D. J. and WHITE, J. P. (eds) *Australians to 1788* (Sydney, 1987).

OXLEY, DEBORAH, *Convict Maids: The Forced Migration of Women to Australia* (Cambridge & Melbourne, 1996).

REYNOLDS, HENRY, *Frontier* (St Leonards, NSW, 1987/1996).

REYNOLDS, HENRY, *The Other Side of the Frontier* (Ringwood, VIC, 1995).

ROBERTSON, JOHN, *Australia Goes to War 1939–1945* (Sydney, 1984).

SHAW, A. G. L., *Convicts and the Colonies* (London, 1966/Melbourne, 1977).

STATHAM, PAMELA (ed.) *The Origins of Australia's Capital Cities* (Cambridge & Melbourne, 1989).

TENCH, WATKIN *1788* (including *A Narrative of the Expedition to Botany Bay* and *A Complete Account of the Settlement at Port Jackson*) (London, 1789/1793; Melbourne, 1996).

THOMPSON, ROGER C., *Religion in Australia* (Melbourne, 1994).

TROLLOPE, ANTONY, *Australia and New Zealand* (London, 1872).

TWOPENNY, RICHARD, *Town Life in Australia* (London, 1883/Melbourne, 1977).

WARD, RUSSEL, *The Australian Legend* (Melbourne, 1958/1995).

WHITE, RICHARD, *Inventing Australia* (St Leonards, NSW, 1981).

WHITLAM, R. G., *The Whitlam Government 1972–1975* (Melbourne, 1985).

Australian Lives

BASSETT, MARNIE, *The Governor's Lady: Mrs Phillip Gidley King* (London, 1940/Melbourne, 1956).

BLAINEY, GEOFFREY, *The Steel Master: a Life of Essington Lewis* (Melbourne, 1971).

BOWEN, JILL, *Kidman* (Sydney, 1987/1998).

ELLIS, M. H., *John Macarthur* (Sydney, 1955/1978).

FITZHARDINGE, L. F., *William Morris Hughes* (2 vols) (Sydney, 1964/1979).

HASLUCK, SIR PAUL, *Sir Robert Menzies* (Melbourne, 1984).

HOBAN, MARY, *Caroline Chisholm* (Melbourne, 1984).

KERR, JOHN, *Matters of Judgment* (Melbourne, 1978).

LA NAUZE, J. A., *Alfred Deakin* (Melbourne, 1965).

MARTIN, A. W., *Henry Parkes* (Melbourne, 1980).

RICKARD, JOHN, *H. B. Higgins* (Sydney, 1984).
RITCHIE, J., *Lachlan Macquarie* (Melbourne, 1986).
SERLE, GEOFFREY, *John Monash* (Melbourne, 1982).

Historical Gazetteer

Numbers in bold refer to main text

Adelaide & Region Established in 1836 as the capital of the new free settler province of South Australia, Adelaide was named after the consort of King William IV, and was incorporated as Australia's first municipal government in 1840. The original town plan of the Colonial Surveyor, Colonel Light, with a central city square mile surrounded by vast parklands, is little altered. It has a Mediterranean climate with hot summers. The fertile countryside, easy access to the **Murray River** (q.v.) lowlands, and mineral deposits relatively close at hand forced the city's early growth. Adelaide's development followed the colony's cycles of boom and bust, thus the 1870s and '80s, a time of prosperity based on wheat, saw considerable building, much still extant. City landmarks include Town Hall (1866), and Sturt's Cottage, home of the famous explorer (1840s); University of Adelaide (1874); Parliament House (1889); Government House (1840); South Australian Museum; and two cathedrals, St Peter's (Anglican) (1876), and St Xavier's (Roman Catholic) (1856). The beach suburb

of Glenelg has many fine Victorian mansions built by successful nine-teenth-century squatters. The biennial Festival of Arts begun 1960 is Australia's best.

Just to the east lie the beautiful **Adelaide Hills**, settled from 1839, and, about 40 miles north-east, the gentle **Barossa Valley**. The Valley was settled from 1842 by successive groups of Germans seeking religious freedom, and became and remains Australia's premier wine-making region and an enduringly popular tourist destination. Adelaide is within easy reach of the **Flinders Ranges** (q.v.) to the north, the charming **Fleurieu Peninsula** to the south, pleasant seaside towns to the south-east (e.g. Robe, founded 1845), and **Yorke Peninsula** to the west. Hundred-mile long **Kangaroo Island**, where the first official settlement in South Australia was made in July 1836, is a haven of wildlife, reached by ferry or plane. **86, 101–7, 115, 135**

Alice Springs, Uluru (Ayers Rock), and the Centre Almost in the geographical heart of the continent, **Alice Springs** lies on the normally

completely dry Todd River and the Stuart Highway, 1028 road miles north of Adelaide (q.v.) and 954 south of Darwin (q.v.). It is the commercial, tourist, and government base for the approximately 200,000 square miles of semi-desert, desert, and spectacular weathered mountains and gorges, known as 'the Centre'. Capital of the short-lived Territory of Central Australia (1926-31), it began in 1871 as a station (now refurbished) on the overland telegraph line from Adelaide to Darwin, completed in 1872.

Following a gold-rush in 1887 the present site was surveyed. Army activity during World War II brought more rapid development, and tourism has recently transformed it. Camels were brought into the region in the mid-nineteenth century for transport and exploration and today about 60,000 feral camels range to the south. The railway reached here in 1929. The train journey from Port Augusta in South Australia (called 'The Ghan' after the original Afghan cameleers) is popular. Tourism is now the main industry (600,000 visitors annually) mostly during the less-enervating winter. The town is a regional centre for the Royal Flying Doctor Service and the School of the Air (1951) – the latter a radio-based education service for outback children. There is a major US-Australian intelligence facility at **Pine Gap** (1970) 12 miles south-west. A Lutheran Mission, the first Christian mission to Aborigines, 82 miles west, at **Hermannsburg**, began in 1877; its facilities passed to Aboriginal

ownership in 1982 and now include some model Aboriginal villages such as Wallace Rockhole where alcohol is banned by the inhabitants. Albert Namatjira, the first Aboriginal artist to win fame painting in the Western tradition, grew up at Hermannsburg. To the north-west lies Goss Bluff (Tnorala), one of the world's best preserved comet impact craters. To the south through the **Finke Gorge National Park** runs the Finke River, that may be the oldest in the world.

'The Alice' is the nearest town for significant sites such as: the ancient gorges, valleys, and hills of the **McDonnell Ranges**; **Chambers Pillar**; the 30,000-square-mile great red sand-ridges of the **Simpson Desert**, entered by the explorer Charles Sturt in 1845, and named only in 1932 following the explorations of C. T. Madigan; and spectacular **Uluru (Ayers Rock)**. For thousands of years a sacred site to the Aborigines, this 1200 ft-high monolith of arkosic sandstone, 230 miles south-west of Alice Springs was placed on the map in 1873 by W. C. Goss travelling west from the overland telegraph station. Originally named after a premier of South Australia, the Aboriginal 'Uluru' is now the site's more common designation. Indigo blue just before sunrise, deep ochre-red at sunset, and various shades between, the rock is a key tourist venue. Nearby, the **Kata Juta** (the **Olgas**) cluster of domes, slightly higher, is almost equally popular. Land title to the national park, passed to local Aborigines in 1985, was leased to the federal government for

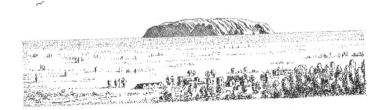

ninety-nine years. To service tourism the modern resort town of **Yulara** was opened in 1984 – 7 miles north of the rock. About half way between Uluru and Hermannsburg is **Watarrka National Park** with spectacular **Kings Canyon** and its 400-feet-high walls rising sheer from the creek. The Luritja Aborigines have inhabited this area for perhaps 20,000 years, and three communities live there today. Explorer Ernest Giles was the first European, in 1872, and from 1885 his pastoral lease became part of a cattle station, and in the 1980s the national park. In the Centre many local Aborigines kept to their traditional ways until the 1930s, and many today combine bush life with access to schools and social services. **4, 115, 122–4, 129, 282, 285**

Australian Alps are the highest section of the Great Dividing Range (q.v.) straddling the Victorian-NSW border which divides the Murray River system (q.v.) from short, fast-flowing eastern rivers, e.g., Snowy River. Named because of relative height in flat Australia, and because of the snow cover of the **Snowy Mountains** section for five months of the year. Has several peaks above 7000 feet, including Australia's highest

peak, **Kosciusko** (7310 feet), named after the Polish patriot by P. Strzelecki who explored the region in 1840. Considerable tourism and winter sports have developed, with good facilities. The vast **Snowy Mountains Hydro-electric Scheme**, one of the world's largest, with headquarters at Cooma, dominates the region. Begun in 1949, it took fifteen years to complete, and diverts much of the waters of the Snowy River westwards into the Murray, thereby providing water for inland irrigation and electricity for south-east Australia. The federal capital of **Canberra** (q.v.) lies within easy driving distance. **4, 243, 247**

Blue Mountains Aborigines inhabited these mountains for some 14,000 years. Part of the great Dividing Range (q.v.) the mountains frustrated westward progress from Sydney until 1813. By the late nineteenth century the Mountains had become a popular vacation destination. Though overshadowed by modern developments in other parts of Australia, the region retains some of its popularity, particularly in resort towns such as **Katoomba** and **Medlow Bath**, and the famous and vast **Jenolan Caves** to the west – the first- and still the

best-developed of Australian cave systems, already visited by more-intrepid Sydney residents in the 1840s, and well developed for tourists by the end of the century. **Bathurst**, the first town west of the Blue Mountains, was founded by Governor Macquarie in 1815. Named for the then British Secretary of State for the Colonies, it became the point of departure for numerous early exploring expeditions. Grew rapidly after Australia's first large-scale goldfield was discovered nearby in 1851. Possesses well-preserved late nineteenth-, early twentieth-century buildings. **79, 115**

Brisbane and Region Established in 1825, on the Brisbane River, as a centre for recidivist convicts, the city became capital of the colony of Queensland, proclaimed in 1859. Today there is little evidence of convict origins except in the Commissariat Stores in William Street (1829) and the treadmill on Wickham Terrace (1829). Development was almost static until the area was opened to free settlement in 1842. Rapid settler growth occurred after 1859: 6000 people in 1861 were over 100,000 by 1890. During World War II the city was a key strategic base for the Pacific campaign against Japan and more than a million American and Australian troops passed through it. This subtropical metropolis, the centre of the fastest-growing region

Convict-built Mill, Brisbane

in Australia, has a welcoming, informal lifestyle.

Magnificent Botanical Gardens, early established as a convict vegetable garden, still thrive, an easy walk from the city centre. The first director introduced spectacular Poinciana and Jacaranda trees from other parts of the British Empire which have so flourished in Queensland they are usually considered natives. Dotted among the modern skyscrapers are numerous elegant late-Victorian and Edwardian structures: Old Parliament House (1889); classical revival Old Government House (1862); Customs House (1889); General Post Office, on the site of the former female convict barracks; ornate Treasury Building, now a casino; eye-catching, towered Old Queensland Museum (1891); striking neo-Gothic St John's Anglican Cathedral – begun in 1901, to be completed in 2001. Modern structures include: neoclassical City Hall (1930); sandstone buildings around the Great Court at the University of Queensland; Queensland Cultural Centre on the south bank of the Brisbane River, built on the site of the bicentennial 1988 International Expo; and the Story Bridge, which arches high above the river and provides the best vantage point from which to view the city proper. There are many parks and reserves, including Mount Coot-tha Botanical Gardens, with Australia's largest display of tropical and subtropical flora.

Brisbane is within easy reach of the **Gold Coast** (q.v.) to the south. The white sandy beaches of the less-crowded **Sunshine Coast** lie to the north, complemented by the green national parks, waterfalls and hill towns of the hinterland, and the spectacular volcanic tors of the **Glasshouse Mountains**. Some 24 miles west of Brisbane, and an early rival for Queensland colonial capital, the neat city of **Ipswich** was founded in 1827 by convicts mining limestone and coal. The second oldest town in the state, from the beginning of free settlement in 1842 it was the early trade and provisioning centre for the squatters of the Darling Downs, first mapped by the explorer Allan Cunningham in 1827. Contains several of the most extensive clusters of traditional Australian houses in the nation. The most spectacularly sited of all Australian inland cities, **Toowoomba**, 82 miles west of Brisbane, stands on the escarpment of the Great Dividing Range (q.v.) some 2500 feet above sea-level. Founded in 1849 to service the farm needs of the Darling Downs. Before World War I, Toowoomba functioned as a sort of hill station for the élite of Brisbane during the torrid Queensland summer. It has excellent parks and gardens, the Picnic Point Lookout offering superb views over the coastal plain to Brisbane. **62, 86, 87–92, 137, 162, 167, 168, 169, 191, 235, 290–1**

Cairns and Cape York Peninsula Founded in 1870 as a customs collecting point, Cairns lies on Trinity Bay in north Queensland, named by James Cook in 1770. Cairns grew in the 1880s as a port for the sugar-cane farms and the Palmer River goldfields. Named for the then governor of Queensland, it has grown rapidly

in recent decades as a centre for international tourism for the Great Barrier Reef (q.v.) and big-game fishing, with direct flights from Japan and the United States. It now services more than a million tourists a year. About 18 miles off Cairns is the tiny, spectacular, coral cay of **Green Island**. To the west by train or road or cable car lies the **Atherton Tableland**, originally opened to European settlement by tin and gold prospectors in the late 1800s, and now known for its rich tropical forest, spectacular crater-lakes and gorges, and picturesque waterfalls.

To the north and west of Cairns, Cape York Peninsula has the world's largest bauxite (aluminium) mines at **Weipa** on the Gulf of Carpentaria (the red bauxite cliffs were noted by Matthew Flinders on his circumnavigation of Australia in 1802–03). The peninsula supports a large cattle industry, begun when the Jardine Brothers drove stock into the area in 1864. There is a burgeoning tourist industry in the massive tropical rainforest of **Daintree National Park** and the breathtaking beauty of **Cape Tribulation National Park** (the cape named by Cook in 1770 following the near-wreck of the *Endeavour*.) These forests, which boast species of fern dating back more than 100 million years, lie west of the port of **Port Douglas** (1877), with its spectacular modern resorts and access to the Great Barrier Reef, about 60 miles north of Cairns. Further north again stands **Cooktown**, a small town on the site where Cook careened *Endeavour* in 1770. There

are six monuments to Cook, including a cairn where the ship was dragged ashore. Inland, around Laura, lie some of Australia's most extensive clusters of Aboriginal rock art, painted in the distinctive Quinkan style. **6, 20, 21, 22, 34, 45, 119–21, 165, 247, 291**

Canberra Constructed on a Walter Burley Griffin plan which won an international competition for the new capital city of Australia, the foundation stone for Parliament House was laid in 1913. Canberra became the federal capital in 1927. Growth was slow until after World War II, rapid from the 1960s. Lake Burley Griffin was created in 1964 by damming the Molonglo River. St John's Church (1841) and Blundell's Farmhouse (1860) are the oldest buildings. There are many striking embassies in the suburb of Yarralumla (all post-World War II), built in styles to symbolize their nations, that of China perhaps the most extraordinary. Also of significance are Old Parliament House (1927), War Memorial (1941), National Library (1968), High Court (1980), National Gallery (1982), and New Parliament House (1988). The National Library possesses the original ship's journal of Cook's voyage to Australia and his cannon thrown overboard on the Barrier Reef, as well as key papers concerning the federation movement, and one of the three surviving copies of the Inspeximus issue (1297) of *Magna Carta*. More than 3 million cubic feet of soil were removed from Capital Hill to make space for New Parliament House, Australia's largest building,

some returned to support the lawn straddling its roof. Some 25 miles south-west stands **Tidbinbilla**, an Australian/US deep-space tracking station open to the public. **23, 110, 208–9, 281**

Darwin, Kakadu and the Top End In the early nineteenth century, three separate British settlements were established in the far north in the hope of developing an Australian Singapore: the first was at Melville Island (1824–28) to the north-west of present-day Darwin, the others at Raffles Bay (1826–29), and Victoria, on Port Essington (1836–49) both on the **Cobourg Peninsula** about 100 miles to the north-east. All three were failures and abandoned. The forlorn ruins at Port Essington, vegetation-covered, are visitable by sea.

Originally called Palmerston, and founded in 1863 as the region's administrative centre, in 1872 Darwin became the ingress for the international submarine cable from Java for the new Overland Telegraph Line to **Adelaide** (q.v.). Named after its harbour, Port Darwin, itself named after Charles Darwin, it became the capital of the Northern Territory in 1911 when responsibility for that region was transferred by South Australia to the new federal government. It remained a Conradesque small tropical port until World War II, during which it was bombed many times by the Japanese. Large sections destroyed by Cyclone Tracy in 1974 have now been completely rebuilt.

About 70 miles south lies attractive **Litchfield National Park**, but the most spectacular scenery in the Top End is in **Kakadu National Park**, mostly Aboriginal land, 95 road miles east of Darwin, covering about 9000 square miles and one of Australia's natural marvels. (To its east is the 37,000-square-mile Aboriginal-controlled **Arnhem Land**.) Kakadu has striking scenery and multitudinous wildlife. During the wet season (over 50 inches of rain) creeks cross the plateau and thunder off the escarpment as waterfalls. **Twin Falls** and **Jim Jim Falls** (sheer 700-foot drop) are spectacular. They join the four rivers to make a huge vegetated lake in the northern sections of the Park, home to myriads of tropical birds (a third of all Australian bird species). The flood plains are then under some 10 feet of water in areas perfectly dry in September. The **Arnhem Land Escarpment**, a dramatic 500-foot high cliff, the edge of the Arnhem Land Plateau, crosses the south-east of the park. The most comfortable time for tourists is the late dry season – July and August. New animal and insect species are continually being discovered. Some of the 1000 plant species are still used by local Aborigines as food and bush medicine. About 5000 sites of Aboriginal rock painting exist, some having been dated to 20,000 years, and several of the best are open to tourists. There is bushwalking, boating, and fishing, though it is wise to be wary of crocodiles. **8, 12, 29, 109–10, 122–3, 233–4, 263, 285, 291**

Flinders Ranges For thousands of years the Flinders Ranges were inhabited by the Adnyamathanha, or 'hill people', as they are now called.

The last full-blooded Adnya-mathanha died in 1973 but mixed-blood descendants still live there. The first European to observe the ranges was Matthew Flinders from the deck of his *Investigator* in 1802. The English explorer, E. J. Eyre (1815–1901) was the next European to visit, in 1839, and, during the following two years when exploring along the western side of the ranges, he encountered the series of vast salt lakes to the north, including **Lake Eyre**, Australia's largest lake (4000 square miles) which fills with water only once or twice in a quarter century. Within four years, the pastoral expansion had reached the southern edge of the region and beautiful **Wilpena Pound**: a spectacular natural oval amphitheatre about 12 miles by 5 miles. St Mary Peak (3900 feet), on its north-west, is the highest point in South Australia. In the second half of the nineteenth century, farmers used the Pound for sheep, cattle, and wheat. In the ranges in the 1920s uranium ore was mined for the production of radium, and later South Australia's only coal deposit was opened. The Flinders Ranges are cut by the theoretical 'Goyder's Line'. Goyder was the surveyor-general who drew a line on the map [actually the 10-in isohyet (line of equal rainfall)] separating land with sufficient rainfall for agriculture, from land suitable only for sheep and cattle. Optimistic farmers ignored his advice, and met disaster – here and there abandoned farmhouses provide witness. The Ranges are among the most accessible and popular of all outback tourist destinations. **4, 25**

Gold Coast and Hinterland This south-east Queensland string of seaside towns that coalesced is Australia's premier coastal holiday area (particularly **Surfers' Paradise**), with 25 miles of superb sunny beaches, and endless high-rise apartments and hotels to suit every pocket, as well as numerous theme parks, nature

Queensland House

reserves, sporting complexes, and theme-based shopping areas. **Tweed Heads**, across the NSW border, is part of the urban complex. The first holiday hotel was erected in 1888 but, until after World War II, there was little development except in **Southport**, the administrative centre. Since 1952, when building restrictions were removed, it has enjoyed a continual boom. Population trebles during the Christmas holidays.

To the south lie the fertile green fields of northern NSW with picturesque country towns such as **Murwillumbah**. In the hinterland behind the Gold Coast stands the spectacular mountain scenery of **Lamington National Park** with its great stretches of unspoiled highlands. Here the rainforest and hundreds of waterfalls provide the sources of the coastal rivers. Peaceful villages, such as Tamborine Mountain and Canungra with quaint tea and craft shops, offer a restful contrast to the coast. (The forest around Canungra is home to a special jungle training school for the Australian army.) Bush walks give superb views to the coast and inland. Of scientific interest are the unique 1000-year-old stands of Antarctic Beech trees. **110, 291**

Great Barrier Reef With an area of about 80,000 square miles, and extending for over 1250 miles along the Queensland coast, as far as we know this is the largest structure ever built by living organisms. It includes more than 350 species of coral and endless varieties of sea life. Mapping of the reef began in 1770 with James Cook, whose ship *Endeavour* tempo-

rally ran aground on it. The British Admiralty continued this survey work during the nineteenth century: Owen Stanley's ship, which took Kennedy's ill-fated exploring expedition to Cape York Peninsula (q.v.) in 1848, was charting a route for the new steamships. The 1928–29 Great Barrier Reef Expedition contributed the first large-scale systematic knowledge of the reef's coral physiology and ecology, and a modern laboratory on **Heron Island** continues such investigation. Borings have shown coral growth as early as the Miocene Epoch (25–5 m.y.a.). The multitudinous islands and white sand beaches within the reef form ideal vacation centres and, since World War II, hundreds of resorts, many of international standard, have been constructed on the **Whitsundays, Heron, Great Keppel**, and many other islands. Water is crystal clear with good visibility up to 100 feet. **4–6, 44–5, 167, 291**

Great Dividing Range runs the entire east coast of the continent, so called because it divides the rivers of the coastal plain from those that flow inland – systems such as the Darling and Murray (q.v.), and the rivers of the Gulf of Carpentaria. The section known as the **Blue Mountains** (q.v.), to the west of Sydney (q.v.), prevented movement to the inland for the first twenty-five years of the Sydney settlement. The highest and most extensively snow-covered section, on the Victorian-NSW border, is called the **Australian Alps** (q.v.). **4, 6, 7, 8**

Hobart and Tasmania Australia's second-oldest and most southerly city

(founded 1803) on the Derwent Estuary, Hobart was named after the then Secretary of State for the Colonies. Hobart has one of the world's deepest harbours, unhampered by tidal changes. By the 1820s Hobart had become a major port for whalers and sealers and, until mid-century, it was Australia's second-largest city. It has sustained less twentieth-century development than Australia's other capitals. As a result much of its nineteenth-century architecture still stands, as in Battery Point, The Glebe, and Salamanca Place, the now-restored sandstone warehouses of which were erected in the 1830s; Synagogue (Australia's earliest) (1845); Parliament House (1834); Town Hall (1864); old University (1890); Hobart's great Tasman Bridge (1965) was severed by an ore freighter in 1974.

Though largely mountainous, Tasmania has a diverse agricultural and mineral economy, with numerous hydro-electric projects for refining and for domestic use. The temperate rainforest and eucalyptus forests support many of the well-known Australian mammals and birds, and the unique marsupial carnivore, the Tasmanian Devil. It is believed that the Tasmanian Tiger (or Wolf), with its striking striped coat, is now extinct. All the holiday pleasures of Tasmania are within a few hours' drive of Hobart: close by **Mount Wellington**, often snow-capped; trout fishing in the highland lakes; surfing on Bass Strait beaches; bushwalking and white-water rafting in the magnificent, almost untouched **Tasmanian Wilderness World Heritage Area** in the south-west, where the Huon Pine trees can be 2000 years old; skiing during the short season on Ben Lomond and Mount Field; boating in Macquarie Harbour on the west coast; touring the former notorious convict settlement at **Port Arthur** (1836–77); sightseeing in **Launceston.** This second city of Tasmania, founded in 1804 at the headwaters of the Tamar River, was for its first 100 years one of the most significant towns in Australia. Launcestonians J. Batman and J. P. Faulkner were responsible for the founding of Melbourne (q.v.). St John's Church (1824–30), the pioneer Entally House (1820), Clarendon House (1838) one of the great rural residences of Australia, and Queen Victoria Museum provide reminders of early times. One of the world's first hydro-electric plants (1895) was constructed on rugged Cataract Gorge, a mile from the city centre, and now a spectacular public park. **4, 15–16, 39, 51, 62, 67, 72, 80, 81–4, 98, 135, 177–8, 194, 208, 226, 274**

Indian–Pacific and Nullarbor Plain Australia's most famous train journey, the Indian-Pacific, traverses the continent and the 2460 rail miles from Sydney to Perth in sixty-five hours. It crosses the dry NSW plains to **Broken Hill**, on to **Adelaide** (q.v.) in SA, and then to Port Augusta. The most famous and seemingly-endless section from Port Augusta to the gold-mining town of **Kalgoorlie** (q.v.) in Western Australia takes about twenty-four hours to cross, and was built to fulfil a promise made to WA

Eyre Highway across the desert of Nullarbor Plain

at the time of federation to link the eastern states with WA across 1100 miles of desert. The work on this section, begun in 1912, from the two existing railheads was completed in 1917, passing through the parched outback north of the Great Australian Bight, including the **Nullarbor Plain**. This plain straddles the Western Australia–South Australia border, and its first recorded crossing, at great peril, was by explorer E. J. Eyre in 1840. Its nearly 100,000 square miles of desolation form the world's largest flat surface. Here the Indian–Pacific runs on the world's longest straight stretch of railway line – 300 miles. Latinate 'Nullarbor' means 'no tree'.
Kalgoorlie-Boulder These classic

gold-rush towns about 370 miles east of Perth on the western fringe of the **Nullarbor Plain** (q.v.) were amalgamated in 1989. Gold was first found at nearby **Coolgardie** in 1892, but Patrick Hannan discovered the much larger Kalgoorlie deposits a year later, and these economically transformed the colony of Western Australia. The main area of deep rich ores became known as the 'Golden Mile'. Hannan's statue sits in front of the great 1908 town hall. On either side of main Hannan Street, wide enough to turn a camel-train, stand solid public buildings and self-important old hotels. Site of the Western Australian School of Mines (1903) the town's fortunes fluctuate according to world

gold prices, though nickel is now the chief product of the region. Water is brought by a 340-mile-long pipeline (completed in 1903), from the Mundaring Weir near Perth, built across the desert. **164–5**

The Kimberleys or, the Kimberley, are a sparcely populated rugged sandstone plateau region of about 140,000 square miles in far-north Western Australia, cut by picturesque gorges, such as **Geikie** and **Windjana**, and named for the 1880s' British colonial secretary. In the 1880s, following exploration by Alexander Forrest (later premier of WA), cattle grazing began, with a short-lived gold-rush in 1881. In the late 1880s Windjana Gorge was the site of the exploits of the black bushranger, Jundamarra (Pigeon), who for several years halted the white pastoral advance. Since World War II, some large-scale, moderately successful irrigation projects (Ord and Fitzroy Rivers) have produced rice, sugar-cane, and other tropical crops. In 1979 the world's largest diamond deposits were found at **Argyle**. There is spectacular scenery of river, gorge, and lake. **Broome** on Roebuck Bay, is the main town, 1392 road miles north of Perth (q.v.), with a 2700-foot jetty to overcome 30-foot tides. It lies on the coast first explored by the English buccaneer, William Dampier in 1688 and 1699, whose adverse reports helped discourage settlement until the discovery of pearls in 1883. Named after the then governor, Broome's pearl trade thrived until the 1930s (first with Aboriginal and later with Japanese

divers), and it now services the Kimberley cattle and tourist industries, and the huge offshore North-West Shelf oil and gas field. Severely bombed by the Japanese in World War II. **4, 5, 190, 234, 274, 289**

Melbourne and Region Melbourne stands on the River Yarra, on Port Phillip bay, first mapped by Matthew Flinders in 1802. Proclaimed capital of the colony of Victoria in 1851, this is the world's most southerly urban area of over a million people. Founded in 1835 by pastoral syndicates led by J. Batman and J. P. Fawkner from Tasmania, Melbourne was named for the British prime minister, and in 1836 the first government administrator arrived from Sydney. Melbourne growth was merely solid until 1851 and the discovery of vast gold-fields nearby at Ballarat and elsewhere. Boosted by gold, and later aided by Victoria's protectionist economy, it captured most of the colony's trade, constructed railways to all the leading Victorian towns between 1856 and 1873, and became an important manufacturing centre. Its astonishing growth made it the financial centre of Australia and the largest city by 1880. By then one of the world's metropolises with half-a-million people, it had facilities to match any in the new worlds. A financial crash began in 1889 and, seared by seven years of drought 1895–1902, the city remained in the economic doldrums until the beginning of the twentieth century. In the 1880s and '90s what is now the inner suburb of Heidelberg was a village where the first great group of

Australian painters, the Heidelberg School, came regularly to capture the landscape. Melbourne served as the federal capital from 1901 to 1927. Manufacturing was stimulated by the World Wars. After World War II Melbourne saw the arrival of large numbers of European migrants, which began the trend to its current multicultural character. Melbourne was laid out on a huge grid pattern by the Colonial Surveyor, in 1836, an intriguing innovation being the string of 'Little' streets between the main thoroughfares. The central city is surrounded by large parks and recreational areas. Notable are the Royal Botanic Gardens, the finest in the continent, founded in 1846, and given world significance by the work of their first government botanist, Ferdinand von Mueller. Numerous striking nineteenth-century public and ecclesiastical buildings still exist: the massive Law Courts; St Paul's Anglican Cathedral; Gothic Revival St Patrick's Catholic Cathedral (begun 1836, completed 1939); the University of Melbourne, opened in 1854, has a number of elegant Gothic-style buildings; the humble home of the first governor, La Trobe's Cottage (1840) prefabricated in Britain, forms a striking contrast to the imposing Government House (1872), a copy of Queen Victoria's palace on the Isle of Wight; a surprising number of buildings from Melbourne's boom period of the 1870s still survive, the three on the corner of Collins and Queens Streets being representative of the extravagance; the striking Parliament Building at the top of Bourke Street (begun in 1856 but still incomplete) and the huge Royal Exhibition Building (1880) in Carlton Gardens represent nineteenth-century Melbourne at its most confident. Spectacular twentieth-century architecture includes: the Victorian Arts Centre (1968), a vast modern complex housing theatres, studios, auditoriums, and art galleries, encompassing the National Gallery of Victoria (first opened elsewhere in 1861), with its splendid collection of Australian paintings; and the massive Shrine of Remembrance, inspired by the Temple of Halicarnassus, dedicated to Victorians killed in the World War I (1934).

Early Australian Rules Football was played in the 1850s where the Melbourne Cricket Ground (MCG) now stands. In 1877 the world's first cricket Test was played here between England and Australia, and the Centenary Test 100 years later. The MCG was the main stadium for the 1956 Olympics and is the site for the Australian Football Final each year. Flemington Racecourse hosts the Melbourne Cup, run annually since 1861. Melbourne Zoo, begun in 1861, is the third oldest in the world. From early times Port Phillip Bay has provided facilities for swimming, sailing, and fishing; and, to the northeast, the winter ski-slopes around **Mount Buller** are within easy reach. The city is but a half-day's driving distance from most of the tourist areas of the state.

Melbourne has retained its extensive early twentieth-century electric

tramway system. This is integrated with an equally extensive suburban rail network constructed in the nineteenth century, radiating from the striking Flinders Street Railway Station (1899). The 1970s and '80s witnessed major developments to the transport system, such as the huge Westgate Bridge over the lower Yarra River, linking the western and south-eastern suburbs, and the underground rail loop in the central city. Annual range of temperature is large, with some midsummer days over 100 °F.

Some 65 miles north-west of Melbourne, **Ballarat** was first settled as a sheep-rearing area in 1838. The largest of the cities that grew from the 1850s' gold rushes, it was the site of Eureka Stockade rebellion of gold miners (1854), now commemorated in a memorial. It has fine private and public buildings, many from the 1850s and 1860s. Mining continued until 1918. Gold-fields life is repro-duced at 'Old Ballarat' and 'Sovereign Hill' theme parks. There are Anglican and Roman Catholic cathedrals, and a university which has absorbed the famous School of Mines. South-west of Melbourne, and founded in 1837, **Geelong** was a port for the wool of clipper ships and still markets a sig-nificant proportion of the nation's wool and wheat. The closest port for the Ballarat gold-fields in the 1850s, it was depopulated by the rushes, but recovered. Here begins the **Great Ocean Road** along the south-west coast of Victoria, with its spectacular scenery – such as the **Twelve Apostles** ocean rock formation. About 40 per cent of the city area is

parkland; site of Deakin University (1977) and famous Geelong Gram-mar School (1854), it has several charming seaside resort towns nearby. **7, 8, 98–101, 137, 141–9, 150–2, 161, 170, 189, 242**

Murray-Darling Rivers Australia's greatest river system, named after the then Colonial Secretary, Sir George Murray, and the seventh governor of NSW, Lieutenant-General Ralph Darling. First put on the map by Hume and Hovell in 1824, and explored by Charles Sturt to its mouth in Lake Alexandrina in 1829, the Murray is 1609 miles long. Home of the river-boat trade in wool, wheat etc. (Murray River Navigation Co.) from 1851 until the coming of railways. Today vacation steamboats ply the Murray's waters. **Echuca** (founded 1855) with its mile-long wharf, and first iron bridge spanning the Murray (1878), became Australia's busiest inland port, now a centre for tourists and many restored steamboats. From 1885 **Mildura**, further west, became the centre of a large irrigation area using Murray River water to produce fruits and wines. Further east, **Albury-Wodonga**, with its spectacular rail-way station, was where customs were levied between Victoria and NSW in the nineteenth century, and where travellers changed trains because of the different railway gauges on the Mel-bourne–Sydney run; today a con-siderable manufacturing centre. Since the 1830s, the Murray valley has been of immense economic significance cutting as it does Australia's largest fertile plain, and Australia's most intensely settled wheat and sheep

region. Almost since its foundation, Adelaide (q.v.) has depended upon the Murray for its supplies of water. The Murray's main tributary, the Darling, is 1700 miles long. First mapped by Charles Sturt in 1829, it drains a semi-arid pastoral region, opened in the mid-nineteenth century.

In 1915 the Murray River Commission representing NSW, South Australia, Victoria, and the Commonwealth Government was established to regulate use of the waters. The **Dartmouth Dam**, on its tributary the Mitta Mitta, is 591 feet high, the highest in the Southern hemisphere. The multipurpose **Snowy Mountains Scheme** greatly increased the water carried by the Murray for irrigation, and the Murray's irrigated areas are easily the largest in the continent. There has been some negative impact upon the environment, and today the Murray releases into the ocean only about a quarter of the volume it released prior to European settlement. **6, 116–17, 160–1**

Newcastle and Hunter River Valley Some 100 road miles north of Sydney, Newcastle, at the estuarine mouth of the Hunter River, is Australia's greatest industrial city, based on the Hunter coal mines, BHP steel works (1915), and metallurgy. It began in 1801 as the tiny penal settlement of Coal Harbour. After 1915, a diversified industrialization followed, including metallurgy, engineering, textiles, and shipbuilding (*Aurora Australis*, Australia's modern Antarctic icebreaker was built here.) First visited by convicts in 1791, the

287-mile Hunter River was named for the second governor of NSW. Its fertile valley began producing wheat, wool, beef, and dairy products from the 1830s. The valley supplies the Newcastle steelworks with coal, and has become one of Australia's choicest wine-producing regions. There are fine cultural and educational institutions. **62, 110, 194, 216, 280**

New England is the region that straddles the **Great Dividing Range** (q.v.) in central-north NSW. Much of the region is an extensive 200 by 80-mile wooded plateau with 9000 square miles above 3000 feet – the most extensive high plateau in Australia. First settled in the 1830s, it supports mixed farming and mineral production. The plateau is the source of many rivers flowing to the coast and inland to the Murray-Darling system (q.v.). **The New England Highway**, which bisects the plateau, provides a popular alternative road route between Sydney (q.v.) and Brisbane (q.v.), and passes through the typical country towns of **Tamworth** ('capital' of Australian country music) just south of the plateau, **Armidale** (university, cathedrals, boarding schools), and **Glen Innes**, as well as the southern Darling Downs in Queensland. **91, 188–9**

Perth and Region Capital of Western Australia, Perth was founded in 1829 on the Swan River (Black Swans), and named for the Scottish county. Begun by private enterprise, its progress was painfully slow but increased somewhat when convicts were brought to Western Australia after 1850 at the request of the colo-

Town Hall, Perth *c.* 1870

nists. To the south lay the magnificent Jarrah hardwood forests, which provided one of the colony's earliest exports. Perth was linked to Adelaide by telegraph line in 1877, and burgeoned with the influx of miners following the gold discoveries in the 1890s at Kalgoorlie in the desert to the east, and the improvement of the harbour at Fremantle in 1901. The city was joined to the eastern states by the Trans-Australian Railway in 1917. As a result of vast Western Australian mineral finds of iron, natural gas, and diamonds, Perth has boomed in recent decades. King's Park gives spectacular views, has a notable statue of explorer-premier

John Forrest, and a circuit with a mile of plaques listing names of the state's soldiers killed in World War I. There are Roman Catholic and Anglican cathedrals, and the University of Western Australia, a few miles from the city (opened 1911), has a splendid set of architecturally unified buildings. The Perth Mint (1899) still produces Australia's gold, silver, and platinum bullion coins. North of the river mouth lies a string of excellent surfing beaches. The city has a moderate to warm Mediterranean climate for about eight months, but the early year is very hot.

Perth's port town of **Fremantle**, 12 miles from the city, has Australia's

best-preserved late-Victorian-Edwardian townscape, with whole streets virtually as they were constructed. The Maritime Museum displays an impressive section of the Dutch ship *Batavia* wrecked on the Western Australian coast in 1629. The large convict-built gaol is perhaps the best-preserved such nineteenth-century structure in the continent. Some 80 miles north is the Benedictine monastery of **New Norcia**, developed by Spanish monks from 1846 as a mission to the Aborigines. About 12 miles west, **Rottnest Island,** first settled in 1838, is popular with day-trippers. And 60 miles inland, **York**, Western Australia's oldest inland town (1831), has numerous restored colonial/Victorian buildings. **164, 186, 192–7, 275**

Shark Bay World Heritage Area lies about 400 miles north of Perth. The Shark Bay region, named by the English buccaneer, William Dampier, in 1699, was originally the home of the Nganda and Malgana Aboriginal peoples, with evidence of occupation from 22,000 years ago. The first European was Dutch navigator, Dirck Hartog, who landed in 1616 on the island that now bears his name. The area is rich in bird-life, amphibians, and reptiles, and renowned for its marine fauna, such as its 10,000 Dugongs (Sea Cows), the largest colony in the world, and the tame Bottle-nosed Dolphins of **Monkey Mia**, as well as for some of the most variegated and massive clusters of seagrass in the world. In hypersaline **Hamelin Pool** are the world's most diverse and abundant examples of the cushion-like stromatolites – formed by the world's oldest known living species of cyanobacteria, which evolved 3500 million years ago, and living examples of which may be several thousand years old. **38, 113**

Sydney, Australia's oldest and largest city, site of the first British settlement in 1788, is perhaps the most young in heart. It was named after Thomas Townshend, Lord Sydney, the Colonial Secretary. The best place to gain a feeling for its early history is Circular Quay, with the great bridge on one side, the rearing Opera House on the other, and the 'Tank Stream', the original source of water for the infant city now debouching from a large sewer beside Pier 6. It was here that the colonists landed and European Australia began, and it is still the centre of daily life with its railways, ferries, buses and taxis. Nearby, The Rocks, is presently a place to wander at leisure to savour the early colonial atmosphere, but was originally notorious for its crime and degradation. Named after its sandstone ridge, through which was hacked the Argyle Cut in convict times, it was tamed by demolition after an outbreak of plague in 1900, and later for the construction of the Bridge. Nearby in Argyle Place is Holy Trinity, the former British garrison church – rich in military memorabilia.

The harbour itself is a focal point of business and pleasure, and links the various parts of the city by ferry. The many beach suburbs to the south, such as Bondi and Coogee, and to the north, such as Manly and Palm Beach,

have facilities and surf equal to any in the world. Daytime surfing was forbidden in Sydney until the early twentieth century.

Among the steel and glass skyscrapers of the modern city can still be found graceful structures from earlier periods: Hyde Park Convict Barracks, St James's Church, and 'The Rum Hospital' (now serving as the Parliament House of NSW), all designed by early convict architect, Francis Greenway, and built during Macquarie's governorship; Cadman's Cottage (1816) on the western Quay, once directly on the beach, now 60 yards inland, is the oldest structure in central Sydney; the 'Ivanhoe Gothic' Government House in the Domain (1843); the Australian Museum (begun in the 1860s), Australia's largest museum of natural history; architecturally eclectic St Andrew's Anglican Cathedral (completed 1868); epitomic St Mary's Roman Catholic Cathedral (completed 1882); Art Gallery of NSW (1887), which still houses Australia's greatest collection; Queen Victoria Building (1898), now one of the world's most elegant shopping malls; elegant Edwardian structures on Macquarie Street now house leading businesses, lawyers, and doctors.

Sydney was the nineteenth-century Australian base for the Royal Navy, a succession of twelve British admirals supervising from Admiralty House at Kirribilli, opposite the Quay – now the official Sydney residence of the Australian governor-general. Sydney has remained the base for the Royal Australian Navy whose first

ships arrived in 1911. Some of the city's most handsome Georgian buildings grace the naval dockyard at Garden Island – the most southerly examples of the dockyard style which marked British bases around the world. In inner-city Paddington stands the fine Victorian military architecture of Victoria Barracks. A little further out is W. C. Wentworth's Gothic-Revival Vaucluse House, its grounds now a public park, and site of Sydney's most famous party in 1831 on the departure of unpopular Governor Darling; Sydney Church of England Grammar School occupies the original home of B. O. Holtermann the gold-rush millionaire; on Kurnell Peninsula in Botany Bay an obelisk and museum mark the spot where Cook landed in 1770.

The twentieth century has produced much of interest: the Sydney Harbour Bridge (1932) still the world's largest (not longest) single-arch bridge, designed by Australian J. C. Bradfield and built by Dorman Long of Britain; linked by monorail to down-town, nearby Darling Harbour recently rebuilt from former dockyards has radical modern architecture and museums; the extraordinary Sydney Opera House, which Sydneysiders treat like a club; Anzac Memorial in Hyde Park, with its glorious sculptures; the arcades of small shops, like some medieval town; Centrepoint Tower's spectacular views.

Of unique interest is the variety of suburbs. Inner-city Paddington, originally bourgeois, then proletarian, now 'gentrified', has striking streets of

terraced houses; in Burwood, the development called Appian Way (1911) looks like a bit of Newport RI; Castlecrag overlooking Middle Harbour has many of Burley Griffin's original houses, blending into nature; Haberfield has numerous federation-style houses; Manly and Bondi are models of seaside suburbs. Though **Parramatta** is now trapped in Sydney's urban sprawl, much of the original 1790 plan is still observable. A road was built as early as 1794 but, for decades, it was easier to bring people and goods up the river. Old Government House (1799), though added to over the years, is Australia's oldest public building and for several decades was an official home of the NSW governor. Nearby are Elizabeth Farm (begun 1793), originally home to the Macarthur sheep-industry pioneers, and Experiment Farm Cottage, erected on the land originally owned by Australia's first convict farmer, James Ruse. The elegant sandstone Lancers' Barracks, in use since 1820, are the oldest military establishment in the continent.

In many suburbs tangled gullies of bushland survive far below the connecting bridges. There is a diversity of parklands and themeparks: **Kuringai Chase National Park** (19 miles north), designated in 1894, remains in its natural state, giving exceptional views of Broken Bay; in Gosford *Old Sydney Town* imitates life in the convict era; Taronga Zoo, with Australia's largest selection of native animals, stands on a rocky peninsula a ferry ride from Circular Quay. **16, 44, 51–9, 71, 76–7, 95, 100, 151, 152–4, 171, 224, 226, 276–7**

Index

A TRAVELLER'S HISTORY OF CHINA

Stephen G. Haw

"Haw manages to get 2 million years in 300 pages – and he does it without gimmicks or colour pictures. An excellent addition to a series which is already invaluable. Whether you're travelling or not." **The Guardian (London)**

A Traveller's History of China provides a concise but fascinating journey from the country's earliest beginnings right up to the creation of the economic powerhouse that is today's China. Stephen Haw carries the reader back in time to the prehistoric civilizations of 4,000 years ago, and from there to the centuries of China's silk trade with the less-developed countries of Europe. Some of the most significant inventions of the pre-modern world, including paper, gunpowder and the magnetic compass originated in China and were transmitted to the West. The author describes the glories of the Tang and Song dynasties which saw the creation of the great Chinese cities to the period of its decline and the efforts of Europe to conquer and subdue this giant land. It covers the tumult and triumphs of the Chinese revolution and the dramatic changes in political policies since the late 1970s which have now made it one of the world's fastest-developing countries.

A TRAVELLER'S HISTORY OF INDIA

SinhaRajah Tammita-Delgoda

"For anyone . . . planning a trip to India, the latest in the excellent Traveller's History series . . . provides a useful grounding for those whose curiosity exceeds the time available for research." **The London Evening Standard**

India is heir to one of the world's oldest and richest civilizations and the origin of many of the ideas, philosophies and movements which have shaped the destiny of humankind.

For the traveller, India is both an inspiration and a challenge. The sheer wealth of Indian culture has fascinated generations of visitors. We see the sweeping panorama of Indian history, from the ancient origins of Hinduism, Jainism, Buddhism, and the other great religions, through the tumultuous political history of India's epic struggle against colonialism, to the ravages of Partition, Non-Alignment, and finally the emergence of India as a powerful modern state still grounded in the literature and culture of an ancient land. *A Traveller's History of India* covers the whole scope of India's past and present history and allows the reader to make sense of what they see in a way that no other guide book can.

A TRAVELLER'S HISTORY OF GREECE

Timothy Boatswain and Colin Nicolson

The many facets of Greece are presented in this unique book.

In *A Traveller's History of Greece*, the reader is provided with an authoritative general history of Greece from its earlier beginnings down to the present day. It covers in a clear and comprehensive manner the classical past, the conflict with Persia, the conquest by the Romans, the Byzantine era and the occupation by the Turks; the struggle for Independence and the turbulence of recent years, right up to current events.

This history will help the visitor make sense of modern Greece against the background of its diverse heritage. A Gazetteer, cross-referenced with the main text highlights the importance of sites, towns and ancient battlefields. A Chronology details the significant dates and a brief survey of the artistic styles of each period is given. Illustrated with maps and line drawings *A Traveller's History of Greece* is an invaluable companion for your holiday.

A TRAVELLER'S HISTORY OF ITALY

Valerio Lintner

In *A Traveller's History of Italy* the author analyses the development of the Italian people from pre-historic times right through to the imaginative, resourceful and fiercely independent Italians we know today.

All of the major periods of Italian history are dealt with, including the Etruscans, the Romans, the communes and the city states which spawned the glories of the Renaissance. In more modern times, Unification and the development and regeneration of the Liberal state into Fascism are covered, as well as the rise of Italy to the position it currently enjoys as a leading member of the European Community.

The Gazetteer, which is cross-referenced to the main text, highlights sites, towns, churches and cathedrals of historical importance for the visitor.

A TRAVELLER'S HISTORY OF JAPAN

Richard Tames

Whether you are going to Japan on business, to study, to teach or simply on holiday, you know that you are going to a country which really does merit the title 'unique'. A century ago the first modern guidebook to Japan warned the visitor that 'he ... who should essay to travel without having learnt a word concerning Japan's past, would still run the risk of forming opinions ludicrously erroneous.' This is still sound advice.

A Traveller's History of Japan not only offers the reader a chronological outline of the nation's development but also provides an invaluable introduction to its language, literature and arts, from *kabuki to karaoke*. Political, social and industrial history and economics are also well covered; this clearly written history explains how a country embedded in the traditions of Shinto, Shoguns and Samurai has achieved stupendous economic growth and dominance in the twentieth century.

There is a Historical Gazetteer, cross-referenced to the main text and particular attention is paid to the classic historical sites which feature on any visitor's itinerary. Special emphasis is given to the writings and reactions of travellers through the centuries.

A TRAVELLER'S HISTORY OF TURKEY

Richard Stoneman

A Traveller's History of Turkey offers a full and accurate portrait of the region from Prehistory right up to the present day. Particular emphasis is given to those aspects of history which have left their mark in the sites and monuments that are still visible today.

Modern Turkey is the creation of the present century, but at least seven ancient civilisations had their homes in the region. Turkey has also formed a significant part of several empires – those of Persia, Rome and Byzantium, before becoming the centre of the opulent Ottoman Empire. All of these great cultures have left their marks on the landscape, architecture and art of Turkey – a place of bewildering facets where East meets West with a flourish.

Richard Stoneman's concise and readable account covers everything including the legendary Flood of Noah, the early civilisation of Çatal Hüyük seven thousand years before Christ, the treasures of Troy, Alexander the Great, the Romans, Selcuks, Byzantines and the Golden Age of the Sultans to the twentieth century's great changes wrought by Kemal Atatürk and the strong position Turkey now holds in the world community.

A TRAVELLER'S HISTORY OF FRANCE

Robert Cole

"Undoubtedly the best way to prepare for a trip to France is to bone up on some history. The Traveller's History of France by Robert Cole is concise and gives the essential facts in a very readable form" **The Independent on Sunday**

"Hundreds of thousands of travellers, visit France each year. The glories of the French countryside, the essential harmony of much of French architecture, the wealth of historical remains and associations, the enormous variety of experience that France offers, act as a perennial and irresistible attraction. For these visitors this lively and useful guide provides the essential clues to an understanding of France's past, and present, in entertaining and sometimes surprising detail"
From the Preface by the Series Editor, Denis Judd.

In *A Traveller's History of France*, the reader is provided with a comprehensive and yet very enjoyable, general history of France, from earliest times to the present day.

An extensive Gazetteer which is cross-referenced with the main text pinpoints the historical importance of sites and towns. Illustrated with maps and line drawings *A Traveller's History of France* will add to the enjoyment of every holidaymaker who likes to do more than lie on a beach.

A TRAVELLER'S HISTORY OF PARIS

Robert Cole

". . . an excellent resource . . . Robert Cole presents a complete picture of this historic city . . ." **Small Press**

Paris, in many people's thoughts, is the epitome of the perfect city – beautiful, romantic and imbued with vitality and culture. It is a wonderful place to visit and to live.

Packed with fact, anecdote and insight. *A Traveller's History of Paris* offers a complete history of Paris and the people who have shaped its destiny, from its earliest settlement as the Roman village of *Lutetia Parisiorum* with a few hundred inhabitants, to 20 centuries later when Paris is a city of well over 2 million – nearly one-fifth of the population of France.

This handy paperback is fully indexed and includes a Chronology of Major Events, a section on Notre-Dame and historic churches. Modernism. Paris parks, bridges, cemeteries, museums and galleries, the Metro and The Environs. Illustrated with line drawings and historical maps, this is an invaluable book for all visitors to read and enjoy.

A TRAVELLER'S HISTORY OF ENGLAND

Christopher Daniell

A Traveller's History of England gives a comprehensive and enjoyable survey of England's past from prehistoric times right through to the 1990s.

All the major periods of English history are dealt with, including the Roman occupation, and the invasions of the Anglo-Saxons, Vikings and Normans, and the power struggles of the medieval kings. The Reformation, the Renaissance and the Civil War are discussed, as well as the consequences of the Industrial Revolution and urbanism, and the establishment of an Empire which encompassed a quarter of the human race. In this century the Empire has been transformed into the Commonwealth, two victorious, but costly, World Wars have been fought, the Welfare State was established, and membership of the European Union was finally achieved.

Illustrated throughout with maps and line drawings, *A Traveller's History of England* offers an insight into the country's past and present and is an invaluable companion for all those who want to know more about a nation whose impact upon the rest of the world has been profound.

A TRAVELLER'S HISTORY OF LONDON

Richard Tames

A full and comprehensive historical background to the capital's past which covers the period from London's first beginnings, right up to the present day – from *Londinium* and *Lundenwic* to Docklands' development. London has always been an international city and visitors from all over the world have recorded their impressions and these views have been drawn on extensively throughout this book.

At different points in London's 2000-year history, it has been praised for its elegance and civility and damned for its riots, rudeness, fogs and squalor. Visitors and London's own residents will enjoy discovering more about the city from this fascinating book.

There are special sections on the Cathedrals, Royal Palaces, Parks and Gardens, Railway Termini, The Underground, Bridges, Cemeteries, Museums and Galleries, The London Year as well as a full Chronology of Major Events, Maps and Index.

A TRAVELLER'S HISTORY OF SCOTLAND

Andrew Fisher

'. . . the book is an extremely enjoyable journey through our nation's past.'

A Traveller's History of Scotland begins with Scotland's first people and their culture. Before the Vikings in 900 it was a land of romantic kingdoms and saints, gradually overtaken by more pragmatic struggles for power. Centuries of strife lead up to the turbulent years of Mary Queen of Scots, the Calvinistic legacy of Knox, and the bitterness of final defeat.

The dreams of the Jacobites are contrasted with the cruel reality of the end of the Stuarts and the Act of Union with England. Scotland now saw an age of industry and despoliation. The result was much emigration and an obsession with the nation's past which glorified the legends of the Highlander and the Clans. In this century, the loss of identity and drift to the south have been followed by a new surge of national pride with higher aspirations for the future. In the millenium the effects of devolution and a separate Scottish parliament are eagerly awaited.

A Traveller's History of Scotland explains the roots of Scottish history and is an invaluable companion for visitors.

A TRAVELLER'S HISTORY OF IRELAND

Peter Neville

A Traveller's History of Ireland gives a full and accurate portrait of Ireland from Prehistory right up to the 1990s.

Hundreds of thousands of tourists visit Ireland every year drawn by the landscape, the people and the underlying atmosphere created by its rich heritage.

The story opens with mysterious early Celtic Ireland where no Roman stood, through Saint Patrick's mission to Ireland which began the process of making it 'an island of saints', to the struggle with Viking and Irish enemies alike.

It moves through the arrival of the Norman 'Strongbow' in the twelfth century, and the beginnings of the difficult and tragic Anglo-Irish relationship. Great historical figures like Hugh O'Neill, Cromwell, and Jonathan Swift figure as well as ordinary people like the Londonderry 'apprentice boys; who helped change the course of Irish history. Then into modern times with the great revolts of 1798, the horrors of the Potato Famine and the careers of the leading constitutional nationalists, O'Connell and Parnell. The book ends with a description of modern Ireland, and of its two separate Catholic Nationalist and Protestant Unionist traditions.

A TRAVELLER'S HISTORY OF THE CARIBBEAN

James Ferguson

A concise and authoritative history of the entire region covering the larger nations of the Bahamas, Cuba, Jamaica, Haiti, the Dominican Republic, Puerto Rico and Trinidad and Tobago as well as the smaller islands of the Eastern Caribbean and the French, British and Dutch territories.

The Caribbean, a region of spectacular natural beauty, has a turbulent history of colonialism, slavery and resistance in which people from all continents have played their part. Described by Columbus as an earthly paradise, the Caribbean has long enticed foreigners with its promise of wealth. From the gold-seeking exploits of the Spanish conquistadors to modern-day tourist cruises, the islands have exerted a fascination on generations of visitors.

Tracing the islands' path from slavery to revolution and independence, *A Traveller's History of the Caribbean* looks at the history of countries as different as Cuba, Jamaica and Haiti, explaining their diversity and their common experiences. It reveals a region in which a tumulous past has created a culturally vibrant and intriguing present.

A TRAVELLER'S HISTORY OF NORTH AFRICA

Barnaby Rogerson

"Remarkable – Barnaby Rogerson has succeeded in isolating all the different strands of North African history and weaving them into a clear and comprehensive narrative. No one interested in the Maghreb can afford to be without this book.' **– John Julius Norwich**

This Traveller's History covers the countries of Morocco, Tunisia, Libya and Algeria and is written by an expert on the area. It endeavours to provide a concise and readable history of the region's journey from its earliest beginnings right up to the politics and life of the present day.

North Africa is an island surrounded by three seas, the Mediterranean, the Atlantic and to the south by the sand sea of the Sahara. It has seen wave upon wave of invasion break on its rocky shores. From the Carthaginians in the fifth century BC to the French in the twentieth century, the North African people have assimilated what suits them and remained resiliently aloof to what does not.

Onto this complex cultural background *A Traveller's History of North Africa* weaves a cast of memorable characters. Dido, the lovelorn Queen of Carthage, Hannibal, the general's general and St Augustine all play their part, as do such lesser-known luminaries as the Berber queen Kahina and the horseback Muslim conqueror Oqba Ibn Nafi'.

For travellers on the ground or students at their desks, this handy paperback will prove invaluable for sorting out the Almohads from the Almoravids and for explaining the dazzling wealth and art of Roman North Africa.

GAYLORD S